Arts and Aesthetics in a Glo...

ASA Monographs

ISSN 0066–9679

The Relevance of Models for Social Anthropology, ed M. Banton
Political Systems and the Distribution of Power, ed M. Banton
Anthropological Approaches to the Study of Religion, ed M. Banton
The Social Anthropology of Complex Societies, ed M. Banton
The Structural Study of Myth and Totemism, ed E. R. Leach
Themes in Economic Anthropology, ed R. Firth
History and Social Anthropology, ed I. M. Lewis
Socialization: The Approach from Social Anthropology, ed P. Mayer
Witchcraft Confessions and Accusations, ed M. Douglas
Social Anthropology and Language, ed E. Ardener
Rethinking Kinship and Marriage, ed R. Needham
Urban Ethnicity, ed A. Cohen
Social Anthropology and Medicine, ed J. B. Loudon
Social Anthropology and Law, ed I. Hamnett
The Anthropology of the Body, ed J. Blacking
Regional Cults, ed R. P. Werbner
Sex and Age as Principles of Social Differentiation, ed J. La Fontaine
Social and Ecological Systems, ed P. C. Burnham and R. F. Ellen
Social Anthropology of Work, ed S. Wallman
The Structure of Folk Models, ed L. Holy and L. Stuchlik
Religious Organization and Religious Experience, ed J. Davis
Semantic Anthropology, ed D. Parkin
Social Anthropology and Development Policy, ed R. Grillo and A. Rew
Reason and Morality, ed J. Overing
Anthropology at Home, ed A. Jackson
Migrants, Workers, and the Social Order, ed J. S. Eades
History and Ethnicity, ed E. Tonkin, M. McDonald and M. Chapman
Anthropology and the Riddle of the Sphinx: Paradox and Change in the Life Course, ed P. Spencer
Anthropology and Autobiography, eds J. Okely and H. Callaway
Contemporary Futures: Perspectives from Social Anthropology, ed S. Wallman
Socialism: Ideals, Ideologies and Local Practice, ed C. M. Hann
Environmentalism: The View from Anthropology, ed K. Milton
Questions of Consciousness, eds A. P. Cohen and N. Rapport
After Writing Culture: Epistemology and Praxis in Contemporary Anthropology, eds A. James, A. Dawson and J. Hockey
Ritual, Performance, Media, ed F. Hughes-Freeland

The Anthropology of Power, ed A. Cheater
An Anthropology of Indirect Communication, ed J. Hendry and C. W. Watson
Elite Cultures, ed C. Shore and S. Nugent
Participating in Development, eds P. Sillitoe, A. Bicker and J. Pottier
Human Rights in Global Perspective, ed R. A. Wilson and J. P. Mitchell
The Qualities of Time, eds W. James and D. Mills
Locating the Field: Space, Place and Context in Anthropology, eds S. Coleman and
 P. Collins
Anthropology and Science: Epistemologies in Practice, eds J. Edwards, P. Harvey
 and P. Wade
Creativity and Cultural Improvisation, eds E. Hallam and T. Ingold
*Anthropology and the New Cosmopolitanism: Rooted, Feminist and Vernacular
 Perspectives*, ed P. Werbner
Thinking Through Tourism, ed J. Scott and T. Selwyn
Ownership and Appropriation, eds V. Strang and M. Busse
Archaeology and Anthropology, ed D. Shankland
The Interview: An Ethnographic Approach, ed J. Skinner
Living Beings: Perspectives on Interspecies Engagements, ed Penelope Dransart

ASA Publications Officer and Series Editor
James Staples (Brunel University, UK)

All chapters accepted for inclusion in ASA volumes are sent out for peer review
to two or more reviewers in addition to the volume editor. The ASA draws on the
expertise of its Editorial Board – appointed from the ASA membership – in selecting
appropriate peer reviewers.

Editorial Board
Aleksandar Boskovic (University of Belgrade, Serbia); Glenn Bowman (University
of Kent, UK); Pat Caplan (Goldsmiths, University of London, UK); Emma Crewe
(SOAS, University of London, UK); Geert De Neve (University of Sussex, UK);
Wenzel Geissler (University of Oslo, Norway, and London School of Hygiene
and Tropical Medicine, UK); John Gledhill (University of Manchester, UK);
Andrée Grau (University of Roehampton, UK); Jakob Klein (SOAS, University
of London, UK); Chris Knight (Radical Anthropology Group); Roland Littlewood
(UCL, UK); Nayanika Mookherjee (Durham University, UK); Julie Scott (London
Metropolitan University, UK); Mitch Sedgewick (Oxford Brookes University, UK);
Jonathan Skinner (Queens University, Belfast, Northern Ireland); Marilyn Strathern
(University of Cambridge, UK); Christina Toren (University of St Andrews,
UK); Maya Unnithan (University of Sussex, UK); Pnina Werbner (University of
Manchester, UK); Gisa Weszkalnys (LSE, UK).

Arts and Aesthetics in a Globalizing World

Edited by
Raminder Kaur and Parul Dave-Mukherji

Bloomsbury Academic
An imprint of Bloomsbury Publishing Plc

B L O O M S B U R Y
LONDON • NEW DELHI • NEW YORK • SYDNEY

Bloomsbury Academic
An imprint of Bloomsbury Publishing Plc

50 Bedford Square	1385 Broadway
London	New York
WC1B 3DP	NY 10018
UK	USA

www.bloomsbury.com

BLOOMSBURY and the Diana logo are trademarks of Bloomsbury Publishing Plc

First published 2014

© The Association of Social Anthropologists, 2014

The Association of Social Anthropologists has asserted its right under the Copyright, Designs and Patents Act, 1988, to be identified as Author of this work.

British Library Cataloguing-in-Publication Data
A catalogue record for this book is available from the British Library.

ISBN: HB: 978-1-4725-1930-6
PB: 978-1-4725-1931-3
ePDF: 978-0-8578-5759-0
ePub: 978-0-8578-5547-3

Library of Congress Cataloging-in-Publication Data
A catalog record for this book is available from the Library of Congress.

Typeset by Fakenham Prepress Solutions, Fakenham, Norfolk NR21 8NN
Printed and bound in India

Contents

List of Illustrations

Plates

1 Faith Ringgold, *Picasso's Studio*, 1991.
2 Raqs Media Collective Installation view with Raqs Media Collective, *The Great Bare Mat*, 2012; and *The Vinegar Tasters*, Japan, Kanō School, 17th century.
3 Sheba Chhachhi's *The Winged Pilgrims,* 10 moving image light boxes (digital print on dura trans), 5 Silk and fibreglass Robe objects with motion lamps, sound, 2006–8.
4 Francesco Clemente (in collaboration with an Oriya artist), *Story of My Country – I*, pigment on rag board, 23 × 40 cm.
5 'Terribly sympathetic', *The Realm of the Absurd*, lithograph, by Gaganendranath Tagore, Calcutta, 1917.
6 'Astronomical scream. The first Bengali Governor. Where is H.E.?', watercolour on postcard, preparatory sketch for lithograph, by Gaganendranath Tagore, Calcutta, 1919.
7 'Premier scream, Montford in labour – behold the outcome', *Reform Screams*, lithograph, by Gaganendranath Tagore, Calcutta, 1921.
8 Cloud Gate, Millennium Park, Chicago.
9 Sky Mirror, by Anish Kapoor. Kensington Gardens, London.
10 Cloud Gate's 'Omphalos', Millennium Park, Chicago.
11 John Yesayas, billboard of Jesus overlooking Ambon Island, Ambon, 2006.
12 John Yesayas, billboard at the entrance to a Christian neighbourhood, Ambon, 2011.
13 John Yesayas, painting after a mural: Jesus overlooks the destruction of the Silo church, 2005.
14 *Aj ke Dhritarashtra* (Today's Dhritrashtra). A Photoshopped placard displayed at the Ramlila Maidan protest. Mother India is shown being disrobed in the centre of the image, Anna Hazare appears incarnated as Krishna on the left and a blind Manmohan Singh (the Prime Minister) appears on the right above Salman Kalmadi and A. Raja.
15 A modern Karni Bharni image showing actions and their punishments in hell. Photographed in rural Madhya Pradesh in 2011.

Figures

Notes on Contributors

Giulia Battaglia is a postdoctoral fellow in visual anthropology at the Musée du Quai Branly, Paris. She holds a PhD in Social Anthropology from SOAS, University of London, and taught in the department of Media and Communications at the LSE. She has researched and published on documentary film practices in India. Her current research focuses on ethnographic practices of image-making and image-sharing in India.

Christiane Brosius holds the Chair of Visual and Media Anthropology at the Heidelberg Centre for Transcultural Studies. With a background in Cultural and Social Anthropology, Art History and Art Education, her main regional foci are North India and Nepal, where she studies urban spatialization; youth culture, gender and media representations, as well as artistic production and networks. Brosius also co-organizes Tasveer Ghar/House of Pictures: A Digital Network of South Asian Popular Visual Culture (www.tasveerghar.net).

Parul Dave-Mukherji is Professor at the School of Arts and Aesthetics, Jawaharlal Nehru University, New Delhi, India. She holds a PhD in Indology from Oxford University. Her recent publications include *InFlux – Contemporary Art in Asia* (New Delhi, Sage, 2013, co-edited) and forthcoming *20th Century Indian Art* (Skira, co-edited). Her research interests include global art history and comparative aesthetics.

Paolo Favero is Associate Professor in Film Studies and Visual Culture at the Department of Communication Studies, University of Antwerp. He has devoted the core of his career to the study of visual culture in India and Italy and presently conducts research on image-making practices in contemporary India.

Mattia Fumanti teaches social anthropology at the University of St Andrews. He has conducted anthropological research in Namibia, elite formation among Kavangos; Ghana, religious and family transnational networks; and London, Methodism in the Akan Diaspora. Fumanti has published several edited volumes and articles in peer-reviewed journals. This is his third co-edited work with Professor Pnina Werbner.

Andrea Grieder received her PhD from École des Hautes études en Sciences Sociales, Paris and the University of Zurich. Her dissertation *Hills of a thousand*

memories explores ways of dealing with the traumatic past in post-genocide Rwanda. She initiated the culture events *Rwanda: Words and Images on Beauty and Death* and teaches Trauma and Genocide Studies as well as poetry classes.

Raminder Kaur is Professor of Anthropology and Cultural Studies at the University of Sussex. She is the author of *Atomic Mumbai* (2013) and *Performative Politics and the Cultures of Hinduism* (2003/5). She is also co-author of *Diaspora and Hybridity* (2005), and co-editor of *Censorship in South Asia* (2009), *Bollyworld: Popular Indian Cinema Through A Transnational Lens* (2005) and *Travel Worlds* (1999).

Akshaya Kumar is a doctoral candidate at the University of Glasgow where he is working on the political economy of India's vernacular media as one of the first two recipients of a *Screen* fellowship. He has published essays and reviews in *South Asian Popular Culture* and other journals.

Soumendra Patnaik is Professor of Anthropology at University of Delhi. He has done fieldwork among indigenous communities of north-east and central India, Nepal and Sri Lanka. His research publications focus on development policy and practice, displacement and resettlement, and the anthropology of globalization and tourism. Currently he is President of the Indian Anthropological Association.

Christopher Pinney is Professor of Anthropology and Visual Culture at University College London. From 2007–9 he was Visiting Crowe Professor in the Department of Art History at Northwestern University. His publications include *Photography and Anthropology* (Reaktion, 2011), *The Coming of Photography in India* (British Library, 2008), *'Photos of the Gods': The Printed Image and Political Struggle in India* (Reaktion, OUP, 2004) and *Photography's Other Histories* (co-edited with Nicolas Peterson, Duke University Press, 2003).

Susanne Schmitt obtained her PhD in anthropology with a sensory ethnography of a medical history museum as a workplace from the University of Munich, where she was also a research associate at the Department of Sociology. Her new research is on aquarium design strategies and related affective and sensory politics of biodiversity conservation. She works in academic, applied and artistic contexts.

Atreyee Sen is Lecturer in Contemporary Religion and Conflict in the Department of Religions and Theology, University of Manchester. She is an urban anthropologist of South Asia with a research interest in social inequality and violence. She is the author of *Shiv Sena Women: Violence and Communalism in a Bombay Slum* (2007) and the co-editor of *Global Vigilantes* (2008).

Patricia Spyer is Chair of Cultural Anthropology of Contemporary Indonesia at Leiden University and was Global Distinguished Professor at New York University from 2009–12. She is the author of *The Memory of Trade*, editor of *Border Fetishisms*, co-editor of the *Handbook of Material Culture* and of *Images That Move*.

Leili Sreberny-Mohammadi is a PhD candidate in Socio-Cultural Anthropology at New York University. Her research is concerned with collection practices of contemporary Middle Eastern art in Europe and the Middle East.

Marilyn Strathern is Emeritus Professor of Social Anthropology, Cambridge University. Her ethnographic forays are divided between Papua New Guinea and Britain. Over the last twenty years she has written on reproductive technologies; on audit and accountability; and on intellectual and cultural property, which renewed an earlier interest in art forms.

Emilia Terracciano has a PhD from the Courtauld Institute of Art (2013). She was the recipient of the Nehru Trust Award (2008) and the AHRC Collaborative Doctoral Award at the Victoria and Albert Museum (2008–12). She teaches at the Sotheby's Institute of Art and University College London. Her book *In the Eye of Emergency: Modernism and Art in Colonial and Postcolonial India* is forthcoming with I. B. Tauris.

Denis Vidal is a social anthropologist, a Senior Research Fellow at IRD (URMIS-Paris Diderot) and an Associate Professor at the Musée du Quai Branly and at Hautes études en Sciences Sociales, Paris. His current research focuses on visual culture and on new ways of approaching technology from an anthropological perspective.

Shiv Visvanathan is Professor at the School of Government and Public Policy at the O. P. Jindal Global University. He has been visiting Professor at Stanford University; Arizona State University; University of Maastricht, the Netherlands; University of Natal, South Africa; Goldsmiths, University of London; Henry Luce Visiting Professor, Smith College, Massachusetts; and Distinguished SARCHI Fellow at UNISA, South Africa. He is the author of *Organizing for Science* (OUP, 1984) and *Carnival for Science* (OUP, 1997) and co-author of *Foul Play: Chronicles of Corruption* (Banyan books, 1997).

Pnina Werbner is Professor Emerita of Social Anthropology, Keele University, author of 'The Manchester Migration Trilogy' – *The Migration Process* (1990/2002), *Imagined Diasporas* (2002) and *Pilgrims of Love* (2003) – and of *The Making of an African Working Class* (Pluto Press, 2014), and editor of several theoretical collections on hybridity, cosmopolitanism, multiculturalism, migration and citizenship.

Foreword

Arts and Aesthetics in a Globalizing World has arisen out of a collaboration between the Association of Social Anthropologists (ASA) with the School of Arts and Aesthetics and the Centre for the Study of Social Sciences at Jawaharlal Nehru University (JNU) in Delhi.[1] Following the precedent set by the ASA conference in Arusha, Tanzania in 2002, for 2012 we had wanted to co-organize an international conference in India, a country to which in our various ways we owed a particular debt – whether by dint of birth, education, residence, heritage, or the place of our fieldwork and continuing inspiration – and we had wanted to share and engage our work with those numerous scholars and students who were based in the region, including in neighbouring countries. It is for this reason that the conference attracted a high percentage of South Asianists. But the focus was by no means limited to the subcontinent, and in this volume on the theme of art and aesthetics, in their widest senses, we have also taken care to include outstanding contributions from established and emerging scholars, focusing on countries as wide-ranging as Iran, Indonesia, Russia, Rwanda and Germany, as well as those who take transnational or diasporic perspectives.

Throughout the 52 panels and four plenary sessions in Delhi, conference delegates were encouraged to reassess Eurocentric assumptions about arts and aesthetics, and presented highly stimulating works around a cluster of themes including anthropological understandings of the work of contemporary artists, artistic practice and indigenous artworks. Investigations of media such as cinema, photography, digital technologies, literature, music, along with cultural performances, spectacle and experimental arts also provided much food for thought. The affective materiality of lives was reconsidered with a consideration of clothing, fashion and jewellery, among other artefacts. Politics directly entered the discussions via the aesthetics of protest, movements, social justice and governance, while the ecologies of aesthetics were investigated through foci on landscape, tourism, natural resources and their interface with local lives. The body became a prime site in the consideration of healing and the arts. Multisensory communion between the mundane and the other-worldly were also examined with a focus on the material and sensory aspects of religion, conversion, ritual and religion. And the conventional distinction between the arts and sciences was eroded in view of enquiries into the aesthetics of science, technologies and representations.[2] In the limited scope of this book, we have tried to incorporate a flavour of all of these myriad perspectives, and would like to thank all those who made the conference a memorable success.

Notes

1. The organizing committee comprised of Susan Visvanathan, Parul Dave-Mukherji, Raminder Kaur, Anand Kumar, Bharat Kumar, Vivek Kumar, Nilika Mehrotra, Ranjani Mazumdar, Bimol, Nayanika Mookherjee, Atreyee Sen, G. Srinivas, James Staples and Rohan Jackson. Those on the advisory committee included Sharon Macdonald (University of Manchester), Soumendra Patnaik (University of Delhi), Christopher Pinney (UCL) and Renuka Singh (Centre for the Study of Social Systems, JNU, Delhi). A special thanks to James Staples for his help in bringing this volume to fruition and for overseeing the peer reviews of the chapters.
2. The Firth lecture that was presented by Professor Ghassan Hage during this conference entitled 'The transnational family as an aesthetic field' is available on the ASA website, www.theasa.org

1

Introduction

Raminder Kaur, University of Sussex and Parul Dave-Mukherji, Jawaharlal Nehru University

The art of knowing is knowing what to ignore.

Jalāl ad-Dīn Muḥammad Rūmī

The world is a work of art that gives birth to itself.

Friedrich Nietzsche

Artworks and artworlds have never been far from the anthropological remit, nor anthropological enquiry divorced from artistic practice, art history and theory. They have lurked in each other's shadows, tracing and embracing while suspecting and misrecognizing. In the process, age-old anthropological conundrums concerning universalism versus relativism, as well as thorny issues about semantics and definitions have regularly been raised. Art's separation from quotidian life has increasingly come under critical scrutiny even as Eurocentric notions of its autonomy continue to have an enduring presence both within and outside of Europe. Our emphasis in this volume on the arts in the plural is to encompass this transnational nexus of artworlds but also those that are ordinarily not seen as art as per salon or gallery definitions (Becker 1984; Bundgaard 1999; Jain 2007). If anthropology has powerfully shaped art history's broadening into vernacular terrain, the latter has compelled anthropologists towards a closer engagement with the sensuality of perception, aesthetic affect and the centrality of visuality in a mediatized world. The increasing migration and mobility of people, objects, ideas, images and other sensory data demands a globalizing perspective and a post-national geography, a drive that has not come without its oppositions in the (re)entrenchment of borders, physical, cultural and epistemological.

How one defines art, who has the authority to define it as such and what might be excluded from such definitions are, of course, all open to debate, while aesthetics

might also be explored more broadly not only as applying to concrete objects, but also to processes of production and contexts of meaning, affect, performance and (re)interpretation (Gell 1998; Pinney and Thomas 2001). Our emphasis on aesthetics is to include but also to move away from the visual (or audio-visual) to embrace more synaesthetic realms, the multisensory (Howes 1991; 2004) and the bodily (Csordas 1994; Desjarlais 1992), as well as enabling an engagement with more political ideas about aesthetics as ideology (Bloch 1980; Redfield 2003), surplus and/or resistance (Lyotard 2011; Rancière 2006; Hinderliter and Maimon 2003). In so doing, we appreciate the *work* that goes into the production of objects, an ensemble, a process or performance for sensory and intellectual contemplation as much as the *work* the assemblage performs in its *aesthetic effects*. Similarly, adapting Arthur Danto's (1964) original meaning for 'artworld' – the idea that art is designated when the context decrees it as worthy of artistic appreciation – we extend 'artworlds' here to include the multiple contexts and sites of production and reception, all the time crossing temporal and spatial zones. On the basis of this foundational flux, we can then hone in on semantic, affective and purposive densities converging on the world and the work of the artform.

From the early twentieth century when anthropology was attempting to establish itself as a serious science under the tutelage of Bronislaw Malinowski and others, arts and aesthetics *sui generis* were ignored as Western preoccupations with a purportedly autonomous zone that did not quite match with other culturally inflected ideational and sensory arenas. When artworks were considered in other cultural contexts, they were largely compressed into a functionalist frame, appreciated more for their socio-political dimensions. Conversely, art history for the most part prioritized the ideational, with other aspects of the circulation and reception of artworks largely overlooked. At once defining and dissolving disciplines, art and anthropology have forged a firmer and more communicable relationship in more recent decades (Marcus and Myers 1995; Schneider and Wright 2006, 2010), while also bringing into the frame other disciplinary insights, including those drawn from social history (e.g. Baxandall 1972), sociology (e.g. Becker 1982; Bourdieu 1984) and archaeology (see Shankland 2011).

Prominent among early anthropologists to consider artworks seriously was Franz Boas. He was keen to challenge ideas that 'primitive art' was somehow a relic or debased form of Western civilization, noting its inherently dynamic character. In his 1927 publication, *Primitive Art*, almost anticipating contemporary concerns, he wrote: 'Wherever we have detailed information, we see forms of objects and cultures in constant flux, sometimes stable for a period, then undergoing rapid changes' (Boas 1955: 7). With his focus on elucidating the 'formal elements' of 'primitive art', Boas threw light on representative art, symbolism, style, literature, music and dance particularly as it applied to the artworks of North Pacific Coast Native Americans. He went on:

> Muscular, visual and auditory sensations are the pleasures that give us esthetic [sic] pleasure and that are used in art. We may also speak of impressions that appeal to the sense of smell, taste and touch. A composition of scents, a gastronomical repast may be called works of art provided they excite pleasurable sensations. (Boas 1955: 10)

Universalist ambitions aside, some of Boas' 'gastronomical' observations ring true in the light of more recent research on the public reception of olfactory and other sensory experiences that move the definition of aesthetics beyond the ocularcentricism of visual anthropology.

Likewise, from a postcolonial perspective, the much-overlooked work of the exiled German anthropologist Julius Lips (1937) zooms into prominence with contemporary resonance. Lips, with his illustrated book on the motif of the white man appearing in 'primitive art', points to the fluid and yet contested exchanges between the colonizer and the colonized (see Taussig 1993; Bhabha 1993). He accorded the usually 'objectified' with the means to 'strike back'. Collated in a context of rising fascism in 1930s Europe and defying the authenticity attributed to holistic untouched cultures, Lips' work is a pioneering study of the questionable invisibility of whiteness, revealing a motley melange of witty, critical and exaggerated caricatures of the European in non-Western representations.[1]

These two early vignettes of anthropology's interface with artworks point to very different concerns: one with the mission to preserve and document what otherwise was dismissed as infantile trivia or objects of curiosity; the other with a means to highlight tense and ambivalent contours of colonial encounters, throwing the Conrad-like gaze back at the West, forcing it to reconcile itself with its own heart of darkness. While not altogether escaping the myth of alterity, such early portrayals of artistic works carry incipient lessons. In their particular ways, they came about as a result of critical engagements with non-Western cultural practices and global currents – whether they be Eurocentric views on culture and civilization, colonialism, world wars or fascist regimes. While Boas may have privileged the alterity of the primitive Other, Lips tried to dismantle the misplaced edifice that saw the 'primitive' as distinct and divorced from the rest of the world (see Wolf 1982; Latour 1993).

In this volume, we look to such precedents while casting a critical eye on suspect distinctions between the self and the Other, modern and primitive, (neo)colonizer and colonized, the West and the rest. While the ethnographic consideration of artworks remains important, we also recognize that context is not stable and often overlaps with other sites and concerns (Marcus 1995; see also Bard 1999).

Aesthetics has received much attention in philosophical and sociological thought in the West. Following on from discussions laid out by earlier philosophers on rational as well as empirical considerations of aesthetics, Immanuel Kant's *Critique of Judgement* is probably the most notable. While aware of historically and culturally specific opinion on beauty, Kant's (2005) interest was more on the

nature of judgements, noting that all people made judgements of taste. His focus lay on their 'conditions of possibility' rather than on the empirical variations in judgements. Whereas aesthetics may be equated with beauty and pleasure, it was also somewhat distinct, Kant proposed. A contemporary lens opens up Kant's writings on aesthetics in a way that places them within a postcolonial anthropological frame. The self–other dichotomy that sustained his argument of aesthetic autonomy is dislodged with the insertion of the 'native informant' who lurks along the margins of such hegemonic texts (see Spivak 1999).

Post-Enlightenment debate on aesthetics proliferated, but nevertheless remained circumscribed to the categorical arts in the boxed-off space of the salon. As a consequence of the entrenchment of universalizing conceptions, Alfred Gell (1998) proposed that we leave aesthetics alone as it did not equate with other cultural histories. He forwarded the idea of art as agentive: artworks are not passive objects but 'doing' objects with intentions and efficacy. In his own words, they are devices for 'securing the acquiescence of individuals in the network of intentionalities in which they are enmeshed' (1998: 43). Gell's is an action-centred approach to artworks rather than one that sees them as texts to be interpreted. His view was of an 'aesthetic agnosticism' which decreed that aesthetics *per se* lay outside anthropological priorities. Nevertheless, other anthropologists have taken up the challenge of analysing cross-cultural aesthetics. Howard Morphy and Morgan Perkins, for instance, highlight the 'double problem of interpretation' (2006: 14). The double helix alludes to 'the quality of the aesthetic effect 'and then its 'interpretative context to determine its meaning – how it is felt – in the context of the producing society' (2006: 14). How it is 'felt' then is as much about what meanings artworks encapsulate as much as it is about what they do. To this performative concern, we may add a third dimension to do with shifting and cross-cutting contexts at a time of increasing cross-cultural encounter, multiple mediation and global, political turbulence (Werbner et al. 2014).

Both the agenda and location of the ASA conference at JNU in New Delhi make geo-political distinctions at once bridgeable and yet markedly disparate as further inequities and neo-liberal hierarchies take root across the globe. The global dynamic underlined the internationalism of this collaboration and delegate participation, but also our more political agenda to move away from Euro-American hegemonies (Kapur 2000; Guha-Thakurta 1992; Mitter 1994, 2007, 2008), to question the borders and boundaries that nation-states impose (Mookherjee and Pinney 2011), and to seek out more vernacular perspectives, those voices that in many other discourses of arts and aesthetics get little hearsay. Thus, we return to the history of anthropology and the history of art practice and theory to reflect on eclipsed narratives and blind spots, continuities and discontinuities, upheavals and rapprochements through the critical lens of situated, archival and/or ethnographic studies. Earlier volumes in the ASA series have already produced a veritable feast of perspectives on globalization – arguing for the imbrication of the global in the local,

and an appreciation of the diverse and discrepant flows of modernities, prioritizing instead the significance of situated, ethnographic studies (Fardon 1995; James 1995; Miller 1995; Moore 1995; Strathern 1995). We continue this precedent with a turn now to artworks, differently imagined, practised and pursued in all realms of the culturally attuned lifeworld. Yet we hold back from uncritically embracing 'globalization' (see Robertson 1992; Featherstone 1990; Featherstone et al. 1995; Appadurai 1996), given the situation when neo-liberal development projects to modernize and globalize also come with deeply fraught practices of displacement, legitimized robbery, police and paramilitary sieges, intimidation and the murder of local residents. We put the term under interrogation, preferring 'globalizing' over 'globalization', to seek out processual, located, critical and vernacular perspectives on a vastly interconnected world however it is encountered and interpreted, and seek out other alliances that do not seek to impose hegemonic regimes. This remit is also to provincialize those debates emanating from post-Enlightenment Europe as they pertain to the travel and embedding of objects and practices around the world (Chakrabarty 2000; Dave-Mukherji 2013).

Whether as a cognitive or a sensuous endeavour, aesthetics is inherently about epistemologies, where representation and knowledge are mutually entangled. Artworks then become a canvas for an epistemological enquiry, a means of thinking and knowing. Fittingly, Michel Foucault begins his *Order of Things* with an artistic representation. He describes the 1656 painting, *Las Meninas* (*The Maids of Honour*), by the Spanish artist, Diego Velasquez, in which the artist portrays himself in one corner alongside figures from the Spanish court staring back at the viewer:

> We are looking at a picture in which the painter is in turn looking out at us. A mere confrontation, eyes catching one another's glance, direct looks superimposing themselves upon one another as they cross. And yet this slender line of reciprocal visibility embraces a whole complex network of uncertainties, exchanges, and feints. The painter is turning his eyes towards us only in so far as we happen to occupy the same position as his subject. (1996: 4)

Throwing back the gaze indicates a discontinuity between the classical and the rise of the modern, an opening up of new spaces. Foucault's brief has only spanned the European context, but this has not stopped the discursive logics of his analysis being applied elsewhere – to the relations between the West and the rest, through colonial and postcolonial encounters (Said 1979). Perhaps we could look to the ironic and critical engagements with Velasquez's art through the eyes of the Colombian artist, Fernando Botero. With his seemingly naïve portrayals of large, quasi-bucolic figures, Botero sought to create what he described as an 'aesthetic unrest', a response from the post-colony to the enshrined national oeuvre of a former power (Hanstein 2003: 77). With his exaggerated reproductions of Velasquez's figures, Botero brings to attention what could be described as an epistemological unrest, not only between

subject and object, the classical and the modern, but also between the metropole and (post)colony.

Similarly, the most visible entry point of non-Western artworks into the Western fray was controversially highlighted through the works of Paris-based artists. *La Demoiselle D'Avignon* (1907, *The Young Women of Avignon*), a highly stylized painting by Pablo Picasso, is seen as the epitome of Cubist era. For some the painting is a register of Europe's selective cannibalization (Araeen 1987), while for others an indication of the dual dynamics of a more nuanced 'appropriation' (Schneider 2006). This one image encapsulates the artist's corral of the primitive to shatter Western conventions of civilizations where 'primitive art' was held to represent the 'fundamental, primeval psychic energy of man' (Morphy and Perkins 2006: 5), ironically at a time in which anthropologists were keen to establish a holistic *science* of cultures deemed as equivalent to those in the West (Grimshaw 2001; Schneider and Wright 2006). Faith Ringgold's image, *Picasso's Studio* (1991), is a fitting rebuttal to art history's Eurocentric and patriarchal leanings (Plate 1). An African-American female artist strikes back by consigning the canonical *Les Demoiselles D'Avignon* to the background while occupying the space of his model, not simply as a passive, supine body that follows the command of the white male artist, but as an artist now masquerading as his model, who reminds him about the source of his 'avant garde' inspiration.

Evidently, in the currents of globalizing, issues about knowledge and representation cannot be let adrift among the waves of inequities, upheavals and hurdles. They are integral to this enquiry on artworks and aesthetics whether the focus be on lithographic art (Terracciano), sculpture (Vidal), digital media (Favero and Battaglia), tourist artworks (Patnaik), or even the more evanescent zephyrs of performative and multisensory engagements (Werbner and Fumanti, Brosius, Kumar, Schmitt). If the Delhi-based Raqs Media Collective encounter the contemporary world by embracing an aspirational globalism through their *The Great Bare Mat*, a carpet being the traditional 'oriental' emblem for conviviality and the exchange of ideas (Plate 2), Jagannath Panda's contemporary allegory captures the uneven processes of globalization: a fantastic half-kite, half-bird hovers over a landscape of labouring bodies while carrying nation-states as flags that jostle together, altogether an image that evokes a litany of suitable themes underlining our choice of image for this book cover.

Interruptive encounters

A distinctive trait of this volume, as it was for the earlier ASA volume on anthropology and archaeology (Shankland 2011), is its appreciation of the inherently interdisciplinary pathways that contemporary enquiries have assumed. The limited and sometimes protracted encounters between the fluid zones of anthropology and art

may be summarized by five cross-cutting perspectival approaches: (i) the traditional and the canonical; (ii) the global and the intercultural, that has necessitated at least three more specific approaches; (iii) the forging of interdisciplinary relationships; (iv) innovative research methods; and (v) a reconfiguration of the aesthetic and the political. Each area complements differential notions of art/aesthetics as 'object', as context, as practice, as methodology and as a creative-political undertaking.

To turn to the first thematic, there is the earlier anthropological focus on 'traditional' art in non-Western, 'small-scale' or 'tribal' societies, focusing on the function and meaning of art and/or material culture in particular socio-cultural contexts. It was this image of non-Western art that also fuelled the history of Western modern art, as we have seen above. On a related point, the birth of ethnographic filmmaking conventions tried to marry conventions between the arts and anthropology conceived as a humanistic science, but its outputs were largely part of a sub-discipline in anthropology. This was so much so that even the highly reflexive and experimental works of the French anthropologist and filmmaker, Jean Rouch, who anticipated the paradigm-shifting, reflexive and critical turn of anthropology in the 1980s by about three decades, had, up until recently, escaped widespread anthropological attention (Henley 2009). Nevertheless, the struggle between information and aesthetics as distinctly different conduits of knowledge continued unabated and is particularly heightened in debates about whether ethnographic film should follow a more artistic remit or serve the primary purpose of providing ethnographic information (see Henley 1984; Wilson and Kildea 1986).

Where anthropology lent an analytical frame to art history is most notable with Claude Levi Strauss' (1983) turn to linguistics for his structuralist proposals. This is not to overlook late nineteenth-century formalist art historians such as Aois Riegl and Heinrich Wolfflin of the Vienna School, who had anticipated the visual grammar of images to study historical shifts in style (see Podro 1982: 151). By the 1970s, Levi-Strauss' semiotic models of cultural artefacts were widely borrowed in art as a system of signs, not dissimilar to language (Brenner 1977). Nevertheless, the question still eluded the analysts of the differential modes of perception and representation that attended the non-textual work. The visual was not simply comparable to language; and the figural could not be compressed to discourse without seepage (Baxandall 1972; Lyotard 2011).

From the 1970s, more ethnographic studies of non-Western artworks began to appear (e.g. Forge 1973; Layton 1991; Coote and Shelton 1992; Morphy 1994, 1996). Anthropologists asked how the artworks were produced, what their significance was, what meanings they articulated, and how they expressed culturally specific world-views on art, aesthetics, objects, personhood and agency. The consistent problem with their albeit illuminating studies is that their focus remains on artworks as emblems of holistic cultures divorced from wider signs of 'contact' – iridescent feather headdresses, textiles, figurines and other such artworks reigned supreme to the neglect of other more 'contaminated' artistic developments.

Recent decades, to turn to our second thematic, have underlined how the interconnectedness of artworlds cannot be ignored along with the power and politics under which art is produced, represented, distributed and consumed across globalized cultural landscapes (see Spyer, this volume). The history of relations and encounters between anthropology and collectables from the colonies was revisited. Nelson Graburn's (1976) edited volume is a pioneering study on the development of touristic art from that previously might have been identified as 'ethnic art' (Fabian 1996; see Patnaik, this volume). Howard Becker's (1982) *Art Worlds* considered objects in context and art markets, dialogues and exchanges based on a series of fundamental misrecognitions. George E. Marcus and Fred Myers (1995) continued such enquiries advocating also anthropological studies of Western 'art worlds', an area in which Pierre Bourdieu's (1984) investigations of artistic knowledge and appreciation, class and capitalism were prescient (see Vidal, this volume). In the process, calls were made to acknowledge that even Western art is not as coherent, individualist and object-focused as anthropologists had made out (Morphy and Perkins 2006: 2).

Up until recent decades, artists from non-Western backgrounds pursuing modern art conventions were dismissed as inauthentic, 'a function of a new Primitivism' (Araeen 1987: 10). Whether it applied to artists positioned outside the West or to those from migrant backgrounds in the West, the story was a familiar one – expectations of an infantile primitivism, mythicized exotica and often silent exclusions from the high ranks of the international art circuits. Art history has in recent decades begun to consider the arts beyond Western canonical developments. Seminal here are studies on non-Western contexts that have thrown light on the gross distortions and shortcomings of the West's engagements with the art of the Other (Mitter 1994, 2007; Guha-Thakurta 1992; Baker 1987; Brown 2009). Moves have been made to question the premises of modernism (Kapur 2000), 'deform' the mastery of the modern (Baker 1987), and/or to provincialize Eurocentric debates (Chakrabarty 2000). In their critical retakes, modernism stops being seen as an insular and autonomous development that has its only authentic provenance in the West but was always and already 'contaminated' by its cultural others (Spivak 1999). It is perhaps the recognition of this fact that has allowed for the shrinkage of distance between ethnographic museums that showcase the art of the non-Western cultures as curios, and the modern art museums' display of high art produced by self-reflective Western metropolitan artists (Belting and Buddensieg 2009). The *Magiciens de La Terre* exhibition in 1989 was a landmark move in this direction that had already signified the transformation of a globalized art world (Clifford 1988; see Sreberny-Mohammadi, this volume). However, the asymmetry of the cultural capital between folk and tribal artists from the non-West and the Western metropolitan artists sharing the same space in this exhibition caused an outcry, only to be recently redressed in a show entitled *When is Now* in Karlsruhe, Germany in 2012.

On art, aesthetics and anthropology as research practice, there are several perspectives that could be pursued, signalling throughout a dissolution of disciplinary

borders. We have already noted above how an anthropology of art and aesthetics most fruitfully connects with postcolonial art histories and subaltern politics. At the level of practice, anthropologists have initiated enquiries into the close relationships between ethnography and forms of contemporary art such as installation, performance, site-specific and relational art. The latter is well exemplified by a South-South interaction when an artist from India reflects on Asian identity by a lateral gaze at China and Japan (Plate 3: Sheba Chhachhi's *The Winged Pilgrims*), antecedents of which were apparent in the early twentieth-century works of Abanindranath Tagore in colonial Bengal. The problem that lay in culture and the representational turn took fresh impetus particularly from post-1980s anthropology when calls were made for an interrogative turn in representation (Clifford and Marcus 1986; Marcus and Fischer 1986). More links between ethnography as a critical enquiry shared by anthropologists and artists alike began to be forged. This might well have led to a 'poetic' turn in anthropology, but it did not necessarily embrace other artistic approaches (Schneider and Wright 2006). The focus remained on the written form of expression. Meanwhile, the 'ethnographic turn' in art, of artists dabbling with the art of the Other, continued with piecemeal and primitivist fantasies (Foster 1996). While not altogether undermining the paradigm of the 'genius artist', Francesco Clemente strikes a slightly different note in collaborating with albeit an 'anonymous' rural artist from Orissa in eastern India. *The Story of My Country* (Plate 4) is transcultural in its reference as 'my country' has different valences for Clemente and the Indian artist: the style remains folk but acquires contemporary resonance when Clemente transforms the scale of its pictorial vocabulary marking 'his style' while showcasing Oriyan folk art.

Semiotic-ideological or symbolic perspectives slowly became complemented or transplanted by more discursive and interdisciplinary fields of interpretation, an interdisciplinarity that, while it promised a positive, porous and productive engagement, was also one that was racked by individual and institutional uncertainties and anxieties. There has been a move away from the visual alone, the ocularcentric with its imbrication in a panoptic hierarchy of the senses to appreciate multisensory artistic engagements (Howes 1991, 2001; Werbner and Fumanti, Brosius, this volume). Along with the movement towards prioritizing the body rather than the mind as a conduit for knowledge (Csordas 1994; Jackson 1989), affect theory on the sensuous and felt has shifted the focus away merely from semiotic models (see Massumi 2002; Kumar, this volume).

To push interdisciplinary practice into creative and critical methodologies, anthropologists have begun to use aesthetic practice as a research method as well as disseminating their work through artistic forms. Recently Arnd Schneider and Christopher Wright argued for the need to critically and creatively nurture the 'border zones' between anthropologists and artists (2010: 1). Here, the arts are not to be seen as an appendage or illustration, but a repository and producer of knowledge and culture in the making. They note:

The practices we are advocating point beyond the textual linearity and rigidity of the anthropological monograph, which attempts to subsume visual material into its narrative structure without exploring its potentials, and beyond those art practices that claim to be 'informed' by anthropological debates but effectively only reference a series of keywords or invoke an aura, and do not readily engage productively with anthropological arguments or methodologies. (Schneider and Wright 2006: 26)

Their scope is to prioritize 'anthropological practices of representation' (Schneider and Wright 2006: 12). Such proposals follow in the wake of Nicolas Bourriaud's (2002) concept of 'relational aesthetics', a means by which 'social interstices' or intersubjective encounters through artistic activities enable the collaborative development of meanings that can overcome the alienation of modernization. Nevertheless, such approaches have been taken to task for not being critical enough, since these proposed practices remain ensconced in the fetishizing field of capitalism (see Martin 2007). From another complementary angle, there has been a significant 'aesthetic turn' in sociology and political science in particular, and in the social sciences and humanities in general, following Jacques Rancière's *Politics of Aesthetics* which proposed that the 'aesthetic regime' reconnects the artwork with the socio-political world, an aesthetic that does not refer to 'a theory of sensibility, taste, and pleasure for art amateurs. [Rather] it strictly refers to the specific mode of being of whatever falls within the arts, to the mode of being of the objects of art' (Rancière 2004: 3). Art, like politics, thus becomes acts of intervention that map the 'visible, the sayable and the thinkable', that resist signification (2004: 63). Artists have striven to overcome primitivist and Orientalist misapprehensions, to make their creations more socially valid, carrying the potential for social exchange and political transformation. This trend has seen artists looking more deeply, critically and occasionally ethnographically at the historical edifice and politics of representing the Other. When, as for instance, Pushpamala revisits the colonial archive and fashions herself as a tribal, she enacts a performative mimesis through the lens of anthropology and confronts the viewer through the double gaze of a Toda woman and a contemporary artist (Figure 1.1).

Such aforementioned developments, to turn to our final thematic, converge with the move in anthropology to be more socially relevant and engaged in public culture and political dialogue (Visvanathan, this volume). Consensus has been steadily growing to ensure that the inter-cultural be accommodated with the inter-national by way of projects for collaborative equity across socio-political barriers. In particular the field of critical development studies have been adopted to produce collaborative and agentive artistic practices with ambitions to empower participants on the basis of their ethnicity/race, gender, age, sexuality, class, global inequalities and with respect to new political movements. By way of illustration, collaborative artists such as Navjot Altaf and Amar Kanwar have critically and creatively engaged with anthropological practices of representation. Kanwar, in particular, has prominently

Figure 1.1 Pushpamala N and Clare Arni, 'Toda (based on late 19c anthropometric study)' from the project 'Native Women of India: Manners and Customs' sepia toned silver gelatin print, 2004. Permission granted.

entered the global art circuit, having been part of Documenta 11 and 13, international exhibitions of modern art in Germany that serve to reconcile and repress the history and enduring presence of extreme right-wing movements. The risk here is that aesthetics is reduced to playing simply an instrumental role – what we call the 'NGO-ization' of art practice. The challenge is to embrace aesthetics in its multi-dimensional senses and levels while enhancing its purposive potentials. As Hal Foster (1996) proposes, if there is to be a 'return to the real', a real grounded in the materiality of bodies, sites and events, then we would need a highly charged yet nuanced reading of how that real is lived, experienced, imagined, felt and mobilized across the cross-societal spectrum.

Navigating the book

While the volume cannot do full justice to the numerous themes and developments outlined here, all our authors, in their own particular ways, investigate art and aesthetics in their widest senses and experiences, from a variety of perspectives and in numerous contexts branching from the metaphysical to the political. Moving beyond art as expressions of the inner mind and inventions of the individual self, the volume bridges the gap between changing perceptions of contemporary art and aesthetics, and maps globalizing currents in a number of areas and regions. The many nuances in these contributions cover the tangible and the intangible, the material and the sensual, the solid and ephemeral. In order to do justice to the various contributions, the book does not have a structure so much as it has a flow that encourages us to think laterally across regions, disciplines and categories.

First, we begin with a consideration of non-Eurocentric perspectives on artworlds, figures and practices. To these ends, Emilia Terracciano refuses the ambitions of teleological historicism that characterizes the metanarrative of Eurocentric modern art. Using the overlooked lithographs by the Indian artist, Gaganendranath Tagore, the chapter reappraises the cartoonist's contributions outside the umbrella of the national archive to underline the discrepant character of Indian modernism. Denis Vidal's chapter moves us to the contemporary period by considering the contradictory demands and expectations made on 'universal artists' from the global south with a focus on the well-known artist, Anish Kapoor. Leili Sreberny-Mohammadi considers the methodological implications of multi-sited, potentially unbounded, fields when it comes to art spaces in Tehran and their mediation outside the country through physical and digital connections, despite the constraints of an authoritarian political regime. Even while the region remains the focus of extreme political tensions both internally and internationally, the author/artist considers how the art of Iran – and of the Middle East more generally – has been making a steady impact on the contemporary art market.

We then attend to how artworks circulate in highly charged campaigns and contexts of economic and political distress, highlighting osmotic relationship

with the politics of containment and surplus, and resistance and change. Patricia Spyer provides a comparative lens on images of war in an enquiry into aesthetic transformation and political change with the examples of World War II Russia and contemporary Indonesia. Devastatingly transformative, violence often compels a turn to novel forms of expression that she terms 'art under siege'.

With a focus on the anti-corruption campaigns of Anna Hazare, Christopher Pinney considers the Indian political 'archive' as it is rearticulated in contemporary times in posters and media images. Proposing the concept of the 'media-fold', he demonstrates how the political 'archive' is highly dynamic, an unstable and recursive location which has certain authorizing functions but which, in the absence of systematic sedimentation, renders images 'live' and ready to fall into the future.

Shiv Visvanathan considers the marginalized and the repressed with reference to a reworked theory of waste that can create a new ethics of memory, materiality and what he terms as 'an aesthetics of justice'. Waste has been seen as an externality in economics and as generally polluting or useless by social sciences in general. Instead, Visvanathan proposes that a reworked theory of waste can create not just a new ethics of memory and materiality but reconfigure current ideas of innovation and modernity into plural notions of time, justice and history.

Recapturing the art of resistance among Marxist-Naxal women prisoners in 1970s Calcutta, Atreyee Sen looks at how practices such as puppet shows provide a means of an affective and resilient political aesthetic. Her ethnography highlights women prisoners' activities that demonstrated an affective and resilient political aesthetic, and which in turn contested repressive cultures of confinement. By comparison, Andrea Grieder considers how poetry provides both a resistive dynamic as well as a means of healing among individuals and communities in post-genocide Rwanda. Drawing on her ethnographic research, her chapter explores how such resistant poetry expressed an aesthetics of memory.

The volume then moves on to the pulse of life and vivacity with a particular focus on the multisensory and multi-perspectival resonances of 'aesthetics' that breaks out of conventional associations with the visual. With the example of diasporic performances, Pnina Werbner and Mattia Fumanti propose that aesthetics be seen not as 'sensuous cognition' (Wiseman 2008: 7) but as 'sensuous participation' – the appreciation and making of beauty, distinction and sheer sensual pleasure as these come to be embedded and re-embedded in social worlds of literary, artistic, musical and performative celebration in diaspora. Christiane Brosius provides a lens on the multisensory aesthetics of Hindu wedding rituals in contemporary Nepal as they engage with alternative consumer cultures, identity politics and emotional ecologies. Akshaya Kumar provides an ethnographic study of the 'rebellious aesthetic' among spectators of Bhojpuri films in the north-east Indian state of Bihar. Through an ethnographic study of the spectatorship performed in the decrepit single-screen theatres in the middle of the city, Kumar attempts to grip this rebellion in terms of 'class as performance', and highlights the complex relationships across cinematic

image, sites of exhibition, architectonics of space, and spectatorial behaviour, thereby reassessing casually transacted notions of 'decency' and 'masculinity'. Susanne Schmitt focuses on the use, reception and interpretations of odours and their implications for olfactory aesthetics in a science and medical history museum in Germany. Drawing upon sensory anthropology and ethnography, she elaborates on the use of odours that are (or have once been) considered aphrodisiac within a Western European context.

We then return to the theme of the fetishized 'primitive' in the context of contemporary tourism, while questioning registers of the 'aesthetic' and its interface with what may be described as the 'non-aesthetic' – that is, those conventions ordinarily seen as mundane, contrary or oppositional to the highly affective realm of aesthetics. To these ends, Soumendra Patnaik considers the commodification of cultural artefacts and performances in Nagaland in north-eastern India. He highlights the fact that while commercialization strengthens the monopoly of a culturally non-producing emerging elite and marginalizes local artisans and cultural performers, the latter often attempt to subvert their marginalization by fashioning their identities and resisting the touristic gaze.

We end the sequence of chapters with Paolo Favero and Giulia Battaglia who together address the triangular relationship between technology, aesthetics and politics and reflect upon the relationship between anthropologists interested in digital visual culture and artists entrenched in digital practices in India. These range from the renowned activities of the Raqs Media Collective (New Delhi), to the experimental digital annotation of Pad.ma (Berlin-Mumbai-Bangalore), and the open space for media(tion) of *Khetro* (Kolkata) digital practices.

Finally, the volume is sealed with reflections by Marilyn Strathern. Based on her summing up of the conference, her contribution is a free-flowing journey through several panel, plenary and contributors' accounts.

Altogether, the chapters here open up a productive space in the dialogues between aesthetics and anthropology. Attention has been given as much to this enabling space between the disciplines as to the tensions and ruptures that necessarily attend such conversations. There is as much outside of this volume as there is inside it. It cannot be an exhaustive record of the illustrious conference, but to adapt Strathern's well-known phrase, as a 'part of a shifting whole', it can seek to provide suggestive glimpses.

Staging an interdisciplinary conversation across anthropology, art history, sociology and philosophy, *Arts and Aesthetics in a Globalizing World* opens up aesthetics that takes cognizance as much of artworks as it does of artworlds. It moves the discourse beyond the well-entrenched binaries of universalism and cultural speci-ficity by shattering fixed notions about aesthetics that are no longer about visuality alone. It entails a revisiting of modernism itself in a colonial past as it reflects on contemporaneity when aesthetics takes on new avatars in a mediatized, digitized and globalized world through new configurations of increasingly connected and reflexive

artworlds. We can but hope for more experimental and ingenious engagements across disciplines, while embracing the textural richness and political potentials that lie within, across and outside of institutional settings.

Note

1. The book project was even seen as 'sabotage' and a threat to ideas about Aryan supremacy under the National Socialist state where the initiative was first developed in 1930s Germany.

References

Appadurai, Arjun (1996) *Modernity at Large: Cultural Dimensions of Globalization,* Minneapolis: University of Minnesota Press.

Araeen, Rasheed (1987) 'From primitivism to ethnic arts', *Third Text,* 1(1): 6–25.

Baker, Houston A. Jr (1987) *Modernism and the Harlem Renaissance,* Chicago: University of Chicago Press.

Banerjee, Sumanta (1998) *The Parlour and the Streets,* Calcutta: Seagull Books.

Baxandall, Michael (1972) *Painting and Experience in Fifteenth Century Italy,* Oxford: Oxford University Press.

Becker, Howard S. (1984) *Art Worlds,* Berkeley: University of California Press.

Belting, Hans and Andrea Buddensieg (eds) (2009) *The Global Art World. Audiences, Markets and Museums,* Ostfildern: Hatje Cantz Verlag.

Bhabha, Homi K. (2004) 'Of Mimicry and Man', in *The Location of Culture,* New York and London: Routledge.

Bloch, Ernst (ed.) (1980) *Aesthetics and Politics,* London: Verso.

Bourdieu, Pierre (1984) *Distinction: A Social Critique of the Judgement of Taste,* trans. Richard Nice, Cambridge, MA: Harvard University Press.

Bourriaud, Nicolas (2002) *Relational Aesthetics,* trans. Simon Pleasance and Fronza Woods with M. Copeland, Dijon: Les Presses du Réel.

Brenner, Art (1977) 'The structuralism of Claude Lévi-Strauss and the visual arts', *Leonardo,* 10(4): 303–6.

Brown, Rebecca (2009) *Art for a Modern India, 1947–1980,* Durham, NC: Duke University Press.

Bundgaard, Helle (1999) Indian Art Worlds in Contention: Local, Regional and National Discourses on Orissan Patta Paintings, *Nordic Institute of Asian Studies,* vol. 80, Fischer Taschenbuch Verlag – Forum Wissenschaft Hochschule.

Brosius, Christiane (2005) *Empowering Visions: The Politics of Representation in Hindu Nationalism*, London: Anthem Press.

Chakrabarty, Dipesh (2000) *Provincializing Europe: Postcolonial Thought and Historical Difference*, Princeton: Princeton University Press.

Clifford, James (1988) *The Predicament of Culture: Twentieth Century Ethnography, Literature and Art*, Cambridge, MA: Harvard University Press.

Clifford, James and George Marcus (eds) (1986) *Writing Culture: The Poetics and Politics of Ethnography*, Berkeley: University of California Press.

Coote, Jeremy and Anthony Shelton (eds) (1992) *Anthropology Art and Aesthetics*, Oxford: Clarendon Press.

Csordas, Thomas J. (1994) *Embodiment and Experience: The Existential Ground of Culture and Self*, Cambridge: Cambridge University Press.

Danto, Arthur (1964) 'The artworld', *Journal of Philosophy*, LXI: 571–84.

Dave-Mukherji, Parul (2013) 'Art History and its Discontents in Global Times', in *Art History in the Wake of the Global Turn*, Jill Casid and Aruna D'Souza (eds), New Haven: Yale University Press.

Desjarlais, Robert R. (1992) *Body and Emotion: The Aesthetics of Illness and Healing in the Nepal Himalayas*, Pennsylvania: University of Pennsylvania Press.

Fabian, Johannes (1996) *Remembering the Present: Painting and Popular History in Zaire*, Berkeley: University of California Press.

Featherstone, Michael (ed.) (1990) *Global Culture: Nationalism, Globalization and Modernity: A Theory, Culture and Society Special Issue*, London: Sage.

Featherstone, Michael, Scott Lash and Roland Robertson (1995) *Global Modernities*, London: Sage.

Forge, Anthony (ed.) (1973) *Primitive Art and Society*, London: Wenner-Gren Foundation and Oxford University Press.

Foster, Hal (1996) *The Return of the Real: The Avant Garde at the End of the Century*, Cambridge, MA and London: MIT Press.

Gell, Alfred (1998) *Art and Agency: An Anthropological Theory*, Oxford: Oxford University Press.

Graburn, Nelson H. H. (ed.) (1976) *Ethnic and Tourist Arts: Cultural Expressions of the Fourth World*, Berkeley: University of California Press.

Grimshaw, Anna (2001) *The Ethnographer's Eye: Ways of Seeing in Modern Anthropology*. Cambridge: Cambridge University Press.

Guha-Thakurta, Tapati (1992) *The Making of a New "Indian" Art: Artists, Aesthetics and Nationalism in Bengal, c. 1850–1920*, Cambridge: Cambridge University Press.

Hansen, Miriam Bratu (1999) 'Benjamin and Cinema: Not a One Way Street', *Critical Inquiry*, 25(2): 306–43.

Hanstein, Mariana (2003) *Fernando Botero*, London: Taschen.

Hart, Lynn (1995) 'Three Walls: Regional aesthetics and the international art world', in *The Traffic in Culture*, George E. Marcus and Fred Myers (eds), 127–50.

Henley, Paul (1984) 'The 1984 RAI Film Prize', *RAIN*, 62: 9–12.

—(2009) *The Adventure of the Real: Jean Rouch and the Craft of Ethnographic Cinema*, Chicago and London: University of Chicago Press.

Hinderliter, Beth and Vered Maimon (eds) (2003) *Communities of Sense: Rethinking Aesthetics and Politics*, Durham, NC: Duke University Press.

Houlberg, Marilyn (1973) 'Ibeji images of the Yoruba', *African Arts* 7(1): 20–7.

—(1976) 'Collecting the anthropology of African art', *African Arts* 9(3): 15–19.

Howes, David (1991) 'Sensorial Anthropology', in *The Varieties of Sensory Experience: A Sourcebook in the Anthropology of the Senses*, David Howes (ed.), Toronto: Toronto University Press.

—(2004) *Empire of the Senses: The Sensual Culture Reader*, Oxford: Berg.

Jackson, Michael (1989) *Paths towards a Clearing: Radical Empiricism and Ethnographic Enquiry*, Bloomington: Indiana University Press.

Jain, Kajri (2007) *Gods in the Bazaar: The Economies of Indian Calendar Art*, Durham, NC: Duke University Press.

James, W. (ed.) (1995) *The Pursuit of Certainty: Religious and Cultural Formations*, London: Routledge.

Kant, Immanuel (2005) *Critique of Judgment*, trans. John Henry Bernard, New York: Barnes and Noble Publishing.

Kaur, Raminder (2003) *Performative Politics and the Cultures of Hinduism: Public Use of Religion in Western India*, New Delhi: Permanent Black.

Kapur, Geeta (1991) 'Place of the modern in Indian cultural practice', *Economic and Political Weekly*, December 7.

—(2000) *When was Modernism: Essays on Contemporary Cultural Practice in India*, New Delhi: Tulika.

Layton, Robert (1991) *The Anthropology of Art*, Cambridge: Cambridge University Press.

Lévi-Strauss, Claude (1983) *The Raw and the Cooked: Mythologiques Volume 1*, Chicago: University of Chicago Press.

Latour, Bruno (1993) *We Have Never Been Modern*, Cambridge, MA: Harvard University Press.

Lips, Julius E. (1937) *The Savage Hits Back, or the White Man through Native Eyes*, New Haven: Yale University Press.

Lyotard, Jean-François (2011) *Discourse, Figure*, trans. Antony Hudek and Mary Lydon, Minneapolis: University of Minnesota Press.

Marcus, George (1995) 'Ethnography in/of the world system: the emergence of multi-sited ethnography', *Annual Review of Anthropology*, 24: 95–117.

Marcus, George E. and Michael Fischer (1986) *Anthropology as Cultural Critique: An Experimental Moment in the Human Sciences,* Berkeley: University of California Press.

Marcus, George and Fred Myers (1995) *The Traffic in Culture: Refiguring Art and Anthropology,* Berkeley: University of California Press.

Martin, Stewart (2007) 'Critique of relational aesthetics', *Third Text,* 21(4): 369–86.

Massumi, Brian (2002) *Parables for the Virtual: Movement, Affect, Sensation (Post-Contemporary Interventions),* Durham, NC: Duke University Press.

Mitter, Partha (1994) *Art and Nationalism in Colonial India, 1850–1922: Occidental Orientations,* Cambridge: Cambridge University Press.

—(2007) *The Triumph of Modernism, India's Artists and the Avant-garde, 1922–47,* London: Reaktion Books.

—(2008) 'Interventions: Decentering modernism: Art history and avant-garde art from the periphery', *Art Bulletin,* XO(1): December.

Mookherjee, Nayanika and Christopher Pinney (2011) 'The aesthetics of nations: anthropological and historical approaches', *JRAI,* 17(S1).

Pinney, Christopher (2006) 'Four Types of Visual Culture', in *Handbook of Material Culture,* Christopher Tilley, Webb Keane, Susanne Küchler, Michael Rowlands and Patricia Spyer (eds), 132–45.

Pinney, Christopher and Nicholas Thomas (eds) (2001) *Beyond Aesthetics,* Oxford: Berg.

Rancière, Jacques (2006) *The Politics of Aesthetics: The Distribution of the Sensible,* New York: Continuum Publishing.

Podro, Michael (1982) *The Critical Historians of Art,* New Haven: Yale University Press.

Redfield, Marc (2003) *The Politics of Aesthetics: Nationalism, Gender, Romanticism,* Stanford: Stanford University Press.

Robertson, Roland (ed.) (1992) *Globalization: Social Theory and Global Culture,* London: Sage.

Rycroft, Daniel (2006) *Representing Rebellion*: *Visual Aspects of Counter-Insurgency in Colonial India,* Delhi: Oxford University Press.

Said, Edward W. (1979) *Orientalism,* New York: Vintage.

Schneider, Arnd and Chris Wright (2010) *Between Art and Anthropology: Contemporary Ethnographic Practice,* Oxford: Berg.

Shankland, David (ed.) (2011) *Archaeology and Anthropology: Past, Present and Future,* Oxford: Berg.

Spivak, Gayatri Chakraborty (1999) *Critique of Postcolonial Reason: Toward a History of the Vanishing Present,* New Haven: Yale University Press.

Sprague, Stephen F. (1978a) 'Yoruba photography: How the Yoruba see themselves', *African Arts,* 12: 52–9.

—(1978b) 'How I see the Yoruba see themselves', *Studies in the Anthropology of Visual Communications,* 5(1).

Strathern, Marilyn (ed.) (1995) *Shifting Contexts: Transformations in Anthropological Knowledge,* London: Routledge.

Taussig, Michael (1993) *Mimesis and Alterity: A Particular History of the Senses,* New York: Routledge.

Willson, M. and Gary Kildea (1986) 'Interpreting Ethnographic Film: An Exchange about *Celso and Cora'*, *Anthropology Today* 2(4): 15–17.

Werbner, P., M. Webb and K. Spellman (eds) (2014) *The Political Aesthetics of Global Protest: the Arab Spring and Beyond,* Aga Khan series, New York: Edinburgh University Press and Oxford University Press.

Wolf, Eric (1982) *Europe and the People Without History,* Berkeley: University of California Press.

2

Of Mockery and Mimicking: Gaganendranath Tagore's Critique of Henri Bergson's *Laughter* (1911)

Emilia Terracciano

Sometimes this literature of just-before-the-battle is dominated by humour and allegory; but often too it is symptomatic of a period of distress and difficulty, where death is experienced and disgust too. We spew ourselves up, but already underneath laughter can be heard.

(Fanon 1967: 2)

From inside a train carriage, a corpulent man kicks a compartment door into the face of a gentleman, who is about to alight. The imposing door divorces a world of *rigidity* from one of flowing *vitality*, darkness from light. Clad incongruously in Western attire with his breeches stretched to bursting capacity, the man blurts out: 'Not here *Baboo*'. Radiating light on the other side of the carriage door is the gentleman wearing a loose, white *kurta* and *dhoti*. Tucked under his arm is the book *Laughter* by Henri Bergson. Who is this man?

The gentleman is Gaganendranath Tagore and designer of the print. Entitled 'Courtesy to countrymen', the image described is part of the larger album of prints, *Wry Thunderbolt*, published in Calcutta in 1915. By this time, the moving railway carriage had become a dangerous *othering* space, prompting the colonial subject to take up volatile identities and sabotage the colonial oppressor in spectacular ways (Pinney 2007: 53).[1]

A man of irresistible charm and refined taste, Gaganendranath belonged to the prominent and wealthy Tagore family, which resided north of Calcutta (Marquess of Zetland 1964: 5).[2] Firmly rooted in this city, Gaganendranath, unlike his globe-trotting uncle Rabindranath, was indifferent to travel. The artist formed his impressions of European modern art movements from prints and magazine illustrations.

Anthropologist Arjun Appadurai, who opposes 'fantasy' to 'imagination', suggests that while the former divorces thought from action, connoting escapism

and passivity, the latter can be interpreted as a social force, capable of engendering ideas of commonality and creating the wherewithal for action (Appadurai 1996: 7). Appadurai's focus is on how the contemporary global circulation of electronic media transforms everyday subjectivities, producing diasporic public spheres (he cites the example of terrorists emulating Rambo-like figures or housewives internalizing soap operas to create their lives) (Appadurai 1996: 8–9). With regard to Gaganendranath's work of the early twentieth century, we witness him already tapping into the circulation of global images to foster a virtual cosmopolitanism.

Art historian Iftikhar Dadi argues that the Benjaminian circulation of the magazine layout enabled far-away artists to reinterpret the aesthetic conventions of European, metropolitan-based modernism. 'Mistranslation', he argues, frees works from their contexts and reconfigures European modernism (Dadi 2010: 151).

One is tempted to go back to the etymology of the word 'translation', which derives from the latin '*tradūcere*', meaning 'to carry from one place to another' and from 'trans' (on the other side) and '*dūcere*' (to guide). This carrying from one place to another can be seen as a fruitful process. Linguist Umberto Eco (Eco 1997) interprets translation as an act of creative betrayal (*tradurre è tradire* – to translate is to betray). In this view, translation is a playful form of mimicry, an act of travesty, similar to wearing a denture or a wig, or using a prosthetic limb which replaces a missing body part (Eco 1997).

These observations are particularly useful when considering the work of Gaganendranath, who settled his account with modernist art movements in a colonial environment which had a more than tenuous relationship with industrial modernity. Emerging from the same orientalist art circles as his brother Abanindranath (the Bichitra Studio and the Indian Society of Oriental Art), Gaganendranath was among the first to re-forge links between art and contemporary social reality. In his prints the artist escorts us into a world in which he singles out victims to be mocked. He compels us to take sides with *him* against *them*. At work here is a subtle politics of laughter, vicious as it is enjoyable.

The prints under scrutiny exemplify an ambiguous and contracted form of mechanical reproduction. The elegantly bound format of these albums suggests that the context in which they were circulated was not the bazaar. Indeed Gaganendranath's prints are very different from the kind of chromolithographs and popular prints so far considered. Rather, the albums appear to be more suited for diffusion in the elitist space of *adda*, defined by historian Dipesh Chakrabarty as the 'specific site of struggle to be at home in modernity' (2000: 180–1). No records survive of the Jorasanko Bichitra press, so we can only speculate as to the number of prints circulated in Calcutta. Notwithstanding the hyperbolic accounts that boasted of the numerous copies sold, the price of the albums ranged between four and six Indian rupees, not negligible sums in 1917. For this reason, we can assume that the albums were produced as limited editions for an elite group of British and Bengali readers.[3] These considerations acquire weight when we consider that the British-owned

liberal newspaper *The Englishman* and the *Hindu-Patriot* positively reviewed the album *Wry Thunderbolt* published in 1916. Ramananda Chatterjee's progressive journals *The Modern Review* and *Prabasi*, moreover, observed how the success of Gaganendranath's social cartoons – 'comedy of curious distortion' – had caused considerable *wrath* among the native population (Mitter 1994).

'When deformities grow unchecked but are cherished by blind habit', writes Gaganendranath in 1915, 'it becomes the duty of the artist to show that they are ugly and vulgar and therefore abnormal' (Tagore 1915). Informed by Henri Bergson's book *Laughter: An Essay on the Meaning of the Comic*, published in English by Macmillan Press (1911), Gaganendranath followed the philosopher and argued that laughter is perennially directed at an inherent stiffness of the body or mind, in lieu of the elasticity, alertness or *élan* bestowed by nature.[4] Through laughter, society is able to achieve a mode of self-reflection and free itself from latent destructive tendencies (Bergson 1914: 29). Singling out the medium of caricature, Bergson believed that the most important skill of the caricaturist lies in his ability to see beneath the apparently harmonious composure of individuals and uncover their incongruity. It is this innate sense of discrepancy which Gaganendranath dramatizes to provoke the spectator's laughter.

Colonialism and class issues were remote from the concerns of the philosopher, who had never been subject to imperial domination. Bergson was far more engrossed with universalist human values and foibles and in *Laughter* he contends a metaphysical theory of this human activity.[5] It is Gaganendranath who, in his 'graphic' interpretation of Bergson's theory, infuses life into the philosopher's writings, through sketching out the mechanical habits and quirks assumed by the ruled since the onset of colonialism. Gaganendranath may well have been inspired by Japanese *ukiyo-e*, *Punch* as well as Kalighat *pats*, a dying popular form of satire, which had flourished in Calcutta in the early nineteenth century (Ghosh 2006: 196; Jain 1999; Banerjee 1989: 144).[6]

In his essay 'Of mimicry and man', Bhabha argues that the discourse of colonialism reveals the inherent irony of Western knowledge (1994: 86). The colonizer's stereotyping of the colonial Other produces a subject recognizably the same as the colonizer, but still different: *not quite/not white* (Bhabha 1994: 86). Bhabha furnishes as his example the English-educated Indian employed in the Indian civil service, who mediates between the imperial power and the colonized people. Although it is to a degree comforting for the colonizer that Indians should become 'English', the creation of mimic Englishmen is also unsettling, for 'mimicry is at once resemblance and menace' (Bhabha 1994: 90). The mimic Englishman, since he is not the same as the colonizer, *white but not quite*, embodies merely his partial representation. Hence, far from feeling at ease, the colonizer perceives a monstrously displaced image of himself (Young 2003: 194).

In his prints, however, Gaganendranath pokes fun at the pitiful desire of his Bengali social peers to be *more English than the English*, while maintaining their

ingrained social habits: *almost the same but not quite* (Bhabha 1994: 92). The *babu* is depicted as the product of a warped colonial mimesis; to become anglicized is 'emphatically *not to be English*' (Bhabha 1994: 87). Mimicry engenders stiffness, and devitalizes the colonial subject. Hence, it is not so much the colonizer who is relentlessly scorned, but rather the absurd behaviour of the mimic man which the cartoonist holds up for public ridicule.

The first body of images considered in this article are part of the album *The Realm of the Absurd*, made between 1915–17, following Lord Curzon's Partition of Bengal (1905) and the failure of the *swadeshi* movement.[7] Many intellectuals, including Gaganendranath, attributed the disastrous collapse of *swadeshi* 'to a profound moral failure on the part of the Bengali people to live up to the cultural principle that *swadeshi* discourse had identified as the core rationality of indigenous tradition' (Sartori 2008: 24).[8] The discovery of a Western inclination for self-pursuit within the Bengali *bhadralok* groups triggered a deep ideological crisis (Sartori 2008: 14).

Bhabha suggests that the civilizing mission occurs in an ambiguous area between mimicry and mockery (1994: 86). Gaganendranath, in exposing the farcical nature of the post-Enlightenment civilizing mission, mocks mimicry and ridicules 'its power to be a model, that power which supposedly makes it *imitable*' (Bhabha 1994: 88). Through turning the grand colonial narrative of civilization – the very idea that some races need to be 'helped' towards a civilized rule of law – into the object of scathing mockery, Gaganendranath exposes the irony embedded in the ambivalent claims of liberty and ethics underpinning colonial rule – an irony of which many of his peers were unaware.

In the second part of the article, the author considers a later series of prints from the album *Reform Screams* designed by Gaganendranath in the aftermath of the Jallianwalla Bagh Massacre of 1919 (Ram 1978; Hussain 2003: 195). Invocation of martial law removed all irony, laying bare the brutality underpinning British government in India. In times of extreme political convulsion the function of laughter ceases to be that of a social signal. It neither encourages pleasure nor desire to be accepted; moreover, it ceases to engender community feeling. '*Chitkaar kora*', meaning 'loud screech in response to horror or shock' in Bengali, highlights the Eurocentrism of Bergsonian metaphysics. Critique of Eurocentric thought is pursued in a small Cubist painting entitled *Laughter* created by Gaganendranath in 1922. In the Cubist reincarnation, the modernist blasting of forms evokes the convulsive movements that a body undergoes when laughing has become beyond control. Violent laughter affords a temporary escape from horror.

Heterotopic sites

For colonial officials, the railway had a special role to play in modernizing India. While interpreting India as a place where modernity could be only partially

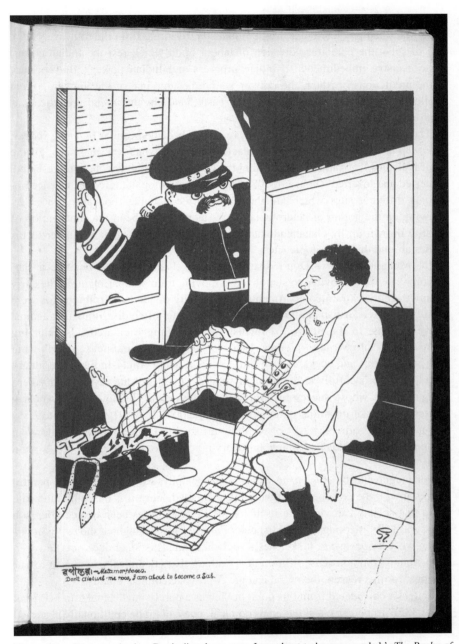

Figure 2.1 'Metamorphosis – Don't disturb me now, I am about to become a saheb', *The Realm of the Absurd*, lithograph, by Gaganendranath Tagore, Calcutta, 1917. © Victoria and Albert Museum, London.

re-enacted, they invested the railway with a modernizing role in the colony. In 1853 Marx had predicted that 'Modern industry, resulting from the railway system, will dissolve the hereditary division of labour upon which rest the Indian castes, those decisive impediments to Indian progress and Indian power'. But contrary to the predictions of Marx, the railway station became one of the most important public venues, where the exacerbation of caste hierarchy and racial prejudice was reinforced (Gbah Bear 1994: 533).

The train compartment and the railway station became peculiar *othering spaces*, *heterotopias*: 'a kind of effectively enacted utopia in which the real sites, all the other real sites that can be found within the culture are simultaneously represented, contested and inverted' (Foucault 1986: 22). The heterotopia, moreover, can accommodate different sites which are themselves irreconcilable (Foucault 1986: 22). Drawing on the notion of heterotopia allows us to comprehend the contestation of identity thrown up by Gaganendranath's images. The artist plots a number of his scenes around this heterotopic site.

In 'Metamorphosis – Don't disturb me now, I am about to become a sab' (Figure 2.1), we are invited to step inside a moving train compartment. In the early twentieth century, train compartments were racially divided and train guards were usually of mixed British and Indian ancestry, the latter often discriminating against native Indians. In the image a clownish *babu*, puffing a cigarette, is changing from a *dhoti* into Western clothes. Lying on the floor is a suitcase overflowing with various ties and socks. Above him towers a bulky Anglo-Indian train guard, who looks reproachfully at the train passenger. This is not the revolutionary hero Bhagat Singh, whose successful mimicry as English *sahib* allowed him to carry out terrorist tasks on trains unnoticed (Pinney 2004: 127). The effeminate *babu* was a common satirical target of Kalighat artists and Gaganendranath follows in this genealogy. He attaches no revolutionary potential to travesty; the *babu* is plain vain.

For laughter to be *efficient* in Bergsonian metaphysics, it must make a painful impression on the person against whom it is directed, since it is only through acute scorn that society can vindicate itself for the liberties it has been denied (Bergson 1914: 197). By marking out what society *does not want*, laughter shows by implication what it *does want*: it sketches a societal ideal. This ideal does not, however, stem from a common sense of morality. Nothing that is comical can appeal to our feelings; for this reason, the moral can never provoke comical effects.

Laughter considered from this point of view is a purely intellectual affair (Prusak 2004: 385). To perceive a situation as comical, one cannot be emotionally absorbed in it, but must rather step back, in the same way that a spectator observes a performance. The suspension of feeling in the viewer and his complete alienation are required to perceive the mechanical in human behaviour: to burst forth, laughter requires a sudden 'insensibility' or 'a momentary *anesthesia* of the heart' (Bergson 1914: 9–11).

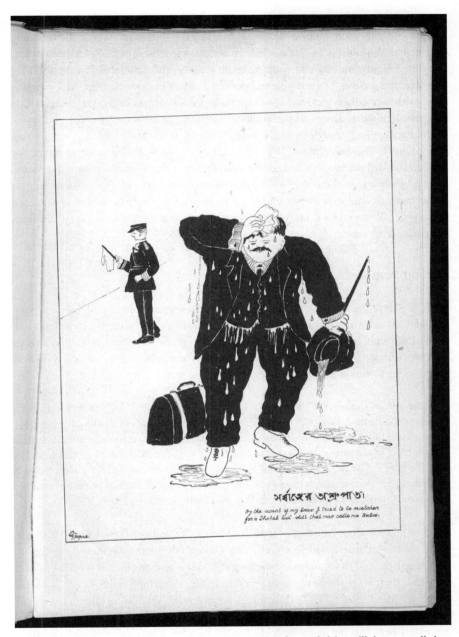

Figure 2.2 'By the sweat of my brow I tried to be mistaken for a *saheb* but still that man called me *baboo*', *The Realm of the Absurd*, lithograph, by Gaganendranath Tagore, Calcutta, 1917. © Victoria and Albert Museum, London.

Moving on from the intimate space of the train compartment, Gaganendranath takes us to the more public space of the railway platform, where an amusing spectacle is unfolding. A *babu* clad in a three-piece suit with necktie and hat, carrying a Gladstone bag and walking stick, sweats profusely in the sweltering heat of a Calcutta station. His struggle to become a *saheb* is not rewarded. Mopping his brow with a handkerchief, we see large drops of sweat run down the fabric of his suit. Inside his hat, a pool of perspiration accrues: the *babu* melts before our eyes. In the background, oblivious to the *babu*'s plight, is a train guard waving his flag nonchalantly. The *babu* utters: 'By the sweat of my brow I tried to be mistaken for a *saheb* but still that man called me *baboo*' (Figure 2.2). Gaganendranath mocks the absurd behaviour of the *babu*, whose inappropriate Western clothing causes him to sweat buckets. The expression translated in English as 'by the sweat', is rendered as 'crying all over one's body' in Bengali. Gaganendranath's mockery becomes increasingly mordant.

Beyond laughter …

In 'The offending shadow' (Figure 2.3) a 'crisis heterotopia' violently unfolds. A *babu* clad in a *kurta*, his right fist clenched, smashes a mirror with a large hammer. Convulsed with frenzy, he seeks to rid himself of the repellent reflection that is his own image. Foucault suggests that the mirror elicits an agonistically hybrid experience, at once a utopia and a heterotopia. He writes:

> In the mirror, I see myself there where I am not, in an unreal, virtual space that opens up behind the surface; I am over there, there where I am not, a sort of shadow that gives my own visibility to myself, that enables me to see myself there where I am absent: such is the utopia of the mirror. But it is also a heterotopia … it makes this place that I occupy at the moment when I look at myself in the glass at once absolutely real, connected with all the space that surrounds it, and absolutely unreal, since in order to be perceived it has to pass through this virtual point which is over there. (Foucault 1986: 21)

Scattered on the floor lie sharp mirror fragments. Behind the *babu* looms a sinister, black shadow that is about to engulf him. Gaganendranath was among the first to introduce light and shade in his paintings and was also responsible for creating figures that 'cast their own shadows on the picture itself, something quite novel in Indian painting' (Mitra 1965: 45). In this image, however, the shadow as allegory does not suggest the inseparability between body and shadow, but reinforces the 'offending' mismatch between the *babu* and his flawed psyche. The *babu*'s distancing from his own Indianness was pursued through a scrupulously exact English costume, by look, word and gesture. Heteronomy, however, could never grant him the 'status of an Englishman, and could only reduce him to a pathetic caricature of that notional model of enlightened, virile independence' (Sartori 2008: 104).

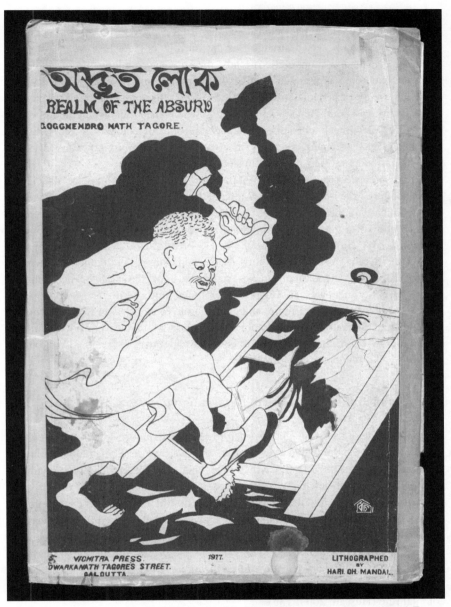

Figure 2.3 'The offending shadow', *The Realm of the Absurd*, lithograph, by Gaganendranath Tagore, Calcutta, 1917. © Victoria and Albert Museum, London.

The mirror does not return the utopian reflection of the *babu* but functions more as a metaphor for discrepant contradictions. Like a prison, the mirror 'contains' his undesirable body, yet destruction of the mirror does not restore his (utopian) freedom. The shadow mockingly 'offends' the *babu* and reminds him of his flawed mimesis. Far from triggering corrective laughter, the print leaves its viewers with a paralysing sense of bleakness regarding the absurd effects that the blind mimicry of the West brings about. Hence, one can see how Gaganendranath's depiction of the *babu*'s flawed mimesis challenges Bhabha's account of colonial mimicry. Contra Bhabha, Gaganendranath perceives that the process of mimicry can only turn humans into vulgar, offensive creatures lacking vital elasticity.

In the sarcastic print 'Terribly Sympathetic' (Plate 5), the violence underlying the smashing of the mirrored image is directed outward. Small figures, waving their arms frantically in the air, seek to escape an advancing threat. Above them towers the colossal body of a fiendish, ginger-haired British politician, complete with bowtie, monocle glass, cufflinks and buttonhole. He brandishes a whip and stamps his feet on the fleeing crowd.[11] Exploiting a common, English colloquialism, 'terribly sympathetic', Gaganendranath makes a mockery of the ambivalence inherent in the despotic and paternalist nature of colonial rule. Terror and sympathy are mutually exclusive, so too Empire and ethics: brute force rules. In *Reform Screams*, Gaganendranath continues his graphic exploration of themes considered in *The Realm of the Absurd*. Before turning to consider a number of screams, I will outline the historical circumstances of the time.

Emergency and law's violence: *Reform Screams*

Disappointment at the Montagu-Chelmsford reforms transformed into outrage at the enforcement of the draconian Rowlatt Act, approved by the British Government in 1919, which undermined basic civil liberties and gave the colonial administration unlimited powers of detention and repression (Bose and Jalal 2011: 69–70). The intimate and anxious relationship between the rule of law and the exception was made explicit. Moreover, it unambiguously revealed that racial difference was the 'limit condition' for the articulation of liberal conditions of rule and positive conceptions of legality (Hussain 2003: 125). Race, as the origin of differentiation which structures the evolutionary narrative of civilization – the idea that some races need to be aided toward a civilized rule of law – prompted the tutelary justification of colonial rule (Hussain 2003: 136).

But as Partha Chatterjee suggests, race also functions as the limit condition which the colonial state cannot incorporate into its normative ideology. The Jallianwala Bagh Massacre of 1919, in which Brigadier-General Reginald Dyer fired upon a civilian mass of unarmed, religious believers (killing an estimated 379 people and injuring many more), represented a desperate attempt on the part of the colonial state

to preserve and reinstitute state power through a performative display of *mythical violence* (Hussain 2003: 100).[9] In *Reform Screams* (1921) we see Gaganendranath distance himself from the healing dialectic of Bergsonian laughter to proffer a powerful critique of mimicry and the progressive claims of civilization.

In Bergson's metaphysics, creative evolution is committed to a principle of harmony, whereby harmony triumphs over discord. Evolution of life is based on the harmonious, if precarious, balance between resistance of matter and the explosive force of life itself. Adopting the Bergsonian interpretation, Gaganendranath had invested laughter with a redeeming power that could potentially repair the torn fabric of society. But now, Gaganendranath mocked the optimistic principle of harmonious equilibrium endorsed by Bergson. In *Reform Screams*, we sense the workings of a destructive force, which cannot restore the *élan* of the universe to society. Not a single print induces redemptive laughter in the viewer, but rather '*chitkaar kora*', meaning 'scream' in Bengali, which can be translated as a loud screech in response to horror or shock.

Formerly, the *babu* was a notorious subject of mockery, but this is not the case with 'Astronomical Scream. The First Bengali Governor. Where is H.E.?' (Plate 6); fellow Indian politicians are depicted as sinister, identical automatons, wearing Western suits and shiny top hats and accompanied by uniformed mascots. Lord Sinha, the first Indian to be appointed by the British as Governor of Bihar and Orissa, cannot be identified.

The scream from space turns into a deadly scream in the print 'Premier Scream, Montford in Labour – Behold the Outcome' (Plate 7). In the image, we see a cadmium red, stillborn baby with a stethoscope stuck like a suction cap on his swollen brain: the baby represents India. Held forcefully by an old woman, the baby is force-fed from a small bottle displaying the word 'deficit'. Next to him, a man immerses his bloodstained arms in a bright red bowl; a large mercurial thermometer is on the brink of exploding, while in the background, a monocled gentleman looks puzzled. 'Premier scream, Montford in labour' is an allegorical depiction which invites the viewer to consider the grim repercussions of the Montagu-Chelmsford Act. The latter had inaugurated the birth of a new constitution in a 'very anemic condition' (Tagore 1921). Gaganendranath represents the country's Budget Deficit as a stillborn child, whom the Viceroy and his ministers are struggling to keep alive by artificial respiration. The old woman, Annie Besant, head of the Home Rule Movement, looks reproachfully at the New Constitution. Gaganendranath casti-gates the colonial administration for wanting to extract their 'pound of flesh' and compensate for the drain on the colony's economy. Red is smeared over the image, the doctor, the bloodshot eye of the monocled gentleman and the baby, suggesting the nation bleeding to death. Bergson's idea of the relative success of each vital solution is seriously questioned. The precarious conditions of the baby intimate the already compromised 'evolution' of the Indian state.

In its subsequent Cubist incarnation, laughter erupts into an explosive force conveyed visually through the blasting of forms. Laughter occurs in excess of

itself, convulsing the body; transformed into a plexus, it contracts into a spasm 'to approximate the horror of abjection' (Deleuze 2004: 15). In this Bergsonian reversal, the body seeks to transcend itself through the screaming mouth and reunite with the material field.

Explosive laughter

According to the account of Mohanlal Gangoly (the artist's nephew), Gaganendranath's interest in light refraction occurred fortuitously in 1921, which would subsequently spark off his fascination with Cubism (Gangoly 1928: 74–7). Following a mysterious explosion, which took place during a visit to the *swadeshi mela* organized by Gandhi in Calcutta, Gaganendranath came across a large piece of broken glass. The glass had cracked in the fire, creating fantastic light patterns. The spectacle provided by the moving spinning wheels at the *mela* had been thoroughly disappointing for the artist: 'nothing new is ever produced in India' (Tagore 1928: 77). But the discovery of this piece of glass pleased Gaganendranath enormously, redeeming the unalleviated boredom of the *mela*. In 1922, Gaganendranath published his Cubist paintings anonymously in the magazine *Rupam: An Illustrated Quarterly Journal of Oriental Art, Chiefly Indian*, alongside an article by the Viennese art historian Stella Kramrisch. The latter, appointed by Rabindranath at Kala Bhavan, observed that while Cubism was a European phenomenon it shared the formalist concerns of other (non-European), non-illusionist artistic forms. Among the works of Gaganendranath described by Kramrisch was a watercolour entitled *Laughter*. This is how the art historian describes the image:

> In *Laughter*, at last that great deliberator hurries triumphantly laughing, laughing in all the white nooks, laughing from all the dark peaks out of its shelter that earnest, composed left portion of the composition, which quivers already with restrained laughter. This composition does not depict a psychological state. It is the created form of a smile, which starts clear and acute and rushes full of *music* towards the end. (Kramrisch 1922: 109)

The black and white watercolour depicts an intricate mass of sharp patterns and broken shapes. The image from within stretches across the entire picture surface, seemingly cropped from a larger continuum. The fragments splinter the image from within. In *Laughter,* Gaganendranath does not rely on the mimetic capacities of the line to evoke violence. Receding and accumulating ad infinitum, the planes contract and expand to imply convulsion. Like the experience of laughing itself, which leaves our bodies disorganized, the strangeness of this image deprives one of the means to describe it. Like laughter, it leaves us speechless: 'Laughter is many things, of course; it is, among other things, a wordless language spoken by the body when our standard vocabularies desert us' (Batchelor 2000: 104).

For the artist, Cubism is not a technique that needs to be mastered: it offers neither rules nor norms, but is interpreted by him as a liberating process (Tagore 1926).[11] Freedom acquires a physical sense: '"to detonate" an explosive, to use it for more and more powerful movements' (Deleuze 1988: 107). The artist points out how much of Calcutta society is laughable and absurd to the extent that little if any value remains: laughter tinges all aspects of life with a wash of devastating pessimism. This may account for why his patterns of inflation and deflation lie uneasily between pathos and hysterical laughter, reminding us less, now, of Bergson and more of Gilles Deleuze and Felix Guattari's observations regarding the nature of humour. The two philosophers suggest that laughter is 'an art of consequences and descents, of suspensions and falls' (Deleuze and Guattari 1986: 5). The comical laughter is the loophole, but the bleakness with which it is so intimately linked is never far from sealing it off completely.

A contradictory figure, a canny aristocrat aware of his incongruous circumstances, Gaganendranath was bemused at his own historical good fortune, revealing a remarkably *elastic* capacity for adaptation and survival. Initially, through his reading of Bergson's theories on mechanicity, Gaganendranath had sought through laughter to rectify the ills of colonial society. Draconian state measures prompted the artist to reconsider the philosopher's critical ideas and highlight the limits of its alleged universal efficacy. During times of emergency the power of laughter does not so much lie in repairing the wounds afflicting society but merely affords a temporary escape from horror (Buck-Morss 1992: 41–4).

To 'provincialize' the legacy of European thought is not enough, writes Rustom Bharucha (2001: 119). Confronting head-on Dipesh Chakrabarty – a founding figure of subaltern thought – Bharucha argues that the European conceptual heritage is a burden that the South can happily do without. Of course, to reject gifts breaches diplomatic etiquette, offends the giver and severs links. But this uncivilized gesture is, for Bharucha, ethically necessary as a means to dispute liberal 'generosity' – a refusal to be bought up. Injecting political urgency into the debate, Bharucha indicts the cool, contemporary collusion of postcolonial intellectuals in the narrative of globalization (2001: 226). 'Provincializing', if anything, is a cowardly pantomime that rings of neoliberal reconciliation and reaffirms the arrogant power of the West (Bharucha 2001: 226). Cosmopolitanism camouflages privilege and falls short of grasping the importance of solidarity, especially for those deprived of power, writes Craig Calhoun. It is vital, he explains, to take up a more politicized and contracted form of global cosmopolitanism, one which can accommodate hybridity, making it a more valuable motor of political change (Calhoun 2006: 536). Gaganendranath's laughter *de-europeanizes* Bergsonian metaphysics and derides the civility and respectability of European self-knowledge. That his critique took place in a virtual cosmopolis makes his contribution all the more remarkable.

Notes

1. In the article, Pinney refers to the revolutionary terrorist, Bhagat Singh (1907–31), who, in 1929, perfectly mimicked an Englishman and was able to fool an entire police squad at Lahore Railway Station.

2. The Tagore family was one of the most influential Brahmo communities of Calcutta, notwithstanding their unorthodox attitude towards religious affairs and the caste system. The family was among the first social groups to urbanize Calcutta in the early nineteenth century and to collaborate with imperial rule as compradors since the early days of the East India Company. Their lifestyle was marked by conspicuous consumption.

3. To gain a sense of what this price meant, it is worth considering that between 1912–16 the value of gold was around Rs14.00 and that the subscription for non-lunching members of the Calcutta Club was Rs6.00 and lunching members Rs12.00 a month. The highest salary received by the Bengali Maharaja Mohindra Chandra Nandy's staff was Rs200.00 p/m while the menial staff received a mere Rs4.00 down to Rs1.00 p/m.

4. The work of Bergson reached the British public through his lectures, texts and wider discursive press. Bergson delivered lectures at Oxford in 1912 and was widely read among the Bloomsbury group which Rabindranath frequented.

5. Bergson died in 1941 in occupied Paris. Hence, he would have come to experience 'imperial' domination only towards the end of his life.

6. Kalighat *pats* characters often inhabited a topsy-turvy society, which artists perceived to be increasingly spiralling into chaos. Among the scandalous events illustrated by lower caste members was the Mohanta-Elokeshi affair, which shocked Calcutta in the 1870s. The incident revolved around a notorious case of adultery involving a temple priest and a housewife. The discovery of adultery led the husband to murder his wife.

7. The word *swadeshi* derives from Sanskrit and is a conjunction of two Sanskrit words. 'Swa' means 'self' or 'own', while 'desh' means 'country'. Thus, the word '*swadeshi*' denotes 'own country' and in its adjectival form, 'of my own country'. Other reasons contributed to fomenting the rise of anti-British feeling, including Curzon's attempt to reduce concessions previously granted in the realms of education and local government to educated Indians. In this case, laws curtailing the autonomy of educational institutions and local government were passed. While the English-speaking, educated elite voiced its disaffection with British rule in an organized manner, a small number of industrial labourers raised their concerns through a combination of class and communitarian strategies.

8. Rabindranath Tagore, who by 1907 had reversed his ideological stand on the *swadeshi* question, published the novel *Gora* (1907–9), where his decisive break with the revivalist and extremist temper of his earlier writings is apparent.

9. Official statistics claim that the result of the Jallianwalla Bagh Massacre was the death of 379 unarmed civilians with a further 1,137 injured. Unofficial estimates range considerably higher. Hussain borrows the term 'mythical violence' from Walter Benjamin.
10. Independent scholar Tapash Ray has identified the figure as either Lloyd George or Bampfylde Fuller. See the Victoria and Albert Museum archives.
11. In a conversation with the journalist K. Vakil, the artist suggested that Cubism is a really 'wonderful stimulant'.

Bibliography

Appadurai, A. (1996) *Modernity at Large: Cultural Dimensions of Globalization*, Minneapolis: University of Minnesota Press.

Banerjee, S. (1989) *The Parlour and the Street, Elite and Popular Culture in Nineteenth Century*, Calcutta: Seagull Books.

Batchelor, D. (2000) *Chromophobia*, London: Reaktion.

Benjamin, W. (1999) *Illuminations Essays and Reflections,* London: Pimlico.

Bhabha, H. (1994) *The Location of Culture*, London: Routledge.

Bergson, H. (1911) *Laughter: An Essay on the Meaning of the Comic*, London: Macmillan Press.

Bose, S. and Jalal, A. (2011) *Modern South Asia: History, Culture, Political Economy*, London: Routledge.

Buck-Morss, S. (1992) 'Aesthetics and anaesthetics: Walter Benjamin's artwork essay reconsidered', *October*, 62: 3–41.

Calhoun, C. (2003) '"Belonging" in the cosmopolitan imaginary', *Ethnicities (Debate)*, 4: 531–68.

Chakrabarty, D. (2000) *Provincialising Europe: Postcolonial Thought and Historical Difference*, Princeton: Princeton University Press.

Clifford, J. (1998) 'Mixed feelings', in *Cosmopolitics: Thinking and Feeling Beyond the Nation*, P. Cheah and B. Robbins (eds), Minneapolis: University of Minnesota Press.

Dadi, I. (2010) *Modernism and the Art of Muslim South Asia*, Chapel Hill: University of North Carolina Press.

Deleuze, G. (1988) *Bergsonism*, New York: Zone Books.

—(2004) *Francis Bacon: The Logic of Sensation*, Minneapolis: University of Minnesota Press.

Deleuze, G. and Guattari, F. (1986) *Kafka Toward a Minor Literature*, Minneapolis: University of Minnesota Press.

De Mille, C. E. (2008) 'Bergson in Britain ca. 1890–1914', Doctoral Thesis, London: Courtauld Institute of Art.

Eco, U. (1977) *Come Si Fa Una Tesi di Laurea*, Milan: Bompiani.

Fanon, F. (1967) *The Wretched of the Earth*, Harmondsworth: Penguin Books.

Foucault, M. (1986) 'Of other spaces', *Diacritics*, 16: 22–7.

Gangoly, M. (1928) *The Southern Veranda*, Calcutta: Visva-Bharati.

Ghosh, A. (2006) *Power in Print: Popular Publishing and the Politics of Language and Culture in a Colonial Society, 1778–1905*, Oxford: Oxford University Press.

Hussain, N. (2003) *The Jurisprudence of Emergency: Colonialism and the Rule of Law*, Ann Arbor: University of Michigan Press.

Jain, J. (1999) *Kalighat Painting: Images from a Changing World*, Ahmedabad: Mapin Publishing.

Jain, K. (2007) *Gods in the Bazaar: The Economies of Indian Calendar Art*, Durham, NC and London: Duke University Press.

Kramrisch, S. (1922) 'An Indian cubist', *Rupam: An Illustrated Quarterly Journal of Oriental Art, Chiefly Indian*, 11.

Marx, K. (1853) 'The future results of British rule in India', *New York Daily Tribune*, New York (8 May).

McGuire, J. (1983) *The Making of a Colonial Mind: A Quantitative Study of the Bhadralok in Calcutta, 1857–1885*, Canberra: ANU.

Mitra, A. (1965) *Four Painters*, Calcutta: New Age Publishers.

Mitter, P. (1994) *Art and Nationalism in Colonial India 1852–1922: Occidental Orientations*, Cambridge: Cambridge University Press.

—(2012) 'Frameworks for considering cultural exchange: The case of India and America', in *East-West Interchanges in American Art: A Long and Tumultuous Relationship*, L. Glazer, A. A. Goerlitz and C. Mills (eds), Washington, DC: Smithsonian Institution Scholarly Press.

Pinney, C. (2004) *Photos of the Gods: The Printed Image and Political Struggle in India*, London: Reaktion.

—(2007) 'The body and the bomb: Technologies of modernity in colonial India', in *Picturing the Nation: Iconographies of Modern India*, R. H. Davies (ed.), New Delhi: Orient Longman.

Prusak, B. G. (2004) 'Le rire à nouveau', *The Journal of Aesthetics and Art Criticism*, 4: 377–88.

Ram, R. (1978) *The Jallianwala Bagh Massacre: A Premeditated Plan*, Chandigarh: Publication Bureau, Punjab University.

Roy, K. (1964) *Gaganendranath Tagore*, New Delhi: Lalit Kala Akademi.

Rustom, B. (2011) 'Infiltrating Europe: Outside the borders of postcolonial cool', in *Unpacking Europe: Towards a Critical Reading*, I. Dadi and S. Hassan (eds), Rotterdam: Museum Boijmans Van Beuningen.

Sarkar, S. (1973) *The Swadeshi Movement in Bengal, 1903–1908*, Calcutta: People's Publishing House.

Sartori, A. (2008) *Bengal in Global Concept History: Culturalism in the Age of Capital*, Chicago: University of Chicago Press.

Seal, A. (1968) *The Emergence of Indian Nationalism. Competition and Collaboration in the later Nineteenth Century*, Cambridge: Cambridge University Press.

Tagore, G. (1915) *Wry Thunderbolt*, Calcutta: Thacker, Spink & Co.

—(1921) *Reform Screams: A Pictorial Review at the Close of the Year 1921*, Calcutta: Thacker, Spink & Co.

Tagore, G. and Vakil, K. (1926) *The Bombay Chronicle* (30 June).

Young, R. J. C. (2003) *White Mythologies: Writing History and the West*, London: Routledge.

3

The Return of the *Aura*: Anish Kapoor: The Studio and the World

Denis Vidal

According to Rashed Araeen, the well-known contemporary artist and a fierce critic of the contemporary art world, 'the problem with the policies of multiculturalism, or theories of cultural diversity, is that they have failed to address the main issues of art as an individual practice rather than an expression of community as a whole, or of art as an expression of post-colonial subject who in order to come to terms with his or her modernity, must to some extent free him – or herself from the constraints of a specific culture' (Araeen 1999: 233). There is still a lot of sociological truth in the point Rasheed Araeen made 14 years ago. Many contemporary artists, all over the world, have accepted, more or less willingly, to define themselves or to be defined through a logic which continues 'to privilege cultural differences as the basis of artistic difference by the post-colonial artist' (Araeen 1999: 23). However, one should not forget that recognition of this dilemma is neither particularly new nor exclusively determined by the 'West'. It was played out over and over in colonial times. To give just one example, modern Bengali artists and intellectuals were always aware of it and they took very contrasted positions in response to it (Guha Thakurtha 1992). One should not forget exhortations like the one made by Rabindranath Tagore in 1926: 'I strongly urge our artists vehemently to deny their obligation to produce something that can be labelled as Indian art, according to some old world mannerism' (Vidal 2011). Luckily enough such exhortations did not remain completely unheard, even before artists like Rasheed Aareen took the 'historical responsibility' of taking up the torch. But one can't perhaps find any better example of it in recent times than the work and career of Anish Kapoor, the well-known sculptor of Indian origin (Figure 3.1). In his personal case, as in that of a few other 'post-colonial' artists and intellectuals, it no longer makes sense to ask if they successfully managed or not to find their place in 'the historically transforming process of modernity'; it is rather to assess how their work effectively obliges us to revise some of the stereotypes which are still commonly used when any definition of 'modernity' or 'post-modernism' is at stake, whether in the arts or in any other cultural domain.

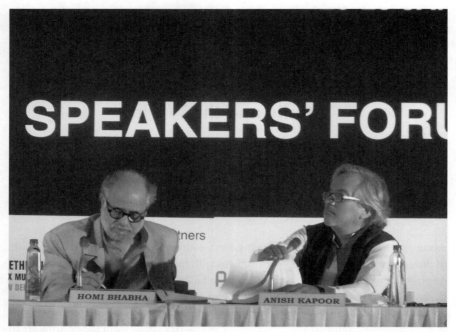

Figure 3.1 Anish Kapoor and Homi Bhabha at the speaker's forum, India Art Summit (20–23 January 2011). Image courtesy of V. P. Balakrishnan.

A game of mirrors

Bourdieu's sociological analysis of art and culture remains to this day one of the most systematic attempts to analyse, scrutinize and deconstruct the mysterious *aura* that surrounds the idea of art (Bourdieu 1965, 1966, 1992). The main focus of his analysis is to demystify the strategies that social actors employ – consciously or not – to present artworks as if they subscribed to a logic in which social determinism and personal interest do not play a part and where universal values and all sorts of idealism prevail.

In many ways Anish Kapoor would seem to embody, perhaps more than any other artist, the perfect archetype of all that Bourdieu is targeting: whether through Kapoor's refusal to be defined by his personal biography, the way he relates to money, or how he deliberately cultivates a universal conception of 'art' and of the 'artist'. There is no aspect of his artistic identity which seems to escape the devastating form of sociological criticism which is at the core of Bourdieu's work and that continues to inspire a huge number of critics of the contemporary art world today. There is, however, a paradox that one cannot fail to notice if one attempts to apply a Bourdieu-like analysis to Anish Kapoor: that is, indeed, the striking parallel

between most of the analysis that Kapoor applies to his own artistic practice and that of Bourdieu's on art, more generally, even if such 'family resemblance' does not preclude them from having otherwise nearly opposite perspectives about the art world and the practice of art.

It would seem, indeed, that Anish Kapoor openly values and advocates more or less everything that Bourdieu attempts – as far as he is concerned – to critically deconstruct in his analysis of the art world: whether it is the acknowledged ambition to get global recognition, based on his belief in universal aesthetic values; or the explicit search for metaphysical depth in his artistic work, self-acknowledged recourse to illusionism but also, more generally, practically all the opinions that he may be professing as an artist. But one should also recognize, however – whether agreeing or not with his point of view – that even if Anish Kapoor is effectively defending a rather idealistic and universalist conception of art, he certainly not does do it either in an idealistic manner or a sociologically naïve one, as I will show in detail here.

Anish Kapoor would never say, for example, that the social and cultural origins of an artist do not influence his work; but he would argue that one should not take them into account for appreciating artworks. Neither will he deny the importance of money in art; rather he will highlight it in an even cruder manner than Bourdieu, describing in detail how the price of an artwork deeply colours the reception of it. More fundamentally, he will insist on the fact that any good work of art should radiate some sort of 'magical' *aura* in the eyes of the viewer, resting on subtle forms of 'illusionism' and of fetishism; not only that, but he will always be looking for new ways of triggering such 'illusionist' effects. As a matter of fact, he believes that it is precisely in such effects that the very essence of art resides.

What distinguishes fundamentally the analysis of art by an artist like Anish Kapoor and by sociologists is not so much their respective manner of looking at it, but rather how they value what they find in it. While in the case of some artists, such analysis is used in order to understand how someone makes art, in the case of sociologists, very similar insights are used to analyse but also, sometimes, sometimes, to demystify the very process of making it. But this is also why an anthropological perspective may help us to deconstruct such a game of mirrors – more precisely, the sort of 'mirrors' that Anish Kapoor knows so well how to manipulate not only when he is answering art critics, journalists and art historians, but also that he is using as a privileged material in some of his most famous works of art.[1]

A question of conceptual authority

There are various ways of approaching the anthropology of art. One may do it in a rather classical manner and try basically to unveil the social and cultural structure of the art world today in a manner reminiscent of the method employed by sociologists

and art historians. One may also share the theoretical ambition of someone like Alfred Gell and propose a 'grand' theory of art (Gell 1998). But what I wish to do here is more simply to follow a methodological injunction that one finds not only among anthropologists, but also in the preface of the catalogue of the last retrospective of Anish Kapoor in London by Homi Bhabha, where he urges his reader to engage with 'the aesthetics and ethnography of an art practice, and also with its conceptual authority' (Kapoor 2009: 27). If I intend to follow such advice here, it is not only because it would be difficult to find another artist whose work and artistic personality is so emblematic of the globalization of the art world today; it is also because if one accepts to seriously engage with Anish Kapoor's 'conceptual authority', one may gain some rather unexpected anthropological insights in the evolution of the art world today: his work personifies – better than in the case of any other artist – a trend that I would be tempted to identify as the return of the *aura* in the contemporary art world.

I will begin by examining how Anish Kapoor defines his identity as an artist. Then I will describe how he defines his activity in the studio. And, finally, I will look at the way he deals with diverse questions related to the reception of his work. By articulating together these three approaches, I hope also to demonstrate that one should look at the globalization of the art world today not only as a form of rhetoric or as the simple consequence of the actual evolution of the art market, but also in terms of how such evolution equally feeds on the concrete sort of creative engagement that artists like Anish Kapoor are putting into their work.

I
Adieu to Psychobiography

Let me recall firstly – even if it is well known by all who follow his work closely – how Anish Kapoor progressively managed to obtain for himself the right for his art not to be defined either by his cultural origins or by his cosmopolitism as such.[2]

Not a question of denial

For a start, let us be clear on an important point: Anish Kapoor is not someone who ever tried to deny his cultural roots. He never attempted to hide either his Indian origins (he was born in Bombay in 1954) or the Jewish element in his genealogy: his mother was Jewish and his maternal grandfather was a cantor at the synagogue of Poone. Iraqi by birth, this grandfather had come to live in Bombay in the 1930s because of the increasing antisemitism in Iraq.

Anish Kapoor left India in 1971 when he was 17 years old. He stayed in Israel for two years (1971–3), then came to London, where he pursued an artistic training

at two different art schools: Hornsey College of Art from 1973 to 1977 and Chelsea School of Art from 1978 to 1980. London then became his first place of residence and it has remained so up to the present day. But in spite of this, his work remained strongly associated at the beginning of his career with his Indian origins and with Indian culture. Different facts can attest for this: one may recall, for example, that both the shape, the style and the material of his initial works were understandably associated with India; and that he also used titles for some of them which linked them indirectly to Indian culture. Moreover, Anish Kapoor did not hesitate during the first years of his public life to mention the influence of Indian culture and its visual world on his work, which could then also be associated with the neo-tantrism fashionable among contemporary artists in India. However, the many interviews that he gave show clearly that while he rarely missed the opportunity to declare his pride at being Indian and recognized the influence of such origins at some deeper level, he nevertheless became more and more intolerant with critics who suggested the presence of recognizable Indian elements in his work. One may give a few examples of this attitude from various interviews and catalogues:

> In 1979, Kapoor returned to India for a visit after some years' absence. He feels, that in the past, too much has been made of his trip in relation to subsequent developments in his technique and imagery.[3]

> In the late seventies, early eighties, when I first started making work after being an art student and showing it and so on, I was making objects out of colour pigment. They were perhaps, on the face of it, they looked more Indian than some of the things I'm doing now. What was interesting or problematic for me then was that they were referred to as exotic. Now that's the thing that I find difficult, and I've always found difficult. The exotic is a tag that seems to be akin to the touristic. It seems to be something to do with a rather peripheral, unknowledgeable view of something...[4]

Ultimately, Kapoor says he resents classification, especially when he is defined by his Indian origins.

> I think we have to resist being pigeonholed. I'm not interested in being an Indian artist. I don't need that as a peg to hang on.[5]

One may add that Anish Kapoor adopted exactly the same attitude concerning his Jewishness. While he never tried to deny such influence in his biography – and while he sometimes also used Jewish symbols and titles in some of his works – he became equally careful not to let critics attempt to define his work through the Jewish elements of his identity.

Cosmopolitism: Yes; but don't make too much of it, please

Most commentators have learnt their lesson, and they know that insistent reference to his cultural roots may now not be the best way of introducing the work of Anish Kapoor – especially so if they do not want to be immediately contradicted by him. So a safer strategy, adopted by most of his critics in order to discuss his artistic identity, has become to insist on his 'cosmopolitism', knowing, in particular, that he left India at a very young age and that he has often confessed to the difficulty he has in feeling at home, either in India, England, or anywhere else:

> My own particular story, even when I was growing up, was always one of being slightly outside. There are not that many Jews in India, and there were none at all at my school. I always felt slightly outside the main social framework.[6]

> I found it very disorientating, very difficult … but I think that's an old story, being in a foreign place where one has to reevaluate one's sense of belonging. It took me twenty years to have that sense in London.[7]

One may effectively point to various passages where he seems to define himself through his cosmopolitism. So one is not surprised to find that an 'authorized' commentator like Homi Bhabha did not hesitate to put a strong emphasis on this aspect of Anish Kapoor's life, insisting, for example, on the cosmopolitanism of the city where the two of them were born and on their shared experience as cosmopolitan artists or intellectuals:

> We grew up, Anish Kapoor and I in a great cosmopolitan city … Those of us with post-colonial diasporic presents and God-only-knows-what-and-where-futures are tired of being subjected to the authenticating claims of authenticity.[8]

But in spite of his friendship with Homi Bhabha, Anish Kapoor does not necessarily appear to be more at ease when he is 'pigeonholed' nowadays as a cosmopolitan artist than when he was defined previously through his cultural origins. This is not only because – in spite of the striking diversity of the cultural references that he is mobilizing in his work – he does not like to be identified with some cheap version of the 'post-modern' artist selecting at will cultural bits here and there. It is just not how he conceives his work:

> Madame Butterfly-like, from which one can – it comes back to the conversation about the exotics – from which one can extract those bits that are attractive, and have them reside in a resident culture, then it's cheap and trivial.[9]

And not too much of a Freudian explanation, either, please

When one looks at the work of Anish Kapoor, it is difficult to ignore the obvious sexual connotations of some of his best-known works.[10] So, one may be tempted, rather that discussing his work in terms of his cultural background, to interpret it by reference to more intimate dimensions of his personal biography. Such an interpretation may also appear to get some legitimacy from the fact that Anish Kapoor – who for years underwent psychoanalysis – is never afraid of pointing out the sexual connotations of his art or referring jokingly to them in his interviews:

> Sculptor Anish Kapoor invites Simon Hattenstone to his studio to talk size, price tags and whether his art is really about vaginas … *'My art is upside down and inside out. I've always said that. You might be quoting me there, hahahaa'.* (*Guardian,* 23 September 2006)

But here again, Anish Kapoor likes to emphasize the fact that it is not because his works may have sexual connotations that one should feel allowed to relate them in any way to his intimate history, his sexuality, or even to his own gender.

Basically, what he contests is the very idea that the identity of an artist should be used for defining the meaning of his art. And so, it is the very nature of the relationship between the artist and his work that he systematically attempts to deconstruct when he comments on his artistic activity. Of course, one may simply regard such a personal stance as a form of denegation. But, as I suggested above, if one wishes to approach the work of an artist from an anthropological point of view, it does not make any more sense to ignore his 'conceptual authority' (to use once more the felicitous formula of Homi Bhabha) than it does to ignore the religious beliefs of people when studying their rituals.

II
The studio as a liminal place

In spite of recent advances in the analysis of rituals, the seminal work by Arnold Van Gennep on 'rites de passage' has lost nothing of its anthropological relevance. The core of it – as is well known – is to have analytically distinguished three successive stages for characterizing one of the most important families of rituals in all societies, which he identifies as 'rites of passages'. The preliminary step that one may find in all these rituals is defined by a symbolic dissociation with one's previous identity and with any previous cultural or institutional forms of integration. Then comes a liminal stage of life which may last up to a few days, a few months or a few years, and which is characterized by the fact that one remains at the margins of established norms and institutions. Finally, a post-liminal stage is defined by a process of reintegration under a new guise and a new identity within the social world.

Now, one may be wary of the insidious tendency of anthropologists to find a 'ritual' dimension to every aspect of social life. But in the particular case of Anish Kapoor – as in the case of a few other artists – it is difficult not to feel tempted to establish an obvious parallel with the sort of ternary logic that Van Gennep identifies in the structure of many rituals. As a matter of a fact, I have already dealt – even if a little too succinctly – with the first of these three stages when I showed how Anish Kapoor managed to dissociate his work as an artist from his previous identity. So let me now consider his activity in the studio and demonstrate why it makes sense to use the anthropological notion of 'liminal space' to characterize more precisely the role that his studio occupies in the genesis of his work.

> ... the conquests for an artist, in the end, are not out there in the world; they are all there in the studio.

Whether they are artists or not, most of the people who are living a diasporic life must accommodate the divide between their place of birth or ancestry and the place(s) where they spend most of their time. This is not necessarily easy and in spite of all his fame and success, Anish Kapoor never pretended it was easier for him than for any one else:

> You know, I have lived in the UK for nearly forty years; I am a foreigner there; and I grew up in India; and, in some ways, I am a foreigner there; so, that's the way it is for me, that is slightly uncomfortable.[11]

However, he insists equally on the fact that for an artist like him, the significant divide has never been that between India and England or the 'East' and the 'West':

> I don't think that's true at all. Because there are good artists and bad artists, or not-so-good artists. This kind of East-West stuff is rubbish. I mean, for me, being an Indian artist is not important.[12]

The only divide which matters for him has nothing to do, indeed, with cultural or geographical borders; it is rather the one between his studio and the world. And this is true, in his particular case, not only in terms of artistic practice but also in terms of the definition of self. The question then is to know what the institution of the studio represents for him.

The studio has come to be generally seen since the Renaissance in Europe as one of the places for excellence where artists deal fundamentally with the creative dimension of their art and really express themselves. And one may certainly find some echo of this conception in the clear importance that Anish Kapoor gives to it as the unique *locus* of his creative work. There is, however, a twist in his conception of the studio: what defines it for him is not only the fact that it is associated with the

place where art is 'created'; but more fundamentally, in his own words, the fact that creativity may occur only because the studio is also the place where one gets rid of one's cultural identity and social status:

> The studio remains the meditative home of the work; all the other stuff of the world, success, etc., in reality get in the way of the studio. One must keep the freedom of going in the studio and to behave as a hero, as a victim, as a child. One must keep this ability to wander and to wonder.[13]

In other words, the studio precisely corresponds – in anthropological terms – to the definition of a 'liminal' place where one is supposed to temporarily stop being defined by one's social identity; so let us see a bit more precisely how such 'process' may effectively occur.

The shifting identities of Anish Kapoor as a creator

There are at least three ideas of 'self' which are creeping back regularly when Anish Kapoor is asked to define himself: the first one is linked to his psychobiography; but this is also the one – as we have seen before – that he is keen to leave behind. Another definition of self is the one that he acknowledges himself as an unavoidable obligation to assume 'in the world': that is the public façade of the 'cultural hero', more or less obliged to display on demand the sense of his vocation, the meaning of his art or the precise nature of his 'creative' self. But when he comes back to his studio, a very different 'self' takes over: that is a much more hesitant and anxious part of himself – Anish Kapoor explains – because he rarely knows clearly what he is really aiming at while he is working in his studio. But according to him, it is precisely the freedom to maintain this fragile state of mind in the studio, somewhere in between a more intimate identity and a more public one, that allows him to exist as an artist and to act as a creator:

> I am a real believer in the studio; shows are great, but that is not where the real problems are … So the only place where one may really be fragile is in the studio; and I think that it is vital for artists to be fragile, to not say 'I know' but to do exactly the opposite, to say 'I don't know'. … We spend most of our time, acting through what we know, but this sense of 'I am really not knowing what I am going to do; I will do it anyway…'[14]

The question then is to better understand what he is doing when he is not simply presenting himself as an 'artist', outside 'in the world', and when he is effectively processing his art as a creator in this 'liminal' place that his studio represents.

Getting rid of explicit meanings in his art

When Anish Kapoor mentions the studio, it is first of all to insist on the fact that it is the place where he can get rid of his cultural baggage and where, more funda- mentally, no predefined meaning should be admitted. As he explains beautifully: 'In fact, I feel very passionately that I do not have anything to say as an artist, that the moment I do have something to say, the game is lost, the space is closed up.'[15] But what he is doing there more precisely is better summarized in the following passage:

> To challenge myself. To make art that I've not made before. As I was trying to say earlier, the modern world has a huge range of formal possibilities, whether one's talking about spaces to show in, or materials to work with. I'm ambitious to try and occupy if you like as much of that territory as I can allow myself to. So what I see this as is, it's me battling against my own limitations. The image that I've conjured here of Picasso liberating himself in order to be able to go to a fractured world or a whole world is one, is a battle that he fought with himself. At least that's the way I see it. And I think there is something about opening one's heart to the possibilities that one doesn't even truly or readily know are there – emotional possibilities as much as anything else.[16]

But the fact that Anish Kapoor considers that he has nothing to say in particular as an artist within the space of the studio does not mean that new meanings cannot emerge from his works, once outside of it and back in the world:

> I really feel that I have nothing to say as an artist, I don't have an agenda, I don't want particularly to say anything, but what I do feel is that the real work of an artist happens in the practice in a studio; and from that practice things emerge that are worth saying.[17]
>
> Come to the studio and do my thing. What one does in the studio in fact is to pose a series of problems to oneself. You can come in and say yes I have this funny notion that I want to make a big blob of gooey mass of … dimensions, of certain dimensions, that has a certain effect. And then I've got to look for, having made it I've got to look for some deeper meaning, for some reason for this thing to be in the world. There's enough stuff in the world …[18]

Not your romantic image of the sculptor

What Anish Kapoor is doing in his studio has not much to do, in reality, with the conventional image of a Rodin fighting with his material and leaving the imprint of his craft – preferably also of his genius – on the work itself. While nobody ever contested the fact that Anish Kapoor's works are really his own and are conceived by him, this does not mean that he necessarily plays the most important role in fabricating them. Like many other artists today – especially sculptors – most of the artwork is left, as a matter of fact, to assistants or to specialized firms; and even if

some part of the studio is more exclusively used by Anish Kapoor for conceiving his work, it looks rather like a workshop, even a small factory:[19]

> *Let's talk practicalities for a moment. You said that you're a terrible carver – indeed you do very little at all – so what makes you a sculptor? Is it an instinctive three-dimensional urge?* I think I understand something about space. I think the job of a, so to speak, sculptor is spatial as much as it is to do with form. The idea that an artist has to make everything themselves is…

> *It lingers there doesn't it?*[20]
> Well it lingers, it's certainly not true, it's certainly not necessary, and I doubt that it's ever been true, frankly. The problem with stone carving is that it takes months and months and months, and I have a very dedicated, wonderful team of young fellows who do a lot of the preparatory work for me. Roughing out a stone is just damned hard work.

> *But finishing it off you'll do?*
> Well I'll do some of it, where it's necessary.[21]

What characterizes the work of Anish Kapoor, however, is not only the fact that it does not clearly bear the imprint of its creator; it is more fundamentally the fact that the whole process of art-making is systematically obliterated in the final product. Of course, Anish Kapoor is not the only artist to process art in this way. But the quality of finish of some of his sculptures is such that they have a particular aesthetic poignancy. It is no coincidence that the title of one of his well-known sculptures is called *swayambhu* – the Sanskrit for 'self-made' or 'non-created' (neither naturally or artificially). And it is no coincidence either if Anish Kapoor often insists on the fact that his art will acquire new meaning in the world, largely independently of himself.

III
The alchemy of reception

To comment or to be commented upon

It should be clear by now that Anish Kapoor does not particularly valorize the material dimension of art, nor does he consider that an artist should necessarily 'express' himself through his work:

> Yes, mm, I feel that one of the great currents in the contemporary experience of art is that it seems to come out of the experience of the author. That is to say whether we're talking about the surrealist experience or any inclination to expression – all of that is, dwells so to speak in the author. It seems to me that there's another route in which the

artist looks for a content that is on the face of it abstract, but at a deeper level symbolic, and that that content is necessarily philosophical and religious. I think it's attempting to dig away at – without wanting to sound too pompous – at the great mystery of being. And that, while it has a route through my psychobiography, isn't based in it.[22]

If there is any positive association between a work of art and the name of a particular artist, it is not really because he made it but rather because of the mythology associated with the most famous artists:

> Let's just underline this by saying that artists don't make objects. Artists make mythologies. That when you buy a work or go and see a work by Picasso, because it's a very obvious example, what you look at is the mythological context in which Picasso worked. It's as if one's almost looking beyond the image, beyond the work as displayed, at this incredible man's ability to make art in so varied a series of ways, and declare life as a creative endeavour from beginning to end. What a great thing to do.[23]

Of course one may find that such conception is a bit too close to the most common marketing strategy in the commercial world which consists in valorizing any commercial brand by associating it with *ad hoc* 'mythologies' rather than focusing on the 'product' itself. But it is equally worth considering in more detail how such a mythology may be built in this particular case.

A particularly telling comment from this point of view was made by Anish Kapoor when he divided his artistic career into two periods: before he was asked to represent the United Kingdom at the Biennale of Venice in 1990, he explains how he was the one who had to explain the meaning of his art. But after Venice, it was the job of his commentators to describe and interpret it. He was no longer so burdened with having to make sense of his work: others would take most of the responsibility for it, even if – unlike Beckett or Picasso – he would not hesitate to make it known loudly when he disagreed with his commentators:

> Up to then, it was like if I was telling people what it was about. And suddenly [after his biennale in Venice], in Venice, people were telling me what it was about. It was astonishing, surprising, an amazing moment of change.[24]

The transubstantation of art

Even if most artists do not feel constrained nowadays to proclaim as loudly as before the purity of their artistic vocation, not many of them are as much at ease as Salvador Dali[25] in discussing in detail their relationship with money. Anish Kapoor, however, deals with this question in the same way that he deals with other aspects of his art: he will acknowledge without hesitation the fact that money plays a crucial role – a rather positive one from his point of view – both for art generally, and in his own

art, in particular. But he will nevertheless ferociously despise the very idea that 'art' could be determined or defined by the art market:

> Money is part of the mythology of art. Money and art have lived together for centuries … I don't feel that I have to apologize for that money.[26]
> Money is a mythological tool in the functioning of an object … it brings a emotional quality to the work which gives it a different value … I think that this value is alchemical … it literally performs a change in the object.

Of course, one may be tempted, once more, to interpret such a comment as a form of ideological denial. But there again, it would not lead us very far in understanding Anish Kapoor's own perspective about his artistic vocation.

The performativity of art

A natural stone or a sculpture does not cease to exist if no one is looking at it. But this is precisely what makes the difference between them and most of Anish Kapoor's artworks. Because an illusion may only function if there is someone to be deluded, a work of art deliberately made to stimulate the reactions of beholders needs them in order to exist as a work of art:

> In a sense, this idea about something partial is also there in the relationship between the viewer and the work. The work doesn't exist without the viewer, without somebody looking at it. To a large extent, all work is incomplete. It's completed by the person who is looking at it. That relationship is what makes it whole. All of creation is set about by the relation of Shiva and Parvati – how does it go? It's all like that.
> There's something immanent in the work but the circle is only completed by the viewer. Now that's a very different position from a work let us say with a subject matter, where the work itself, so to speak, has a complete circle of meaning and counterpoint. [27]

This continuous process of redefinition is at the core of what Anish Kapoor defines as the 'alchemy' of art, to use a term that he frequently invokes. From his point of view, making a work of art does not require only the sort the 'creativity' conventionally attributed to all good artists; it requires also some equivalent of the know-how of the 'illusionist' whose experience consists not only in learning how to master his tricks, but also, more decisively, how to anticipate his viewers' reactions and how all sorts of details of the environment will influence their impressions. Once a work of art is exhibited, its performativity will depend exclusively on the effect that it may produce on the viewer. And even if he cannot fully determine the impact of an artwork upon the latter one, the anticipation of this encounter plays a crucial role in the way Anish Kapoor conceives his work. This appears particularly clearly when he explains the reasons why he likes to work with concave mirrors:

Because mirrors are concave, they have a certain focus that does something to your body … It plays on the way you approach it. It is almost as if the art is performative; like a film, like a play; it manipulates, if you wish, the way you stand at a certain place and look in a certain way … All these objects go with a certain sensation of vertigo.[28]

The acquisition of new meanings

If Anish Kapoor does not consider that any meaning is co-substantial with the materiality of the artwork or with the very process of creating it, this does not mean that it cannot be 'added' to it. And, as with any other topic, he does not hesitate to explain quite frankly how this might be done. So, one of the most effective ways of doing so, according to him, is a crafty use of the performative power associated with suggestive titles that one may give to artworks:

> But you can't invest it, you can't invest it with a meaning after you've made it.
> Oh I think those processes are very complex. One can find a way to do precisely that. Naming is one of those ways. Context is another of those ways.[29]

Perhaps the best illustration of this is the curiously powerful effect of one of his best-known sculptures, where the spectacle of a simple bump in the middle of a white wall acquires deep new connotations when one reads the work's title: 'When I was pregnant'.

Another way, however, of giving more profound connotations to his work is to play expertly with all sorts of cultural references, a technique often used in twentieth-century art.[30] It is not necessary here to mention the rather dreaded label of post-modernism; but one cannot fail to notice Anish Kapoor's expert use of all sorts of mythological and religious connotations in his works – whether Hindu, Jewish, Christian, Islamic or whatever. It is, however, at some 'deeper' level – by playing with shape, light, colour or with materials – that Anish Kapoor truly attempts, as he explains himself, to attain some sort of archetypical meaning in his art.

A deeper level of signification

From his first sculptures where he played with coloured powders to more recent works, there is perhaps no other contemporary artist who has put such emphasis on colour in their work. As he proved again and again, whether at the Tate Modern with *Marsyas* (2,003) or at the Grand Palais more recently with the *Leviathan* (2,012), it is the way he combines colours with scale which really makes some of his best-known pieces stand apart from other contemporary sculpture:

> I have always felt that colour has a way to meaning, that form has a propensity for

meaning and that both in a certain way are part of a certain language of the abstract. The forms that I make have a sort of human recall; I don't hope that it is an early human record, a primordial human record; it is what I am after; and colour, of course, does that incredibly well.[31]

By playing with colour and scale, Anish Kapoor attempts to elicit emotive responses which go beyond any discursive meaning and which may attain some deeper level of resonance, among the viewers of his works:

> Red is a colour I've felt very strongly about. Maybe red is a very Indian colour, maybe it's one of those things that I grew up with and recognise at some other level. Of course it's the colour of the interior of our bodies. In a way it's inside out, red.[32]

The artist as an illusionist

It is not only the colour, however, that one notices immediately in the sculptures of Anish Kapoor. Most of them are remarkable as well for the exceptional quality of their material: whether it is stone, powder colours, mirrors, textiles or anything else, the same desire for perfection is clearly visible. Anish Kapoor, who certainly manages to get serious funding for creating his art, is also spending it lavishly to obtain exactly the sort of making that he wants. Such a preoccupation may appear, however, slightly contradictory with the fact that he often stresses his apparent indifference for the materiality of his sculptures. So, one may ask why he would not satisfy himself simply with the use of any readily available material, like so many artists have done throughout the twentieth century. To answer this question is to arrive at a last dimension – perhaps also the most fundamental one – in his conception of his work: that is, the very fact that he considers his own artworks, but also more generally all artistic activity, as a form of illusionism: 'I believe very strongly that it is not something as a real object.'[33]

The reason, for example, that he is giving for using mirrors of unequalled quality in his works has little to do with the rather striking beauty of their surface, noticed by anyone who looks at them; but rather, according to him, because this is the only way he could find to obtain the sort of illusion that he is aiming at, to give to the viewers the illusion of being confronted not so much with a material sculpture as with some uncanny reflection of the world itself. One can give another example of this by referring to another of his famous sculptures which consists of an enormous stone in the shape of a menhir with an empty volume, in the shape of a cube, carefully carved in its centre. The main point of this work, according to the artist, is to direct the attention of the viewer to this dark cavity while the stone itself serves only to frame the void.

> What happens, having made this object, if I put it next to another object? How does that change its reason for being in the world, its effect on the body? One of the phenomena

that I've worked with over many years is darkness. Darkness is an idea that we all know about, in a way an idea about the absence of light. Very simple. What interests me however is the sense of the darkness that we carry within us, the darkness that's akin to one of the principal subjects of the sublime – terror. A work will only have that deep resonance that I try to indicate is there if the kind of darkness that I can generate, let's say in a block of stone with a cavity in it that's very dark, if the resonance that's in that stone is something that is resident in you already. That's to say that you are completing that circle, but perhaps without knowingly you're completing that circle. It's not a verbal connection, but a bodily one. That's why sculpture occupies the same space as your body.[34]

Anish Kapoor is then more interested in the idea of creating some specific illusory effect in his sculptures than to highlight the quality of their 'thingness' as such:

What are your limitations as a sculptor?
Oh they're manifold. I don't know. I don't know. Do you know, much of the work that I've made over many years now proposes the idea that for every form there is a kind, there is a kind of counterpoint in non-form. One of the things that I see myself battling with now is not the non-form, because in a way I feel I've done some of that, but the form. So what happens when there's form and no non-form? Where can I go with that? That's a battle I need to investigate, fight, whatever.[35]

At this point, however, it may be time to leave Anish Kapoor to his own artistic 'fight' and to conclude by reassessing briefly his conception of art from an anthropological perspective.

The return of the *aura*

Hans Belting has claimed that with the evolution of contemporary art, we have arrived at a final point which can be legitimately defined as 'the end of art', at least in the traditional form as understood in Europe from the Renaissance onward (Belting 1,984). And there is little doubt, indeed, that art history has been marked in the twentieth century by the radical attempts made by various 'avant-gardes' to deconstruct the artistic practices and most of the accepted ideas and expectations upon which the idea of art had developed and had been appreciated previously.

Meanwhile, during the same period, most art historians have been equally busy deconstructing most of the common notions and perceptions upon which the very idea of art history had been founded at least from the European Renaissance: the idea of art as fundamentally distinct from skilled craftsmanship; the cult of the artistic genius as an individual which outplays the restrictions imposed by his time and culture; or the common idea that 'great art' is recognizable by the fact that it is able to 'speak' to anyone as well as to 'move' everyone. At a more fundamental

level, also, what most art historians and anthropologists have questioned is the very idea that any notion of aesthetic may be given any sort of universal relevance. And if one puts aside a few well-known exceptions (Aby Warburg, for example[36]), the vocation of art history has mostly become to provide the sort of socio-cultural and historical background analysis, which is supposed to give a better informed or deeper understanding of art.

One should not conclude, of course, that the conventional conception of art and aesthetics has not survived. As a matter of fact it has flourished more than ever, as one can see from the sort of gloss used for attracting the crowds to the retrospectives dedicated to the best-known artists. Similarly, the ferocity of some of the debates surrounding contemporary art demonstrates clearly enough that older conceptions of art and aesthetics are far from being dead. As a matter of fact, any attempt to analyse the sociological realities of artistic taste show the profound chasm which exists between 'popular', 'conventional' or 'classic' tastes and more 'elitist' or 'avant-garde' ones. What is fascinating, however, in the case of Anish Kapoor and his art, is precisely how he manages to eschew such sociological and well-entrenched divides.

As we have seen, neither his works nor his conception of art are of the sort that one could simply define by placing him among the many artists who have busied themselves in deconstructing a more conventional conception of art and of aesthetics. Yet neither can one suspect him of simply following a more conventional conception of art and ignoring what has been going on in the evolution of the contemporary art world.

When one examines carefully not only how Anish Kapoor conceives and interprets his work, but also how it is received, it appears clearly that what he manages to do – often quite successfully – is to find new ways acceptable both for the elite of the art world and for the general public to restore a rather conventional conception of art and to promote it with great enthusiasm and without any sort of ironical twist or any form of second degree interpretation; he is endorsing very explicitly his ambition to make an art which has an 'universal' appeal and which mythologizes, once more, the status of the artist on the public scene. And he proclaims openly his right to use any means to get such recognition: whether it is the scale of some of his works, the fascination linked to their price, the quality of the materials used or the sort of symbolism associated with them.

By restoring a rather classical conception of art where artworks are fundamentally defined once more by the *aura* they may possess in the eyes of the beholder, Anish Kapoor defies those who, following in the steps of Walter Benjamin or Theodor Adorno, believe that such traditional conception of art has nowadays become definitely obsolete. Finding powerful allies in the general public and with wealthy patrons like Lakshmi Mittal or with intellectual luminaries and celebrated writers like Homi Bhabha or Salman Rushdie, the recognition of Kapoor's work demonstrates clearly that the importance of *aura* in art does not refer only to a popular and nostalgic conception of art and of its history.

As a matter of fact, it is principally in the work of essayists like Walter Benjamin, the Frankfurt School and their successors that such a notion is supposed to remain forever the hallmark of an extinct era. But while the use of this notion may have taken a more restrictive meaning in the work of Benjamin and a few others after him, one may argue, more generally, that it has never disappeared, in reality, either in the 'world of art' or elsewhere, because of the advent of new techniques of mechanical reproduction like photography or the phonogram at the end of the nineteenth century.[37] Sociologists of art as diverse as Natalie Heinnich (1,984) and Bruno Latour or Antoine Hennion (1,997) have summarily but rightly insisted on the fact that such new modes of reproduction helped to 'sacralize' works of art rather than desacralize them. One should not be too surprised, then, if the very notion of *aura* and the whole conception idealist conception of art traditionally associated with it has come back with a vengeance to haunt the very centre of the contemporary art world. This does not mean, however, that one should be, once more, sociologically naïve and believe, for example, that it happened only because of the prevailing historical and sociological conditions or because of any form of technological 'advances' as such.

Alfred Gell was certainly right to stress the methodological importance of recognizing any form of 'art' as a 'technology' by itself, from an anthropological perspective. But one should not forget either that, in doing so, he was simply recalling a well-known fact that few 'artists' may afford to ignore. The real challenge, however – both for artists and for anthropologists – is rather to grasp what this often disconcerting 'technology' is more specifically about. And one may perhaps acknowledge that Anish Kapoor is one of these artists who has managed to find some sort of answer to this question in our time, even if it is not the only one. This is why it is worth, I believe, not only considering his work, but also what he has to say about it – even if when listening to his words, one may be rather tempted, in his case, to evoke the legendary *metis* of the ancient Greeks rather than any post-modern notion of *métissage* or *hybridity.*

Notes

1. Hundreds of articles and dozens of books and catalogues have been dedicated to Anish Kapoor. He has never ceased also to give interviews to art critics, curators and journalists throughout his career. I have used here the most representative of them.
2. For a fuller analysis of this specific aspect of Anish Kapoor's personality, see also Vidal (2009).
3. *The Tate Gallery 1982–84: Illustrated Catalogue of Acquisitions* (1986).

4. 'Transcript of the John Tusa Interview with the sculptor Anish Kapoor' (2006).
5. 'Entretien avec Farah Nayeri' (2008).
6. 'Anish Kapoor: Smooth operator', *Independent* (2003).
7. 'Anish Kapoor', *Guardian* (2006).
8. 'Bhabha, H. K., 'Elusive Objects: Anish Kapoor Fissionary Art' (2009: 25, 27).
9. 'Transcript of the John Tusa Interview with the sculptor Anish Kapoor' (2006). 'Entretien avec Farah Nayeri', *Bloomberg News* (2008).
10. For example, he stated: 'I have always been interested in involuted form, which is often vaginal, female. It would be dishonest not to recognise that it's blatantly sexual. You can't be coy about it' (Wullshlager 2012).
11. 'Entretien avec Anish Kapoor' (2011).
12. 'Anish Kapoor by Ameena Meer' (1990).
13. 'Entretien avec Anish Kapoor' (2011).
14. *Idem.*
15. 'BBC Radio 3 Entretien avec Anish Kapoor par Joan Bakewell' (2001).
16. *Idem.*
17. 'Transcript of the John Tusa Interview with the sculptor Anish Kapoor' (2003).
18. *Idem.*
19. 'We must have had one hundred people involved in the making of this' 'Entretien avec Anish Kapoor' (2011).
20. 'Transcript of the John Tusa Interview with the sculptor, Anish Kapoor' (2003).
21. *Idem.*
22. *Idem.*
23. *Idem.*
24. *Idem.*
25. Dali never seemed to hide his apparent attraction to money, even if he could also be generous. This may also explain why the unflattering nickname of 'Salvador Dali–Avida Dollars' given to him by André Breton remained attached to him (Descharnes 1987: 36).
26. 'Entretien avec Anish Kapoor' (2011).
27. *Idem.*
28. 'Transcript of the John Tusa Interview with the sculptor Anish Kapoor' (2003). 'Entretien avec Farah Nayeri' (2008).
29. 'Transcript of the John Tusa Interview with the sculptor Anish Kapoor' (2003).
30. The work of Cy Twombly illustrates perfectly this tendency in contemporary art.
31. 'Entretien avec Anish Kapoor' (2011).
32. 'Transcript of the John Tusa Interview with the sculptor Anish Kapoor' (2003). 'Entretien avec Farah Nayeri' (2008).
33. 'Entretien avec Anish Kapoor, Monumenta' (2011).
34. 'Transcript of the John Tusa Interview with the sculptor Anish Kapoor' (2003).
35. *Idem.*

36. While Warburg had been one of the first art historians to promote a rigorous methodology for interpreting artworks in their historical and sociological contexts, his way of analysing the everlasting appeal of some of them was going well beyond such interpretations (on this topic, see for example Didi-Huberman 2002).

37. For a rather confusing definition of the notion of *aura*, one may always look at the often contradictory use that Benjamin himself made of this notion; and how the interpretation of his thinking on this topic became some sort of small cottage industry – a fact widely acknowledged, even by his most ardent interpreters. One may find, for example, on the first page of an edited volume entirely dedicated to his work the following exergue: 'More books on Benjamin and still the pile grows ... Benjamin prose breeds commentary like vaccine in a lab' (Cole 1998: 8). For an admittedly more restrictive definition of 'aura', one may look however at Benjamin's famous essay 'The Work of Art in the Age of Mechanical Reproduction' (1935–6); or examine how this notion is used (rather than 'defined') by most of his commentators: aura is then generally identified as 'the power and authority that a unique or original work of art possessed by virtue of its authenticity, and which disappears, for Benjamin, as the actual object of the work of art becomes a reproducible entity, as in a photograph or a film, for example' (Steinberg 1996: 95).

Bibliography

Interviews with Anish Kapoor
'Anish Kapoor by Ameena Meer' (1990) in BOMB 30/Winter 1990, ART, http://bombsite.com/issues/30/articles/1273

'Interview d'Anish Kapoor par Joan Bakewell' (2001) *BBC Radio 3*, 5 January.

'Anish Kapoor: Smooth operator' (2003) *Independent,* 24 November.

'Anish Kapoor' (2006) *Guardian,* 23 September.

Anish Kapoor in conversation with Marcello Dantas (2007) http://anishkapoor.com/178/In-conversation-with-Marcello-Dantas.html

'Entretien avec Farah Nayeri' (2008) *Bloomberg News,* 30 October.

'Entretien avec Anish Kapoor, Monumenta 2011 (1)' http://www.dailymotion.com/video/xinhjq_entretien-avec-anish-kapoor-monumenta-2011_creation

'Entretien avec Anish Kapoor, Monumenta 2011 (2)' http://www.dailymotion.com/video/xituzz_ii-anish-kapoor-presente-leviathan-monumenta-2011-2eme-partie_creation

Tusa, J. (2003) 'Transcript of the John Tusa Interview with the sculptor Anish Kapoor', 6 July, http://www.bbc.co.uk/radio3/johntusainterview/kapoor_transcript.shtml

Wullshlager, J. (2012) 'Lunch with the FT: Anish Kapoor' *Financial Times,*

5 May, http://www.ft.com/cms/s/2/04b333f0-9457-11e1-bb47-00144feab49a.
html#axzz2gyBoe2TT

Other texts

Araeen, R. (1999) 'The Artist as a Post-colonial Subject and this Individual's
Journey Toward the "Centre"', in C. King (ed.) *Views of Difference, different
views of art*, New Haven: Yale University.

Belting, H. (1983) *L'histoire de l'art est-elle finie?* Paris: Folio Essais.

Benjamin, W. (2012) *L'œuvre d'art à l'époque de sa reproductibilité technique*
(1939) Paris: Allia; also in Benjamin, W. (1968) *Illuminations: Essays and
Reflections*, Hannah Arendt (ed.), New York: Schocken Books.

Bhabha, Homi K. (2009) 'Elusive Objects: Anish Kapoor Fissionary Art', in *Anish
Kapoor*, London: Royal Academy of Arts, 25–39.

Bourdieu, P. (1992) *Les règles de l'art: genèse et structure du champ littéraire*,
Paris : Seuil.

Bourdieu, P., Castel, R., Boltanski, L. and Chamboredon, J. C. (1965), *Un art moyen:
Essai sur les usages sociaux de la photographie*, Paris: Les Éditions de Minuit.

Bourdieu, P. and Dardel, A. (1966), *L'amour de l'art: Les musées et leur public*,
Paris: Les Éditions de Minuit.

Coles, A. (1998) *The Optic of Walter Benjamin*, London: Black Dog Publishing.

Descharnes, R. (1987) *Salvador Dali*, Paris: Les nouvelles éditions françaises.

Didi-Huberman, G. (2002) *L'Image survivante. Histoire de l'art et temps des
fantômes selon Aby Warburg*, Paris: Minuit.

Gell, A. (1998) *Art and Agency: An Anthropological Theory*, Oxford: University
Press.

Guha-Thakurta, T. (1992) *The making of a new 'Indian' Art: Artists, Aesthetics and
Nationalism in Bengal, 1850–1920*, Cambridge: Cambridge University Press.

Hansen, M. B. (2008) 'Benjamin's aura', *Critical Inquiry*, 34 (Winter 2008):
336–74.

Heinich, N. (1983) 'L'aura de Walter Benjamin. Note sur "L'œuvre d'art à l'ère
de sa reproductibilité technique"', *Actes de la recherche en sciences sociales*,
vol. 49: 107–9.

Hennion, A. and Latour, B. (2003) 'How To Make Mistakes on So Many Things at
Once – and Become Famous for it', in H. Gumbrecht and M. Marrinam (eds),
Mapping Benjamin. The Work of the Art in the Digital Age, Stanford: Stanford
University Press.

King, C. (ed.) (1999) *Views of Difference, Different Views of Art*, New Haven: Yale
University Press.

Steinberg, M. P. (1996) 'The Collector as Allegorist: Goods, Gods, and the Object
of History', in *Walter Benjamin and the Demands of History*, M. P. Steinberg
(ed.), New York: Cornell University Press.

The Tate Gallery 1982–84: Illustrated Catalogue of Acquisitions (1986), London: The Tate Gallery.

Vidal, D. (2009) 'Anish Kapoor et ses interprètes. De la mondialisation de l'art contemporain à une nouvelle figure de l'artiste universel', *Revue Européenne de migration internationale*, 25: 69–82.

—(2011) 'Primitivism and Post-primitivism in Modern Indian Painting' in Ch. Jaffrelot (ed.), *India since 1950, Society, Politics, Economy and Culture*, Delhi: Yatra Books.

4

The Practice of Art: An Alternative View of Contemporary Art-making in Tehran

Leili Sreberny-Mohammadi

The Sazmanab Project Space is located on the ground floor of a small, unassuming apartment block, in a lower-middle-class neighbourhood in the west of Tehran. Approaching by car and exiting from one of Tehran's many mammoth highways, the sprawling pipes and imposing tanks of the waterboard across the street, from which Sazmanab draws its name, come into view before the gallery entrance. There is no sign outside and the space is towards the back of the building so there are also no windows to peek into from the street. Just above the buzzer that must be rung to gain entry is a small blue sticker bearing the Sazmanab name and logo. Once inside, a narrow white room awaits. Two doors, one leading to a unisex bathroom and the other to the office, are directly opposite the entrance. Otherwise, the space is entirely open, with a projector mounted on the back wall and a small lectern positioned opposite.[1] A bookcase houses the latest copies of *Art Forum*, *Bidoun* and *Art Asia Pacific*. A small sign in Persian reminds women to remain veiled while at Sazmanab.

Sazmanab Project Space has been open since 2009 and is one of many organizations operating within the emerging and dynamic visual art scene in Tehran today. Sazmanab operates as an unofficial space – in the sense that it has not been granted official permission by *Vezerate Ershad* or the Ministry of Islamic Guidance and Culture, who are responsible for permissions for all artistic and cultural production. On the last count there were over 60 private galleries in Tehran, which host changing exhibitions, usually of local artists, every two weeks. The gallery owners are required to seek a permit prior to opening and to provide officials with information on their exhibitions when requested. Artworks on public display must follow the guidelines of the censors; they cannot show female nudes, for example. There is also one official, state-sponsored museum dedicated to exhibiting art, the Tehran Museum of Contemporary Art, which holds the largest collection of modern art, including works by Andy Warhol and Robert Rauschenberg, outside of the Western world.

In such a context, what does the small, intimate space of Sazmanab tell us about current art-making practices in Tehran? Purporting to be a location for multiple

activities – a gallery, project space, café, library and meeting place – the work of Sazmanab suggests a diverse and evolving sense of art-making in the Tehran context. I imagine art to encompass a broad spectrum of practices not solely centred on producing and circulating art objects, but rather inclusive of a multitude of practices surrounding the creation of an artistic event, encounter, dialogue and/or discourse. To this end I see the work of Sazmanab to act as part of the process of 'culture-making' (Myers 1994), producing an open-ended idea of art and arts practice. Sazmanab Project Space is an exemplar of dynamic contemporary arts practices operating out of Tehran, in which artists and arts spaces imagine themselves as participants in broader contemporary cultural production transcending the borders and limitations of Iranian society under the Islamic Republic. In this chapter I explore the complications of this notion within the Iranian context and articulate the ways in which Sazmanab Project Space in particular practises art-making that connects itself to global discussions while still being decidedly local. I argue that these practices can be viewed as alternative within the current ecology of contemporary culture-making in Tehran. My primary focus is the period in which my research was conducted during the final years of Mahmoud Ahmadinejad's second term as president, which ended in August 2013.

Visual arts in post-revolution Iran

First, I will briefly contextualize arts practice in Iran and define what Sazmanab is an alternative to. I start in 1979 because it was during that year that the Islamic Republic, after a quick, bloody revolution, was established and the socio-cultural landscape underwent massive upheavals. During the years immediately following the revolution, the newly instated regime was caught up in a lengthy process of Islamification in which indigenous cultural production became highly regulated; popular music was banned, and theatre, film and literature highly censored (Khosravi 2008). Modes of artistic production were evaluated only in terms of their capacity to convey theological and political messages, including anti-West slogans, propaganda, war and martyrdom, or religious icons. In the realm of the visual arts, much of the work of cultural institutions – many of which were created with the support of the previous queen, Farah Diba, who had been actively involved in promoting the arts – was completely undone. Over the course of her years on the throne she amassed a huge collection of modern art that was donated to the Tehran Museum of Contemporary Art, which opened in 1977. The huge collection, which is still at the museum today, was banished into storage by the newly installed Islamic theocracy, where it stayed for 20 years until it was exhibited in 2005.[2] Paintings and sculptures of previously successful local artists were desecrated or auctioned off and the vast majority of private galleries were either forced to close or were abandoned (Issa 2001). The Seyhoun gallery, which is still open today, is one of the only galleries that has been operational since before the revolution.

It also became increasingly difficult to continue with experimental artistic practice during the first years of the Islamic Republic. Universities were closed for two years while curriculums were revised to suit Islamic ideals, resulting in the permanent closure of a number of art history departments. Painters who shared Islamic ideals were able to find work painting huge murals of revolutionary figures, anti-American slogans and later motifs in support of Palestine across cities and villages. Artforms recognized as traditional, such as miniature painting and calligraphy, were permitted for their value as authentic and 'true' forms of Irano-Islamic culture that the government was keen to promote. In these early years of the new state, practitioners working in film and photography were able to hastily reinvent themselves, mainly by providing documentation of the Iran-Iraq war and making films supporting Islamic ideals (Ram 2002). During this period, then, a state-sanctioned visual culture emerged in many forms with the primary aim of cementing the ideals of the Islamic Republic. This visual imagery was particularly present in urban areas, with slogans, banners and murals painted onto walls and hung across highways explicating Islamic values and enshrining the leaders of the Islamic Republic (Varzi 2006; Khosravi 2008).

A period of relative reform emerged by the early 1990s once the eight-year war with Iraq had finally ended and the economy had slowly begun to recover. Iranians living in diaspora began to visit Iran more frequently, bringing with them cultural products from elsewhere (Nooshin 2005). An increasing penetration of satellite television and the internet meant it was much harder for the government to control the supposedly polluting influence of Western culture. Iranian cinema began to garner success on the international film festival circuit, encouraging international interest in other forms of cultural production inside Iran. Furthermore, the increasing success of many artists who had fled Iran during the revolution, Shirin Neshat in particular, increased curiosity in Iranian visual culture within the contemporary art world (Issa 2001). In 1997 Mohammad Khatami, a reformist candidate, won the presidency with a landslide victory and was keen to promote democracy and dialogue with other nations (Ehteshami and Zweiri 2008). Over the eight years that Khatami was president a number of independent galleries sprung up across the capital city, providing increasing opportunities for artistic exhibitions. At the same time, the state was also eager to support the development and expression of the arts in ways which had not yet occurred within the Islamic Republic, that is, the support of artistic production without a state-sanctioned ideological message. During Khatami's two terms in office a series of state-funded biennials and exhibitions grew across the country with particular support from the Tehran Museum of Contemporary Art. Art historian Hamid Keshmirshekan explains that it was during this period that the relatively young population, born after the Revolution, came of age; mainly from educated, middle-class, urban backgrounds, they were keen to participate in the evolving artistic communities (Keshmirshekan 2010). He suggests that during this period young artists began to experiment with new mediums including photography,

video, installation and performance. At this moment 'the relaxation of restrictions on art led to the emergence of a generation of artists whose main preoccupation was the idea of contemporaneity' (2010: 504). It was during this period that Iranian relations with Western powers were also at their most congenial, resulting in a few seminal exhibitions of contemporary Iranian art outside the country. Importantly, the 2001 exhibition at London's Barbican Centre involved close collaboration with the institution and the Tehran Museum of Contemporary Art.

However, since Mahmoud Ahmadinejad was elected president in 2005 there has been a shift in the cultural policies of the previous reformist government, resulting in further challenges for artists, musicians and filmmakers seeking audiences for their work. The leadership of the Tehran Museum of Contemporary Art was changed soon after Ahmadinejad entered office resulting in much more limited support for biennials and competitions. Furthermore, many artists who were not aligned with Ahmadinejad's hard-line policies became resistant to participating in any state-funded activities. Concurrently, the number of privately owned galleries has grown exponentially, resulting in neighbourhoods where clusters of galleries have formed. Often galleries are to be found on the ground or lower ground floor of private homes; such is the case for many of the galleries that are in the affluent northern part of the city. There is a further collection of galleries in central and downtown Tehran, particularly in and around Karim Khane Zand Street where the Khaneye Honarmandan museum is located. This proliferation of private galleries is not limited to Tehran, as galleries have also opened in the major cities of Isfahan, Shiraz and Mashad. With few artworks and artists travelling to Iran from abroad, galleries show Iranian artists almost exclusively. Shows change every two weeks, providing ample opportunity for Iranian artists to exhibit. Openings are usually held on Friday afternoons and gallery-hopping has become a popular outing. Tea and pastries are served to guests while the art takes backstage and chatting with friends and acquaintances becomes the primary activity.

Alongside the increase in gallery spaces, a variety of websites and Facebook groups have also proliferated with the primary purpose of providing space to discuss and debate artistic activity as well as to promote exhibitions and individual artists. The website *Tavoos*, established in 2001 when the print quarterly of the same name ceased operations, provides profiles of artists and exhibitions and is available in Persian and English. A Facebook group called Iranian Contemporary Art has over 12,000 members who actively post reviews of recent exhibitions of Iranian artists in Iran and abroad and portfolios of their own artworks. Print publications such as *Tandis, Herfe Honarmand* and *Honare Farda* provide further space for artistic discourse to flourish and provide the crucial space for arts criticism. The Iranian art world, then, is arguably incredibly active in the organizing of exhibitions, promotion of artists, criticism both online and in print and pedagogy. With galleries and websites opening regularly, and more arts students graduating from university each year, the ecology of contemporary visual arts in Iran and Tehran specifically continues to evolve.

While artistic activity has been expanding in Iran, Ahmadinejad's government has actually placed tougher restrictions on social freedom and has increased censorship of the press and cultural production. Aggressive foreign policy and disregard for the International Atomic Energy Agency nuclear arms watchdogs has resulted in tougher international sanctions, putting further pressure on an already stagnant economy. Yet, in stark contrast, the market for art produced in Iran and the broader Middle East has seen unprecedented growth over the same time period. Christie's auction house established a Dubai branch in 2005. Sotheby's quickly moved in a year later, with both houses making regular record sales of Iranian art. 2007 marks the year the first Iranian artist sold work for over one million dollars. A wealthy diasporic population both in Europe, North America and the United Arab Emirates has become increasingly interested in the patronage of the arts as a way of reclaiming their own ties with the nation (Bembery 2012). Large arts institutions in Western art capitals have also begun to collect artworks by Middle Eastern artists more seriously, with steering groups now present at major institutions such as the Tate Modern in London. So, as Iran grew more politically isolated, international interest in Iranian artistic production has increased. While political stalemate between Iran and many Western nations has rendered collaborative efforts between non-Iranian arts institutions and local ones sporadic at best, the market for Iranian art has erupted and been sustained.

Sazmanab Project Space and alternative arts practice

How then does the Sazmanab Project Space operate in such a context? As I have outlined above, the art scene in Tehran is relatively lively, but operates almost exclusively either through state-sponsored exhibitions and competitions, which have seen less participation since 2009, or private galleries, focused exclusively on marketable, sellable artworks. In this configuration, the art object takes precedence as it moves from artist studio to gallery to collection. The practice of Sazmanab indicates the opening up of a third space, intent on creating dialogue and discussion, rather than art objects. Sazmanab is a third space literally, in the sense that it is a different sort of art institute from the other two already present in Tehran, as well as occupying a third space in the terms of Homi Bhabha (1994). For Bhabha, a third space provides the opportunity for resistance to a dominant notion of whole and complete cultures, unaffected by their relationship to others. Sazmanab provides such a space, in the sense of an alternative to the dominant discourse on art in Iran, but also as a space which allows articulation of an artistic identity engaged with and problematizing notions of Iranian art and culture itself. In this sense the practices of Sazmanab engage Bhabha's notion of in-betweeness by exploring and unpicking elements of artistic practice in Iran in form and content and situating them among wider cultural trends and ideas. I shall expand on this further in the next section.

As I outlined above, governmental support for contemporary visual arts inside Iran is relatively limited. Yet there are at least 14 arts universities across Iran producing new arts graduates each year. The University of the Arts, Tehran and Tehran University are both heavily populated with arts majors. A private art school called Mah-e Mehr recently opened in Tehran offering course and workshops in various arts practices and art history. Keen to extend their businesses, a few Tehran-based galleries have also opened branches in Dubai. Clearly, the visual arts scene is lively. While there are both pedagogical spaces and galleries involved in the display and circulation of art objects, usually paintings or photographs, the space to articulate an arts practice which may be socially engaged, discursive and not necessarily object-based is relatively limited. Apart from Sazmanab there are only two other such independent project spaces: one which is run out of a private home and which acts primarily as a studio and meeting space for the incubation of ideas with occasional exhibitions, and another which hosts occasional film screenings and talks for an exclusive mailing list.

Since its establishment in May 2009, Sazmanab has been engaged in a variety of projects and exhibitions, many of which are markedly different from the art on offer elsewhere in Tehran. According to the Sazmanab website:

Sazmanab Project is a non-profit project space in Tehran initiated by artist/curator Sohrab Kashani. The Sazmanab Project organizes exhibitions, events, talks and workshops, runs projects and makes collaborations on projects initiated by other project spaces and artist initiatives. The Sazmanab Project is comprised of an exhibition space, a studio, a library and a cafe that hosts Sazmanab's walk-by cinema, a unique platform that showcases videos and special programs. The Sazmanab Project also offers artist-in-residence and curator-in-residence opportunities to international artists and curators.[3]

On the right-hand corner of each webpage, a button reads FA, offering Farsi or Persian translations of each page. Yet when clicked, no translated pages appear. This is significant, as it suggests that Sazmanab Project Space is interested in engaging a wider non-Persian-speaking public as well as Persian speakers whose English language ability is advanced.

Since its establishment in May 2009, Sazmanab has been engaged in a variety of projects and exhibitions, many of which are markedly different from the art on offer elsewhere in Tehran. One of the first projects for which the organization gained publicity was *Kubideh Kitchen*, a pop-up Iranian take-away restaurant developed in collaboration with members of the Pittsburgh Iranian community, students at the local Carnegie Mellon Art College and Sazmanab. On 5 June 2009, diners sat down in each city, at a table that extended into a live projected video of the other table in the other city, for an Iranian meal. Diners were able to converse as if sharing a meal together. The Tehran part of the project was located at Sazmanab, where young Tehranis sat down for a meal with Pittsburgh residents. The whole event was

conducted over Skype and include a question-and-answer session where participants in each city were able to ask the others questions, typically simple inquiries into their everyday lives. In 2010, *Much Love from Tehran* involved a live audio-visual performance simultaneously performed at Sazmanab and BK Projects, Copenhagen, where images and sound were received in each location, mixed live and sent back via a live feed to be further mixed in the other locations.

A number of exhibitions of local artists have also been held at Sazmanab; crucially a publication and talk often accompanies them, a practice that is less common elsewhere in Tehran. A series of artist talks have also been held exclusively via Skype to a live audience in Sazmanab. By using internet-based communication tools, Sazmanab is able to introduce artists based anywhere in the world to a Tehran audience.

Since 2011 Sazmanab has hosted a variety of international artists and curators as part of its burgeoning residence programme, including artists from Singapore, South Africa and Canada. Again, each resident is invited to give a talk about their practice which is then made available on the Sazmanab website. Sazmanab also provides space in which Iranian artists in diaspora are able to communicate with artists and audiences in Iran, evidenced by recent talks by Anahita Razmi and Abbaz Akhavan. In this sense then, Sazmanab operates rather like an arts institution or not-for-profit space might do, where public engagement and dialogue is paramount. The availability of much of this output via the Sazmanab website also implies a desire to connect to audiences beyond the physical boundaries of the Sazmanab building.

On my most recent visit to Sazmanab, the internationally renowned art historian James Elkins gave a talk on anti-aesthetics to an audience at full capacity. Professor Elkins had tried to visit Iran twice before but had had his visa rejected. He was finally granted a visa but was to remain part of an official tour group and to be accompanied by a tour guide at all times, as is necessary for any American visitors.[4] Elkins arrived in the country with the details of about 20 people with whom he wished to make contact, including Sohrab, who all met him at his hotel on his first day before his minder had arrived. Sohrab and Elkins spent the entire week persuading and bargaining with his tour guide to allow Elkins to present at the Sazmanab project space. Eventually the guide capitulated on the condition that any religious elements would be removed from the talk and that he accompanied Elkins to Sazmanab. When the agreement was finally made, the night before Elkins was due to present, Sohrab publicized the event via the Sazmanab Facebook page, email and SMS to his mailing list. Only the SMS provided very detailed directions on how to reach Sazmanab.

That evening Sazmanab was at capacity and although the talk was billed to include simultaneous translation, it was unnecessary, as all who attended could follow in English. The evening lasted around two hours, with a long question-and-answer session. Elkins did not make any religious references in his presentation, as agreed. Instead he outlined the main arguments of his then forthcoming book

Beyond the Aesthetic and the Anti-aesthetic. Primarily his talk was concerned with foregrounding the historical division within artistic practice, beginning with Hal Foster's coinage of the term 'anti-aesthetics' in the 1980s. For Elkins, this has created a false dichotomy in artistic practice, obscuring other theoretical analysis or methods and dividing artists in terms of those who work alone in studios and those who engage in socially situated practice. The audience, a mixture of young art students and academics, all of whom had been trained abroad, made for a convivial group.

A few days prior to Elkins' talk, Sohrab had returned from Sharjah, where he had spent 15 days alone in a hotel with little to do while waiting for the British Embassy to process his visa application. Sohrab had been invited by a British arts institution to spend a month in residence in London and participate in a conference on emerging art spaces in the Middle East. Sohrab explained to me that he had actually been at the British Embassy in Tehran a few weeks earlier, on 29 November to be exact, the day it was attacked by protesters.[5] The attack had resulted in the speedy exit of the British diplomat and all embassy staff, as well as the closure of the Iranian Embassy in the United Kingdom 48 hours later. Diplomatic relations between the two countries had not been as dire for the past 20 years. Of course, Sohrab did not manage to file his paperwork that day and eventually, after a two-week wait in Sharjah, his British visa was declined.

I recount these anecdotes as they demonstrate the factors that make possible or impossible an alternative arts practice inside Tehran. In the stories of both Elkins and Sohrab, their movement in and out of art worlds is predicated entirely on the politics of citizenship. For Elkins, an American citizen wishing to travel to Iran, his options are very limited. For Sohrab, an Iranian citizen wishing to travel to the United Kingdom, bureaucracy and strained diplomatic relations cause him considerable grief. Sohrab does lament the limits he faces working in Tehran, negatively comparing it to the lively art scene of Istanbul. He suggests that if Sazmanab was located there he could have a storefront gallery so that passers-by could visit.[6] Usually visitors to Sazmanab already have an idea of what the current programme or exhibition is before they visit. The gallery location just next to a large motorway also means that foot traffic is minimal and besides there are no markings outside the building to demarcate it or announce the presence of Sazmanab. Thus the public that Sazmanab caters for is rather limited; indeed, the audience at Elkins' talk had at the very least competent English comprehension, suggesting that visitors are of a particular social standing. Operating without a permit means that broad publicity and visibility is not an option open to Sazmanab; rather events are often organized on a carefully coordinated, highly uncertain basis. Perhaps because of these limitations, or in spite of them, Sazmanab articulates an entirely alternative practice, not based solely on the physical interaction of producers, audiences and objects. In fact contemporary art is often understood to be a vehicle for a version of hypermodernity, in which ideas and objects move around freely at a staggering pace, denying

physical borders and boundaries in the realm of the conceptual and discursive. The operations of Sazmanab demonstrate the desire of its owner and ability of its visitors to participate in global contemporary art discourse in whatever manner they are able. Many of the events reveal an engagement (or at least the attempt) with a broader, non-local public.

Contemporary art encapsulates the prospect of contemporaneity through the mobility of ideas and exchange in which artists may imagine themselves as part of a post-ethnic utopia (Belting 2010) in which ethnicity becomes a matter of individual articulation and not an identification marker to be discovered in artwork. The fact is that such mobility and exchange is often predicated on an uneven power structure, allowing certain people to move and others not. Claire Harris complicates mobility by pointing out: 'All of this rather belies the idea of the artist as a free agent, able to roam without interruption through the virtual landscapes of the international post-modernist art world, and reiterates my point about the insistent logic of particular locations' (2006: 710). Indeed, the brief anecdotes described here suggest that physical mobility is decidedly tipped against many of the artists living and working in Tehran.

In the essay 'Culture and Administration' (1978), Theodor Adorno argues that the administrative aspects of making art inhibit the artistic project itself. For Adorno, when artworks enter the public realm via an institution they at once cease to be art and instead become dull bureaucracy. In the case of Sazmanab, the process is in fact the opposite. It is the very fact that the administered art event is itself so precarious that lends the artwork its possibilities. For artistic activity to happen in such unofficial spaces, an awful lot of chance and serendipity is involved. Quite simply, it is often very unclear if something is going to happen until the very last minute. Recent ethnographies of Iranian youth and defiance (Varzi 2006; Khosravi 2008) testify to the fact that this is not exclusive to the arts, but is something that is arguably the case in Iranian life today, where political unrest, a fluctuating currency, intense traffic, heavy pollution, low energy and water supplies mean that you might be stuck in traffic for an hour, face a power cut for two, become dizzy from the pollution, find that the price of tomatoes has doubled over the course of a day, get arrested by the police for improper dress, or have a private gathering interrupted by yet more police. Or, of course, your day can quite easily pass without any of these occurrences. The point, though, is that anything can happen. What is notable about the practices of Sohrab and the Sazmanab Project Space is its ability to negate this, by conducting a huge amount of its work on spaces engendered via Skype and digital technologies, which is no easy feat considering censorship and speeds of the internet inside Iran make it cripplingly slow. The Tehran/Pittsburgh TV dinner illuminates a highly creative, flexible approach to making artworks and discourse that is not predicated only on the appreciation of art objects in a physical space. The notion of an administered art event in this context is highly fluid and flexible; negotiating the complicated bureaucracy and the possibility of nothing happening requires as much creativity as the more traditional idea of painting a picture or sculpting an object.

As I described earlier, a huge number of galleries are active in Tehran, with a growing number opening second branches in Dubai – another important site in the sale of Iranian and regional art. What might be a productive way of thinking through these multiple sites and differing practices? It is here that Mary Pratt's notion of 'contact zones', expanded upon by James Clifford (1997), remains pertinent. For Clifford, art institutions become places for dialogue between and around collections, at different times and through multiple people, including the producers, curators and audiences themselves. In thinking of collections of artworks and the museums that house them as contact zones, Clifford argues, 'contact zones are constituted through reciprocal movements of people, not just of objects, messages, commodities and money' (1997: 195). Sazmanab acts as an institution might through a pedagogical programme that brings different actors together under the banner of art-making. The work of Sazmanab demonstrates the nature of a contact zone in Tehran, in which the official, administered art event can be circumscribed via negotiation, or indeed negated altogether, via the use of digital communication technologies to open up the very space of contact, thus creating a different kind of reciprocal visit. The 'contact zone' of Sazmanab is not predicated on shared physical presence of objects or people, but instead flattens physical and temporal boundaries. But of course an inclusion of other sensory experiences – sounds, taste, touch – in the experience of an artwork or event are still an important part of experiencing it (Phillips 1999), rather than through the hollow, disembodied voice at the end of a Skype call, or a larger-than-life head projected on a screen. Indeed, those that have only ever interacted with Sazmanab and its visitors in this way might never know that at the end of such events Sohrab's mother hands out cups of tea and walnut biscuits, a sweet note with which to discuss art.

The multiple scapes as imagined by Arjun Appadurai (1990) are a productive crossing of people, images and ideas, which makes a persuasive case for understanding multi-directional global cultural flows of hypermodernity. Contemporary artistic practice, temporally located in the contemporary itself, is certainly concomitant of the ideas Appadurai outlines. Contemporary art and the multiple global art worlds which support it are evidence of the ability for commodities and ideas to circulate at lightning speed, pausing momentarily in the contact zones of the gallery, auction house or even online. This interpretation is not based exclusively on the movement of art objects but ideas as well. The talk James Elkins gave on anti-aesthetics at Sazmanab makes this point quite concretely. Indeed, in my conversations with Sohrab he never spoke of a desire to promote Iranian art per se, but to be part of the 'conversation'. A contact zone, as described by Clifford, can allow a rethinking of centre and peripheries of art-making, of us and them, audiences and makers. Indeed, in an art world still interested in essentializing notions of otherness in non-Western art practice, there is little to find in the output of Sazmanab that represents any specific idea or ideal of Iranian art. One would be hard pressed to specify the Iranianness of the Sazmanab Project Space apart from

the dexterity of its operations, necessitated by its context and location in Tehran. Instead the art practices of Sazmanab participate in the project of contemporary art itself, by enabling its makers and audiences to be at once contemporaneous with one another.

Notes

1. This is the way Sazmanab was organized when the author last visited in January 2012. The Sazmanab website, accessed August 2013, says it is currently closed for relocation.
2. The exhibition was organized by Dr Alireza Sami-Azar, the previous director of the Tehran Museum of Contemporary Art. Parts of the collection have been shown since then but for the most part it remains in storage.
3. This explanation was retrieved from the Sazmanab website in March 2012.
4. Personal communication, January 2012.
5. Personal communication, January 2012.
6. Personal communication, January 2012.

Bibliography

Adorno, T. (1978) 'Culture and administration', *Telos* 37, Fall.

Appadurai, A. (1990) 'Disjuncture and difference in the global cultural economy', *Public Culture*, 2(2).

Bembery, V. (2012) 'Don't call it contemporary: the market for Iranian art', *Journal* 3, 1(3): 77–81.

Bhabha, H. (1994) *The Location of Culture*, London and New York: Routledge.

—(2006) 'Another Country', in Fereshteh Daftari, *Without Boundary: Seventeen Ways of Looking*, exhib. cat., New York: Museum of Modern Art, 30–5.

Clifford, J. (1997) *Travelling Cultures in Routes: Travel and Translation in the Late Twentieth Century*, Cambridge, MA and London: Harvard University Press.

Ehteshami, A. and Zweiri, M. (2008) *Iran's Foreign Policy: From Khatami to Ahmadinejad*, Reading: Ithaca Press.

Harris, C. (2006) 'The buddha goes global: some thoughts towards a transnational art history', in *Art History,* 29(4): 698–720.

Issa, R. (2001) *Iranian Contemporary Art*, London: Booth Clibborn Editions.

Keshmirshekan, H. (2010) 'The question of identity *vis-à-vis* exoticism in contemporary Iranian art', *Iranian Studies*, 43(4): 489–512.

Khosravi, S. (2008) *Young and Defiant in Tehran*, Philadelphia: University of Pennsylvania Press.

Myers, F. (1994) 'Culture-making: performing Aboriginality at the Asia Society Gallery', *American Ethnologist*, 21(4): 679–99.

Nooshin, L. (2005) 'Underground, overground: rock music and youth discourses in Iran', *Iranian Studies*, 38(3): 463–94.

Phillips, R. B. and Steiner, C. B. (eds) (1999) *Unpacking Culture: Art and Commodity in Colonial and Postcolonial Worlds*, Berkeley: University of California Press.

Ram, H. (2002) 'Multiple Iconographies: Political Posters in the Iranian Revolution', in *Picturing Iran: Art, Society and Revolution*, S. Balaghi and L. Gumpert (eds), London: I. B. Tauris.

Varzi, R. (2006) *Warring Souls: Youth, Media, and Martyrdom in Post-revolution Iran*, Durham, NC: Duke University Press.

5

Art under Siege: Perils and Possibilities of Aesthetic Forms in a Globalizing World

Patricia Spyer

... for reality in a world, like realism in a picture, is largely a matter of habit.

Nelson Goodman

Much of the scholarly work on art produced in conditions of crisis, during wartime or under siege singles out and celebrates resistance: art as an expression of resilience in the face of oppression; art that stakes a claim to representation, redresses a historical wrong, exposes injustice, or defends memory; art that, by and large, is anti-state or anti-the-powers-that-be. Admittedly, the very expression 'art under siege' directs our attention to how various art forms hold their ground and survive under duress, while the common association of art with that which makes us especially human as opposed to animal or even inhuman may assume a special poignancy in crisis and war.[1] Qualities that are often seized upon as distinguishing the art produced in such charged circumstances are its eloquence, starkness and defiance.[2] While many scholars, in other words, tend to emphasize the more dramatic and often more politically compelling dimensions of art under siege, I explore in this chapter the more modest ways in which such art may rely upon and seek solace in timeworn routine and repetition, aiming, in so doing, to reconstitute the reassuring outlines of the everyday. Although retroactively my examples may also be construed as forms of resistance, I claim that no such intention is foremost or perhaps even at stake for the social actors and artists involved. The point here is not some definitional exercise meant to demarcate what counts as resistance from that which does not, but to direct our attention instead to more subtle world-making dimensions of such productions and to how, post-crisis, the world often comes to be made in a different image, whether such was in fact intended or not.

 While my first example considers a Dutch artist's take on a series of tours given at the Hermitage Museum during the siege of Leningrad in World War II, the second looks at street art that arose in the religiously inflected violence between Muslims

and Christians at the turn of the present century in the provincial capital of Ambon, Indonesia. My larger interest lies in the relationship between aesthetic transformation and socio-political change or, more specifically, how the taken-for-granted investment in images and, generally, appearances in sustaining the very fabric of the world – not just in Leningrad or Ambon but elsewhere as well – becomes explicit and problematic in situations of crisis. Here, and more extensively elsewhere, I explore the varying implications thereof.[3]

In April 1942, during the brutal German siege of Leningrad, Pavel Gubchevsky, head of security and longtime tour guide at the Hermitage Museum, led a group of army cadets from Siberia on a tour of the museum (Figure 5.1).[4] The tour was a token of thanks for their assistance in moving a collection of the museum's valuable French furniture, already waterlogged, to a place where it might be protected from the elements as well as from the mischances of war. What made the tour remarkable was that the museum's paintings had already been removed from their frames and taken away to safe storage. As the young soldiers walked past the empty frames and the labels that remained, the guide described what they would have seen if the paintings had still been there. 'That was the most curious excursion in my life', Gubchevsky recalled. 'And it turned out even the empty frames left an impression' (Adramovitch and Granin in Moti 2004: 34).

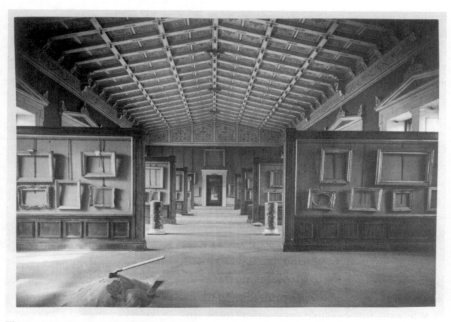

Figure 5.1 The Tent Hall, Hermitage Museum, during the Siege of Leningrad, 1942, The State Hermitage Museum, St Petersburg. Photograph © The State Hermitage Museum/photo by Vladimir Terebenin, Leonard Kheifets, Yuri Molodkovets.

This event, one of several Empty Frame tours that Gubchevsky conducted during the war, is the subject of the Dutch artist Melvin Moti's exquisite, moving film *No Show*. What we see on screen for the 22 minutes of the film's duration is an empty room graced by three tall windows framing some leafy trees. The only visible movement in the room is the lengthening and softening of the light reflected on the floor through the windows; in this gradual darkening of the room we witness the passage of time, which lends historicity and actuality to the narration of the tour. This quiet scene has the effect of foregrounding voices and sounds: the tour guide's invitation to the soldier-comrades to gather around as he describes in great detail the pictures that had previously hung there; his admonitions to attend to the broken glass shattered on the floor of some galleries; the sound of heavy army boots as the men move past and pause before the images; the laughter at the tour guide's jokes. The tour guide makes occasional reference to the pictures' physical absence. At times he invites his audience to 'look closely' while he discloses what was once there. Viewers of the film are doubly – or indeed triply, in the case of those who must rely on the English subtitles of the Russian narration – removed from the pictures that had previously inhabited the empty frames. The film constructs 'an absorbing aesthetic out of a visual void',[5] an effect that is heightened towards the film's conclusion when the screen turns wholly black. Reflected back to us from this increasingly opaque surface is not only the phantasmatic presence of images and the vivid work of the imagination but the way in which every image evokes an absence and a beyond.

War and crises often put objects at risk and may precipitate movement, in the form of their physical removal to a place of greater safety, or when they are confiscated as loot, the fate from which the Hermitage staff hoped to safeguard the collection by shipping off artefacts to more secure surroundings. Devastatingly transformative, violence often compels a turn to novel forms of expression, as we will see, even if the aim is to reconstitute the familiar and everyday. In situations of social and political turmoil or profound change, images and other objects may be at risk not only materially but also conceptually. What images are, what they do socially, politically, aesthetically, epistemologically, psychologically, ideologically, and so on, may become foci of attention and contribute to their revaluing and refiguration. Images may be abandoned, forgotten, disavowed, or even destroyed, as in the drastic refiguration of iconoclasm, in its literal sense of 'idol-breaking' – the physical destruction of images of false gods – or the more widespread and commonplace 'metaphorical iconoclasms' of commodification (the image as vessel of exchange-value) and philosophical negation (the image as false or outmoded representation), both of which find expression in the protective seclusion of the museum (Simpson 2010).

Iconoclastic destruction, the collateral damage of incidentally inflicted injury and even the aesthetics of aging and deterioration can also be productive and creative; they can initiate a process of literal *re-vision* that opens a space for new ways of looking and engaging with images and other artefacts. Thus – to remain within

the precincts of the besieged Hermitage Museum – it was only in the absence of the museum's art collection, when the buildings' vulnerability to the forces of war and environment had already been marked by their torn and scarred surfaces, that their architectural beauty came into view. As graphic artist and theatrical designer Vera Miliutina described their exposed, partially ruined grandeur, 'the emptied halls were huge and majestic, their walls covered in crystals of frost. They had never before seemed so splendid to me. Before one's attention had usually been fixed on the painting, sculpture or applied art and the art of those remarkable architects and decorators who created the palaces went little noticed. Now, though, all that was left was their astonishing art (and the traces everywhere [she added] of the savage, implacable Fascist barbarity).'[6]

In an explicit act of resistance against Fascist barbarity, such destruction itself became the subject of image-making. A group of Leningrad artists, including Miliutina, produced a series of drawings, 'The Hermitage under Siege', documenting the broken windows, pools of water and ice-encrusted floors, the damaged façade and other destruction to the museum buildings resulting from German bombardment and artillery fire.[7] These drawings, now housed in the Russian National Museum, have been the subject of repeated exhibitions in which they served not only as aesthetic objects in their own right but as evidence of the indomitable spirit of the Russian people in the face of 'Fascist barbarity'. If Pavel Gubchevsky's Empty Frame tours, offered in the first instance as a simple thank-you to Soviet soldiers by a man bent on going about his business-as-usual, perhaps unwittingly ushered into view an image of the Russian nation in spiritual triumph and defiance under siege, this image explicitly infused the work of Vera Miliutina and her fellow artists carried out in the Hermitage. Melvin Moti in his interpretation of the Empty Frame tours takes us a step further by staging the affective power of images – in so doing, drawing our attention to the complex work they do and intimating powerfully what viewers themselves bring to them: 'Even the empty frames left an impression', as Gubchevsky put it. For even if the soldiers on his tour – 'country boys' hailing from places like Vologda, Chrepovets and Ust'laga – 'came to the Hermitage for the first time and some had never even been to a museum before', they shared some general frames of reference and affective resonances with the tour guide who conjured the absent images for them (Moti 2004). In addition to familiar works of classical art, these might have included such popular cinematic representations as well as the hearty socialist realism of propaganda posters and public art. Viewers of Moti's film might be expected to imaginatively experience these affective resonances too – or something like them – as well as a heightened awareness of the status of the unseen pictures as 'art', and the moment of the restaged 'tour' as both present and past (cf. Bal 2006).

Finally, Moti's cinematic reproduction of the Empty Frame tour draws attention to *movement* – to those processes of circulation, imagination and reception, in which in a globalizing world, as Arjun Appadurai puts it, 'moving images meet

deterritorialized viewers' (Appadurai 1996: 4). The film presumes the movement of objects – antique furniture carried to safety, for which the tour provides a thank-you, as well as the absent paintings themselves – but it equally highlights the *tour*'s movement as the guide and soldiers navigate their way, unseen by the film's viewers, through the empty rooms, past the frames and labels that serve as placeholders for the missing images. Movement here figures in a double sense, both intransitive and transitive, images that move *around* and images that move *us*.

My second example explores the rise of billboards and murals of Jesus Christ that sprang up and proliferated across Ambon City during the conflict that engulfed this Indonesian provincial capital and the neighbouring Moluccan islands in rampant violence from 1999 until 2000, with ongoing tension and occasional outbreaks long thereafter.[8] During the war and in its aftermath, popular Christian painters have been plastering the city's main thoroughfares and Christian neighbourhood gateways with gigantic portraits of Jesus and scenes from his life, Christian symbols, martyrdom and resurrection. Monumental and assertive in public space, these artefacts perform in several capacities: as visible emblems of Christian territory; as a way of making manifest and presencing God; as a pedagogical mode of intervention in everyday Christian behaviour; as a material counter to the public visibility of Islam in Muslim majority Indonesia; as a way of branding Christian community identity; and – one suspects – as a kind of huge amulet meant to ward off the Muslim Other. The postwar explosion of Christ pictures is a manifestation of deep uncertainty and crisis; they constitute an effort to ensure the solace of home and security in the face of what many Christians understood as their own imminent annihilation. At issue, too, is how the billboards and murals bear witness and give material form to Christian anxieties about their own invisibility vis-à-vis the Indonesian state and its potential stand-ins – the United Nations, the European Union, the former Dutch colonizer – and perhaps even their invisibility with respect to God himself; at the same time these artefacts would appear to alleviate the very condition of being unseen.

I have written elsewhere of my initial encounter with these pictures. How, during a brief visit in 2003, under emergency conditions, my curiosity had been piqued by the few pictures that whizzed by me as I navigated the city by car with colleagues from a local university. How, subsequently, as I came to know Ambon in its new postwar circumstances, I encountered a city crowded with such pictures. I was amazed to see murals of Christ surrounded by Roman soldiers stretching out on public walls, a monumental replica of a Heinrich Hoffman original of Christ's face in front of the city's Maranatha Church, and a billboard overlooking a globe turned to Ambon Island – none of which had been in these spaces before. Subsequent trips yielded more such productions. They range from the billboard of Christ under a crown of thorns that greets the visitor on the highway running from the island airport into Ambon, to others dispersed throughout the city, commonly marking the entrance to Christian neighbourhoods. Since then I have not ceased to be amazed by the surprising facility with which the oversize Christian images emerged in the

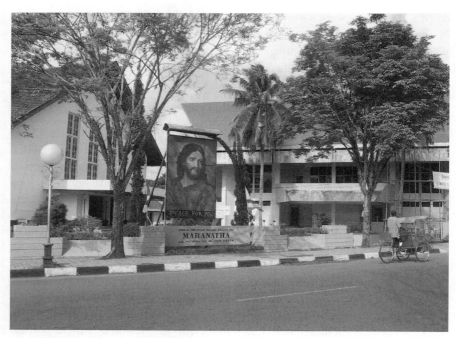

Figure 5.2 John Yesayas, Christian billboard in front of the Maranatha Church, Ambon, 2005. Reproduced with permission of the artist (photo: P. Spyer).

streets, rose up behind church altars, and infiltrated the more intimate spaces of some of the city's more well-to-do Christian homes (see Figure 5.2 and Plates 11 and 12).

Yet for all their performative punch and drama, I propose that what these pictures *want* is to still a world in restless and, at times, terrifying motion, and to re-establish and secure the familiar terms of quotidian existence – in particular, the prior privileged position of the elite Ambonese Christian community.[9] Almost without exception, the city's new pictures rely on the transnational print repertoire of the Christian canon reproduced in Sunday school prayer books and on calendars and posters that have long been conventional props of religious identity in Ambon's Christian homes and stores. Where possible, pictures thrown up on hijacked billboards or sprayed on city walls adhere closely to the Christian print canon original, replicating its models faithfully – as, for instance, the painting of Hoffman's Christ head in front of the Maranatha Church does, or the various Warner Sallman Christs encountered in Christian neighbourhoods across the city do also.

At times, though, the fit between this canon and the world to which it loosely corresponds, a world of families, neighbourhood- and island-based communities, religion, and traditional Ambonese Christian privilege – a fit that is always provisional and hence fragile or a matter of habit not recognized as such – appears too out of joint with respect to the new conditions of violence and uncertainty in which

it operates. This is why scattered among the numerous conventional images of the Protestant Christian canon reproduced in city streets we come upon a Sallman Christ overlooking Ambon Bay rather than Jerusalem, a Christ overseeing the destruction of a landmark Protestant Church, or another with bloody tears streaming down his face floating over a map of Ambon and the neighbouring Moluccan islands (Plate 13). Each and every one of these is evidence that the street artists and their male supporters struggled to make the familiar canon correspond to the realities of the war around them. Similarly, when it comes to explanations offered by Ambonese themselves concerning the turn to pictures, one of the most frequently heard, echoed in different versions across the city, highlights the hitherto taken-for-granted and therefore *unremarked* presence of God for Christian Ambonese. Tellingly, such explanations underscore at one and the same time how God's image arose in Ambon due to his indisputable presence in the city – *we were always convinced that God was here* – and the desire as opposed to such certainty to *ensure that God would really and truly be present in the conflict*, betraying the doubt that things might be otherwise.[10]

To paint and to turn to pictures in the calamitous, edgy environment of the war was then both to reiterate the familiar and to experiment in certain desperation, to launch a new medium in the hope that it might engage and moor the Christian god who appeared to be drifting or at least too far away to provide the necessary solace. Yet going about business as usual in the new circumstances of violence and destruction could only take place following some crucial adjustments. First and foremost among these was the act, repeated with urgency throughout the city during the war and in its aftermath, of seizing upon the travelling images of a globalized Christian print capitalism and blowing them up in the streets. This act entailed a break with the aniconic tradition of Ambon's Dutch-derived Calvinist church, experimentation with a new medium of expression and communication, and was further notable for its self-organizing capacity – no church or other institution or authority rallied around or pushed the production of the images.

Yet while apparently radical in so many ways, not the least in the banal fact of their physical presence at prominent crossroads and along the city's main thoroughfares, in most respects these picturing projects are quite conservative, especially in their positing of a visual public that excludes anything considered incompatible with a wholly Christian universe. Constituting what might be called a postwar *poetics of world-making*, what these pictures *want* is to repair and restore the everyday lifeworlds of a pre-violent moment when Ambonese Christians still, by and large, enjoyed relative power and privilege (Warner 2002: 82). Yet they are *world-making* too, in their dramatic sense of arrival and in the general novelty with which the pictures and the Christian scenes they portray stand out aggressively from the ruins of the recent war and force themselves into public view.

To a large extent this defensive attitude has to do with the changing nature and physical transformation of public space in Indonesia and, in particular, the

enhanced public visibility and publicity of the nation's embattled religious composition beginning in the 1980s. Ambon's pictures rise in the midst of what scholars describe as a burgeoning 'public Islam' – including its salient visible, audible, and physical presence in Indonesia, as in other parts of the world since the 1979 Iranian Revolution, along with many more recent factors (Salvatore and Eickelman 2004).[11] In the streets of Ambon and across Indonesia, Islam's indisputable public presence registers visibly and audibly in the many new mosques being built, the popularity of Quranic reading sessions and typical Muslim fashions, the rise in the number of Indonesian Muslims performing the *haj*, the resurgence of Islamic print media, the development of new forms of cyber and cellular proselytizing, and the spread of Islamic economic institutions. Or, as one Protestant minister volunteered, characterizing the city's new street paintings as a direct parallel to this public Islam, 'it's the same. They don't make pictures much, but they wear headscarves as their own kind of special characteristic. To show that "we are Muslims." Yes that's what stands out.'

That which stands out and figures as an 'invisible backdrop' to the Christian pictures in Ambon's streets, churches and homes is the very fact, then, of Muslim presence, in the form of the overwhelming numerical dominance of Muslims in Indonesia – some 90 per cent of the total population – in the public prominence of Islam throughout the large majority of the country, and in the conviction prevalent during the war among Ambon's Christians that they were the target of a Muslim-driven genocide (Appadurai 1997). Claiming and proclaiming the city as Christian, the pictures perform God's partisan presence in Ambon, at the same time as they pictorially efface the Muslim who hovers at the edge of the frame and charges these public pictures affectively. Through these pictures Christian Ambonese aim to gather a visual world around themselves, hence the frequent emphasis on the public pictures, 'comforting' nature, on the need for their multiple large-scale presence and their continual reiteration. Notwithstanding their immense scale, the scenes depicted in the street pictures are, once again, mediated by a Christian canon that, while formerly identified with intimacy and interiority and, as such, a longstanding conventional feature of the city's more domesticated Christian spaces, has only recently been stood on its head. As the images moved out of houses and stores and grew in size, they did not displace the earlier calendars, posters or embroidered Last Supper scenes but merely supplemented them. Given this local trajectory, the pictures may still somewhat retain the promise and buttress the performance of a Christian Ambonese subject as visually construed in familiar, comfortable, and essentially interiorized surroundings – even as these surroundings have been stretched in new directions.

In the dire, radically undone circumstances of Ambon's war which I have largely glossed over here, a multitude of taken-for-granted appearances fell apart and with them the sense that the world would proceed along familiar lines in which the past would have some hold on the future, subjects, objects and experiences would present themselves in familiar ways, and so on. In such extreme conditions,

the attempt to reconstitute everyday experiences was part of a vast effort to make the world more liveable, knowable, and therein, too, more bearable. In the two examples here we have seen how everyday forms and routines become a resource but also how relying on the everyday in such dramatic circumstances demands innovation, experimentation and, notably, the retooling of its taken-for-granted forms and expressions, often through their enhancement and exaggeration. Pavel Gubchevsky's Empty Frame tours must have been uncanny as they lingered on and drew out the phantasmatic power of invisibility and absence that always haunts the image. In their excessive monumentality, Ambon's street images leave intact the centrality of the city's traditional Protestant religion as the identifying emblem and longstanding source of privilege for Christian Ambonese. Paradoxically, at the same time, they expose how much such centrality has been hollowed out in the circumstances of the war, specifically, and during the last decade of the Suharto regime and in its aftermath, more generally. In aiming to stay the same, in other words, these Ambonese performed their close adherence to the Christian canon over and over again, publicized the presence of Christ by reproducing his face on an immense scale, thereby disclosing anxieties concerning his possible absence, and deployed the fantasy of a Christian enclave infused with all the intimacy and comforting interiority of traditional Christian homes from which any trace of Muslim presence would have been excluded.

All this immense effort to extend, bend and assert a Christian Ambonese presence within the fraught conditions of the conflict and the exaggerated proportions this assumes betrays how much the Ambonese – as anyone else – commonly take for granted what they imagine the world to be, along with the everyday institutions in which such imagination becomes realized and assumes unquestioned authority in our lives. Yet in Ambon as much as in Leningrad, reality – like those realities portrayed in pictures, whether historical, religious, political, economic and so on – is largely a matter of habit (Goodman 1978). As matters of habit, the relationships between imagination and institution tend to obscure their own provisionality by misrecognizing or 'forgetting' the moment and very fact of their institution (Weber 1987). In part, this accounts for the anxiety, shock and extreme uncertainty that prevail once the relationships and tacit agreements that have kept a particular world in place begin to falter and come apart.

Nonetheless, the prevailing sense of an embattled Christian enclave, turned defensively in upon itself and bent on effacing the Muslim other, should not prevent us from looking again briefly, by way of conclusion, at the city's Christian billboards and in particular their positioning in urban space. Without exception, the billboards and murals face outwards, turning away from the community to confront whoever may pass by. Commonly they stand at Christian neighbourhood entrances on kerbs and on pavements at the edge of public streets and on land usually owned by the city. If these pictures gate and brand the community, they also then seem to extend an invitation outwards – to others and to strangers to look back. If this appears too

outrageous a claim, think then of the advertisements whose location the Christian pictures often usurp, or recall the gigantic suffering Jesus faces that dot the highway and greet the visitor on her way from the airport into Ambon – whether she is a fellow Moluccan or Indonesian from elsewhere, a government bureaucrat or business envoy from Jakarta, a national or international NGO activist or humanitarian aid worker, a returning migrant, a journalist, a tourist, a stranger.

There are, in other words, other stories to tell here and other perspectives on this city – a city that, given more space, I would tell you more about: about its many migrants, its densely packed neighbourhoods, its displaced and refugee populations, its urban crowds. Besides the rather narrow vantage of art under siege which I have privileged here, other factors are relevant to thinking about the pictures discussed here and the fraught urban environment in which they arose – a complex postwar environment populated by friends and enemies, strangers and neighbours, others and selves, or the many categories of persons who fall complexly somewhere in between, and who speak, here as elsewhere, to the density and thickening of relations, face-to-face and otherwise in our current globalizing world. Among such factors are the sheer pragmatics of mixed communities and urban living together and therein the urgency of imagining a more viable world open and hospitable to its others.

The extreme circumstances of art under siege that I have tried to sketch in this chapter, whether emergent on war's ruins in Ambon or at risk at the Hermitage, exposes in sharp relief not only the close, habitual bonds between imagination and institution, but also, importantly, the power of images to offer comfort, convey sentiment, marshal courage and, yes, provoke defiance or, in short, to spur the imagination – in the very best of circumstances the kind of poetic imagination that recognizes, even in the most intractable of situations, that things might be otherwise, that a world might be made in a new and different image.

Notes

1. The welcome note by ASA Chair, James Fairhead, to the ASA12 Arts and Aesthetics in a Globalizing World conference programme is exemplary in this regard, where he writes: 'art is surely a celebration of human creativity and reflexivity' (p. 4).
2. There is a great deal of work that might be cited here, but see, for example, the issue 'Taking Sides: The role of visual culture in situations of war, occupation, and resistance', *Radical History Review* 106, 2010.
3. This is the general subject matter of my book in progress – *Orphaned Landscapes: Violence, Visuality, and the Work of Appearances in Post-Authoritarian Indonesia*. For an exploration of different aspects thereof see my articles

'Images without borders: violence, visuality, and landscape in postwar Ambon, Indonesia' (2013), 'Blind faith: painting Christianity in post-conflict Ambon, Indonesia' (2008), and 'Some notes on disorder in the Indonesian postcolony' (2006).

4. This first example is taken from the introduction to an edited collection *Images That Move* co-authored with my colleague Mary Margaret Steedly.

5. Mieke Bal, personal communication.

6. See http://www.hermitagemuseum.org/html_En/05/hm5_3_03.html

7. Some of these drawings, including those of Miliutina, can be found in S. Varshavsky and B. Rest's *The Hermitage during the War of 1941–45*.

8. For an overview, see International Crisis Group, 8 February 2002.

9. 'What do pictures want?' is a question posed by W. J. T. Mitchell in his book *What do Pictures Want? The Lives and Loves of Images* (2005). See also Christopher Pinney (2004) who writes regarding Mitchell: 'Addressing the "wants" of pictures is a strategy advanced by W. J. T. Mitchell as part of an attempt to "refine and complicate our estimate of their power". Mitchell advocates that we invite pictures to speak to us, and in so doing discover that they present "not just a surface, but a *face* that faces the beholder".'

10. Recorded interview, Ambon, 22 June 2005.

11. The term 'public Islam' was coined by Armando Salvatore and Dale Eickelman. For an analysis of the development of public Islam in Indonesia see Noorhaidi Hasan, *The Making of Public Islam: piety, agency, and commodification on the landscape of the Indonesian public sphere*. Published online: 24 October 2009, Springer Science & Business Media B.V. 2009.

6

Hot Bricolage: Magical Mimesis in Modern India

Christopher Pinney

Popular visual culture in India, and the politics it mobilizes, continues to play out a set of political concerns and 'media tactics' whose basic infrastructure and parameters have been established over the last century. This chapter explores how this constraint and empowerment has operated within the context of the recent mass anti-corruption movement focused initially on the neo-Gandhian anti-corruption campaigner Anna Hazare and subsequently the Right to Information activist Arvind Kejriwal. The aim of the chapter is to investigate what happens when we approach the field of possibilities within which this aesthetic and somatic politics is mobilized not as 'tradition' but as a zone of effervescent bricolage in which politicians pursue magical mimetic strategies in the belief that they 'can produce any effect [they desire] merely by imitating it' (James G. Frazer, cited by Taussig 1993: 47). The 'repetition' that lies at the heart of the aesthetics described here is best considered as part of the 'magician's art of reproduction' in which the copy 'gains through sensuous fidelity something of the power and personality of that of which it is a model' (Taussig 1993: 16).

The citationality which lies at the heart of this politics might be conceived, following Claude Lévi-Strauss, as a kind of *bricolage*, a logic, or science, of the concrete, involving the recirculation of a ready-to-hand syllabary through which the *bricoleur* speaks through the medium of things (Lévi-Strauss 1972: 16–17). Lévi-Strauss drew a contrast between the 'engineer' who mobilized 'raw materials and tools conceived and procured for the purposes of the project' and the bricoleur whose 'universe of instruments is closed' and whose tools are 'the contingent result of all the occasions there have been to renew or enrich the stock or to maintain it with the remains of previous constructions or destructions' (1972: 17).

Bricolage can be, and perhaps usually is, read as a 'cold' system. Lévi-Strauss himself, as we have just seen, refers to it as 'closed' and also stresses its 'limited' repertoire (1972: 17). However, he also stresses the deviousness of the bricoleur and his connection to 'mythical thought'. He is someone different from the English

'handyman' (despite the current popularity of the national French do-it-yourself chain Mr Bricolage), and Lévi-Strauss stresses instead the term's link to 'extraneous movement[s]' such as 'a ball rebounding, a dog straying or a horse swerving from its direct course to avoid an obstacle', trajectories which sound more magically creative and improvisational than statically closed and cold.

This bricolage involves the circulation of signs rather than concepts, an increasing velocity of previously available meaning which (to deliberately corrupt Fredric Jameson) demands that what is potentially politically efficacious is always 'half-seen in advance' (1979) and which (to develop a Deleuzian metaphor) folds inside and outside, signifier and signified into 'media-folds' of origami-like complexity (Deleuze 1992).

This examination of political discontent in contemporary India will take us across the country through a travel narrative that progresses from Delhi in the north, proceeds to Madhya Pradesh in central India (and the town and village where I've been conducting anthropological fieldwork and visual research intermittently since 1982) and finishes in Mumbai on *Anand Chaudas* (blissful 14th), the final day of the Ganesh Chaturthi festival, when tens of thousands of images of the god Ganesh are immersed in the Arabian Sea (see Kaur 2003).

In late August of 2011 much of India was transfixed by the actions of the septuagenarian neo-Gandhian, Anna Hazare. Fasting, possibly until death (he would curtail his hunger strike on the 13th day), he sat on a stage, in Delhi's Ramlila grounds underneath a large photographic image of M. K. Gandhi. The events at the Ramlila grounds received ever-increasing media coverage: dozens of Indian news channel crews erected their own stages on the edge of the ground, numerous cameras mounted on cranes documented every moment, and the visual image of Anna Hazare as a 'second Gandhi' or 'come-again Gandhi' was beamed across the country 24 hours a day.

The relationship between Anna Hazare and M. K. Gandhi powerfully demonstrates the continuing vitality of figures associated with anti-colonial nationalism, not simply as empty points of visual reference but as forces that continue to animate, in complex ways, the political landscape and the repertoire of political possibilities in India. If, as is often claimed, Hazare is in some sense 'repeating' Gandhi, can we also detect a more widespread repetition and citation at work which embeds contemporary Indian politics in something akin to what Jameson termed 'Third World allegory' (Jameson 1986)? It is this (I use the term advisedly[1]) 'burden' of India's colonial history which I hope to illuminate in this presentation, together with Gayatri Spivak's Derridean notion of the 'graphic of iterability' (1980: 36) and a Deleuzean 'texturology' which tangles the inside in the 'pleats of matter' (Deleuze 1992: 11) and what he elsewhere describes as 'moving, living folds' (1992: 27).

The Indian political 'archive' is highly dynamic,[2] an unstable location which has certain authorizing functions but is continually spewing the past into the future. Aspects of this idiom were described as the 'recursive archive' in an earlier book

Photos of the Gods (Pinney 2004) in relation to commercial artists' often extensive collections of earlier image production. These were used as storehouses of future potential visualization and were commonly drawn upon to solve issues relating to present-day commissions. None of these images were sedimented: they all remained 'live', ready to fall into a future which was yet to be.

In a similar manner the recent Anna Hazare agitation 'folded' itself into a past which it remade anew. Centrally conceived as a pious repetition ('second Gandhi' or *aj ke Krishna* – Krishna for today), the campaign also oriented itself around a host of popular media iterations of the history which empowered the movement. These included Gandhi updated via the Hindi film *Lage Raho Munna Bhai* (*Carry On Munna Brother,* dir. Rajkumar Hirani, 2006) and a script already partly written by *Rang de Basanti* (*Colour of Spring,* dir. Raykesh Omprakash Mehra, 2006), the film which perhaps more than any other spectacularly negotiates the role of the archive in the popular.[3]

The image and media-saturated nature of the Hazare political movement was immediately apparent as I approached the Ramlila grounds in Delhi in August 2011: numerous commercial vendors were selling merchandise of various kinds. First the ubiquitous Gandhi caps (*topis*) on which are printed *main anna hun* (I am Anna) and which had become the almost universally worn uniform of his supporters (who aspired to repeat their master's pious repetition). This was a reference to the Tunisian protestors' identification with the self-immolating stallholder Mohamed Bouazizi[4] and helps us make sense of some of the media parallels made between the Arab Spring and Hazare's anti-corruption movement. In addition to the caps, Indian flags in various sizes were available, tricolour scarves that allowed followers to literally drape themselves in the national colours, and plastic waistcoats with various anti-corruption slogans and badges adorned with Hazare's smiling face were also on sale.

On entering the Ramlila ground one was immediately confronted with the tension between the de-individuating possibility of the *topi* which allowed everyone to fuse their identity with the leader and the desire to leave one's individual marks: large printed banners near the inside of the entrance were being energetically overlain with thousands of signatures by those for whom simply *also* being Anna Hazare was insufficient. The individualism of those at the Ramlila ground was also apparent in the extraordinary profusion of handmade images and texts which many protestors brought with them. These ranged from small photocopies – some advocating the hanging of members of the current government or depicting Hazare as a wrestler – to elaborate collaged spreads, to complex cartoons and paintings (often dependent on the pun that Anna was not *andhi*[5] [blind] but was Gandhi) to Photoshopped visual allegories (*Aj ke Dhritaraashtra*) that depicted Hazare as a modern-day Krishna, fighting (in a reanimation of the Mahabharata struggle) corrupt figures such as the disgraced head of the Commonwealth Games Committee (Salman Kalmadi) and a politician implicated in a $40 billion 2G telecom spectrum sales scam (A. Raja), these being presided over by the 'blind' Manmohan Singh who echoes the blind

Dhritarashtra (Plate 14). Dhritarashtra, described in the Mahabharata, was blind from birth, was the father of the Kauravas, uncle to the five Pandavas with whom his sons fought the Kurukshetra war. He was present when Yudhisthira lost the dice game and remained silent when Dushasana tried to disrobe Draupadi (the Pandava's wife) in front of the court. The disrobing of Draupadi, an episode endlessly visualized in early lithography, and then film and subsequently television (Mankekar 1993), became perhaps the archetypal trope of a subjugated India whose chastity was threatened by colonizers.

Other imagery on display mobilized maps of India with Mother India at the centre flanked by images of Gandhi and Anna Hazare with slogans such as *Brastachar Bharat Choro* (Corruption Quit India!) or maps of India in front of which were depicted three monkeys illustrating the (originally Japanese) visual proverb 'see no evil, hear no evil, speak no evil'. Gandhi was very attached to a small wooden carving of three monkeys gifted to him by Chinese devotees. These seem to creatively deform the original east Asian motif into a warning about the dangers of a government which chooses not to see what is occurring in front of it: the images served as demands *to look at* and confront evil in the form of corruption. One protestor at the post-fast 'victory' celebrations at India Gate brought his own placard which depicted a blindfolded Manmohan Singh unable to see his ministers scurrying away with briefcases filled with cash under the slogan *yeh hai hamari andhi sarkar. puri bhrast* (this is our blind government: completely corrupt).

Across this incredible range of visual creativity a common theme emerged: Anna Hazare was an echo of something or someone else – usually Gandhi, but sometimes also Krishna. It was this secondary identity (*dusera Gandhi*) that was foregrounded far more insistently than any 'self-present' claim he might be able to make (as an ex-army sergeant turned village disciplinarian who has spent many decades campaigning against alcohol and meat consumption in his Maharashtrian village). His campaign, indeed, mobilized several of the tropes that feature in late twentieth-century printed images of punishments in hell. Usually known as *karni bharni* (roughly, 'reap as you sow') or *karma ke phal* (the fruits of karma), these pair deeds and consequences, showing misdemeanours and their punishment (Plate 15). Most images illustrate the taking of bribes (*rishvat lene*) through images of smoky backrooms in which sinister men smoke, drink and play cards. The black marketeer and the tax defaulter are also frequently depicted . These are part of a popular visual culture and moral conservatism which seems to directly inform Anna Hazare's worldview (see Sharma 2012: 67–81) and may also have informed Gandhi's own.[6]

The Hazare campaign's own website (www.annahazare.org) celebrates his achievements over many years in his natal Maharashtrian village of Ralegan Siddhi, noting that: 'Today the villagers have completely given up brewing of liquor. Nobody sells liquor in the village. Further, the shopkeepers [have not sold] cigarettes, beedies and tobacco ... for the last 13 years.' Press reports indicate that this transformation was built upon the public thrashing of alcoholics by Hazare himself (they are tied to

a pole and he thrashes them with his army belt). Indeed he has frequently asserted the desirability of hanging corrupt politicians and 'cutting off the hands' of thieves. *India Today* suggested that 'Anyone who drinks [in Ralegon Siddhi] gets a lashing more reminiscent of Pakistan in the reactionary age of General Zia-ul-Haq' (Aji 2011), but we might also add that it is reminiscent of the moral codes of *karni bharni*. Hazare was quoted as saying that compulsive drinkers are taken to the 'temple and he has to swear by God that he won't drink in future. And [if] even after all this he drinks then we will tie him up to the electric pole in front of the temple and then beat him up so that he gets scared' (Aji 2011). Anna Hazare repeats Gandhi's moral conservatism, but energizes it with a dose of populist vengeance.

Alongside the 'secondary' echoes in which Anna was a come-again Gandhi re-enacting the messianic iconography of *karni bharni* imagery, there was also a set of three-way refractions through which Anna Hazare was mediated through the already mediated image of commercial cinema's mediation of Gandhi and other anticolonial nationalists of the early twentieth century. Most of this was presented in ways which were immediately graspable to the audience co-present at the Ramlila ground but which, nevertheless, for our purposes here requires some careful unpacking and analysis.

In this spirit, let us focus on one young man who wandered around the Ramlila grounds bearing a complex tableau of photocopied cartoons and collages (Figure 6.1). One of these showed Anna Hazare, wearing his trade-mark *topi* (hat), riding a motorbike along with two key aides in what became known by the media as 'Team Anna': the former policewoman Kiran Bedi and the Right to Information activist Arvind Kejriwal whose Aam Admi (Common Man) Party now (i.e. mid-2013) spearheads the movement. Beneath this scene is the legend 'Lage Raho Anna Bhai' (Carry On Anna Brother), a reference to the very popular film *Lage Raho Munnabhai* (Carry On Munna Brother) directed by Rajkumar Hirani in 2006, which made Gandhi the hallucinatory moral conscience of a small-time Mumbai hoodlum.

It was through this film that Gandhi acquired a new potency in the form of *Gandhigiri* (Gandhi-coercion). Munnabhai, played by Sanjay Dutt, is infatuated with the voice of Jahnavi, a radio jockey on a Mumbai radio station. Hoping to meet her in person he forces five experts at gunpoint to help him win a phone-in quiz on the Mahatma to commemorate *Gandhi Jaynti*. This successful *dadagiri* (that is the bullying behaviour associated with a *dada* or hoodlum) soon gives way to an equally efficacious *Gandhigiri* as Munna protects an old people's home from an avaricious realtor (to whom the radio station's listeners are urged to send flowers) and finds a hallucinatory Gandhi advising him on a new selfless mode of efficacy: moral power, rather than muscle power. The website www.Gandhigiri.org subsequently sanctified the interchangeability of *dadagiri* and *Gandhigiri*, noting that Sanjay Dutt, following his conviction for the possession of semi-automatic weapons, would be housed in the very same jail (Yerawada in Pune) that Gandhi had formerly occupied. This was grotesque irony translated into destiny. Cinema and televisual

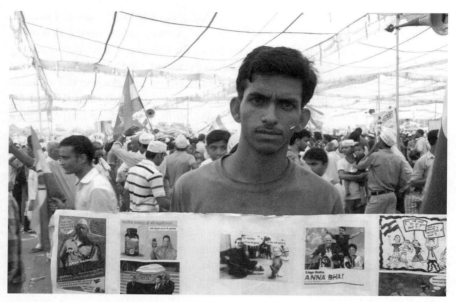

Figure 6.1 An Anna Hazare supporter displays images including *Lage Raho Anna Bhai* (photo: Christopher Pinney).

media once again prophesy the new world. This is a process with a venerable history in India as elsewhere: one thinks of Anuradha Kapur's argument about the way in which early chromolithography, Parsi Theatre and cinema helped make the Gods 'more real': 'representationally the past and the present almost look the same: the time of the Gods appears to be "our" historical contemporary time' (Kapur 1993: 100). Anna Hazare's time – which was also Gandhi's time – was the beneficiary of this historical echo chamber.

The film (*Lage Raho*) brilliantly demolishes the empty 'statist' Gandhi. In one scene Munna, prompted by Gandhi himself, urges the removal of all Gandhi statues and the erasure of his name from all public thoroughfares, and the subsequent internalization in each person's heart of Gandhi as a moral force, divorced from his hollow and used-up state-approved manifestation. Writing at the time of the film's release, Arunabha Ghosh and Tapan Babu observed that the film shrinks from embracing any thorough-going radical re-envisionment of Gandhi's politics: the film continually edges towards and then retreats from the possibility of 'being mired in Gandhi's socio-economic thoughts – a complete no-no for today's consumer economy driven India' (2006: 5227). This 're-purposing' of Gandhian thought for a neo-liberal context perhaps helps explain the easy mobilization of *Lage Raho* in the context of the Anna Hazare campaign.

Hazare's campaign came to a climax on the final Saturday in August 2011 when the Indian Parliament was forced to debate – against the background of Anna's

deteriorating health – the campaign's demands for a Lok Jan Pal (or Ombudsman) Bill which would counter corrupt practices. Parliament voted in principle to proceed with the investigation of the possibility of such a bill and Hazare announced that he would terminate his fast the following morning. This announcement was made while Hazare sat on stage with two media figures who are of relevance to the narrative advanced here. One was – and perhaps you have already guessed this – Rajkumar Hirani, the director of *Lage Raho*, the movie which had established much of the cinematic infrastructure for Anna Hazare's own incarnation of 'Gandhi, Camera, Action!' The other was Aamir Khan, who had been directed in a later movie by Hirani (*3 Idiots*) but who is perhaps best known for his role in Rakeysh Omprakash Mehra's *Rang de Basanti* (2006), a film about the revolutionary freedom fighter Bhagat Singh, the biggest grossing Hindi film of that year, with Bafta and Academy Award nominations.

Bhagat, a revolutionary Marxist executed by the British in 1931, remains prominent in many South Asians' consciousness and *Rang de Basanti* was a sustained exercise in the 'folding' of the past into the present, an exemplary instance of 'texturology'. The film pushed cinema's temporal involutionary potential to its furthest limit through its juxtaposition of different, co-present, histories which gave it the status of a kind of *meta-text* of the possibilities of historical repetition and bricolage. Mehra's own website gives the following synopsis:

> A young London-based filmmaker chances upon the diaries of her grandfather who served in the British police force in India during the freedom struggle … She comes down to Delhi, and casts a group of five friends to play the pivotal roles of these revolutionaries. However, products of modern India, the five youngsters initially refuse to be part of the project as they don't identify with these characters from the past. Not surprising, since they're part of a generation of Indians that believes in consumerism. To them patriotism and giving one's life for one's beliefs are the stuff stuffy text-books are made of. They would rather party than be patriots. In the film both the 1930s British India and the India today run parallel and intersect at crucial points. As the film reaches its resolution the lines between past and present [blur] as they become one in spirit.

This blurring is precipitated by the death of a friend, Ajay, a pilot in the Indian Air Force. His crash is ascribed by the authorities to pilot error, but the friends know that he was killed as the result of faulty parts that a corrupt defence minister acquired through a kickback deal. So the friends have to avenge themselves, just as Bhagat and friends had to avenge the death of Lala Lajput Rai (who died as the result of injuries inflicted by the colonial police during the visit of the Simon Commission in 1928). Initially they hold a candlelit protest at India Gate in Delhi, a gesture subsequently imitated by numerous other campaigns including Anna Hazare's, which gathered at India Gate on the evening of the day on which Anna finally broke his fast. In *Rang de Basanti* past and present blur, and they murder the corrupt defence

minister, a plot line deemed so incendiary that the film was screened privately for the Congress alliance then Defence Minister Pranab Mukherjee for prior approval. The same Pranab Mukherjee would (five years later) broker the rapprochement between the Congress Government and 'Team Anna'. At the Hazare India Gate event there was much evidence of the complexity of the historical echo chamber (for instance, the placard made by one protestor which demanded that 'Black Englishmen Quit India' [*Kale Angrezo Bharat Choro*])[7] and explicit parallels were drawn between the Quit India Movement of August 1942 and Anna's movement of August 2011 (Figure 6.2).

Rang de Basanti upset many on the political right (and was reportedly pulled from all Gujarati cinema halls), but many on the left saw it as an appropriation of a collective struggle for justice into a practice of statist proceduralism in which ideology was of no account, merely participation – 'doing something'. Many on the left complained that *Rang de Basanti* transformed Bhagat into a fashion accessory for Delhi's disaffected young bourgeoisie in the same way that *Lage Raho* transformed Gandhi into a funky grandfather. In the autumn of 2012 Arvind Kejriwal struck out on his own, forming a political party (Aam Admi Party) and seemingly alienating himself from Hazare. He continues to struggle to establish an organizational base for the party but he has clearly signalled a trajectory that steers him away from the Gandhian 'echo'. He now wears a *topi* with the slogan 'Mem hun aam aadmi' (I am the common man) and announced on 5 March 2013 that he would start an indefinite fast from 23 March which he hopes will become the focus of a new

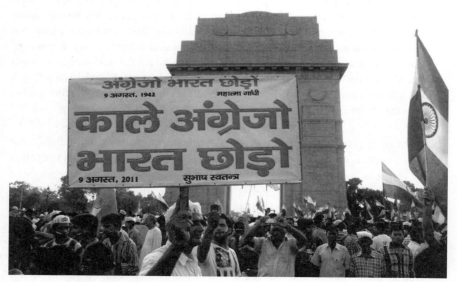

Figure 6.2 *Kale Angrezo Bharat Choro* (Black Englishmen Quit India). Placard displayed at India Gate (photo: Christopher Pinney).

civil disobedience movement in which people will 'stop paying their bills'. Kejriwal points out that 23 March is no arbitrary date: it is, as he pointed out, 'the anniversary of Shaheed Bhagat Singh's martyrdom' (*Hindustan Times* 5 March 2013).

Leaving Delhi and heading ten hours by train south to the town and village in Madhya Pradesh, which I've been visiting since 1982, I found myself speaking with Kalaish 'Haathi', a commercial photographer and old friend. It turned out that he had travelled to the Ramlila grounds a week earlier in order to express his political support for the Hazare campaign. A friend had commented that there was no evidence of anyone from Malwa (this area of Madhya Pradesh) at the protests and that someone should go. Hence Kailash decided to paint himself in Indian national colours and (having affixed a spindly tail) incarnate himself as Hanuman (Plate 16). Being a photographer and having a son engaged in the family business ensured that his departure for Delhi was extensively photographically documented, and it was also covered by a local cable news network. But this was as nothing compared to what (using the English phrase) he termed the 'total media coverage' that awaited him in Delhi. Here he was interviewed by dozens of journalists, and asked to dance continuously in a roped-off area in front of the main stage upon which Hazare sat. Back in Madhya Pradesh his son used his mobile to film his father's numerous appearances on national television and I was shown mp4 footage on the computer in their photostudio in another display of 'folded' media.

In a nearby village, the ongoing site of field research during the last 30 years, I encountered an even more dramatically 'folded' practice. A photographic image of a five-headed cobra which had first appeared in a local newspaper was now being sold through local photo studios in a new variant. Photographed about 35 kilometres from the steel town of Jamshedpur, it was final proof of what everyone already knew, that there were many five-headed snakes. This photographic image, circulating now in a Madhya Pradesh village, served as a prompt to the creation of an elaborate 30-feet long straw and cotton *murti* of the deity, which was taken in procession during Tejas Dasmi (Tejaji's tenth lunar day). Tejas Dasmi is one of several days which celebrate the power of the deity Tejaji to provide protection from snakebites and the procession, accompanied by much possession activity, circumambulates the village over several hours. As of 2011 a very large five-headed snake is now part of this event. It results from the newspaper dissemination of the Jamshedpur image, but other newspapers (the Ujjain/Indore editions of *Nai Duniya* and *Dainik Bhaskar*) have in turn helped transmit this new event to wider audiences in other villages through detailed written accounts complete with photographic documentation of the new *murti*. The histories of such cross-media practices provide further striking instances of 'texturology'.

As I headed further south, after two weeks in Madhya Pradesh en route to Mumbai, Anna Hazare's presence continued to remain inescapable. I attended the Ganesh *visarjan* or immersion on Girgaum beach on a rainswept day throughout the course of which numerous small and massive Ganesh images were 'cooled' in

the Arabian Sea. Many of these had been extracted from tableaux in which the anti-corruption movement had featured prominently: in one case Ganesh was paired with Anna Hazare holding a placard demanding 'Stop Corruption Now!' In several other tableaux a *topi*-wearing Ganesh had himself become a recumbent Anna Hazare, just as the recumbent Anna Hazare at Ramlila Maidan had become Gandhi. Second Gandhi and second Ganesh: everything was already 'half-seen-in-advance' and in its familiarity seemed inevitable. This 'involution' is what Deleuze describes as the 'fold' – that kind of Origami procedure that folds the inside and outside, past and future into each other in complex new 'texturologies' in which old surfaces and historicities no longer have fixed identities.

The crowds at Girgaum, and elsewhere throughout western India on *anand chaudhas* have been gathering since the 1890s when the premier political theorist and nationalist of his epoch, Bal Gangdhar Tilak, decided that a collective occupation of public spaces by Hindus in the name of a colonially authorized 'religion' was one way of circumventing the colonial state's prohibition of potentially 'seditious' political activity (see Kaur 2003). This is one example of what elsewhere I've analysed as 'iatrogenic' politics and religion, a 'contaminated' and new hybrid form of activity precipitated by attempts to escape constraints imposed by the colonial state (Pinney 2009).

Derrida was no doubt correct to observe (in a prefiguration of Latour) that the engineer (see the start of this chapter, above) is simply a myth invented by the *bricoleur* (Derrida 1978). (To put it in Latourian-speak we might say that 'We Have Never Been Modern [nor Engineers]'.) We are all bricoleurs destined to fantasize about the possibility of becoming heroic engineers.

Spivak points to a corresponding (i.e. symmetrical and inverted) danger of essentializing the stability of bricolage as a self-contained and self-present order in which all possible terms are known in advance and are stable (i.e. 'repetition without difference' – the spurious certainty of speech). Anna Hazare and others certainly believe in such a possibility. However, Spivak points to a 'graphic of iterability which introduces a slippage – a fundamental feature of *iteration* in which the self-sameness of the *bricoleur* transforms itself into its other. Bricolage thus ceases to be a closed system and becomes instead a messy zone of citational creativity. Magical mimesis, which strives for 'sensuous fidelity' (Taussig 1993: 16) is thus doomed to an excess, a principle of *political supplementarity*, which drives many of the conflicts in modern India.

The 'graphic of iterability' may be obscure expressed in this Derridean language. However, as part of the science of the concrete – speaking through the medium of things, through visual citation – it may be more easily graspable. Hence the artist Ram Rahman turns *mem anna hun* into something iterably different: a *topi* worn by M. K. Gandhi declaring *main anna nahin hun* (I am not Anna) (Figure 6.3). Here Gandhi himself, ostensibly the ground zero authorization of repetition without difference, insists on its impossibility. 'We Have Never Been Engineers', but equally

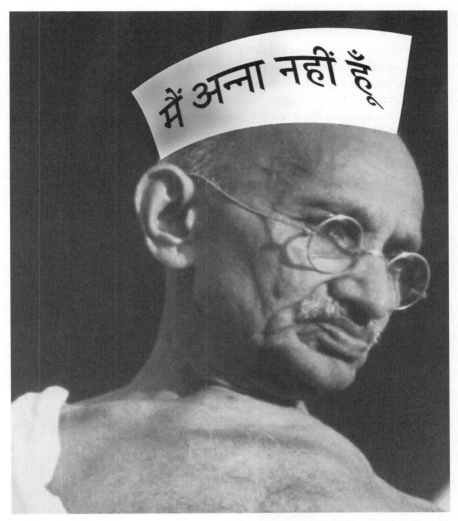

मैं अन्ना नहीं हूँ

Figure 6.3 *Main anna nahin hun* (I am not anna). Photographic montage by Ram Rahman. Courtesy of Ram Rahman.

bricolage has always been performatively and deformatively 'hot' and citation will always be creative and unpredictable.

Acknowledgements

I would like to thank Raminder Kaur, Parul Dave-Mukherji, and two anonymous referees for helpful critiques and suggestions.

Notes

1. See Ahmad (1992) for a celebrated critique of Jameson.
2. I do not necessarily mean that in this regard it differs from other contexts: I am keen to stress the dynamism at the heart of this recursivity, lest it be mistaken for an 'Orientalist' limitation or closure.
3. See below for more details on *Rang de Basanti*. The reader should be clear that this film is not concerned with Gandhi. My interest in it stems from its visual invocation of the past as an archive of possibility.
4. Bouazizi's identity was also assumed ('I am Bouazizi') by Tunisian protestors.
5. The grammatically correct masculine form *andha* is feminized so that it rhymes with Gandhi.
6. Gandhi describes in his autobiography the powerful impact of an itinerant showman's image of Shravan Kumar (see Pinney 2004: 15).
7. I understand 'Black Englishmen' to be a reference to Indians who are continuing the (colonial) work of looting India.

Bibliography

Ahmad, Aijaaz (1992) 'Jameson's rhetoric of otherness and third world allegory', *In Theory*, London: Verso, 95–12.

Aji, Sowmya (2011) 'Spare the rod, don't spoilt the fun', *India Today*, 3 December, http://indiatoday.intoday.in/story/anna-hazare-alcohol-pubs-bangalore/1/162513.html (accessed 1 july 2013).

Deleuze, Gilles (1992) *The Fold: Leibniz and the Baroque*, Minneapolis: University of Minnesota Press.

Derrida, Jacques (1978) 'Structure, Sign and Play in the Discourse of the Human sciences', in *Writing and Difference*, trans. Alan Bass, London: Routledge.

Ghosh, Arunabha and Basu, Tapan (2006) '*Lage Raho Munna Bhai*: Unravelling Brand "Gandhigiri"', *Economic and Political Weekly,* XLI(51): 23 December.

Jameson, Fredric (1979) 'Reification and utopia in mass culture', *Social Text,* 130–48.

—(1986) 'Third-world literature in the era of multinational capitalism', *Social Text*, 15 (Autumn): 65–88.

Kaur, Raminder (2003) *Performative Politics and the Cultures of Hinduism: Public Uses of Religion in Western India*, Delhi: Permanent Black.

Kapur, Anuradha (1993) 'Deity to Crusader: The Changing Iconography of Ram', *Hindus and Pothers: The Question of Identity in India Today*, Gyan Prakashe (ed.), New Delhi: Viking.

Lévi-Strauss, Claude (1972 [1962]) *The Savage Mind,* London: Weidenfeld and Nicolson.

Mankekar, Purnima (1993) 'Television tales and a woman's rage: a nationalist recasting of Draupadi's "Disrobing"', *Public Culture* 5(3): 469–92.

Pinney, Christopher (2004) *'Photos of the Gods': The Printed Image and Political Struggle in India,* London: Reaktion Books.

—(2009) 'Iatrogenic Religion and Politics', in *Cultural Regulation from Sedition to Seduction,* R. Kaur and W. Mazzarella (eds), Bloomington: Indiana University Press.

Sharma, Mukul (2012) *Green and Saffron: Hindu Nationalism and Indian Environmental Politics*, Delhi: Permanent Black.

Spivak, G. C. (1980) 'Revolutions that as yet have no model: Derrida's *Limited inc.*', *Diacritics*, 10: 29–49.

7

Rethinking Waste: Time, Obsolescence, Diversity and Democracy

Shiv Visvanathan

The problem

Modern democracy has a strange sense of the concrete. It absorbs abstract categories, providing them with a tangibility by giving them attributes and propensities. For example, the idea of citizenship evokes qualities of residence, entitlement, suggests rituals of voting. In a similar way, rights become a set of claims which is then hyphenated to a set of conceptual territories. It could be a right to life, property, information, education, health or development. As the list expands, the idea of rights inflates with gravitas and concreteness. But in turning citizenship or rights into 'objects', the idea of democracy acquires a sense of stock, becoming a basketful of claims or properties. While this has added much to the importance of persons and bodies, such an approach does not deal with time, the life cycle ritual, or the wider ecological processes that affect the livelihoods or security of a people. Time and cycles of life create not just new statuses but provide a sense of flow, fluidity and process to the life-world. Democracy as a framework of stock is different from democracy as flow. Flow brings a different set of subtleties to the democratic process. For example, citizenship seen as stock looks complete, bounded, spatially defined, but one needs a new set of concepts to understand situations where citizenship is incomplete.

This chapter seeks to explore the relationship between citizenship, waste, time and democracy by analysing the debates on waste in India. The chapter is divided into eight sections. In the first, one explores some of the ideas of the geologist A. K. Coomaraswamy and Mohandas Gandhi. It tries to suggest that Coomaraswamy's critique of the museum and diversity was a way of reconceptualizing obsolescence. It then explores Gandhi's idea of the body as a site for rethinking waste.

In the next section, I explore the ideas of Patrick Geddes, outlining how he makes waste central to the idea of the city. For Geddes, the garden becomes a way of rethinking waste by mediating ideas of town and country. In the fourth section, I

discuss the works of Frederick Nicholson and Albert Howard's ideas of soils, waste and civilization. While the first four sections focus on waste in the nationalist period, the next few sections deal with waste in the independence period. One contrasts the work of Corbusier and Nek Chand on Chandigarh, independent India's first planned city. This is followed by an exploration of plastic waste touching on the implications of waste for the idea of caste. The next section deals with the ideas of C. V. Seshadri, the chemist who explored the slum. The conclusion then offers a tentative link between dirt, waste, citizenship and democracy.

The sociologist Zygmunt Bauman raised these issues in a poignant way in his monograph *Wasted Lives* (Bauman 2004). He pointed out that the idea of unemployment in political economy and policy was earlier visualized as a state of deficit or lack. It was seen as a temporary state where the unemployed person was part of a reserve army of labour, a pool from which he could return to work as the economy improved. Such an individual remained a person, with dignity and rights. In a profound sense, he was part of the life of storytelling as an individual with an unfolding biography.

Bauman argues that the rise of global economies has altered this perspective. There is a stunning gap between being unemployed and being redundant. Redundancy sparks off the indifference of policy in general, which unemployment rarely evokes. As Bauman states, 'the destination of the unemployed, of the reserve army of labour was to be called back into active service. The destination of waste is the waste yard, the rubbish heap. Redundancy evokes the fact of being disposable just like a used syringe, or a substandard product thrown off the assembly line' (Bauman 2004: 12). Redundancy as a process excludes one from the vital statuses of society and citizenship. Bauman traces this transition to the shift between a society of producers and a society of consumers. He claims that, in a manufacturing society, employment and unemployment were still humane processes. In a consumer-driven society, they were seen as flawed and incomplete. Bauman echoes Samuel Butler's dystopia *Erewhon* where to the tubercular and the poor one could now add the unemployed and the migrant, ejecting them as waste, as human waste, as subject of disposability or indifference.

Bauman's essay on the problem of redundancy is brilliant. However he sees it as a problem of liquid modernity and remarks that waste is a dark, shameful secret of all production. His arguments, while poignant, reveal a sociology which is incomplete. Waste enters his analysis as a political economy, as a theory of entropy, as a classificatory problem in the manner of Mary Douglas and as a situation in postmodern ethics. He raises the issue of waste and sees waste as a necessary branch of production, yet he fails to see the life-redeeming logic of waste. One will try to create an aesthetics of waste, a different sensibility from the visuality of modern society as argued by Bauman. A non-visual aesthetics of waste could create a different sensibility about democracy.

One seeks to do so by juxtaposing the discourse of waste along with the thesaurus of synonyms and antonyms from the Indian debate of waste. The discourse is a

fragmented one, but there are links and connectivities. It also runs across both the colonial and the present era. What I suggest is that waste is an imagination which provides the vocabulary for a different idea of democracy. As a quotation, it was best summed up in the contention of the Indian chemist C. V. Sheshadri, that 'waste is the only resource of the wasted people' (Interview, Seshadri 1995). Even Seshadri's almost celebratory quote needs to be located in the wider diversity of debates and I shall attempt this in the next section.

Waste, obsolescence and the museum

The concept waste is often described as an ordering operation, often a classificatory term. Rather than proposing a definitional exercise, waste is treated here as a floating signifier, whose meaning appears in context, as the Indian discourse debates the clash of different life-worlds. This narrative traces part of the debates from 1904 to 2013, dividing itself into two sections: first, the nationalist against the colonial regime; and second, the civil society debates against the nation-state after 1947.

The Indian national movement was an archive of debates on science and technology. It wanted to understand how India as a civilization and a future nation could respond to modern Western science. One of the most acute periods of analysis was the decade after the Swadeshi movement (1904) when a plethora of groups debated science and technology. This included the Swadeshi advocates, the Theosophists, the traditionalists and a host of British scientists in India. A second wave of debates arose in the seventies and eighties centring around the rise of civil society. This chapter on waste builds on both archives. Probably the best introduction to the debates is the work of the art critic and geologist, Ananda Kentish Coomaraswamy.

Coomaraswamy was a Sinhala geologist, director of the Mineralogical Survey of Ceylon. His sojourns alerted him to the fate of the crafts in the subcontinent. Coomaraswamy followed the socialist ideas of William Morris and, in fact, owned his printing presses. Coomaraswamy's ideas thus hybridized an aesthetic idea of socialism, embedding it in the traditional ideas of craft and craftsmanship in Indian society and cosmology. Coomaraswamy challenged the Renaissance distinction between craft and fine art which he claimed distorted the aesthetic process. In enthroning industrialism, it turned the crafts system into a form of redundancy. He modified Marx's definition of a proletarian man from a person separated from his means of production to an individual separated or disembedded from his culture. Redundancy, for Coomaraswamy, emerged from an alienation from culture and, in that sense, concepts like tradition and heritage were not ornamental but life-giving, as they emphasized ways of life which, rather than being seen as marginal or displaced, created validity, vitality and meaning by sustaining a cosmology and a way of life.

Coomaraswamy located his critique within an idea of tradition, but his argument is seen most clearly in his critique of the museum. Criticizing Western humanism, Coomaraswamy argued that the museum reflected an almost dualist split between progress and disappearance. He claims that 'we preserve the folk song at the very moment we destroy the folk singer' (Coomaraswamy 1981: 74–5). Citing the Sinhala journalist, he asks: 'If God were to return today and ask civilized Western man where the Aztecs and the Incas or where the Australian aboriginals were, would he take them to the museum?' (Coomaraswamy 1947: 22).

Coomaraswamy claimed that the museum smelt of death and formaldehyde and in his *Love and Art* he demanded that the Indian national movement fight a guerilla war against the museum. He felt that tradition was more life-affirming and in a traditional society one dealt with craft in an everyday sense and not as disembedded memories. Aesthetic socialism for Coomaraswamy was an ethics of memory where memory as everyday ritual replayed tradition. He defined the artist not as a special kind of man but that every man was a special kind of artist in the pursuit of his vocation (Coomaraswamy 1956: 98).

It is interesting to note that it was Coomaraswamy who coined the term post-industrial society. The term was borrowed by Alfred George Penty in his Yale thesis. Daniel Bell took it from Penty and popularized it in his contemporary classic. However for Coomaraswamy, the post-industrial society was a craft society where tradition became an antidote to the waste and wastelands of industrial society.

Coomaraswamy developed his critique of waste further through the idea of diversity. He contended that modern synthetic chemistry standardized the chemical dye, creating a homogeneity of colour by standardizing it, and argued against the disappearance of the natural dye at two levels. He responded first to the great Indian chemist, P. C. Ray. Ray had described the work of German chemists as the creation of savants, equating their scholarship with *tapas*, a form of ascetic discipline. Coomaraswamy suggested that such reverence or even a fear and trembling before synthetic chemistry was unnecessary. The synthesis of indigo had already destroyed a way of life, and synthetic red was threatening to replace madder. He argued that colour was not a property of object but a way of life. Red was not the official red in each village but represented a variant of it depending on tools, techniques and the nature of processing. Natural dye created a diversity of redness within the ambit of a colour. Diversity of colour and ways of life became essential, as diversity was one way of preventing a waste of ways of life. Diversity in culture was an antidote to the fetish of efficiency and standardization which created monocultures. Diversity then becomes an ecology challenging the waste and wasted lives that efficiency and obsolescence create. It is interesting that the national movement becomes a challenge to the wastelands of industrialism. The museum was the mirror inversion of progress. Yet one must add the final irony: Coomaraswamy was forced to spend his last years as a curator at the Boston Museum of Fine Arts. Yet his arguments influenced whole generations who saw

diversity as an antidote to the monocultures of mechanical efficiency which also misconstrued the idea of the waste.

A hermeneutic of Indian nationalism can read the above argument as an attempt to fight waste and obsolescence. One can, in fact, argue that what Gandhi did in an ethical sense was what Coomaraswamy provided an aesthetic for. For both, tradition was a way of life that eliminated waste and especially the waste of industrialism. Gandhi was aware of both human waste and the wasted humans of the Indian village. He criticized industrialism for making craft irrelevant. His idea of Khadi was an attempt to fill time as wasted time where work as value returned meaning to the unemployed villager. Neither was a Luddite.

Gandhi's ideas of waste centred around the metaphor of the body. His sense of the body determined his idea of the body politic. For Gandhi, the ascetic body was the beginning of his challenge to the unthinking ways of industrialism. The body was the site for dietic and other experiments and the *ashram* was a laboratory for studying waste, of experimenting with varieties of toilets and with biomass, seeking to convert it to other uses. He realized that human waste was an unsolved problem in India and observed that, in fact, the only thing the country needed from the West was a drainage system. Yet he also realized the scavenger was a problematic figure in the caste system and one of the organizations he established was a university for scavengers located next to the Sabarmati Ashram. He felt everyone should clean up their own waste and, in fact, one of his battles with his wife, Kasturba, centred on her refusal to clean the toilet. Gandhi was a philosopher of waste, working continuously on food and cooking (he made sure no part of the plant was wasted even if it did not quite add up to taste).

In a semiotic sense, the best way to understand waste is to enter the little cottage at Sabarmati Ashram in Ahmedabad where Vinoba Bhave and Madeleine Slade stayed. There are two bare rooms, tiny, like a child's creation. In one, a body can lie on the floor and sleep. In the other is a toilet, polished by incessant washing, glistening like a piece of sculpture. At this moment one is reminded of Marcel Duchamp's attempts to foist a commode as a work of art. Duchamp's object, which challenged the rules of art, was not accepted as an exhibit but remained as a satire on the contemporary notions of aesthetics. Gandhi, by creating an aesthetics out of everydayness, made the commode gleam like an egg. In one sense, both Duchamp and Gandhi are major critics of technology. One uses the commode to challenge the rules of art, the other converts the everydayness of sanitation often seen as polluting into an artform. Duchamp's attempt to satirize art through the urinal met its final irony in that the same world ultimately enshrined the urinal as an *avant-garde* artwork (Paz 1978).

Patrick Geddes: The garden as a framework for waste management

The Indian national movement was extraordinary in its range and diversity of interests. Viewed anthropologically, one often sensed that overthrowing the British was an incidental goal of the movement. Another sign of the plurality of the movement came from the Englishmen/women who participated in it. The roll call included not only Allan Octavian Hume, who was a great ornithologist, but Annie Besant, C. F. Andrews and even Alfred Wallace, the theorist of evolutionary diversity. This led to what can be called the development of the other colonialisms, which provided alternative readings of the West. This plurality of perspectives added to the availability of eccentric ideas contributing to the studies of waste. Probably the most fascinating of these works was that of the Scottish biologist, urban planner and polymath, Patrick Geddes. The ecological and the aesthetic combined formidably in Patrick Geddes' study of urbanism.

Patrick Geddes was the first professor of sociology at Bombay University. He spent two stints in India writing over 30 town plans and outlining his role as a university militant, rethinking the modern university. As a maverick biologist, he was fascinated by systems of energy. He differentiated between the paleo-technic and neo-technic forms of civilization. Modelled on the conventional distinction between Paleolithic and Neolithic societies, each was paradigmatic in terms of its approach to energy. A paleo-technic society, marked by a machine-driven form of industrialism, was mechanical and linear, dominated by the conventional engineer who thought in terms of linearity. A mechanical industrialism was polluting industrialism where waste was an economic and technical externality. A society which did not understand waste created an ugly urbanization. A neo-technic industrialism was an ecological industrialism which understood the organic nature of the city. What linked town and country was the gift of waste and Geddes' idea of the garden city was to create this reciprocity between town and country embodied in the garden. It is in this context that Geddes made his startling claim that the Indian national movement had read the wrong West, or an outdated West. It had criticized the mechanical, Haussmanic paleo-technic city but was ignorant of neo-technic industrialism. For Geddes, a nationalist critique of the West was inadequate without an understanding of thermodynamics, of the laws of entropy (Defries 1927).

As an anthropologist of energy and as an advocate of the new discourse on ecology, Patrick Geddes saw thermodynamics as creating a new set of cognitive attitudes. Ecology created not just an attitude but was a concept that could be applied to knowledge. The new ecology of knowledge systems created a new hermeneutics on waste not as externality but as a life-giving part of the cyclicalities of nature. It was in this context that Geddes commented acutely that it was pity that Indian cosmologies were developed before they had acquired an understanding of human waste. Geddes added that wastefulness was a natural consequence of mechanical

systems of energy which thought in terms of Haussmanic systems of power, where the straight line and the iron grid determined the character of the city. Such an idea of efficiency and a concept of power created a theory of planning which did not see ways of life as forms of work, theories of knowledge as synergetic systems. The distinction between wardom and peacedom lay in their cosmologies of energy, in the different ideas of waste. A theory of waste which stemmed from the organic idea of the city followed principles of conservative surgery. Here the old was not seen as a piece of waste to be disposed of but as forms of life which could be absorbed within the new ecologies of industrialism. Geddes predicted the economics of the leaf and the economies of metals would once again clash before a post-Germanic post-industrial society evolved (Defries 1927: 175). Agriculture would be reinvented and a post-Germanic India would be an agricultural society. Waste almost becomes a leitmotif of his theory of urbanism and of knowledge and power in an ecological society. A theory of waste and a broader concept of ecology are braided together to enable modern society to critique knowledge, power and energy as concepts.

Erosion, soil and waste: Howard and Nicholson

Waste acquires a further density in the Indian reading of the West through the works of Albert Howard, chief botanist at the Institute of Pusa, the man who originated the idea of organic farming based principally on his studies of agriculture, especially composting, at Indore. Albert Howard's main treatise was *Agricultural Testament* (Howard 1940). Published in 1940, it anticipates the problematic of waste bowl economics by providing a civilizational answer to it. Soil becomes the basis of a theory of civilization and his theory of humus as a theory of the health of soils is an emphatic answer to modern agriculture.

For Howard, an attitude to waste is an index of a civilization. Nature, he contends, is the supreme farmer and nature knows no waste. He created an anthropology of four styles of farming based on attitudes to soil and waste. Composting for Howard is the key act of renewal, a life-giving act which protects civilizations. His four farming communities are the methods of nature and include the agriculture of dead civilizations, the practices of the Orient unaffected by Western science and the current methods in vogue in the USA and Europe infected by Liebigian mentality.

Howard begins with an ode to the forest as a system of farming, observing that there is no waste anywhere. The forest manures itself. It makes its own humus and supplies itself with minerals. If we watch a piece of woodland, we find that a gentle accumulation of mixed vegetable and animal residues is constantly taking place on the ground and that these wastes are being converted by fungi and bacteria into humus. 'There is no nuisance of any kind – no smell, no flies, no dustbins, no incinerators, no artificial sewage systems, no water-borne diseases, no town councils and no rats' (Howard 1940: 4).

Treating nature as paradigmatic farmer, Howard then evaluates other systems of agriculture. Soil becomes an index of the survival of civilizations. In this context, the Roman Empire ends in failure because of a failure in maintaining soil fertility. Howard then adds that it is the practices of the Orient, whether India or China, that have passed the supreme test of survival. These systems have been responsible for maintaining soil fertility by understanding that waste is a resource one ploughs back for renewal. The logic of oriental sustainability begins with waste. In contrast, in Western systems, monoculture is the rule and waste is seen as an externality.

Howard claims that the West is responsible for the crime of Liebig, who is contemptuous of waste as humus and introduced synthetic fertilizer, the NPK mentality which turns the idea of soil into a mechanical system. Howard remarks that without a theory of waste and of soil, civilizations cannot renew themselves. The Orient understood this, realizing that waste is a symptom of bad farming because nature as an accounting system kept a balance between processes of growth and decay. Erosion, he points out, is nature's way of healing itself, of removing damaged topsoil so nature can renew itself. Synthetic fertilizer destroys this ecolate view of the world. Waste then becomes not a pile to be composted but an index of failing civilization.

Albert Howard's ideas of waste were echoed in the works of Frederick Nicholson and his comparative anthropology of human waste. Nicholson, who worked in Madras Presidency, anticipated what is today valorized as intermediate technology. He argued that any system of technology must use what is generally under-utilized or ignored as waste. For a technologist like Nicholson, the garden was the epistemic model, mediating between agriculture and industry. In his *Note on Agriculture in Japan* he remarked: 'All land is treated like a garden, agriculture in Japan is horti-culture' (Nicholson 1907: 29).

It is the Japanese intensiveness in the utilization of land and waste that impressed the British technologist. 'With characteristic ingenuity, villagers contrive to attract mules (the plan does not succeed with horses) to particular spots by odorizing such spots with donkey droppings and urine, no passing donkey or mule fails to respond to the suggestion.' In fact, so intensive was the use that even city corporations obtained income by 'leasing out the collection of dejecta to farmers and scavengers' (Nicholson 1907: 45). It was precisely such an economy that Nicholson advocated for Madras, which was poisoning itself with natural waste festering on village sites.

Nek Chand and Corbusier: The remembered city

Despite partition, the first years of independence were euphoric ones. India decided along with Jawaharlal Nehru, its first Prime Minister, that the future belongs to those who make friends with science. It created what an anonymous activist called a set of fatal friendships with state-sponsored development projects. There was an official

distinction between official and unofficial energy. Electricity, hydropower, nuclear, coal were scientific forms of energy while biomass was informal energy dependent on the science of the poor. Apart from the idolization of energy, the Nehruvian era saw the concept of urban planning as a vehicle of the state.

Always wanting the latest and the best, Nehru, invited the French architect Le Corbusier to design the city of Chandigarh. The making of Chandigarh is legendary. But there is a small folktale about waste and aesthetics attached to the making of Chandigarh. It deals with what local residents call inappropriately the Rock Garden of Chandigarh.

These gardens were assembled single-handedly by a PWD employee called Nek Chand. Nek Chand was a refugee from Pakistan, an ordinary worker who watched with awe the making of a new city. He confessed he never met Corbusier but added he once saw him near the lake and was content watching 'Corbu' close by. Nek Chand was fascinated with stones and rubble left over from the building of the city.

Nek Chand was a collector. He collected shapes and fragments from the 17 villages that had been displaced by the new city. All these were dumped in the forests on the outskirts of the city. Covertly, this young worker collected many of them. It began as a personal obsession by a man who claimed that an eroding nature using water and wind was our greatest sculptor. What was waste or rubble to an urban world was assembled as a jumble of curiosities, an unconscious statement where the aesthetics of erosion confronted planning as a conscious design.

As Nek Chand's assemblage of creatures became popular, he was allotted land by the administration. His rock garden was gradually conceptualized in three parts. In the first, nature sculpted itself. It was presented as an assemblage of rocks and stones in various stages and sizes, conveying a sense that even rubble can be rethought. Nek Chand saw erosion as a form of natural waste which has aesthetic possibilities. For him, erosion was an expression of God expressing his aesthetic sensibilities. It was the second phase, however, which was intensely creative and it centred on rubbish.

Nek Chand saw in the piles of rubble, the odd collection of porcelain, glass, bits of steel, commode pieces, broken bangles and window panes, the possibility of a bricolage of new exhibits, a folklorist assemblage of kings, queens, birds, monsters stuck together from waste. He created a castle with a moat and populated his city with a ménage of animals and birds, goats, monkeys, a carnival of animals. It was a child's delight and an adult's surprise. What one witnessed was a garden of waste, a zoo of fabricated animals, a tribute to waste and the culture of waste, where ceramic toilet and glass bangles provided a new aesthetics of urbanism.

It became a tourist attraction and a subject of study for art historians and semioticians. The museum was part of an urban folklore, and waste part of a new urban testament. It conveyed that waste had an aesthetic, an afterlife that went beyond design. To be labelled as waste was not the end of storytelling. The objects merely found a new threshold to cross to find new value and a new career.

Nek Chand had a fondness for waste cloth and plastic which he stitched into huge dolls. There was something droll about the exercise. He would walk around Chandigarh asking people to give him their rubbish. He was content they saw in waste a form of entertainment, and hoped they would eventually see a different framework of values (Interview, Nek Chand 2001).

Nek Chand was invited abroad frequently. Foundations and galleries saw in this untaught artist a collector's item. He grumbled when he visited other countries. He was impressed by their progress but discontented that their rubbish was not 'as playful as our rubbish'. He claimed 'their waste is not like ours'. He hinted that local rubbish had more character – that it was more open and malleable to his sense of bricolage.

Nek Chand had obtained a huge tract of land at the centre of Chandigarh to locate his garden. Often, one saw him walk on the walls of his castle, pretending to be the lord of all he surveyed. One asked him about his plans for a huge section that he had left empty. He was strangely evasive about it, shrugging off any questions with a peremptory 'wait and see'.

Nek Chand was invited to the international Punjabi conference in Pakistan, and rushed to see his old village. Ironically, it was bombed by the Indian Army in 1972. He came back oddly animated and decided to create a third section, a village remembered, created out of plastic and cloth waste. For Nek Chand waste is not an act of forgetfulness but could be the fabric of a reworked memory. If one looks at the three sections of the garden conceptually, erosion, waste and memory are reworked as bastions against obsolescence. Waste is an invitation to playfulness and it breaks through the puritanical definitions of industrial waste which defines it as loss, or uselessness, or as polluting rubbish. Waste acquires a mnemonic dignity through the idea of the garden.

Caste, waste and the city

A reader familiar with the sociology of caste might be tempted to set out a set of caveats about presentation thus far. He could suggest that the disposal of the waste in a caste system has always been a polluting affair and argue that the work of scavengers has always been degrading. A closer ethnography of waste, however, reveals that waste is usually differentiated between wet and dry: between *Kooda Kachra,* wet, unsegregated mix of organic and inorganic waste, possibly contaminated by rotting remains of food excreta, only some of which is recyclable; and *Kabadi,* dry, segregated, inorganic waste which is reusable and recyclable (Gill 2010: 88). Ethnographers of waste like Kaveri Gill have suggested that the two types of waste allow for two different life-worlds and even entrepreneurial strategies. They have pointed out that this distinction is also fiercely asserted by the groups involved. Handlers of wet or organic waste – that is, those castes dealing with carcasses, night

soil, butchery, tanning leather, human waste – are seen as polluting and are low in the caste hierarchy. While there are no hard barriers separating castes handling waste, many of those handling dry waste have used entrepreneurial strategies to become upwardly mobile. One study which offers fascinating insights into such a process is Gill's study of the Khatik caste, handling plastic at Mundka, Asia's biggest village for plastic waste.

The Khatiks distance themselves from those picking and dealing with wet waste. The Mundka scrap market has exploded to a population of 5,000 traders. What is interesting is that the market was non-existent before 1965. It developed as a leasing process, beginning with items likes shoes and sandals. As new plastics products developed, the appropriate technology for recycling plastics was developed.

Gill emphasizes the nature of plastic waste as a domain of knowledge. Knowledge is passed down from one generation to the next. She quotes a Khatik as saying:

> Khatik knowledge of plastic and recycling is unsurpassed – by smelling it, seeing it, burning it, we can tell what sort of plastic it is. Others have to check with painstaking methods. But we have imbibed this knowledge from childhood, we can tell from experience what sort of plastics we are dealing with, what processes may be used to recycle it. We know 190–200 items by sight. Our *biradari* has maximum knowledge of this work. (Gill 2010: 168)

Gill's suggestion of plastic and plastic recycling as sensorium of knowledge is intriguing one.

The political sociologist, Chandrika Parmar and I spent a few weeks researching plastic and one was surprised at the Linnaean elaborateness involved in the classification of plastic. It was interesting that many women regarded it as natural material, a second skin we often shed. One of them also told my team a fascinating story. We asked her about recycling hospital injections. She brushed it aside. 'You see this,' she said, picking up a ball pen, 'we can make it for 25 paise. This is a biro.' She added: 'The government gives us free education but stationery is expensive. Recycling plastic gives us cheap stationery. Recycling allows justice' (Interview, Seshadri 2002).

There is something surreal about Mundka as a market. It is a desert of plastic waste, a dead translucence spread for miles. One felt that if early empires left behind a monument of skulls, Delhi has its graveyards and gravediggers of plastic. Plastic today is seen as a health hazard, an environmental problem, even an eyesore.

We visit Mundka with Santosh Singh, a journalist from *The Statesman*. Our investigations revealed that the rag picker is the Linnaean master of the world of plastics. He is taxonomist, sorter, and salesman of this reusable world. There is a lethal and life-giving axis to the process, given that Mundka processes plastics including hospital waste. As Singh said, 'Hospitals forget that it is not just Bisleri bottles that have to be crushed and shredded after use but syringes and needles and

gloves' (Interview, Singh 2002). Nothing is wasted in this surreal world of sustainability. There is something eerie about a society that refuses to throw things away. Functionally, a motor car is not supposed to be used for ten to 15 years but this is the case in India. Not being a throwaway society can cause its own form of pollution. Instead of a junkyard of cars we have polluting machines. The Central Pollution Control Board (CPCB) in an interview claimed that 67 per cent of the pollution load is due to vehicles registered over a decade earlier. The CPCB claimed that if vehicles aged above ten years were phased out, the carbon load would decrease from 406,000 tonnes to 318,000 tonnes.

We asked CPCB about its policy towards plastic waste. Its in-house magazine *Parvesh* has a remarkable essay on plastic which is both a semiotic of waste and a warning about the dangers of new forms of consumption. The article is dated but helps to read trends. The sociological eye of the CPCB notices there is a delay in disposal of plastic waste. Unlike in the West, there is a secondary and tertiary use of plastics. Accompanying it is a network of plastic waste disposal, a web of rag pickers, waste collectors, waste dealers and recycling enterprises numbering about 20,000. India recycles 60 per cent of its plastic waste. The ratio of recycled plastic is the highest in the world, leading to an industry with a turnover of Rs.25,000 crore per annum. The report notes that this burgeoning industry creates its own 'new occupations' like the plastic mechanic. These enterprising technologists visit residential areas and earn up to Rs.75 a day. Plastic in fact is more remunerative than any form of waste. The report observes that while English newspapers cost Rs.4–5 per kilo, Hindi newspapers Rs.3–4 per kilo, beer bottles sell at Rs.2 per kilo, mixed plastic goes for Rs.12 per kilo.

Mundka represents the anomaly of waste as a category, combining the lethal and the life-giving. It raises issues about how a society responds to waste. If the informal economy found at one end the world of Nek Chand and the bazaars of Mundka, waste found its greatest scientist in the chemist C. V. Seshadri.

Entropy, time, waste and recycling

C. V. Seshadri was a chemist, biotechnologist and engineer. Trained at Mumbai and Carnegie Mellon University, an author of a textbook on fluid mechanics, a faculty member at IIT Kanpur, he was a scion of one of the grand families of South India; Seshadri was grandson of C. P. Ramaswami, the Dewan of Travancore. He left IIT to set up a laboratory close to a slum in Chennai, building not just a practical set of solutions but a theory of waste, science and democracy.

Seshadri argued that entropy was not only a key term in science but a critical concept for state-building. Energy was the concept around which the state and the planned state were conceptualized. This scienticization of the state, he argued, had deep consequences for democracy and civil society.

For Seshadri, the roots of planning went back to Saha and his reading of the Russian Revolution. Meghnad Saha was an astrophysicist who believed that energy was an index of civilization, that the level of civilization was determined by the energy one consumed. When Saha undertook his studies in the 1930s, the energy index for the USA was 2,500, the UK 2,000 and India came up with a medieval 75 (Visvanathan 1984).

Saha realized that the politicians of the Indian national movement had no sense of a planned future. He was inspired by the Bolshevik Revolution and Lenin's attempt to establish the Academy of Sciences. Lenin saw the academy as an institutional reflection of the relation between the scientist and the politician, especially between Lenin and Gleb Krzhizhanovsky. It was this dream of energy that led Lenin to coin the slogan:

Soviets + Electrification = Communism

Meghnad Saha went out in search of his Lenin. He persuaded Subhash Chandra Bose to establish the national planning committee and worked hard to nominate Jawaharlal Nehru as chairman. Nehru's statement that dams and laboratories are the temples of the modern India was a watered-down liberal variant of Lenin's dream (Visvanathan 1984).

The concept of energy provided not only the rationale for the state but the grid of discipline. Discipline and energy become deeply linked and stratified. Energy becomes transformed into what the state and plan considered it to be. Petroleum, nuclear, hydel, electric now constituted the alphabet of energy of the new state. Expert energy becomes official energy, energy generated by the people – the traditional world of dung and fuel wood was not considered either immaculate or scientific. The world of biomass became the world of the marginal society. Seshadri argued that civil society and especially the informal economy had to generate not only the new political economies but new epistemologies of survival. One needed alternative notions of knowledge to accompany the ideas of livelihood and survival in the biomass societies.

To achieve this Seshadri argued one had to deconstruct the idea of entropy. He began his narrative like other philosophers of science with that great subject of technological folklore, the steam engine – an old-fashioned steam engine.

Imagine an engine moves from A to B. The burning coal flows into the boiler and escapes as steam into the atmosphere. Following the laws of conservation of energy, the overall quantity of matter and energy has remained constant. What has occurred is a qualitative change. Coal has been converted to ash. Physics which so far dealt with locomotion had encountered quality. Classical mechanics which could deal with mechanical time that was reversible now confronted directionality. Thermodynamics phenomena are irreversible.

The concept of entropy was coined by Clausius to differentiate between bounded

and free energy available for work. For example, the coal used to run the engine, once burnt into ash, becomes bound energy.

Entropy introduced the arrow of time into physics. More relevantly, by emphasizing qualitative change rather than quality-less locomotion, entropy emphasized waste. Work and waste become central to any production system. Between entropy as heat death and the idea of waste, economics confronted the end of a promethean idea of energy.

What haunted C. V. Seshadri were the cultural implications of thermodynamics. He noted that historians had already pointed to the Judeo-Christian bias and the anthropocentrism. He however emphasized that one needs to look at it from the perspective of marginals, especially in the third world.

The anthropomorphism of thermodynamics is of two kinds: one by virtue of being human and the other by virtue of being Western. Poorer countries, he pointed out, often ignore the second kind of bias, leading to a gross enhancement of existing disparities.

Seshadri argued that since energy is inseparable from use, it becomes a criterion for prioritizing use of resources. Consider a forest. It has a multiplicity of uses. Wood, for instance, can be used for fuel, for smelting iron, boiling sugar, or as household fuel. Forests, however, are marked more and more for the timber and pulp industry. As a result, forest people are deprived of their traditional rights to fuel. Worse, the idea of entropy fails to see the wasted notions of forests when the wood is converted to pulp. One is confronting two value frames, the world of the tribal and the world of industry.

It is in this context that Seshadri raised the question of the epistemology of a biomass society. Biomass is characterized as a way of life of societies outside the rule of industrialisms. It summons waste as the central resource of a people.

Seshadri talked in aphorisms and epigrams. I remember him grinning and observing 'pollution is someone else's profit' or 'one man's waste is another man's resource'. But these were not just pretty proverbs. Consider the popular idea of recycling. He said: 'You can't recycle waste without violating the second law of thermodynamics. The question of recycling has to be looked at in this perspective for all waste is useful in some context.' For Seshadri it was more fruitful to recycle ideas instead of things. He provided the example of sheet metal recycling.

> Circular blanks of metal are stamped out of metal sheets leaving behind perforated sheets which the manufacturers characterize as waste. But one man's waste is another man's resource. The perforated sheets are used by several poor people as fencing, structural elements in housing, tracks for paths etc. What has been recycled is neither material nor energy. *Only the idea*. Waste has been turned into a resource by perceiving it differently. A low value high entropy perforated sheet becomes a high value low entropy fence, tracks and such by recycling ideas. The process also adds value locally. (Interview, Seshadri 1996)

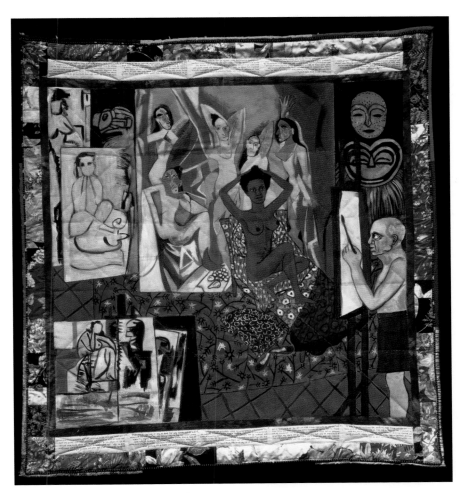

Plate 1 Faith Ringgold, *Picasso's Studio.*

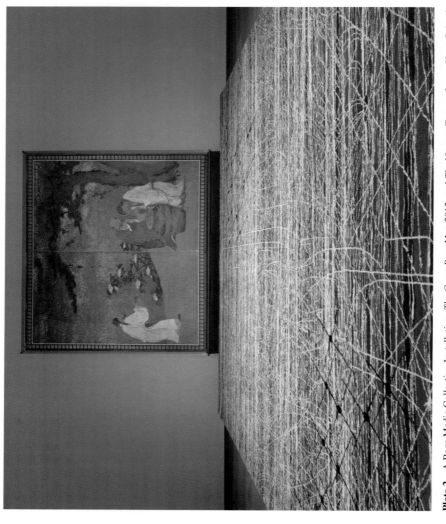

Plate 2 A Raqs Media Collective Installation, *The Great Bare Mat*, 2012; and *The Vinegar Tasters*, Japan, Kanō School, 17th century. Isabella Stewart Gardner Museum. Image courtesy: Isabella Stewart Gardner Museum.

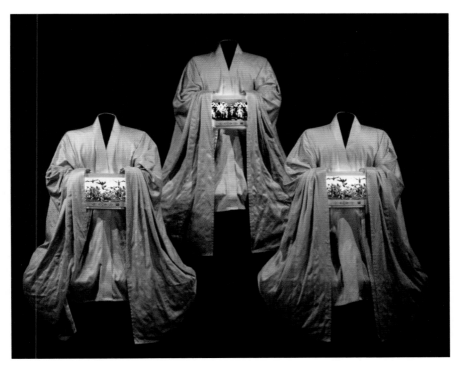

Plate 3 Sheba Chhachhi's *The Winged Pilgrims,* 10 moving image light boxes (digital print on dura trans), 5 Silk and fibreglass Robe objects with motion lamps, sound, 2006–8.

Plate 4 Francesco Clemente (in collaboration with an Oriya artist), *Story of My Country – I*, pigment on rag board, 23 × 40 cm, from the collection of Jutta Jain and Jyotindra Jain, 1990. Permission granted.

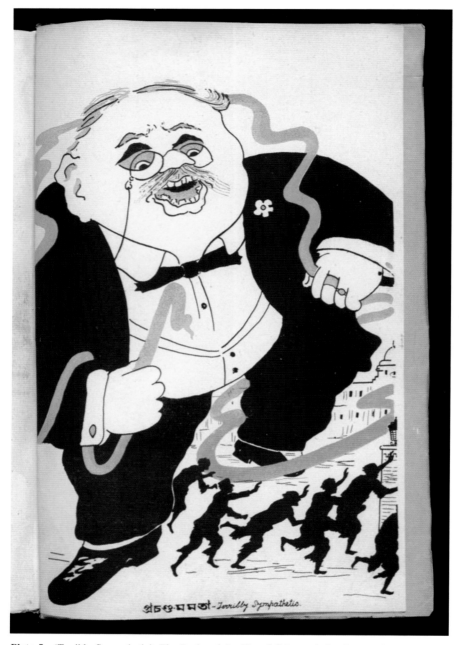

Plate 5 'Terribly Sympathetic', *The Realm of the Absurd*, lithograph, by Gaganendranath Tagore, Calcutta, 1917. © Victoria and Albert Museum, London.

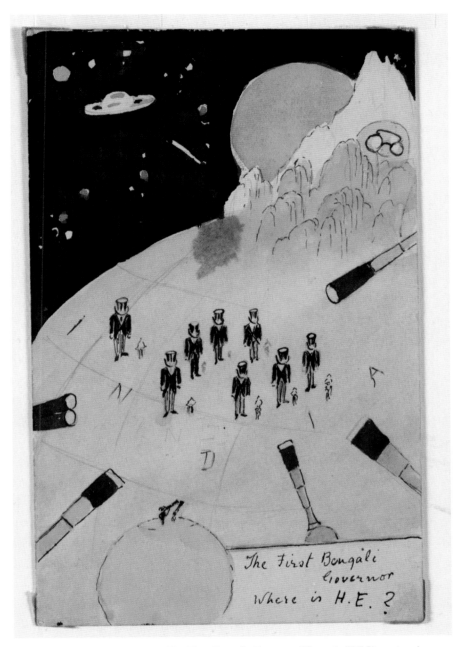

Plate 6 'Astronomical Scream. The First Bengali Governor. Where is H.E.?', watercolour on postcard, preparatory sketch for lithograph, by Gaganendranath Tagore, Calcutta, 1919. © Victoria and Albert Museum, London.

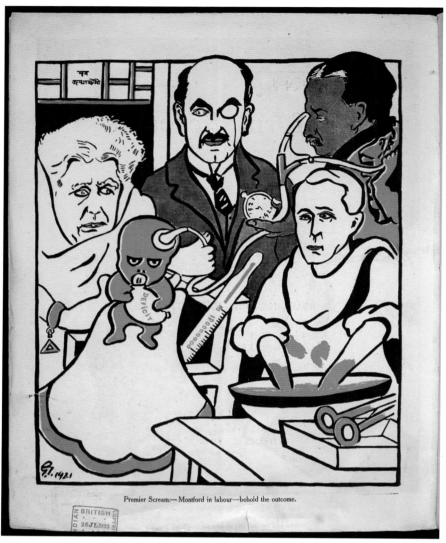

Premier Scream:—Montford in labour—behold the outcome.

Plate 7 'Premier Scream, Montford in Labour – Behold the Outcome', *Reform Screams*, lithograph, by Gaganendranath Tagore, Calcutta, 1921. © The British Library Board (J/12315.w.5).

Plate 8 Cloud Gate, Millennium Park, Chicago. Image available at http://commons.wikimedia.org/wiki/File:Cloud_Gate_Sculpture.jpg, under a Creative Commons Attribution-Share Alike 3.0 Unported license.

Plate 9 Sky Mirror, by Anish Kapoor. Kensington Gardens, London. Image available at http://commons.wikimedia.org/wiki/File:Sky_Mirror,_Kensington_Gardens,_London,_close_up.jpg, under a Creative Commons Attribution-Share Alike 3.0 Unported license.

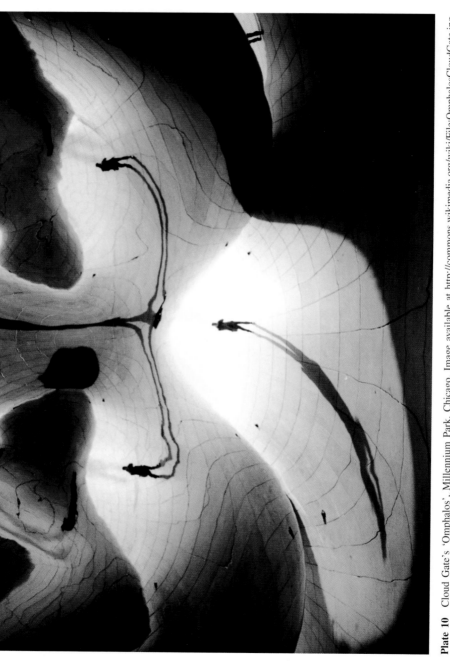

Plate 10 Cloud Gate's 'Omphalos', Millennium Park, Chicago. Image available at http://commons.wikimedia.org/wiki/File:OmphalosCloudGate.jpg, under a Creative Commons Attribution 2.0 Generic license.

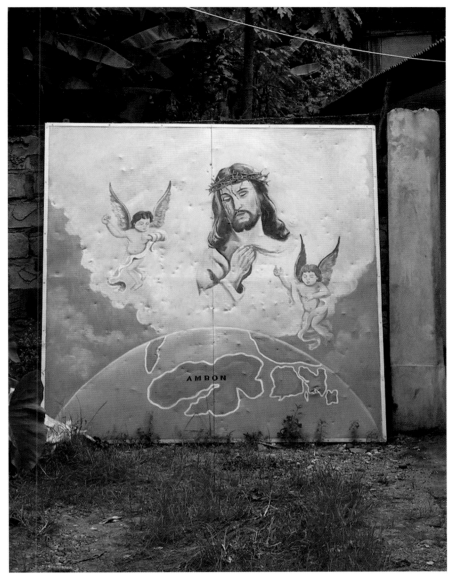

Plate 11 John Yesayas, billboard of Jesus overlooking Ambon Island, Ambon, 2006. Reproduced with permission of the artist (photo: P. Spyer).

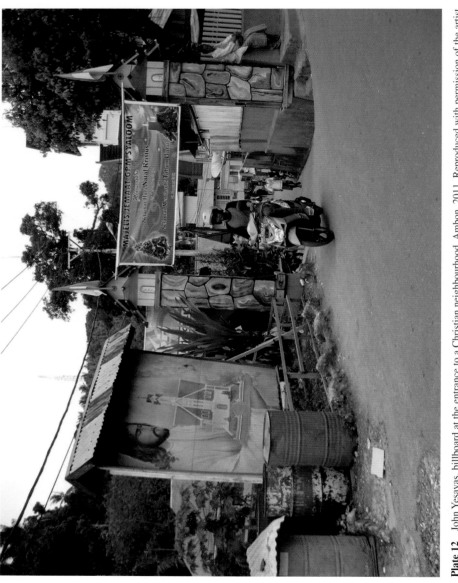

Plate 12 John Yesayas, billboard at the entrance to a Christian neighbourhood, Ambon, 2011. Reproduced with permission of the artist (photo: P. Spyer).

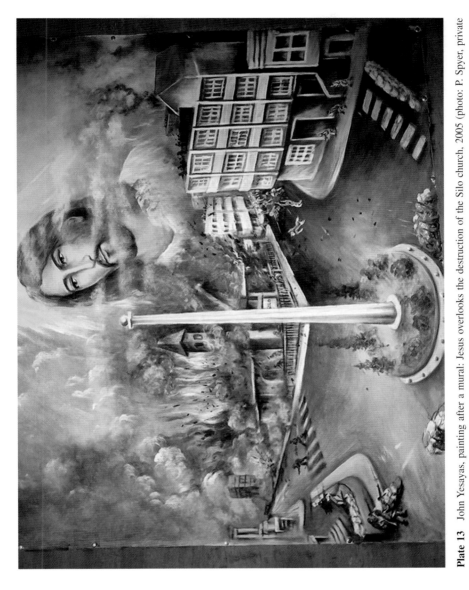

Plate 13 John Yesayas, painting after a mural: Jesus overlooks the destruction of the Silo church, 2005 (photo: P. Spyer, private collection Patricia Spyer).

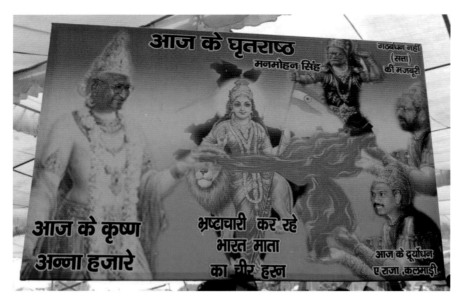

Plate 14 *Aj ke Dhritarashtra* (Today's Dhritrashtra). A Photoshopped placard displayed at the Ramlila Maidan protest. Mother India is shown being disrobed in the centre of the image, Anna Hazare appears incarnated as Krishna on the left and a blind Manmohan Singh (the Prime Minister) appears on the right above Salman Kalmadi and A. Raja (photo: Christopher Pinney).

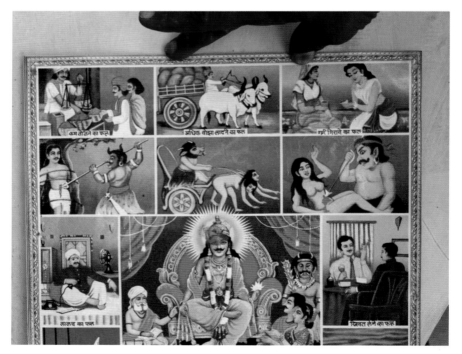

Plate 15 A modern Karni Bharni image showing actions and their punishments in hell. Photographed in rural Madhya Pradesh in 2011 (photo: Christopher Pinney).

Plate 16 Kailash leaves Nadga Jn. For Delhi's Ramlila Maidan, dressed as the god Hanuman. Courtesy of Kailash Haathi.

Plate 17 A Ghanaian wedding in Haringey (photo: Mattia Fumanti).

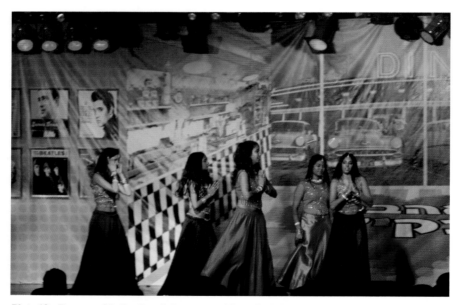

Plate 18 Dancers of Indian-Israeli dance group "Sapna", Hoduyada 2008 (photo: Yossi Aptekar).

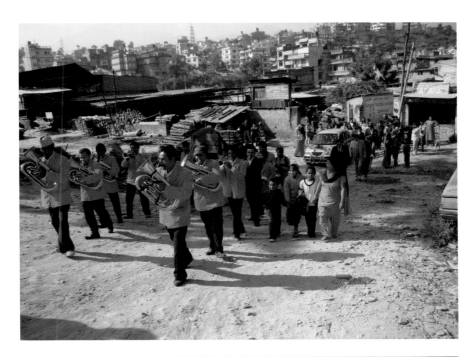

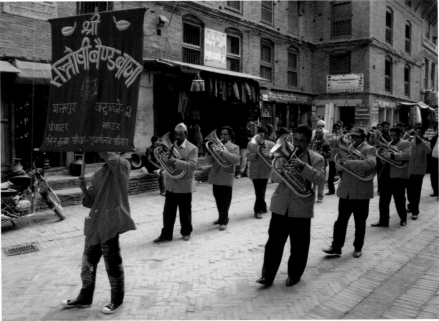

Plates 19 and 20 Wedding procession proceeding through Kathmandu city and the old centre of Bhaktapur (Plate 20) (photo: Christiane Brosius, 2010).

Plate 21 Tailor shop-cum-wedding band 'office', Bhaktapur (photo: Christiane Brosius, 2010).

The classic recycling option would be to melt down the perforated sheets and then re-roll them. The material is recycled at tremendous cost. Idea recycling is far less energy-intensive than material recycling. Recycling of ideas is the forte of the squatter and scavenger. The Indian slum becomes the great laboratory for recycling ideas. 'For wasted people of our states, wastes and nature are the only resources left for them to build on. Only these resources are available outside the commercial mainstream' (Interview, Seshadri 1996).

The idea of cycles substitutes and goes beyond the alchemical limits of the perpetual machine. In fact the idea of cycles is disappearing in modern agriculture. As one Japanese scientist noted, 'modern agriculture has replaced most of the cycles in nature by products of manufacturing, especially with chemical fertilizers and petroleum products. These are not compatible with the cycles of nature.' Waste returns the idea of cyclicality and context to nature. It is around waste that Seshadri argues that the oral economy of science can create a subaltern existence. The state has problems with biomass in a way it does not have with electricity. As he said, 'you can't say soviets + electrification = communism in a biomass society unless you are a Pol Pot' (Interview, Seshadri 1996).

Towards a conclusion: On dirt, waste, diversity and the time of democracy

An anthropologist re-reading the archives of such a debate senses both limits and possibilities. He sees two words determining two life-worlds and in sensing this he differentiates between dirt and waste. The worlds overlap but it is the difference that is interesting.

Dirt is treated more theologically. It is matter out of place, more open to the Linnaean world of classification, more grammatical, more subject to hierarchies. Waste is more fluid, more ambiguous, and more liminal. Dirt 'knows' it is out of place, waste still seeks placement, still touches both life and death. Dirt has arrived; waste is constantly seeking to prolong its life, its life cycle as a material. Dirt is definitional, waste seeks to refine itself. The slight difference between the life-worlds allows for inventive possibilities. This chapter has been an attempt to elaborate this. Dirt accepts the logic of classification, the rituals of pollution. Dirt belongs in a textual sense to culture, immortalized in the writings of Mary Douglas (1966). Dirt summons ideas of pollution, order, domesticity. Waste is fluid and seeks to reinvent itself. In struggling with this process, waste creates a neighbourhood of terms: garbage, rubbish, erosion, junk, obsolescence, triage; each is different, set in a slew of multiple realities. Dirt evokes spatiality while waste summons time and seeks to rework it.

Dirt as a marker creates the pollution rituals of the caste system. Waste as fluidity can rework elements of hierarchy allowing for re-reading. This distinction thus has

consequences we need to explore. An anthropology of waste needs to be developed in parallel to the world of dirt which is more systematically coded. The world of waste might provide fluidities, mobilities, redefinitions that the world of dirt may not allow.

One begins with democracy and citizenship, especially worlds where citizenship as a ritual status is never complete. One begins with the slum and modern democracy.

C. V. Seshadri, the chemist, argued that Indian democracy at its most marginal end is not about entitlements and citizenship which evoke a theatre of arrival, permanence and residence; it is about temporariness, of the struggle to be it. It is between the waste economy and the informal economy that the tacit constitutions of democracy are elaborated. He claimed: 'Official energy gives you official science and the officialdom of Indian democracy, but waste is the only resource of a wasted people' (Interview, Seshadri 1995). In the absence of modern commons, he argued the dustbin becomes the early haven for the refugee. In combining the informal economy, the biomass economy and the waste economy, the slum creates not just a way of life but a way of thought about living. 'It is laboratory life', he said wickedly. 'Your Bruno Latour will treat it like an installation or a spectacle' (Interview, Seshadri 1996). Seshadri felt that the slum created laboratory life for democracy. He claimed it depends on one's sociology or framework of attitudes to consider a slum as a failed ghetto or as a warm, thriving organism. Shesadri wanted to model the aesthetics of a new science around the scavenger and forager as hero. The slum, he observed, is still the hunting backyard of an urban domain where one creates a collage of firewood, weeds and plastic, to create a new life cycle of value. The aesthetics of justice in survival is recreated in the slums of Chennai.

For Seshadri, a slum reset vocabularies and perspectives. It recycled not just materials but thought. He claimed that when you recycle or rework the use of waste, you do not just extend its life, you become its storyteller, adding another chapter to its inventiveness. Recycling waste is not about reworking materiality, it is about the lifeblood of ideas. The thesaurus of waste reworks ideas of obsolescence, memory and craft by suggesting new possibilities. Obsolescence is not treated as inevitable. The metaphysical pathos that technologically 'developed' societies attach to obsolescence, its finality, inevitability is almost theological. For the slum dweller, obsolescence is not a *Karma*, a destiny, it is an everyday contingency, a challenge for survival. It is a pretext for constant reinvention, mimicry, so that one survives one more day. The point one wishes to emphasize is that when people are laid off, they feel useless because they have internalized the categories of the dominant form of knowledge. But the slum contains defeated people without what Foucault dubbed as 'defeated knowledges'. The local knowledges of the slum invite one to bricolage, to tinkering, to what Indian culture dubs as improvisations: *jugaad*. Ethno-science, local knowledge challenge the imperiousness of science and economies, by subverting the very definition of uselessness. It is like saying 'I recycle therefore I continue to be' (Interview, Seshadri 1995). Temporary obsolescence becomes a

pathway to a new usefulness. A slum is a creation of perpetual use value. Prolonging the life of a material is a way of prolonging the relevant life of a community.

Waste also becomes a theory of memory overlapping with a theory of innovation. Waste allows the vernacular to enter the conversation of knowledge and the cities. Local waste is like a spatially located language, an availability of dialects of possibilities. In fact Nek Chand saw waste as a set of dialects that would remake the city.

Language and dialects of waste provide another world of possibilities. The overlapping vocabulary of waste as opposed to the grammar of dirt allows for an ecology of niches, islands of time different from the dominant time of development.

The contrast between the worlds of Corbusier and Nek Chand is relevant and critical here. Nek Chand was in awe of Corbusier, yet he offers a theory of innovation and memory different from the French architect. Nehru built Chandigarh as a geometric, rational monument, a challenge to the anarchy and disorder of the partition. Chandigarh was not a monument to the partition, it was a city designed to forget it. The city as architecture and plan had to sanitize the violence of India's invisible holocaust. Yet Nek Chand showed humbly that it is difficult to evade memory. Nek Chand's first garden had a simple message: it contrasted erosion and abandonment. He collected rocks, stones from the 17 villages that had been abandoned to build Chandigarh. Erosion, he felt, was a natural process of sculpting, creating acts of beauty. Forgetting, abandonment, erasure, neglect are man-made. They are not the attributes of nature. They are facts of culture which allow for re-telling and, therefore, create limited domains of freedom.

Deep in his unconscious, Nek Chand, as a child of partition, wished to evoke it. As one form of lived reality, his old home in Pakistan was dead. But as a remembered village at the centre of Chandigarh, it came alive. Waste becomes the humus of a reworked memory. It allows memories to relive, attach themselves to new processes of significance.

The debate on waste also re-embedded the issue of diversity within an idea of time. Diversity provides an answer to obsolescence. This argument is present in Coomaraswamy's essay on the synthetic dye. As a scientist and an aesthete, he argues colour was a commons and that red was a commons of shade, each shade representative of the skill of a particular village. Red, he hinted, was an English word marching in uniform, proclaiming standardization in a world where Red was a dialect of colours. Red was a way of life, and to introduce the synthetic dye was to predict the reign of uniformity. Deep down, Coomaraswamy's theory of diversity inaugurates a deeper discourse. It captures the idea that diversity is not just about difference but a discourse battling obsolescence, battling erasure using the aesthetics of memory to protect ways of life which are continually innovative.

In the criticism of the Swadeshi movement, diversity becomes a discourse against obsolescence protecting defeated people and defeated knowledges. The body and the organicity of the body metaphor is central to many of these debates. One thinks of the battle between Tagore and Gandhi. Tagore provided an aesthetic critic of

Gandhi and he tried to show that Khadi was a reign of micro-uniformities where every village would look like any other village. For Tagore, diversity demands the erotic and Khadi fails in providing the erotic of technology. It becomes too close to nature to understand desire. Khadi is an aborted interstice between nature and culture, represented as a piety of Gandhian technology. In all these three events, the aesthetics of the body or of nature begins elaborating a theory of time and aesthetics against obsolescence.

Waste also creates hyphens, connectivities and bridges between opposites. One of the most significant of these structural connections emphasized by both Albert Howard and Patrick Geddes was the connection between town and country. Geddes went to the extent of contending that waste was the return gift the town owed the countryside, in their mutuality of renewal.

Waste breaks not only the linearity of the modern innovation, it reworks ideas of time. Waste as a concept in economics is a problem rather than a site for reworking the problems of economics. Waste as a category reworks the narrative of materials and eventually of economics itself. In modern economics, it began as an externality, and then acquired a more systematic edge as life-worlds where current categories are reworked from the margins. Central to this is the way waste reworks the idea of time in democracy. What was dumped as defeated, erased, museumized by the modern ideas of progress, history and scientific and industrial innovation is being reworked as life-affirming. It redeems storytelling. It is in the informal, biomass, waste economies that 'liquid modernity' is actually being reinvented as a commons of new possibilities. There is a science in it but it is not central. It is improvised, collaged, tacit and yet open to being paradigmatic. Consider sustainability. Viewed only within the efficiency framework, waste is seen as external. Viewed as a site for survival battling obsolescence and the classificatory hegemony of the formal economy, waste and sites for waste become theatres for reworking the democratic imagination for new notions of memory, invention, freedom and renewal. The vocabulary of efficiency, speed, obsolescence does not create the thesaurus for democratic renewal statement that the hawker and the scavenger are still a part of industrialism.

I want to suggest that the theories of waste and the battles of craft against obsolescence offer the logic of a different kind of discourse. The mechanical time of industry is full of erasures where the defeated are obsolescent. The Bhopal gas disaster was an outstanding example of an inability to create memory that could guarantee justice. Bhopal is full of wasted people who are seen as vagrants or hypochondriacs. Based on the above descriptions, I want to propose that waste in India is actually a theory of memory, a battle against forgetting which creates a second life not only for a people but for materials. The idea of waste links the organicity of the body, the cyclicality of nature and extends it to the lifetime of a material. Waste provides a new ethic and an aesthetic that extends Gandhi and Tagore into the new aesthetics of industrialism. It goes beyond the narrow vocabularies of the planning commission

and the English of sustainability which cannot think of multiple times in a language beyond economics. A theory of waste expands the notion of diversity to prolong diversity in terms of multiple times. A body is no longer subject to the visual anthropology of enlightenment. The body becomes a sensorium and so does the city. The antiseptic nature of planning yields to the slum as a sensorium, as a cornucopia of smells, sounds, tastes and spectacles. A slum as memory recycles the linearity of innovation. Craft as a skill returns the body back to competence and the polyphony of waste as junk, garbage, filth, pollution and rubbish. It pluralizes waste into a variety of dialects which can be lived out in different ways. In a systemic sense, thus waste creates the world of the sensorium challenging the visuality of the Panopticon and planning. At the second level, we realize that diversity extends to language and mediums. We have to realize that we are simultaneously an oral, digital and textual culture. Orality has its own skills and memories, its own myths of competence, its own information systems. Its languages cannot be wasted because they do not have scripts. To the plurality of the sensorium we add the plurality of mediums. The new McLuhan cannot emphasize the uniqueness of a medium as a message. He has to live in a tripartite world where the oral struggles with the textual and the digital to create a different imagination for democracy.

One needs the drama of waste to achieve that. Eking out value in a world beyond price and efficiency is an artform for survival and sustainability. In that sense waste, by subverting the dominant forms of economy and science, creates what is called 'the democratization of democracy' by returning marginal economies, subsistence and informal societies to the threshold of survival and creativity. A reinvention of categories permits a reinvention of worlds, allowing new ways of defining freedom, subsistence and democracy.

Acknowledgements

This chapter would not have been possible without the collaboration of Chandrika Parmar. She worked closely even in the field while we studied Nek Chand and the Mundka village. I would like to thank the late C. V. Seshadri who helped me formulate many of the links between energy and waste. I would also like to thank Raminder Kaur for her patience and generosity to a wayward anthropologist.

Bibliography

Ammons, A. R. (1993) *Garbage: A Poem*, New York: W. W. Norton.
Bauman, Zygmunt (2004) *Wasted Lives*, Cambridge: Polity Press.
Boardman, Philip (1978) *The World of Patrick Geddes*, London: Routledge & Kegan Paul.

Coomaraswamy, Ananda K. (1909) 'The International Congress of Applied Chemistry and Aniline Dyes', *Modern Review*, VI(3): September: 275–8.
—(1915) 'Love and Art', *Modern Review*, 14(11): May: 574–84 (576).
—(1947) *The Bugbear of Literacy*, London: Dennes Dobson.
—(1956) *Christian and Oriental Philosophy of Art*, New York: Dover Publications.
—(1981) *Essays in National Idealism*, New Delhi: Munshiram Manoharlal.
Defries, Amelia (1927) *The Interpreter: Geddes, The Man and his Gospel*, London: Routledge.
Douglas, Mary (1966) *Purity and Danger*, London, Routledge & Keegan Paul.
Geddes, Patrick (1918) *Town Planning Towards City Development* (Parts 1 and 2), Indore: Holkar State Printing Press.
Gill, Kaveri (2010) *Of Plastic and Poverty*, New Delhi: Oxford University Press.
Howard, Albert (1940) *An Agricultural Testament* (republished), Goa: Other India Press.
Irwin, Robert (1986) *The Limits Of Vision*, New York: Viking.
Lipsey, Roger (1977) *Ananda Coomaraswamy*, Princeton: Princeton University Press.
Mairet, Philip (1957) *Pioneer In Sociology: The Life and Letters of Patrick Geddes*, London: Lund Humphries.
Meller, Helen (1990) *Patrick Geddes: Social Evolutionist and City Planner*, London and New York: Routledge.
Nicholson, F. A. (1907) *Note on Agriculture in Japan*, Madras: Government Press.
Paz, Octavio (1978) *Marcel Duchamp*, New York: Arcade Publishing.
Scanlan, John (2005) *On Garbage*, London: Reaktion Books Ltd.
Thompson, Michael (1979) *Rubbish Theory: The Creation and Destruction of Value*, Oxford: Oxford University Press.
Tyrwhitt, Jacqueline (ed.) (1947) *Patrick Geddes in India*, London: Lund Humphries.
Visvanathan, Shiv (1984) *Organising for Science*, Delhi: Oxford University Press.

8

Slaps, Beatings, Laughter, *Adda*, Puppet Shows: Naxal Women Prisoners in Calcutta and the Art of Happiness in Captivity[1]

Atreyee Sen

Introduction

In a small living room, even while in conversation with the anthropologist, Mita dashed off to find a pen and a paper.[2] She returned with a big smile and said: 'Let me draw a rough sketch of the women's prison.' She carefully illustrated the two-tiered interiors of the women's correctional facility, and marked long bars to show where women like herself were housed in the 1970s. Then she drew an empty space in which she pencilled in a few small stick figures. She had stopped smiling. Pointing her pen at that section of her sketch she said: 'And this is where the children of women convicts were kept huddled together. They cried all the time, night and day. We often stood at the end of our cells, our hands clasped around the iron bars, looking at them helplessly. We did not know how to comfort them. Some of them called out for their mothers, and the sound of their loud weeping would ring in our ears. A small girl found a way to creep up to the edge of my cell through an empty stairwell. Peeping through a crack in the wall, she would incessantly chat to me, talk talk, all day. I didn't know what she looked like, I didn't know her name. If I pushed my face against the crack I could only see a pair of sad eyes. When back amongst the other children, the girl did not dare to identify herself, lest we both got a beating from the guards. One day I was given lots of chores to complete before sunset. And there she was, this nameless faceless girl talking to me from behind the wall. So I told her to get lost, I said I had to finish all the washing otherwise the guards would thrash me. The girl fell silent for a while. She said "tumi amaye ektu bhalobashte parona?" ("can't you just love me a little bit?"). And then she disappeared. I kept staring out into the sea of children to try and recognize her, perhaps find a way to apologize. I wept my heart out. My cell mates, who were also my one-time comrades in the movement, we decided to find a way to make the children happy. We wanted

to show love, not out of pity mind you, but because we were trapped together in this world of misery. We collected whatever odd bits and bobs that we found abandoned in the cell or in the yard (buttons, sari borders, pieces of paper, needle and thread, shards of glass and pieces of wood), and at night, we would pile them up in the middle of the cell. For hours, we sat around these scraps wondering what we could do with them. Even if we made rag toys, we couldn't sneak it out of the cells. If we did, there wouldn't be enough toys for so many children. Then one day, we decided to make puppets out of them. We made crude dolls with our odd collection of things, I had never done anything like this before. We tore long strips out of our sari borders and made sturdy ropes to make the puppets dance. Whenever the guards were not looking, at times in the middle of the night, we would slip the dolls through the bars, make them wiggle about and sing funny songs. It made us laugh, it made the children giggle. One day the guards asked us, "why are those half-dead children chuckling?" ("adh-mora gulo hasche keno?"). We were sitting on our puppets, we could barely move, but we said loudly: "karon ora ekhono more ni" ("they are not dead yet"). It was our little triumph.'

The horrors of state imprisonment in the twenty-first century exploded into headlines worldwide with the perpetuation of human rights atrocities against Iraqi detainees at the Abu Ghraib prison and the serial torture of political prisoners under autocratic and military regimes.[3] In the context of India, the surreptitious execution of Ajmal Kasab (in November 2012),[4] the sole assassin captured during the Mumbai terror attacks, and the furore over the harsh prison sentence meted out to Binayak Sen (in March 2011), a doctor accused of having Maoist affiliations (d'Souza 2012), highlighted the state's failure to develop reliable policies that address the predicament of political imprisonment in the region. This chapter explores this contemporary interest in the persecution of 'anti-national' insurgents in prisons, and shows why and how certain political prisoners survive the physical torture and emotional humiliation of extra-legal incarceration (while some others fail). By examining the relationship between memories of imprisonment and survivors' attempts to negotiate emotive challenges in prison, I investigate the ambivalent and uncertain correlation between homogenization of criminal law, bodily punishment and violation, and the inventive agency of 'non-convict' detainees to resist state-sanctioned brutalities.

In 2008–9, I documented the ethno-histories of a community of aging political prisoners in India, and studied how their ideologies, quotidien practices, familial relations and domestic/sexual lives were influenced and informed by their experiences in the postcolonial prison. This project was based in Calcutta among former Maoist guerrillas (and sympathizers) who were arrested and imprisoned by the state in the 1970s. This chapter will specifically explore the prison experiences of former female cadres of the Naxal movement and focus on the oral histories of women who were once captured, incarcerated and brutally beaten by prison officials in the women's correctional facility under the surveillance of the Alipore Central Jail

in Calcutta. I will highlight the ways in which women political detainees enacted everyday happiness in the face of torture and anguish, primarily to carry on resisting (their tangible and ideological understanding of) a violent, elitist and self-serving state. To the women, this was 'art', i.e. a form of knowledge that was acquired, appreciated and imparted to others through unique codes of communication. Thus by playing loud and enjoyable music with pots and pans, through laughter and refusal to display sadness, and by entertaining children with puppet shows, groups of women political prisoners negated attempts by police guards and interrogators, the lowest rung of a state machinery, 'to break women's bodies and their spirit', said Mita. I argue that these coordinated performances, often after a bruised woman prisoner had been returned to her holding cell after 'questioning', exhibited an affective and resilient political aesthetic, which in turn contested repressive cultures of captivity.

In the broader anthropology of prisons and torture, there are few ethnographies that document the oral histories of former political prisoners (a prominent monograph being by Allen Feldman, who focuses on the bodily construction of 'inmates' within the disciplinary orbit of prison life in Northern Ireland [1991]). Within that genre, scholars exploring informal testimonies of women political prisoners state how the latter have provided an oppositional critique of oppressive and patriarchal cultures of state rule as against objective historiographies and criminological accounts (cf. Belknap 2000; Carlen 1998; Freedman 1981). Holocaust Studies investigating the lives of women in concentration camps in Europe (cf. Jacobs 2004; Linden 1993; Offer and Weitzman 1998), and Kavita Panjabi's comparative analysis of women imprisoned due to their association with radical movements in India and Argentina (1997), have even highlighted the ways in which incarcerated women's critical agency problematized Western understandings of minority and third world feminisms. This cluster of scholarly writing on women prisoners has taken the emphasis away from the public mobilization of marginalized women, and placed the spotlight on muted women's resistance to gendered intimidation in invisible and restricted spaces. Harlow, in her exploratory account of prison novels based on women warriors, or women offering support functions to liberation movements, states:

> What may seem to be incidental as the common features among them, that they are usually written by women in the Third World and deal with the experience of prison, is in fact potentially constructive of a discursive category. Generically, these writings defy traditional gendered distinctions, and combine fictional forms with documentary records. (1986, 502–3)

While most academic literature addressing issues around 'prison subcultures' focuses on racial divisions, regional cliques and identifies prisons as a masculinist space (Fleisher and Decker 2001; Skarbek 2010), Harlow goes on to argue that

representing the voices of women prisoners is significant, as they bring forth the *performative* roles through which women develop a secular and shared discourse in prison, the latter incorporating affective ties beyond gender, race and ethnicity (1996: 506). Drawing upon this analysis, this chapter makes an attempt to dislodge treatises on the interior life of prisons, by analysing the politics of play and performance that mature within regimented cultures of confinement. Through the prison memories of Naxal women, I show how incarceration and alternative performances (and not radical politics) allowed women to truly *overcome* class, caste and religious identities through communal living, supporting fellow prisoners in their mental and physical anguish, and sharing common strategies of survival. I argue that the unconventional relations developed by middle- and lower middle-class women prisoners, low-class convict women, young female delinquents and small children, when they all came to intimately occupy an enclosed subaltern social world, re-politicized the everyday life of a prison.

Methodologically, my chapter also contributes towards recent debates in prison studies on romanticizing 'the female political prisoner' (cf. Rhodes 2001). As a woman anthropologist, I will attempt to develop a writing technique which brackets the ethnographic desire for alignment with one's female subject/informant within the anthropology of prisons. In addition, I move away from an anthropological focus on neighbourhood ethnographies towards studying dispersed communities living in the city who are bonded and bounded by a shared experience which (in their mind's eye) makes them particularly distinctive within their urban environment. The stigma of prison, sustained torture, custodial rape, sexual assaults, physical injuries, solitary confinement, denial of nutrition – the prison enacts violence on the bodies of 'others', and this remains camouflaged by the abstract location of prisons in the public imagination and political landscape of the region. So, how can an anthropologist study people's memories of artistic performances that are extraordinary, exceptional and *not* everyday in mainstream life? And study social behaviour that is not embedded in an individual's immediate environment of the neighborhood or domestic area, or even in migration and movement, but in a restricted space from the distant past which forms an integral part of his/her personal history? My attempt to address these questions opens up an analytical space on vernacular and colloquial art and aesthetic cultures that emerge under conditions of policing and control in South Asia.

A brief history of the Naxal movement in Calcutta

The term 'Naxal' derives from a village named Naxalbari in West Bengal, a federal state in western India, where a radical movement inspired by Maoist political ideology was born (Ghosh 2009). The movement was led by Charu Majumdar, Kanu Sanyal and Jangal Santhal, who initiated a violent anti-state uprising in the village

in 1967. The movement's powerful leadership advocated that Indian peasants and tribals use armed revolution to overthrow the government and the upper classes, and redistribute land to the landless (Banerjee 2009). As the popularity of the movement spread over the region, a large number of urban elites became attracted to the ideology (Donner 2004). In the 1970s, the Naxalites gained prominence among sections of the student population in Calcutta, the capital of West Bengal. To mobilize more urban youth, Majumdar declared that revolutionary warfare could also take place in the cities. His 'annihilation line' clearly encouraged Naxal comrades to assassinate individual 'class enemies', resulting in the murders of a number of landlords, businessmen, police officers and politicians in the city (Ray 1988). The Naxals also systematically targeted unsympathizing civilians who were considered to be the movement's 'traitors', as well as police informants who were identified as 'spies'. In that volatile socio-political context, students left schools and colleges en masse to join the violent movement, and the Naxals eventually gained control of university and college facilities, not only in Calcutta but also in Delhi (Basu 2000).

The chief minister of the ruling Congress party in West Bengal instituted strong counter-measures against the Naxalites. The state government retaliated with extreme violence, torturing and illegally executing large numbers of urban youth, along with threatening their families (Dasgupta 1974). The judiciary justified all forms of extra-legal police brutality and unregulated killing of Naxalites to contest political opposition – extreme powers that were grossly misused on the ground (Jawaid 1979). By sustained torture and systematic execution of young men, described within contemporary studies of conflict as state 'gendercide' (cf. Scheper-Hughes 1995; Mamdani 2001), the post-colonial democratic state represented itself as a new avatar of colonialist repression, and dissolved the idealistic imaginings of political imprisonment that was popularized during the anti-colonial struggle in Bengal (Arnold 2004). When the prisons were full, even the homes of local Congress and soft Left politicians were turned into informal torture chambers by the police and the Congress party cadres. Individual policemen began to settle old scores with non-political youth groups by falsely accusing them of promoting Naxal ideologies. This form of state terror became a source of distress within the popular imagination, even among those communities and neighbourhoods in Calcutta that were *against* the violent actions of the Naxalites (Donner 2009). After suffering a number of political losses, the Naxalites eventually alleged human rights violations by the West Bengal police. In his book *Naxalites Through the Eyes of the Police* (2006), the author, while sieving through police records written by senior intelligence officers during the peak of the movement in Calcutta, discovered that the government responded to these accusations by arguing that they effectively fought a civil war against self-styled assassins.

Several scholars, such as Srila Roy (2012) and Mallarika Sinha Roy (2010), highlight the significant political role played by Naxal women in the 1970s; through

the paradigm of 'cultural memory', they explore the disenchantment of radical women failing to secure their full participation in a supposedly liberatory movement. My own research on Naxal women who were captured and subjected to carceral power for the first time also highlights their disillusionment with a state that was legally unequipped to deal with 'the woman revolutionary'. For example, some women Naxals in Calcutta were severely beaten on their breasts with cricket bats to create 'a male chest' since only politically active men could be accepted within patriarchal societies. In 1977, a new left-wing political party ousted the earlier regime and offered general amnesty to the movement's political prisoners. My study of the prison experiences of these former Naxals (partly though their prison journals, abandoned attempts at memoir-writing, poetry, short stories, prison graffiti) offers an ethnographic perspective on the coping mechanisms of these aging political stalwarts, now marginalized by the state as disabled or mentally unstable.

Initially, the movement had its centre in West Bengal. In later years, it spread into less developed areas of central and eastern India, such as Chhattisgarh, Orissa and Andhra Pradesh through the activities of a number of underground groups (Shah 2010). In recent years, India's intelligence agency has declared Naxalites to be the most serious internal threat to its national security (Gupta 2006). And the movement continues to recruit large numbers of women.

Women inmates and the interior life of a post-colonial prison

Between 1970–7, there was an influx of women political prisoners, whether active members or aides of the Naxal movement, which impacted the internal dynamics of prison life in Calcutta's Alipore Central Jail, the main penal institution built during British rule in Bengal. While the prison governing body was unprepared to cope with the expanding female inmate population, they were also unable to find separate living arrangements for political prisoners and ordinary women criminals. Many Naxal women were clustered together in small cells, and treated with particular disdain for their political activity. They were brutally beaten, sexually assaulted, slapped around and insulted by both male and female prison guards under the guise of 'interrogation', primarily to procure undisclosed information about the underground guerilla movement. Since the Naxals ideologically and physically attacked state authorities, the local police persecuted political women with vengeance. There were few human rights groups or prison reform organizations active in Calcutta at that time, and hardly any individuals and institutions played an interventionist role in the lives of incarcerated women.

The convict women, some of whom were serving life sentences, had developed their own internal nexus for collectively coping with the harshness of prison life. Despite their attempts to maintain a level of hygiene and humanity in their marginal existence, criminalized women and children herded together in prison also suffered

endless abuse. In her prison memoirs entitled *Killing Days* (2004), Joya Mitra, once a young student Naxalite and imprisoned between 1970–4, tells the story of Shanta. The latter was serving several years in prison for stabbing her husband, who regularly thrashed her and their two children in a state of drunken stupor. In her cell, Shanta's precious possession was a nail trimmer with which she carefully clipped her children's nails to keep them clean. However, when she refused to hand over the trimmer to the jail warden (who was keen to acquire the device) she was accused of owning a dangerous weapon. She was stripped, shackled and beaten as internal (and informal) punishment for her deviant behaviour.

Several of my informants stated that poor, low-caste convicts were initially hostile to the presence of Naxal women, and suspected that the latter would get privileged treatment as educated and/or upper-class members of society. Ironically, it was the use of excessive force on Naxalites, as well as growing awareness among inmates that the political cadres had struggled for the rights of the poor, that helped build a fragile camaraderie between incarcerated women. Based on this bonhomie and mobilizing different levels of expertise, clusters of women prisoners designed multiple strategies to ward off the repressive tactics used by prison officials to sustain an authoritarian regime. The following paragraphs will discuss two select examples of carefully coordinated performances in prison, which not only power-fully feminized a contested patriarchal space, but also created a relatively egalitarian political aesthetic in a deeply hierarchical social setting.

Women's performances and the politics of joy

Several of my women informants remembered their fear of both convict and political women 'vanishing' during the night. Criminalized women, especially those abandoned by their families, were trafficked into prostitution rackets in exchange for large sums of money, or sent off to the homes/private parties of unethical police officers as temporary sex slaves. Naxal women also went missing (presumed killed) after night-time interrogation by officials, and rumours were rife about rising body counts in the prison hospital mortuary. In addition to the abuse and beatings, these sudden disappearances were also used as a threat by prison guards to rein in deviant behaviour by women inmates. 'Do you also want to see the inside of a morgue?' a prison guard had asked Mita when she wondered about the absence of an inmate. Since the guards openly doctored jail records to cover up the rate of disappearances, the convicts in collaboration with political prisoners aired a need to patrol illegal activities by prison security. Sushmita (54), once a young Naxalite held as an under-trial in Alipore Central Jail (when she shared a cell with Mita), said:

> We would often wake up in the middle of the night and hear an inmate screaming while she was being dragged away by the guards. Our doors were locked and even though

we protested, there was little we could do. During work and lunch hour, the inmates discussed these atrocities every single day. Mansa, an older prisoner, told me: 'This is going on for so long. You have to wait till you get older and the officers lose interest in devouring your body. But this is the only space where so many *jawan* (young) women with no male guardians can be found, and kinky sex is for free. If they went to a brothel they would have to pay.' But still the women inmates constantly told each other: 'Let's think, let's plan, let's not lose hope.' We knew we had to find a way of staying within the cells, not screaming at the guards, but still ensuring that the prison officials were aware that we were watching and waiting for missing women to be returned to their cells. Forget their dignity, we just wanted their lives to be saved.

Through joint enterprise, the women came up with a number of ploys. By singing songs through the night, loudly playing music with pots and pans, banging together plates and mugs in their cells, by sharing life stories, cracking jokes and laughing loudly across individual lockups, the prisoners stayed awake through the night whenever an inmate was escorted off the premises. 'If the guards came for a woman, her cell mates would reassure her and say "we will be awake till you come back". And then they would start singing, wake up the rest of the prisoners, and spread the news that a girl was gone', said Sushmita. This sent out a warning signal to the guards that the latter were also under surveillance. If inmates were eventually brought back to their cells, they were cared for and bathed by their cellmates, clearly indicating to the officials that the women were not divided by apathy but deeply connected through co-dependent relationships. At times, while tending after battered political prisoners, the convicts sang inspirational songs equating the women 'warriors' with martial goddesses, the latter being gratefully received by Naxal women who once ideologically rejected all religious values. When a woman prisoner died of disease, starvation or torture, the Naxal women sang anti-state political songs. Slogans with clapping such as 'pulish maro, astro karo' ('beat the police, snatch their weapons') and songs with drumming on utensils such as 'tomar bhason, tomar shashon, manbona, shunbona' ('your dictates, your authority, we will not obey, we will not pay heed') were learnt, shared and celebrated by convict women. In this way, women posed a threat to the prison guards, ensured that inmates were accounted for (most of the time), and within a system designed to monitor and dehumanize prisoners the women sustained a counter-culture of scrutiny and compassion to keep prison corruption in check.

Over time, the women's performances spilled into daytime prison routines. Through circulating dramatically divergent life stories, mixing songs across class, caste and rural-urban divides, sharing coarse and posh jokes, learning anecdotes about how to fool the guards, and through performing secrecy (by *ishara* or conveying messages without words), the long-term convicts and new political prisoners overcame biases and boundaries, and created an inner world of inmates and undertrials with its unique culture, music and language. This form of strident

and vociferous *adda* is closely associated with a rhetoric of joy, leisure and freedom within the Bengali cultural cosmos. On the one hand, the prisoners aggravated the guards as 'noise' resisted the muting practices developed by the state; and on the other, they denied the alienating detention system access to the freedom and aesthetics of the inmates' intimate universe. To the Naxal women, this particular ethos of laughter and happiness that emerged through the cooperative effort of divergent women was resistant 'art', and it was etched on a canvas designed to inflict pain and sadness in prison.

A number of Naxal women also remembered the performance of familial relationships in prison, which weathered the guards' attempts to isolate inmates from affective bonds. For most stigmatized convicts, families were lost in the world outside prison. The parents of Naxal women, whether from metropolitan centres or the *moffusils*, were also embarrassed to have incarcerated daughters. Due to the legal complexities and the culture of suspicion generated by the strength of the Naxal movement, families were often denied any visitation rights. Srila Roy's research on revolutionary marriages (2006) show how political women had in most instances walked away from conventional family set-ups to marry fellow comrades, or be their illegitimate lovers and mistresses. Faith in the Maoist ideology had generated a radical understanding of political love, and established an appreciation of alternative moral economies among young Naxals. Many political women were widowed when entering the prison system, often having witnessed the violent death of their revolutionary husbands at the hands of the police. In my multiple personal interactions with Joya Mitra, for example, she reminisced at length about her own life and the experiences of fellow Naxalites who were abandoned by unsympathetic husbands – sometimes the in-laws sent off their small children for adoption, and at other times the husbands kept their children away from the shadow of shamed mothers in prison. Whether stemming from 'radical love' at a particular juncture in urban history, or as compensation for the breakdown of familial relationships, the political women in prison lovingly remembered playing 'happy families', and how the inmates developed sisterly and maternal relationships (calling each other *ma* or *bon* or *didi*).

Many Naxalites confessed that convict inmates had nurtured affectionate relationships among each other for a long period of time, and Naxal women were drawn to these performances as the latter served as a primary coping mechanism in prison. Joyeeta (60), imprisoned for four years for her political activism in her twenties, remembers being comforted, washed and fed by her convict prison mother, especially after prolonged beating sessions organized by the warden. She said: 'Like in a mother-daughter relationship, when *ma* asked me about the bruises I would say I had fallen down the stairs to protect her from the emotional humiliation of seeing her daughter in pain and beaten up by men. We both knew the truth. But we still invested in performing these relationships to give a human face to a loveless prison space.' In her memoirs (2004), Mitra mentions her encounter with Phulmala, jailed for life after she killed her two children. She was married off at 14 and became the

second wife of a sharecropper. After years of domestic violence and starvation, she snapped. In a fit of rage she poisoned her children and slit her own throat with a sickle. A villager found her dying in the field and decided to save her. 'Phulmala? Someone whose arms are never empty?' wondered Mitra after hearing her story. 'Even the filthiest child in the ward finds a place in them. She is always carrying a baby on her hips', she wrote.

Though the prison staff mocked at surrogate motherhood and sisterhood, they had strict rules against same-sex love. Going against the 'two-women-per-cell' prison policy, there were at least three women huddled in a small cell at night to prohibit the pursuit of pleasure between women lovers. Even though most Naxal women abstained from narrating any episodes of same-sex love (if there was a deterring practice, there might have been occurrences), they did mention controversial affective ties in prison, which were considered taboo in mainstream society. Kanaka (60), a political prisoner whose lover was shot dead during a police siege, said her life in prison was made tolerable by her close friendship with a refugee boy. During the Bangladesh Liberation War in 1971, a number of fleeing Muslim families were captured at the India-East Pakistan border and imprisoned in Alipore Central Jail. This added diversity to the nature of prison life as the dominantly Hindu inmates lived in proximity to refugee narratives and everyday practices of Islam. Kanaka was approached by a young Muslim boy who chose to have her as his wife (*bibi*). Kanaka played along and performed a loving marital relationship with the young boy, Mishu. Accused of being perverse by the guards and irreligious by the Hindu convicts, Kanaka insisted that it was a meaningful attachment in which the boy looked after her, got her food, gave her prison gossip and protected her like a good husband. 'Our love play was not about age, religion and sexual duties. There was none of that. We were both just desperate for love and attention in prison. Even in regular adult marriages, women move between being mothers, sisters and friends to their husbands. That was the crux of my profound relationship with Mishu. It's not twisted. I don't expect anyone to understand that', she said. When the boy was eventually released, Kanaka was forlorn. When she was granted amnesty, Kanaka travelled in vain to Pakistan in search of the boy and to this day, the sexagenarian remembers her warmth for her prison husband. In the end, the prison space of Naxal women's 'exceptional past' was an alternative space for non-normative relationships, but it emerged through the repeated *performance* of normative familial ties. The fictive relationships and, at times, impermissible role-playing allowed Naxal women to display their vulnerability and momentarily shed their tough exterior as hardened political insurgents.

The short case studies described above demonstrate how prison politics and practices developed within the context of a radical social movement enabled the materialization of a new culture of 'art' and 'performance' (as theatre, recycled craft, play and keen display of affective ties) through women inmates' experiences of both harshness and humanity. Naxal women's participation in a radical movement

did affect their actions in prisons as they had taken personal and political measures to break down social boundaries; but their encounters in incarceration enabled them to wander beyond grand ideology, and engage with everyday structures of perseverance. There were pre-existing spheres of internal resistance in prison, as women convicts had acquired the skills and intuition to survive life in jail. But the middle-class, educated women guerrillas, having led rebellious and underground lives, brought with them a different set of abilities and emotions, and it deeply impacted the dynamics of survivalism in prison. There were limits to women's solidarity (as the inmates did break out into jealous arguments, they snitched on cell mates, and/or the guards subdued rebellious prisoners with a massive thrashing), but most of my Naxal informants continued to refer to their various enactments as 'the art of performing joy' within the crudeness of captivity.

Some concluding comments

The contents of this chapter complicate ethnographic perspectives on material cultures and their relationship with technologies of enforcement (Wacquant 2002). Scholarly literature on prison welfare underlines the role played by the state machinery that manages penal systems, in prescribing a certain fixedness to prison objects and inmate identities (Rhodes 2004; Coyle 2005; Liebling and Arnold 2005). Several decades ago, for example, Foucault (1991) became concerned with prison histories and viewed the jailhouse as the originating ground for the analysis of disciplinary power in society. He argued that the invention of the penitentiary was directed towards creating a place for the production of conscience through tedious work, and not creative labour or imaginative ventures (1991: 294). My chapter reveals that women prisoners can incorporate fluidities in that invented space, and by simply 'making something out of nothing', they can openly critique the disciplinary dictates developed by the state-society nexus. Transforming an object symbolizing death into a prop epitomizing joy (such as a pencil broken down to a blunt stub, to prevent inmates from jabbing their veins and attempting suicide, turned into horns for a dancing puppet) brings forth a notion of 'aesthetics' beyond beauty and sublimity as encapsulated in classical post-Enlightenment theories. This argument is emphasized further in Theodor Adorno's aesthetic theory (1997) in which he expresses his concern about scholars and critics failing to evaluate the relation between art and its social content. He argues that modern art's freedom from imperial servitude has inflated art's capacity to critique forms of social indifference. He promotes the idea of 'truth-content' (*Wahrheitsgehalt*) in art, and embeds this concept squarely in dialectical interactions between the artist, the artwork and related social commentary on a political epoch. This chapter has shown how the circulation of material objects (such as puppets) and performances (such as spreading joy) in prison can be construed as 'art' by their creators, and can also act as social critique of state torture. However, I

argue further that the truth-content/aesthetic component of these performances was *enriched* by the state representatives' refusal to acknowledge unauthorized prison handiworks and internal practices as 'artistic'. Within the resilient culture of prison life, women's performances gained in creative potential not only through their successes, but they also expanded in scope and innovation when faced with severe opposition from the agents of state enforcement.

These instances of performing joy and role-playing are not dissimilar to the experiences of political prisoners during the colonial period. For example, the romanticism associated with colonial prisons in Calcutta remained contained in an emotional timewarp, since they once housed iconic revolutionary leaders such as Aurobindo and Netaji Subhas Chandra Bose. Several political prisoners who survived years of persecution while the colonial state tried to implicate them in a number of sedition cases, later wrote about the secret social life of prisons. In his autobiography *Ishwar, Prithibi, Bhalobasha* (God, the World, Love), writer and former revolutionary Shibram Chakraborty poignantly described his engagement with political activists and rebel poets in detention; the interior world of prison life was introduced to Chakraborty as 'ekhon amader gaan abritti hoi holla koto ki hobe' – 'now we will have songs, poetry recitals, shouting and fun, so much is about to happen' (2000: 384). Anupama Rao, who explores the continuities of colonial and post-colonial prison governance, shows how the changing perceptions of proof, motive and intention in the enactment of what was considered to be 'crime' within the colonial state discourse eventually produced a police force that continued to understand and represent torture as legitimate in the production of juridical truth (2010: 187). Steven Caton's (2010) research on ordinary ethics is important as it highlights the complexity of good and evil within the moral economy of Abu Ghraib, and how ordinary players become implicated in diabolical prison abuses. Caton argues that people involved within the prison system, whether they are inmates or the administration, are not 'cogs in the machine' but their actions are guided by intention, personal justification and political legitimation (2010: 166). While torture and prison ideologies are directed towards disorienting inmates from structures of time, place and emotions, so that loss of contact with reality can facilitate confessions, my research shows how various groups of prisoners strive to reconstitute relationships and structures of time and place by creating their own internal universe of aesthetics, performances (e.g. during the night) and social and political liaisons.

Victor Turner's concept of *communitas* (1967) denotes powerfully concentrated performances of belonging, which plunges people into betwixt-and-between liminal spaces squarely outside the realm of routine social alignments. Enacting 'anti-structure' which contests scriptural assertions produces 'a realm of pure possibility whence novel configurations of ideas and relations may arise' (1967: 98). With reference to Mary Douglas' *Purity and Danger* (first published in 1966), Turner points out that ritualistic performances by liminal individuals are highly *dangerous*, as through repetition and reiteration of 'outsideness' they can challenge society and

implement change. Evoking Turner's concept of *communitas* in the context of prison life, I suggest further that the passionate gendered performances, whether they involve displaying emotions or exhibiting novel kinship ties, show how a marginalized urban space can turn into a place for the production of a recalcitrant political *communita*s, which in turn leads to the creation of new social identities. I argue that these instances of turning into a communal group, in which women are equal for a moment in time and removed from the accoutrements of social hierarchy, place the individuals participating in these performances in a socially dangerous position to challenge the indistinctness assigned to invisible female communities by both state-led and customary law. These narratives of small prison wars in the history of punishment thus stretch the boundaries of the Foucauldian approach by showing how spaces of regimentation, directed towards suppressing 'disorderly' sections of the population, can become a complex site for feminine aesthetics that enabled people to survive death, desolation and despair.

By re-memorizing the experiences of women surviving state 'despotism', my broader research examined further how the 'silencing practices' of state interrogation intervened in the later reconstruction of survivors' lives. When women political prisoners returned to society, they faced discrimination, ruptures in family relations, the intrusive surveillance of communities, and physical disabilities (often due to poor health, and sustained use of weapons and restraints in prison). While journeying through a life of disgrace, most women retained a high degree of nostalgia for these performances, and for their determination to fill in the emptiness of a crowded prison with 'making happy things'. According to Kay Milton (2005), love, grief, passion, hatred and aggression enable people to develop bonds with their social and physical environment, and this chapter has shown how assertion of womanhood as female political revolutionaries and reassertion of womanhood as prisoners became crucial emotions around which notions of humanity, sisterhood and ethical values eventually coalesced.

After their release, many of my informants sustained an imagination of unexpected and hybrid subjective relations and identifications in prison as *freedom,* as against oppressive and predictable power relations in mainstream society. It suggested that the sense of freedom experienced within a captive social order was not ephemeral but enduring. Mita, for example, ended her prison narrative by talking about her life after she was discharged. She was married off without any delay and her family had to pay a big dowry to cover up her past. Her husband, who taunted her as 'the once jailed daughter-in-law' (*jail khata barir bou*), forced her into domesticity, motherhood and sexual obligations. Her parental family also compelled her to complete her graduation to assuage her aberrant past, and she had to eventually submit to the same social and educational system that she had once battled against. She repeatedly said that her performance of happiness in prisons (*shukher natok*), and her contribution towards its changing material cultures, gave her deep satisfaction despite all the beatings. As she recounted: 'The art of performing happiness

in prison was meaningful, impassioned and truly unfeigned. Superficial performance of happiness in real life, of normative wifehood and motherhood, such as packing tiffin boxes for my grandchildren and giving my husband his wallet when he goes out, they leave me dry and bereft.'

Notes

1. I am grateful to the British Academy Small Research Grant for funding the fieldwork for this research.
2. The names of all the informants involved in this research have been changed to protect their anonymity. The names of authors who have published their memoirs are authentic.
3. http://topics.nytimes.com/topics/news/international/countriesandterritories/iraq/abu_ghraib/index.html
4. http://www.telegraph.co.uk/news/worldnews/asia/india/9692198/Mohammed-Kasab-Last-surviving-Mumbai-gunman-executed-in-India.html

Bibliography

Adorno, T. (1997) *Aesthetic Theory*, G. Adorno and R. Tiedemann (eds), trans. Robert Hullot-Kentor, Minneapolis: University of Minnesota Press.

Arnold, D. (2004) 'The Self and the Cell: Indian Prison Narratives as Life Histories', *Telling Lives in India: Biography, Autobiography, and Life History*, D. Arnold and S. Blackburn (eds), Bloomington: Indiana University Press, 29–53.

Banerjee, S. (2009) *In the Wake of Naxalbari – Four Decades of a Simmering Revolution*, Calcutta: Sahitya Samsad.

Basu, P. (2000) *Towards Naxalbari (1953–1967): An Account of Inner-party Ideological struggle*, Calcutta: Progressive Publishers.

Belknap, J. (2000) *The Invisible Woman: Gender, Crime and Justice*, Belmont, CA: Wadsworth.

Carlen P. (1998) *Sledgehammer: Women's Imprisonment at the Millennium*, London: Macmillan.

Caton, S. (2010) 'Abu Ghraib and the Problem of Evil', *Ordinary Ethics: Anthropology, Language, and Action*, Michael Lambek (ed.), Bronx, NY: Fordham University Press, 165–86.

Chakraborty, S. (2000) *Ishwar Prithibi Bhalobasha*, Calcutta: Nobopotro Prokashon.

Coyle, A. (2005) *Understanding Prisons: Key Issues in Policy and Practice*, Berkshire: Open University Press.

Dasgupta, B. (1974) *The Naxalite Movement*, New Delhi: Allied Publishers.

Donner, H. (2004) *The Significance of Naxalbari: Accounts of Personal Involvement and Politics in West Bengal,* Occasional Papers – 14, Centre of South Asian Studies, University of Cambridge.

—(2009) 'Radical masculinity: morality, sociality and relationships through recollections of Naxalite activists', *Dialectal Anthropology*, 33: 327–43.

Douglas, M. (1966), *Purity and Danger: An Analysis of Concepts of Pollution and Taboo*, London: Routledge.

D'Souza, D. (2012) *The Curious Case of Binayak Sen*, New Delhi: HarperCollins.

Feldman, A. (1991) *Formations of Violence: The Narrative of the Body and Political Terror in Northern Ireland*, Chicago: University of Chicago Press.

Fleisher, M. and Decker, S. (2001) 'An overview of the challenge of prison gangs', *Corrections Management Quarterly*, 5(1): 1–9.

Foucault, M. (1991) *Discipline and Punish: The Birth of the Prison*, London: Penguin (first English edition published in 1975).

Freedman, E. B. (1981) *Their Sisters' Keepers: Women's Prison Reform in America, 1830– 1930*, Ann Arbor: University of Michigan Press.

Ghosh, S. (1975) *The Naxalite Movement: A Maoist Experiment*, Calcutta: Firma K. L. Mukhopadhyay.

—(2009) *Naxalbari Before and After*, New Delhi: New Age Publications.

Gupta, T. (2006) 'Maoism in India: ideology, programme and armed struggle', *Economic and Political Weekly,* 41(29): 3172–6.

Harlow, B. (1986) 'From the women's prison: third world women's narratives of prison', *Feminist Studies,* 12(3): 501–24.

Jacobs, J. (2004) 'Women, genocide, and memory: the ethics of feminist ethnography in holocaust research', *Gender and Society*, 18(2): 223–38.

Jawaid, S. (1979) *The Naxalite Movement in India: Origin and Failure of the Maoist Revolutionary Strategy in West Bengal, 1967–1971*, Delhi: Associated Publishing House.

Liebling, A. and Arnold, H. (2005) *Prisons and their Moral Performance: A Study of Values, Quality, and Prison Life*, Oxford: Oxford University Press.

Linden, R. (1993) *Making Stories, Making Selves. Feminist Reflections on the Holocaust,* Columbus: Ohio State University Press.

Mamdani, M. (2001), *When Victims Become Killers: Colonialism, Nativism and the Genocide in Rwanda,* Princeton, NJ: Princeton University Press.

Milton, K. and Svasek, M. (eds) (2005), *Mixed Emotions: Anthropological Studies of Feeling*, Oxford: Berg Publishers.

Mitra, J. (2004) *Killing Days: Prison Memoirs*, Delhi: Kali for Women.

Mukhopadhyay, A. (2006) *The Naxalites Through the Eyes of the Police: Select Notifications from the Calcutta Police Gazette (1967–1975)*, Kolkata: Dey's Publishing.

Ofer, D. and Weitzman, L. (1999) 'Introduction: The role of Gender in the Holocaust', in *Women in the Holocaust,* New Haven: Yale University Press, 1–19.

Panjabi, K. (1997) 'Probing "Morality" and State Violence: Feminist Values and Communicative Interaction in Prison Testimonies in India and Argentina', in *Feminist Genealogies, Colonial Legacies, Democratic Futures*, J. Alexander and C. Mohanty (eds), New York: Routledge.

Rao, A. (2001) 'Problems of violence, states of terror: torture in colonial India', *Interventions: International Journal of Postcolonial Studies*, 3(2): 186–205.

Ray, R. (1988) *The Naxalites and their Ideology,* Delhi: Oxford University Press.

Rhodes, L. (2001) 'Toward an anthropology of prisons', *Annual Review of Anthropology*, 30: 65–83.

—(2004) *Total Confinement: Madness and Reason in the Maximum Security Prison*, Berkeley and Los Angeles: University of California Press.

Roy, M. (2010), *Gender and Radical Politics in India: Magic Moments of Naxalbari (1967–1975)*, Abingdon, Oxon: Routledge.

Roy, S. (2006), 'Revolutionary marriage: on the politics of sexual stories in Naxalbari', *Feminist Review*, 83(1): 99–118.

—(2012), *Remembering Revolution: Gender, Violence, and Subjectivity in India's Naxalbari Movement*, Delhi: Oxford University Press.

Scheper-Hughes, N. (1995) 'The primacy of the ethical: propositions for a militant anthropology', *Current Anthropology,* 36(3): 409–40.

Shah, A. (2010) *In the Shadows of the State: Indigenous Politics, Enviromentalism, and Insurgency in Jharkhand, India*, Durham, NC: Duke University Press.

Skarbek, D. (2010) 'Putting the "con" into constitutions: the economics of prison gangs', *Journal of Law, Economics and Organizations,* 26(2): 183–211.

Turner, V. (1967) *The Forest of Symbols: Aspects of Ndembu Ritual*, Ithaca, NY: Cornell University Press.

—(1969) *The Ritual Process: Structure and Anti-Structure,* Piscataway, NJ: Aldine Transaction (new edition 1995).

Wacquant, L. (2002) 'The curious eclipse of prison ethnography in the age of mass incarceration', *Ethnography*, 3(4): 371–97.

9

Rwanda: Healing and the Aesthetics of Poetry

Andrea Grieder

How can poetry possibly contribute to healing the pain and suffering that have been caused by genocide? What role can language – and poetry in particular – play in dealing with traumatic memories? My ethnographic research in Rwanda focused on ways of dealing with trauma caused by political violence and the genocide against the Tutsi in 1994.[1] In this chapter, I explore the meaning of language and poetic aesthetics in particular within a context where the past is burdened with terrible memories, and where the social fabric is fractured by jealousy, hatred and crime (Taylor 1999).

Drawing on portraits of individual Rwandans, I argue that poetic and metaphorical language is a way of coping with emotionally intense situations as it is a potent means of transcending pain and suffering. By examining social interaction – through words and gestures – in present-day Rwanda, I attempt to situate the creation of poetry and metaphor in their everyday context, as well as show the continued existence of a subjective, poetic sense of self present in day-to-day life.[2] I analyse the present social interactions with reference to cultural knowledge and traditional ways of dealing with fear, crime and hatred, in order to demonstrate their depth in time as embodied and language-based memories, which both constitute Heideggerian being-in-the-world.

I consider first the portrait of Gaspard.[3] His portrait brings to light the use of 'war metaphors' in dealing with intense emotional situation. Looking at the poetic heritage in Rwanda that has its origins in the monarchic period (fifteenth century to 1962) reveals that this way of speaking represents an important socio-psychological dimension of being in Rwanda.

The portrait of Charles demonstrates how poetic language can be a key to transcending pain. It is also a means of maintaining an inner emotional life in the face of exterior social constraints. The act of creation is, in itself, a way of facing death and at the same time overcoming it. I pay particular attention to the social phenomenon of poisoning and to the traditional methods that are used to counteract it. Within a social context that is determined by the exigencies of emotional control,

poetic expression can become a moment of 'interior vengeance' when confronted with a situation to do with what is perceived to be an unpunished crime.

For Marcel, poetic creation is a 'medication' – a way of dealing with painful memories of the genocide and its reactivation in the everyday context of post-genocide society. Expressing the inner world through the medium of words enables the individual to strike a balance between the memories generated by a painful past and the necessity for the self to exist in the present, the here and now.

In Rwanda, a stigmatization of trauma is linked to a socio-cultural perception that assimilates psychological disorder to moral failings or transgression of a social taboo (Munyandamutsa 2001; Dufatanye 2001). At the same time, the sufferer may be seen to have an alliance with the spirit-world and this endows him with a particular social significance. S/he becomes the bearer of an embodied social truth that concerns the individual as well as the collective body. In traditional understanding, the healer played an important role for the reintegration of the sufferer in the community through a process of mediation between the different parties involved (Dufatanye 2001: 22). In this chapter, I show how the figure of the 'healer' in popular consciousness reappears as the figure of the third within poetic writing: the imagined other through whom inner truth can be expressed. The result is a voice which combines a deep sense of grief with an irreducible dignity.

'War metaphors' in present-day Kigali

The Rwandan psychologist Deogratias Bagilishya (2000) argues that in Rwanda, proverbs (along with bodily gestures) are frequently used strategies when coping with loss and pain. Their use introduces a distance between emotion and action, on the social as well as on the cognitive level. Whereas proverbs are a given set of sayings and words of wisdom, the portrait of Gaspard demonstrates a creative way of acting through language in everyday life in present-day Kigali, the Rwandan capital.

Within the rich tradition of storytelling in Rwanda, a story is often introduced with the Kinyarwanda word *habayeho*, which means 'it happened to be'.

So let me say:

Habayeho, that I left my Rwandan family where I had spent almost a year to move to the house of a Swiss woman. We had been living together for many months, so this marked a separation for all of us. Arriving at my new home turned out to be thoroughly unpleasant, but significant, which is the reason I mention it here.

Gaspard and Françoise, my 'parents' in Rwanda, had lived in exile in Burundi but returned to Kigali after the genocide. Their home was a house in Kacyiru which they shared with their four daughters and which, following my arrival in 2007, became, after a time and with many shared experiences, a family home for me as well. But when, during 2008, I began writing my thesis I realized that I needed to

move to quieter surroundings. An opportunity arose to share a house with another Swiss woman. Ironically, however, I came to realize that living with Rwandans had become so much part of my being that in sharing a house with one of my compatriots, I suddenly felt like a stranger.

The day of my move, Gaspard and Françoise drove me to my new home in Kiyovu, a smart suburb of Kigali. When we arrived at the entrance, a security guard asked us to wait in order to get permission for us to enter the compound. Being treated in this way, like unknowns, prompted Gaspard to say in a half-cheerful, half-irritated manner: 'Maybe we'd better go back home'.[4] I do not think he meant this literally, but imagine it was a way of expressing displeasure at the curt and inhospitable behaviour of the guards.

Things went from bad to worse. As we went up the veranda stairs, I noticed with horror dog excrement on the steps. I glanced at Françoise and saw that she could hardly hold back her tears. The situation made me speechless. Gaspard, however, had started a conversation with my new flatmate. As they talked, I heard him say to her in a very pointed manner: 'You have stolen my daughter.'

In the course of their discussion, Gaspard and my new flatmate realized that they had some common acquaintances and he asked her to pay a visit to his home one day. Although this was a gesture of courtesy, he said: '(When you come to my place) I will bring out my dogs and they will devour yours.'

A closer look at the role of poetry in the past brings to light the meaning of this sentence. Rwanda has a long and rich poetic tradition and poetry was part of the military drilling of young men at the court. This tradition originated in the seventeenth century, the monarchic time of *mwami* – king Ruganzu II Ndori (1600–24). During the period of monarchy, poetry played an important ritualistic, symbolic and power-enhancing role. A part of this poetic tradition is *icyivugo*, the genre of war poetry. Virtuosity in speech was considered as important as the use of weapons for royal warriors. *Icyivugo* is derived from the verb *kuvuga* which means 'to speak' and also contains a reflexive infix.[5] This, therefore, is a means of expression that involves speaking of oneself (Coupez and Kamanzi 1996: 9) and can best be translated as an Ode to the Warrior. The following extract of an *icyivugo* composed by the warrior-poet *Rushenyi* illustrates the particularity of this poetic genre:[6]

> *I am a virtuoso of the bow*
> *Once I killed a man in Ishîshi*
> *Another in Bushoora, near Musekera*
> *Arrows I rained down at Cyiinuma*
> *I killed an enemy at Rubona near Tuunda*
> *My front adorned with pearls at the*
> *Vanguard of the Nyaambo!*[7] *[herds of royal cattle]*
> *I killed another at Rutaambabareenzi*
> *Near Kidâturwâ*

My brow adorned with pearls
Just as I am right now.

Rushenyi lived during the reign of Yuhi IV Gahindiro, *mwami* of Rwanda from 1797 to circa 1830 (Rugamba 1987: 71). In this poem, he quotes the names of places which situate the acts of war in a specific geographical landscape. At the same time, it is a manifestation of heroic acts and a demonstration of masculine strength, and of the value of bravery.

This kind of warrior verse was declaimed on the eve of battle or as part of the training of young fighters. Described as 'self-panegyric' or 'heroic', the verses permitted the author to exalt his own valour by using all the resources of his imagination and his capacity for exaggeration (Coupez and Kamanzi 1962: 9). The performances were used to overcome fear and demonstrate bravery and fighting spirit through the imaginative use of allegorical language. Each warrior would boast of his skills and strength and make favourable comparisons between himself and the most aggressive of wild beasts (Coupez and Kamanzi 1962: 9).

In its performative value, poetry plays a role in the construction of the individual – the socio-cultural meaning of the person – and in the case of war poetry, specifically, masculinity. Even if this period of monarchy and ritual practice of *icyivugo* belongs in the past, listening to ways of speaking in Rwanda today, I am driven to argue that poetry is a form of articulating collective memory. Furthermore, the poetic self is an embodiment of collective memory. With Gaspard, the imaginary fighting of dogs which he referred to in his conversation with my new flatmate served as a means of transferring inner tension to an imaginative register that corresponds to the powerful poetry of *icyivugo*. I use the term 'war metaphors' to describe this metaphorical and transfigured way of speaking when dealing with emotionally complex and dense situations.

Gaspard, no doubt aware of the inequality between himself and his 'adversary' in terms of the virtuosity of speech, later said to my new flatmate: 'Don't worry. My dog is very kind.' However, to the best of my knowledge, she never did take Gaspard up on his invitation to pay him a visit.

Poetry within a world of jealousy and death

The story of Charles takes us to the more rural context of Nyamata, a small town in the district of Bugesera near the border with Burundi. His portrait demonstrates how poetic creation is situated in an emotional and relational world of death and hate, jealousy and fear.

I first met Charles, a young Rwandan man, while I was living at my new home in Kiyovu during the summer of 2008. He worked for a security agency which watched over the compound 24 hours a day. My flatmate was working for the United

Nations, and therefore we were likewise obliged to accept this system of protection and surveillance.

I got into the habit of talking to Charles at the entrance gate and it was through these conversations that I learnt of his passion for story writing and poetry. One of his notebooks bore the title *Inzira*[8] *y'agahinda*[9] – The Way of Sorrow.

The sorrow of which the young man spoke in his writings reached a terrible climax with the brutal death of his grandmother. 'I have just lost my grandmother', he told me one August day. For Charles, the suddenness of her death spoke a language of its own: he explained to me that she had been fatally poisoned. The anthropologists Claudine Vidal (1978: 17) and Christopher Taylor (1992), who have both studied the phenomenon of poisoning in Rwanda, argue that this way of giving meaning to illness or death was common in the rural context and that it was strongly linked to jealousy provoked by the perceived success or prosperity of others.

Françoise, the wife of Gaspard, with whom I had lived before moving to the compound, had experienced poisoning in her own family. Having been born in the Democratic Republic of the Congo, she explained that movements of people to and from neighbouring countries – due to war and outbreaks of genocide in the decades since 1959 – had generated a lot of tension over land ownership which in turn had led to many deaths from poisoning. The political slogan that the soil belongs to all Rwandans was often in contradiction with individual and family claims over land or the lack of willingness to share the scarce land for cultivation. These murders were rarely punished by the courts because of lack of evidence and the unwillingness of people to testify even when many knew who the guilty parties were. 'The crimes are known by everyone, but committed in a hidden place', explained Françoise.

For Charles, the death of his grandmother was the tragic repetition of an ineluctable destiny. 'The same thing happened to my father. He died in June. Only my mother is still alive. But she will not be alive for much longer', Charles stated. 'In the case of my father, the pains started at 8 in the morning. By 10 a.m. it was over. He was spitting blood but an examination could find nothing.'

'One might say that Rwanda is very advanced in the technology of hatred', he observes laconically. Young though he is, Charles has himself been a victim of poisoning. 'They tried to poison me', he remembers and adds, bitterly: '11 years later if I eat a banana I can't stop vomiting.' This nausea, this painful bodily memory is lasting proof of the world of hatred that existed when he was a child. His parents had married in 1966 but remained childless for 16 years, which made them a target of strong social pressure. When Charles was born in 1984, his parents were already getting on in age and they wished him to marry young in order to ensure the continuity of the family line. Charles himself did not accept this imposed responsibility. He also wished to escape the social landscape of jealousy and hatred in which he had grown up. So, this talented poet had moved to Kigali.

On the day of his grandmother's death, Charles had gone to the funeral which took place in his home town in Nyamata. At the graveyard, he had come face to face

with the person whom he considered responsible for her death. The latter suddenly began to talk to him about that very subject.

In the evening Charles returned to Kigali to resume his work guarding the house at Kiyovu. We were sitting together on the little wall by the entry when he told me of the conversation which he had had at the cemetery.[10] 'People say that it was me who killed your father,' the other man had said, 'and now they're starting to say that it was also me who killed your grandmother. Tell me what you think.' 'There are seven billion people living on this planet,' Charles had answered, 'are all of them saying this?' 'No,' was the other man's reply 'but certainly the people who live here are saying it.' Charles challenged him to be more precise: 'Can you give me the name of somebody who says this?' 'No, but I've heard that people are talking like that.' Charles considered this and answered: 'If you are guilty of nothing, my blessing on you. But if people are speaking this way, there must be a reason. Death comes to us all. And that is when you will have to give an account of your actions.'

I was stunned by the audacity of how the man had deliberately provoked a conversation with Charles at the cemetery as to who might be responsible for the death of Charles' grandmother. Unable to confirm the other's guilt or accuse him of the poisoning, Charles had invoked a divine and transcendental justice.

In the past, questions as to responsibility in incidents of poisoning were dealt with by the intervention of a healer or a *umupfumu* (medium or clairvoyant). Christopher Taylor (2002), in his work on conceptions of health and forms of healing in Rwanda, identifies the use of a particular therapeutic approach to instances of poisoning. The healer examined the facts of the case (evil spells or poisoning) very much in the manner of a prosecuting attorney: 'The sufferer's suspicion was oriented toward those with whom he or she has been having difficult social relations' (2002: 148). In this accusatory mode, the suffering of the individual was oriented towards the community as a whole. The healer identified a person or an ancestral spirit for being responsible for the poisoning, thus clearly confirming – or dispelling – any suspicions.

For Charles there was no such intermediary or healer and so the crime could neither be named nor punished. The justice of society had to be replaced by a transcendental justice beyond the life of this world.[11] Charles's references, both universal ('seven billion people living on this planet') and local ('the people living here'), are ways of 'circling the truth'. By these means the crime, not named as such, becomes nevertheless the real core of the exchange. The refusal of the other man to specify who exactly is the source of the rumours concerning the crime allows him to create an imaginary space in which to conceal his possible guilt.

The exchange between Charles and the other man is significant for the way things are expressed in a context of suspicion and many unspoken thoughts. This may be described as a process of 'exploring the trustworthiness of the other' to designate this manner of referring, indirectly and obliquely, to the crime through the medium of words.

I listened in silence as Charles told me of this conversation. However, I felt the need to hear the 'hidden truth' clearly stated, so I asked him directly if this person had harmed his grandmother. There was a pause, then Charles said: 'Certainly.' 'Were people behaving with hostility during the funeral service?' was my next question. He answered me: 'No, but appearances can be deceptive.' I saw this as evidence of wariness behind which lay a deep-seated fear, fear that the evil he sensed beneath the surface could become reality.

It was in this context that Charles said: 'Sometimes, one is afraid to approach them. Afraid that they will do evil again.' He added: 'At times like these, being strong means refusing to take revenge.' 'One must do good to those who have done us harm. If you seek vengeance all you do is create yet more hatred', said the young man. Thereby, he expressed not only his desire to break with the continuing chain of hatred and vengeance but also his fear that evil would only engender more evil. This principle, this philosophy of life, was something he had learnt from his grand-mother – a woman of whom he spoke with great affection and who had practised as a midwife. 'During her life, she had helped people giving birth regardless of their identity', stated Charles.

Following the painful ordeal of the funeral, Charles spoke to me of a poem he intended to write. I imagined the words coming to him in the crowded bus taking him back to Kigali.[12] In Kinyarwanda these minibuses are known, appropriately enough, as *twegerane* – a term which literally translates as 'let's hang on to each other' and that in effect describes the way one travels in such vehicles. Thus, I saw, as it were, the words crowding together in Charles' head, expressing not only his pain and his grief at the loss of his grandmother but also his anger.

The poem that Charles wrote on his grandmother's funeral is called *Après le desert, le dessert*.[13]

La fleur fleurit	*The flower blooms*
Les gousses defiscent	*The plants open*
Les fruits mûrissent	*Fruit ripens*
Mais la chair périt	*But flesh rots.*
On oublie! L'âme s'en va.	*We forget! The soul departs*
Où sont les savants	*Where are the wise men*
Pour aller en avant	*To lead the way?*
La vie mousse comme le savon	*Life foams like soap*
Les jeunes et les vielles s'en vont	*Young and old leave us*
Mais les gens disent « buvons »	*But people cry "Drink up"*
Et mangent même des veaux	*And feed themselves on veal.*
La vie vient comme	*Life comes*
Le vent de mousson	*Like a monsoon wind*

Passe vite comme	*Swims by quickly*
Nage le gros poisson	*Kike some great fish*
La vie est courte, éphémère	*Like the monsoon wind*
Comme le vent de mousson	*Life is short, transitory*
Mes yeux toujours à l'horizon	*My eyes are always fixed on the horizon*
Les gens dansent, mangent	*People dance and eat*
On dirait le cri des anges	*You would think it was the cry of angels*
Moi, la douleur aux phalanges	*My suffering penetrates*
	To the very bones of my fingers
Tous me dérangent	*To me all is pain*
Après la mort	*After death*
Pas de remords	*There is no remorse*
Mais après le désert	*But after the desert*
C'est le dessert.	*Comes the dessert.*

In these verses, Charles speaks of the anger provoked in him by the traditional feast that follows the burial ceremony. Although the sharing of food should be, in a ritualistic, symbolic way, a source of consolation, *Après le désert, le dessert* denounces the absence of any such comfort. The poem may be interpreted as an indictment of the loss of a sense of humanity – in other words, the incapacity of the community as a whole to support its individual members in times of grief.

In the face of solitude and pain, the writing of poetry constitutes a form of interior resistance. The neuropsychiatrist and ethnologist Boris Cyrulnik, whose own parents were Polish Jews deported in 1937, speaks of the resilience that bestows the capacity 'to manage, not only to survive, but even develop one's selfhood in spite of adversity' (1999: 242). Charles' poem bears witness to the rupture between the self and the world and, at the same time, it affirms the possibility of maintaining an interior universe through the creativity of poetic expression. Pain is spoken through the language of poetry, whereas taking part in the burial ceremony demanded self-control. The latter is both a form of social constraint and a strategy for survival – a means of protection – within the prevailing context of hatred and distrust.

The philosopher Paul Audi (2005) has observed that the opposite of dying is not simply to live but also to create. The words of a poem – composed in silence – are thus a challenge to death in order to establish a place of survival. When one is forced to say nothing in the presence of a criminal and burdened with an impotent rage in the face of a world of hatred, poetry and the act of creation can serve as a kind of interior vengeance.

Extension of the self through poetry

'Poetry is my medication', said Marcel, a student and survivor of the genocide in Rwanda that took place in 1994. I met Marcel for the first time in 2005 when he was studying at Kigali Institute of Education (KIE). His second name Ruhurambuga signifies 'the man who throws a spear', in other words 'a man of combat'. He was tall and had a charming personality; Gaspard, working at the Ministry of Education (Ministère de l'Education, de la Science, de la Technologie et de la Recherche) and at KIE had introduced me to the AERG (Genocide Survivors Students Association)[14] of which Marcel was a member. During the time of my research in Rwanda from 2005 until 2009, I spent a lot of time with Marcel and other AERG members both through collective commemoration days and also their individual ways of living with the memory of traumatic experiences. Marcel invited me to accompany him to the *gacaca* meeting[15] (a tribunal assembled for the hearing of crimes linked to the genocide) at his home place; we also attended the marriage of Michel Jackson Rutayisire, national coordinator of AERG during this time, in the village of Nyamata.

Marcel was born in 1977 in Mukingi commune, now known as Ntenyo district in Gitarama. He was the fifth-born in a family of eight brothers and sisters.[16] They were the only Tutsi living in the area because all the others had fled during the 1959 war. As Marcel recounts, in the beginning the Hutu neighbours had helped his father build his house and find a wife; 'They were like his parents or his only relatives' (Whitworth 2004: 176). When the genocide broke out Marcel was 16 years old. His father, two sisters and two brothers were killed; Marcel survived along with his mother, two sisters and one brother. His elder brother Gabriel Burabyo was killed after being betrayed by one of the boys he had grown up with. 'When they were babies, my mother had breastfed Rusizana and Gabriel at the same time like twins', recalls Marcel.

One day Marcel told me that he has not celebrated his birthday since the end of genocide. He had replaced his actual birthday, 20 April – which coincided with a time when the genocide was raging – with 26 May, which he named his day of resurrection. This image of resurrection is proof of a capacity to bestow meaning on the confrontation with death – 'of having died' – by means of an act of symbolization within words. We can understand the imaginary of ressurection with reference to Christianity, as Marcel is a Christian like most of the Rwandan population. Correspondingly, we also find the symbolism of resurrection in the traditional cult of *kubandwa* with its mythical founder Ryangombe (de Heusch 1982: 212; Taylor 1992; Vidal 2002). 'I was dead. But then I was resurrected', said Marcel when talking about the past. 'It was at 6 o'clock in the evening. I had lost consciousness for about 4 or 5 hours. When I came to be found I'd been thrown into a latrine pit with many others, dead or dying. Somehow I managed to get out and I washed my arms. Somebody put cow dung where the *interahamwe* Hutu militia had hit me with a hammer. Now even the scar had disappeared.' However, another bodily memory, namely an allergy to the smell of latrines, remains with him to this day.

Habayeho, that I accompanied Marcel to the neuropsychiatric hospital *Ndera*, situated on the outskirts of Kigali urban centre. Following *gacaca* meetings on the case of the murder of his sisters, Marcel had been suffering from severe head pains and the *Service de Consultation psychosocial* in Kigali sent him to *Ndera* for examinations (electroencephalography). Being sent to Ndera is in colloquial language a synonym for being mad and I used my sense of humour to make this disagreeable trip to the hospital bearable – although some of the patients we saw there did not always make this an easy task.

Sitting on one of the benches in the cold corridors of the hospital, Marcel talked about what the writing of poetry meant to him: 'My poems form a circle around what I have lived through during the genocide', and in saying this, he made a circular movement with his head. 'I always start with the past. The same moments (memories) show up again each time, then I link them with something in relation to the present.' His comment demonstrates that the genocide of the past is omnipresent and that poetry forges a link between the past and the present. At this point in my argument, it is pertinent to mention the meaning of *igisigo/ibisigo,* the term used for a poem, in particular poems from the dynastic period. *Igisigo/ibisigo* derives from the verb *gusiga* which means 'leave behind' and 'compose a dynastic poem'. In Marcel's case we can see that poetic creation which has its source in pain and suffering allows an extension of the self in time. It invokes the possibility of an existence – both symbolic and real – beyond the past and its painful memories.

The neuropsychiatric examination and tests did not bring to light the cause of Marcel's suffering – suffering that he describes in the following powerful words: 'I am angry in my heart.' It may well be that the creative process of poetry contributes to healing the wounds that are invisible and marked in the depths of the heart. An extract from Marcel's poem *Rwanda ngobyi iduhets* (Rwanda, our cradle) illuminates the transformative strength of words within the movement from death and destruction to light and praise, affirmation. In referring to the Rwandan Nation, the poem goes as follows:

None ndaje ngo nkujandure	*I come now to bring you light*
Muri uru rwijiji rw'ijuru rijunditse byinshi	*Under a grey sky that hides much*
Bituma tutajamburana ngo tujore Ibitujegeza	*A sky that will not permit us to help each other*
Ahubwo bikadutanya tugatura amahari	*And pushes us to our own destruction*
Amatongo yaraganje abatuye baratembye	*Our homes have become graveyards*
Ndaje nkumare irungu dutambe ineza	*I come to make your heart beat*
Duce ingando urugamba urarusoje	*To the rhythms of openess and trust*
	Your suffering is over
	You have fought the good fight
Maze nkuririmbe nganji ya Gihanga	*I come to sing your praise*

Cyaguhanze mbyeyi yesa imihigo *Noble creature, son of Gihanga[17]*
Mu ruhando rw'ahamhanga amagana *Your greatness cannot be compared*
 to any other nation.

The ethnographic writings on the tradition of poetry bring to light the dimension of time in relation to the political institution of poetic speaking and the memorization of the monarchical reign. In one of the collections of dynastic poems by the clan of Abasinga, we learn about the role and significance of poetry in projecting the life of the community into the future and thus creating continuity through time: 'Poems are a vehicle of Rwandan history' (*Les poèmes sont le transport de l'histoire du Rwanda*).

Anthropologists such as Jacob Climo and Maria G. Cattell (2002) underline the importance of rituals and performative acts for society in that they become like 'places of memory'. Through participation in myth and ritual, people make collective sense of the past and are able to connect past, present and future by rooting the self and the collective in time. When considering the poetry of Marcel, we realize that it is not only a means of projecting oneself and the nation into the future within a collective, authorized form of coping with pain and suffering, but also 'works' on the memories of the past. Poetry restructures both the perception of time and the place of the person within time and the collectivity.

Augustin Rudacogora (2008: 49) notes the importance of poetic writing in the literature dealing with the subject of the genocide. He observes a strong inclination to fictional forms and particularly 'works which are more faithful to traditional genres;[18] hence the dominance of poetry over other means of expression (novels and plays) within this solemn context'. The use of such intonations and accents in *speaking of* the genocide can express the search to re-establish the value of both the self and the community through the use of a 'tradition' and a recourse to cultural norms which have their roots in pre-colonial times. Such cultural references recall a time before the horror of the genocide and before the destruction of traditional Rwandan values by the colonists.[19]

Poetic self and agency

In common with Deborah Madson (2007) and Aleida Assmann (1999: 95–118), I would argue that, in Rwanda, poetry is a cultural narrative which permits the confrontation with traumatic experiences by means other than those derived from psychoanalytical methods, a dynamic operating within a world where the need for self-control must co-exist with feelings of envy and distrust. Where trauma is frequently equated with madness, the use of poetry permits a dignified expression of suffering. Chaste Uwihoreye, clinical psychologist in charge of the trauma department for the Uyisenga n'Imanzi Association, points out that in Rwanda

traumatism is considered as 'something shameful'. Simon Nsabiyeze (2009: 10) tells us that 'in everyday language "trauma" is used to describe any kind of psychic or relational disorder'. Given this stigma, fear of mockery by others is an obstacle to consulting health professionals.

The stigmatization of mental illness, of traumatism, is influenced by a socio-cultural perception that assimilates such disorders to moral failings. Traditionally, psychological suffering was seen as being provoked by the breaking of some social taboo or interdiction (Munyandamutsa 2001; Dufatanye 2001). The healing process involved the social reintegration of the sufferer. This process functioned through the intervention of a traditional healer who localized the cause of the suffering in a third party (ancestor, spirit or enemy). Edmond Dufatanye (2001) further tells us that this healing could involve not only family members but, sometimes, even the whole village. It favoured the transmission of symbols (*circulation symbolique*), and reinforced social and familial cohesion. Furthermore, Dufatanye (2001: 22) also states that 'mental illness is seen as evidence of an alliance with the spirits of continuity of family lineage and groups. The sufferer is perceived as the keeper of a prestigious message'. In Europe, similar concepts of mental disturbance began to be lost with the introduction of the internment of sufferers and, as Michel Foucault (2001: 197) points out, this marked the beginning of an approach to mental illness which was based on silence and exclusion. Thus, as Foucault puts it, madness was deprived of the power of revelation that it possessed at the time of Shakespeare and Cervantes. (A good example of this would be Lady Macbeth, who only begins to tell the truth when she loses her reason.)

In Rwanda, the healer used natural means (plants, roots, stones) but, above all, words, the 'carriers of healing virtue' (Munyandamutsa 2001: 17). The Rwandan psychiatrist makes it clear that 'without the word there is no treatment. The word which carries within it the art of healing comes from the ancestors and must be acknowledged by the community in which the healer has been called to serve.' The healing power of the word acquires its potency when its link with the past is recognized so that it can be pronounced with authority.

In the absence of the healer as intermediary between individual and collective suffering, between present and future, poetry becomes a means of using the word and, in and through the use of words, a means of re-creating the self. Along with Ngo Semzara Kabuta (2000), professor of literature and African linguistics, I argue that the tradition of war poetry can teach us about the transformative and re-creative force of language – ultimately about its healing power. Ngo Semzara Kabuta introduces *auto-louanges* – the concept of speaking of or praising oneself in speech – as an aid to personal development: it becomes a way of discovering oneself, an act of affirmation and of transformation. The creation of a text about oneself can be compared to the recognition of the inner self, a notion that refers to the relational and emotional configuration of a person. In reworking a text about the self, one also reshapes the self – a kind of interior sculpture. Kabuta, a master of verbal art, teaches

us that one is dealing with 'an open text that is never finished, it is always a work in progress'. This internal elaboration pursues an ideal of beauty, 'the reworkings on paper are also a way of polishing the mind' (2003: 271). For Kabuta, such a process demands the capacity of abstraction and – although this might seem a paradox – it also becomes an act of modesty when it enables the individual to strengthen his or her place within the collectivity and the universe. Through the means of a mythical and poetic portrayal he or she may now consider themselves as an aesthetic figure. In this way, the individual refashions himself or herself[20] and, because this process is realized through the medium of poetry, the person, *the individual becomes a poem.* In other words, a person embodies a metaphoric creativity that enables him or her to consider themselves within the world as a poetic entity.

In Rwanda today, poetry can contribute to the re-creation of the individual in pain who continues to suffer in the aftermath of the genocide or because they are a victim of harmful actions in the present. In a situation where the traumatic past still casts its heavy shadow on the present, poetry can foster a form of agency that takes place within the creative space of words. The individual may be restricted by taboos and exigencies of emotional control but, nevertheless, has access to an imaginative world where the self can re-enact experience.

Ways of expressing and speaking about the traumatic past are strongly influenced by socio-cultural means of dealing with pain and suffering. On the one hand, social taboos on violence are also taboos regarding what can be said and what must be left unspoken. On the other hand, 'keeping face' and 'emotional control' are important in relation to the form and context by which traumatic experiences are expressed. These norms and values influence the corporeal, actual and symbolic ways of dealing with pain, both individually and collectively. Within this specific context poetic creativity can be understood as a method of transforming past experiences into a new relational and emotional configuration of the self.

Acknowledgements

My thanks to Tom O'Brien, Raminder Kaur and Parul Mukherjee for editing the chapter in English and to Gaspard, Marcel and Charles for their friendship.

Notes

1. See, for example, Lemarchand (2004), Kimonyo (2008) or Eltringham (2004) on the topic of violence and genocide in Rwanda.
2. I do not necessarily uphold inner/outer dualisms as is apparent in Western

psychological models (see e.g. Lakoff and Johnson 1999), but it is clear from my ethnographic material that my interlocutors preferred to keep certain feelings to themselves and express other emotions through more public idioms. Hence distinctions as to what is kept hidden and other public modes of expression and acceptability were evident. Furthermore, the areas where I worked were not isolated from the influence of biomedical ways of treating trauma.

3. On consultation and permission from my interlocutors, all people except for Charles have requested me to use their actual first names. Material for this chapter was collated during fieldwork in 2005–9.

4. This and the exchanges that follow are translated from the original French.

5. The reflexive infix in Kinyarwanda –i– gives a sense of reflexiveness that the subject fulfils on itself in relation to the action expressed by the verb (Overdulve and Jacob 2000: 271).

6. Translated from French in *La Poésie face à l'histoire* (Poetry and History) of the Rwandan poet and author Cyprien Rugamba (1987: 71). Alexis Kagame (1969) quotes the original Kinyarwanda version of the *icyivugo cya Rushenyi rwa Ntoranyi (Rushenyi's icyivugo, son of Ntoranyi)*. See also wikirwanda. blogspot.ch/2008/02/ibyivugo-rushenyi-rwa-ntoranyi.html for a partly different version.

7. The pastoral poetry *amazina y'inka* (the names of the cows) is devoted to the inyambo, the royal cows with long curved horns, symbol of beauty and wealth.

8. The term *inzira* figures in the esoteric code of the Nyiginya dynasty (Luc de Heusch 1982: 17).

9. *Agahinda* is traditionally used to describe mental disorders (Bolton 2001: 243–8).

10. The conversation resumed in French by Charles was held in Kinyarwanda.

11. Referring to Richters et al. (2003: 12) we observe that Charles manifests a shift from the traditional concept of judgement (relating to a parallel supernatural world) to a Christian vision which locates judgement in the world that follows death.

12. My research in Rwanda made me become aware of the importance of the bodily receptiveness of the others being-in-the-world through other means than language. This seems particularly important within a cultural context where communication through bodily sensations is as strong as language. It can give way to a sense of imaginative truth or knowledge regarding the being of the other.

13. Charles had written the poem in French.

14. AERG (Association des étudiants et élèves rescapés du Génocide) was founded in 1996 at the National University of Rwanda in Butare. Today AERG is represented nationally at 27 universities and institutes of higher learning and 300 secondary schools in Rwanda.

15. Ingelaere (2009); Reyntjens (1990).

16. Marcel's testimony 'I thought my life was over' is published in *We Survived. Genocide in Rwanda: 28 Personal Testimonies,* Wendy Whitworth (ed.), Aegis Trust (2004).
17. According to Rwandan mythology, Gihanga was the founder of the Nyiginya dynasty.
18. Among the traditional genre of oral literature in ancient Rwanda figure the pastoral poetry *amazina y'inka*, the war poetry *icyivugo* and the dynastic poetry *ibisigo* (Kagame 1969). These poetic genres have been encouraged by the Rwandan kings, or have been part of the royal institutions.
19. I emphasize that the idea of a harmonious, pre-colonial past is by no means generally accepted among historians (of Rwanda). It is a controversial topic regarding the interpretation of the origins of the genocide.
20. The poetess Nyirarumaga, the adoptive mother of King Ruganzu II Ndori (1600–24) was one of the prominent female artists of Rwanda.

References

Assmann, Aleida (1999) 'Trauma des Krieges und Literatur', in *Trauma, zwischen Psychanalyse und kulturellen Beutungsmuster*, Elisabeth Bronfen, Brigit R. Erdle and Sigrid Weige (eds), Weimar, Wien: Böhlau Verlag, 95–118.

Bagilishya, Deogratias (2000) 'Mourning and recovery from trauma: in Rwanda tears flow within', *Transcultural Psychiatry,* 37(3): 337–53.

Borland, Rosilyn M. (2003) 'The gacacas tribunals and Rwanda after the genocide: effective restorative community justice or further abuse of human rights', *A Journal of International Affairs* 13(2).

Climo, Jacob J. and Cattell, Maria G. (eds) (2002) *Social Memory and History: Anthropological Perspectives,* Walnut Creek CA: Alta Mira Press.

Coupez, André and Kamanzi, Thomas (1962) *Récits historiques Rwanda*. Musée Royal de l'Afrique Centrale, Tervuren, Belgique Annales, Serie in 8°, no. 43.

Cyrulnik, Boris (1999) *Un merveilleux malheur*, Paris: Odile Jacob.

Dufatanye, Edmond (2001) *La conception des maladies mentales par les familles des malades mentaux. Cas des quelques familles ayant consultés les tradipraticiens*. Travail de fin de cycle présenté en vue de l'obention du titre gradué en techniques médiales. Option: Santé mentale. Kigali Health Institut, K.H.I., février.

Eltringham, Nigel (2004) *Accounting for Horror. Post-genocide Debates in Rwanda*. London: Pluto Press.

Foucault, Michel (2001) *Dits et ècrits I, 1954–1975*. Paris: Quarto Gallimard.

Heusch, Luc de (1982) *Rois nés d'un coeur de vache*, Paris: Gallimard.

Ingelaere, Bert (2009) 'Les juridictions gacaca au Rwanda', in *Traditional Justice and Reconciliation after Violent Conflict: Learning from African Experiences*

(French), Luc Huyse and Mark Salter (eds), Stockholm: International Institute for Democracy and Electoral Assistance (IDEA), 26–65. www.idea.int/publications/traditional_justice/upload/tj_fr_2.pdf

Lackoff, George and Johnson, Mark (1999) *Philosophy in the Flesh: The Embodied Mind and its Challenge to Western Thought*, New York: Basic Books.

Lemarchand, René (2004) 'The Rwanda genocide', in *Century of Genocide,* Samuel Totten, William S. Parsons and Israel W. Charney (eds), New York and London: Routledge, 395–414.

Kabuta, Ngo Semzara (2000) 'L'autopanégyrique: un genre littéraire panafricain', *Antipodes*, vol. 150.

—(2003) *Eloge de soi, éloge de l'autre,* Brussels: PIE Peter Lang.

Kagame, Alexis (1969) *Introduction aux Grands Genres Lyriques de l'Ancien Rwanda,* Butare: Editions Universitaires du Rwanda.

Kimonyo, Jean-Paul (2008) *Rwanda, un génocide populaire*, Paris: Karthala.

Madson, Deborah (2007) 'Of Time and Trauma: The Possibilities for Narrative in Paula Gunn Allen's *The Woman Who Owned the Shadows*', in *Transatlantic Voices: European Approaches to Native American Literature*, Elvira Pultiano (ed.), Lincoln: University of Nebraska Press, 111–28.

Munyandamutsa, Naasson (2001) *Question du sens et des repères dans le traumatisme psychique. Réflexions autour de l'observation clinique d'enfants et d'adolescents survivants du génocide rwandais de 1994.* Médecine & Hygiène.

Nsabiyeze, Simon (2009) *Reflexion autour du Kubaho et Kubana, Gutunga et Gutanganirwa à travers l'action psychotherapeutique.* Université Nationale du Rwanda. (Maîtrise) (Mémoire Online, www.memoireonline. com/09/09/2689/m_Reflexion-autour-du-Kubaho-et-Kubana-Gutunga-et-Gutunganirwa-a-travers-laction-psychotherap0.html [printed 16 April 2011]).

Overdulve, C. M. and Jacob, Irénée (2000) *Initiation au Kinyarwanda: Manuel d'apprentissage de la langue rwandaise*, Parils/Montréal: Editions l'Harmattan.

Reyntjens, Filip (1990) 'Le *gacaca* ou la justice du gazon au Rwanda', *Politique Africaine*, vol. 40, 31–41.

Richters, Annemick, Dekker, Cora and de Jong, Klaas (2005) 'Reconciliation in the aftermath of violent conflit in Rwanda', *Intervention*, 3(3): 203–21.

Rudacogora, Augustin (2008) *Fictions, témoiganges et autres genres littéraire du génocide dans le camp littéraire rwandais après 1994.* Thèse pour le Doctorat de l'Université de Paris-Nord (Littérature comparée).

Rugamba, Cyprien (1987) *La Poésie face à l'histoire. Cas de la poésie dynastique rwandaise,* Butare: I.N.R.S.

Taylor, Christopher C. (1988) 'The concept of flow in Rwanda popular medicine', *Social Science and Medicine*, 27(12): 1343–8.

—(1992) *Milk, Honey and Money. Changing Concepts in Rwandan Healing*, Washington/London: Smithsonian Institution Press.

—(1999) 'He laughs with you yet he hates you: mistrusting Rwandan refugees' (29 October), http://btcs.wisc.edu/taylor.pdf

Vidal, Claudine (1978) 'Les anthropologues ne pensent pas tous seuls', *L'Homme* 18, no. 3–4, 111–22.

—(2002) 'Rwanda 1994. L'imaginaire traditionnel perverti par le génocide', *L'Homme,* no. 163, 202–16.

Whitworth, Wendy (ed. in association with Kigali Memorial Centre, Rwanda) (2004), *We Survived. Genocide in Rwanda: 28 Personal Testimonies.* Aegis Trust.

10

The Aesthetics of Diaspora: Sensual Milieus and Literary Worlds[1]

Pnina Werbner and Mattia Fumanti

Transnational diaspora aesthetics

What would a distinctively anthropological analysis of transnational diaspora aesthetics look like? In the present chapter, we propose to argue that the aesthetics of diaspora are constituted by the sensual and performative media through which diasporans enact their felt autonomy, while laying claims to 'ownership' of the places and nations in which they settle. The debate so far in cultural and postcolonial studies has centred mainly on the high-cultural products of diasporic musicians, artists and novelists, their capacity to create a 'third space', a hybrid culture that fuses distinct aesthetic traditions and challenges 'pure' narratives of nation. Even analyses of popular music primarily stress their resistive lyrics.[2] Our aim is to move beyond a focus interpretation of such cultural texts to examine the appropriation of both high and popular cultural transnational aesthetics as an experiential, embodied process. Over and above the focus on diasporic artists' and intellectuals' impact on their receiving societies, we want to shift the gaze to the internal affect and sense of ownership of transnational aesthetics has on diasporic or exilic communities from the late colonial period to the present age of cultural globalization, of a digitized world in which the appropriation of films, videos, cassettes, popular music, CDs, or celebrity culture opens up new spaces for celebration and 'community' that enhance diasporas' self-referential claims to distinction.[3]

In theorizing the very possibility of a transnational aesthetics, our primary focus is on aesthetics as more than merely 'sensuous cognition', in Wiseman's definition (2008: 7). Our definition encompasses 'sensuous *participation*' – the appreciation and making of beauty, distinction and sheer sensual pleasure as these come to be embedded and re-embedded in social worlds of literary, artistic, musical and performative celebration in diaspora. The affective *power* of transnational aesthetics, of the milieus imported and actively (re)created in exile through oratory, objects, foods, music, dance and drama, derives not merely from a nostalgic desire to

recapitulate or replicate a lost ambience. It emerges from dialogical forging, in the here and now, of shared canons of taste among diasporic producers and consumers who collectively define what makes for social distinction, and who together recreate the pleasure of joint celebration and worship.

The transnational appropriation of aesthetic literary and embodied performative traditions, objects, sartorial styles, foods and other paraphernalia in the diaspora points to the transformational power of *mimesis*: that which appears on the surface to be derivative and imitative, taken from elsewhere, engenders authentically felt cultural competences and a subjective sense of ontological presence. Thus it is that diasporic sociality and aesthetic cultural performance create the grounds for *appropriation* and *ownership* in the alien place of non-ownership, that is, in the diaspora, the site of exile. Stressing mimesis as the basis for newness follows theorists such as Derrida, for whom there is no original authentic truth, *logos,* only spiralling repetitions in shifting contexts, each with its own trace or 'supplement'. Derrida thus recognizes that apparent repli-cation and repetition nevertheless create *différance,* a deferral and distinction – hence a new product – through performative iteration (Derrida 1981: 168; 1982). As Benjamin too has argued, given that no literary work is ever fixed, every translation is also an act of creativity (Benjamin 1968: 72, 79). It is therefore false to glorify the hybrid products of diaspora as being in some sense superior to the 'mere' reincorporation of transna-tional popular culture. At the most modest level, popular aesthetics enables migrants to forge encapsulated worlds of alternative cultural celebration within the nation. These too constitute liminal, 'third' spaces, in Homi K. Bhabha's terms (1994); they too subvert, by their very presence, a singular, homogeneous national narrative.

Though mostly invisible, such diasporic aesthetics sometimes surfaces into the open in street fiestas, carnivals, festivals and processions that re-envisage the nation as multicultural and plural. As a kind of liminal ritual or performance, diasporic carnivals such as Notting Hill, analysed by Abner Cohen (1993), lay claim to and sacralize the streets of their adopted cities. Carnival in Notting Hill commemorates the racial violence that occurred on its streets and the confrontations with the police, but at the same time it also celebrates multiculturalism and the potential for living in racial harmony – this despite the fact that, as Cohen points out, the 'we' of carnival has changed over the years and continues to change.

To the extent that they reach beyond the encapsulated diaspora group, the aesthetic works of diasporic artists have the capacity to 'interrupt' cultural narratives of colonial hegemony or national singularity, as postcolonial theorists recognize. Outstanding works of high culture such as José Rizal's anti-colonial novel, *Noli me Tangere,* a novel written in Spanish in Madrid and Paris and published in Berlin, illustrate the power of aesthetic works produced in diaspora to irreversibly transform world politics and imaginaries of nationhood. Conceived in exile about a nation-in-the-making, Rizal's novel is, for Benedict Anderson, the first example of a foundational text that evokes the 'simultaneity' of the imagined community, in this case of the Philippines as a nation, even prior to its existence.[4]

Diaspora studies have long emphasized the role and power of hybrid works to challenge or transgress fixed, essentializing imaginaries of the nation. Three authors in particular have contributed significantly to this debate: Homi Bhabha (1990; 1994), Stuart Hall (1990; 1991), and Paul Gilroy (1993). All three stress the fluid, contingent nature of national identity. Gilroy goes further than Bhabha or Hall in arguing that the hybrid works of diasporic artists and intellectuals make claims to ownership; in the case of the Black Atlantic, of modernity and its intellectual traditions. Though more implicit, the remaking of the nation by diasporic artists and intellectuals in the critical writings of Bhabha and Hall effectively imply a validation of diasporic claims to full citizenship and hence ownership, even though, paradoxically, these very artists may deny the legitimacy of the bounded nation.

But hybridity, ambivalence and the Black Atlantic, while remaining seminal concepts for any discussion of the aesthetics of diaspora experience, leave behind what for a better word can be referred to as a *vernacular* and *encapsulated* aesthetics. This is a sense of aesthetics that is cultivated within immigrant diaspora groups, often in the confines of their own gatherings and celebrations. It is an aesthetics that is popular, sensual, materially embedded in aesthetic performance and objects, and frequently exclusive. It forms the grounds for competitive recognition and distinction within, and not simply beyond diasporic groups. It is an aesthetics that is not exclusively made and consumed by and for intellectual and diasporic elites. It is not the aesthetics of diasporic novelists such as Salman Rushdie, nor does it aim to reach wider audiences, as they do. This 'ethnic' aesthetics does not engage with the national or global public spheres. It remains owned by ethnic groups whose members often defend its production and consumption as authentic expressions of cultural and ethnic identities, sometimes even fighting and competing over who 'owns' or controls this or that aspect of their shared culture.

Ethnic and national distinctions remain important, however, for a conceptualization of diaspora aesthetics. Diasporas often borrow from other aesthetic traditions to create hybrid forms. If these aesthetics remain encapsulated and hidden from the mainstream, they nevertheless engender a sense of worth and distinction in otherwise marginalized groups. Through diasporic investment in the creation of aesthetic spaces, members of diaspora transform ugly concrete structures, school halls in London or Tel Aviv, into pleasurable, homely places. Through performance, diasporic groups enact narratives of diaspora subjectivity.

By appropriating local space and imbuing it with a transnational aesthetics, whether of Indian cinema enacted and performed by Indian Jewish immigrants in Israel, Yoruba aesthetics revitalized by Ghanaians in London and New York, or Filipino ambiences recreated by migrant workers in Israel, immigrants and diasporics lay claims to being and ownership. These processes are not simply outward-looking, subverting pure narratives of nation; they are inward-looking and invisible to outsiders. As Werbner has argued, diasporans craft 'alternative identities and lifestyles in the invisible spaces [they] create for themselves, far from the public

eye' (2002: 16). Such spaces are symbolically shaped as 'moments set apart from the flow of the quotidian, of the taken-for-granteds of everyday life'. In arguing thus, we draw first on Don Handelman's (1990) exploration of the 'architectonics' of public events as the crystallizations of particular symbolic complexes and representation of self and community, but also as negotiated encounters or social situations' (ibid.). Second, we refer to Bourdieu's and Lefebvre's analyses of social spaces as imaginatively and materially constructed, yet empowered or negotiated through contestation (Lefebvre 1974/1991; Bourdieu 1985). Because public arenas are symbolically constructed, we propose, the spaces they open up are also cultural embodiments of historically situated identities.

Hence, vernacular and encapsulated aesthetics, in being sensuous, are also ontological, in the sense of making existential claims to belonging. Diasporans actively mark their presence in the diaspora, their 'being-in-the-world' in a Heideggerian sense, as Fumanti argues (2013). Through aesthetically contrived performances, they actively (re)make their subjectivities. This ontological dimension of diaspora aesthetics is a critical feature of transnational aesthetics: the fabrication of a 'multisensorial ambiance,' a space of multiple sensorial experiences that enriches diasporans' sense of self. The emphasis on this multisensorial ambience suggests the potential contribution anthropology can make to a theory of diaspora which focuses on participatory celebration and sensuous pleasure.

Between mana, aura and charisma: Ethno-aesthetics, ontology and mimesis

In a volume entitled *Lévi-Strauss, Anthropology and Aesthetics*, Boris Wiseman (2008) critiques Alfred Gell's argument (1998) that anthropology and aesthetics are incompatible – above all, according to Gell, because in pre-modern societies art is not assigned to a separate sphere as it came to be in eighteenth-century Europe. In the societies anthropologists study, Gell contends, manufactured objects are valorized not for their 'pure' aesthetic qualities but for their occult, ritual power and agency; they are subjectified and humanized through their use and circulation in networks of persons, whose own personhood, in turn, is distributed and dispersed through the movement of these magically powerful objects associated with them. Against the opposition Gell poses between the modern and the pre-modern, however, Wiseman proposes that in Lévi-Strauss' ethno-linguistics, the power and effect of both crafted pre-modern artefacts and 'modern', imaginatively created art objects is similar: in both Western and pre-modern ('primitive') societies, the perceived 'world' is 'detotalised' and 'retotalised' via such objects (Wiseman 2008: 39). The result is a symbolically structured product that exteriorizes mental processes to give them their magical power (ibid.: 31–2). The object is emotionally pleasurable because it both represents and exceeds reality, engaging in a dialogue between necessity and

contingency (ibid.: 30) and mediating between humanity and the phenomenological world: a 'means by which we come to "know" the world as well as construct a certain sense of self' (ibid.: 31).

Even apart from an obvious objection to Gell's anti-historical relegation of anthropology to the study of pre-modern societies, Wiseman notes that in pre-modern societies as in modern ones, according to Lévi-Strauss, there are aesthetic specialists of what he calls 'wild modes of thought' (ibid.: 34 *passim*). Whether shamans or modern artists, they inhabit the margins, mediating between the symbolic order and that which exceeds this order (ibid.: 22, 21–3). In Walter Benjamin's historical account of movements in art, the *aura* of an object of art, its powerfully compelling charisma, is intrinsically linked with the artist who created it. This aura, Benjamin proposes, has replaced the occult power or mana of pre-modern objects: if 'originally the contextual integration of art in tradition found its expression in the cult,' then it

> ... is significant that the existence of the work of art with reference to its aura is never entirely separated from its ritual function. In other words, the 'unique' value of the 'authentic' work of art has its basis in ritual, the location of its original use value. (Benjamin 1992: 217)

The comparison can be taken even further: just as the aura of a work of art increases with the succession of prestigious owners who possess it, so too *kula* valuables gain mana and prestige as the chain of great chiefs who once owned them is lengthened. Although, according to Benjamin, photography has finally 'emancipated' art from ritual (ibid.: 218), the aura of films has not vanished in the age of mechanical reproduction: it has been displaced onto film stars.

Hence we may claim as anthropologists that the magical attraction, mana or charisma of artists, shamans and objects is not unique to either modern or pre-modern societies. Indeed, as Bourdieu has argued, key actors in the contested field of art are those with the symbolic capital to 'consecrate' the 'charisma' of an artwork (1993a: 76–7). Art objects imbue their users and surroundings with their powerful mana. Conversely, it is in the context of diasporic celebratory performances – totalizing sensory experiences-in-the-making – that the intensity of aesthetic expression reaches its zenith. Such moments of collective effervescence endow aesthetic objects and acts with magical, occult, power and truth.

Thus, for example, kente cloth in Ghanaian shrines in New York City is redecorated, Jane Parish argues (2013), in response to the magical charisma of celebrities and the city itself (see Figure 10.1); Claudia Liebelt describes the loving decoration of an icon of the Virgin Mary carried through the streets of Tel Aviv by Filipina migrant carers (2013) (see Figure 10.2), while Mattia Fumanti considers the aesthetics of Ghanaian sartorial styles for different rituals and celebrations (2013) (see Plate 17). Ghanaians living in London display in vivid colours their aesthetically grounded

Figure 10.1 A small section of a customized Kente Cloth (photo: Jane Parish).

sense of propriety and moral superiority vis-à-vis their host nation and other ethnic groups. Mama Mary icons adorning lovingly decorated domestic altars create their own 'sacriscape' of gendered sensual and affective aesthetics, in a collective effort to sanctify urban spaces constructed as dangerous and fraught with sin and temptation: Mama Mary embodies compassion, refuge and protection and through her migrants appropriate and assert cultural claims while living in exile.

In all these cases objects, dance or music-making are embedded in wider sensuous-aesthetic contexts. The significance of these wider performative contexts is increasingly recognized as central to an adequate theorizing of an anthropology of aesthetics (Gell 1998; Pinney and Thomas 2001; Morphy and Perkins 2006). Not only do objects come to be deployed and redeployed in ritual and myth; an adequate anthropological theory of art and aesthetics needs to disclose how such manufactured objects, music or dance are encompassed in the totality of human sensuous production and appreciation.

Works on ritual have often stressed the multisensorial dimensions of ritual as embodiment (Feld 1982; Stoller 1989; Geurtz 2002), as well as the aesthetic performative skills of ritual specialists (Gore 2007). Despite the growing anthropological literature on culture and the senses, however, sensory experiences and the phenomenology of the senses are only rarely and intermittently explicitly applied to the theory of aesthetics expounded here. Even sensory anthropology advocates

Figure 10.2 Shared domestic altar of Filipina domestic workers in southern Tel Aviv (photo: Claudia Liebelt).

such as Howes stresses that 'contemporary Western aesthetics is almost exclusively visual' (Howes 1991: 6).

Instead, we want to follow Adam Chau, who stresses human participation as actively making the social sensorium into an aesthetics of

> ... noise, heat, taste, smell, spectacle, etc. (through speaking, shouting, singing, drumming, making music, blasting the speakers, honking, chanting, clapping, dancing, sweating, getting hot, embracing, caressing, cooking, feasting, toasting, bathing, smoking, perfuming, dressing, setting off firecrackers, lighting incense or candles, processing, engaging in games or battles, torturing, etc.). (Chau, 2008: 490, see also 495)

This point resonates with a number of contributions we make in our special issue on the 'Aesthetics of Diaspora' (Werbner and Johnson 2013). In her paper on Indian Jewish immigrants from India to Israel, Gabriele Shenar (2013) shows that for first-, second- and even third-generation Bene Yisrael, as they are known, Indian cinema – Bollywood – remains a consuming passion. But films are not there only to be viewed; the aesthetics of Indian Bollywood culture must be *performed* in song, dance and more broadly, by creating whole, set-apart aesthetic milieus through festivals, *mehndi* (henna) rituals and other celebrations. Against the folklorists' dismissal of Indian movies as inauthentic cultural *kitsch,* Bene Yisrael appropriate the popular cultural sensorium represented in Bollywood films to create an active, participatory, multisensual performance, which mobilizes smells, tastes, sounds, music, dance, drama, costumes and oratory in an atmosphere of celebration and sheer pleasure. Through such performances Bene Yisrael also *emplace* themselves as integrally part of the wider South Asian diaspora worldwide (on Bollywood consumption in the diaspora see, for example, Kaur and Sinha 2005). They create a tangible, sensuous connection back to India (Plate 18).

Sartorial and cosmetic self-adornment are central to the embodiment of distinction in many diasporic groups. At times they are highly visible and even jarring to others, as is the case for the Islamic veil (Tarlo 2009). Tarlo shows how the hijab scarf is not simply functional or static but has become an object of beauty and fashion for its wearers; hijabi veils as consumer objects have been incorporated into a spiralling global aesthetics detached from their functional use (see Navarro-Yashin 2002: Ch. 3). Similarly, for Akan diasporans their clothes are not simply objects made for consumption, as Fumanti argues (2010, 2013); they are embodied, coming to life only when worn by a person. Dress without a body is an inanimate object that requires incorporation within an aesthetically understood language to be endowed with ontological value and 'presence'. Such displays of aesthetic beauty or 'fashion' are experienced ontologically and cannot simply be dismissed as imitation.

Encapsulation is central for the making in diaspora of a space that is home, one which has a distinct atmosphere, an 'ambience'. We take the term ambience from Friedman's analysis of Congolese young migrants living in France and Belgium (1994:

Ch. 7). *Les sapeurs*, the society of elegant people, as the acronym SAPE (Société Ambienceurs et Personnes Elegantes) reveals, are the eponymous example of sartorial elegance and ambiance in the diaspora. Ambiance refers to a multisensual space that is embedded in community and transformative of the person as a subject. Ambience enables a diasporan to become a proper person, morally, ethically and aesthetically.

Thus our approach to vernacular aesthetics in this volume remains deeply ontological, in the sense of being 'concrete and rooted in experience' (Wiseman 2007: 24). For Lévi-Strauss, ethno-aesthetics are rooted in a sensory experience of the world. Drawing on Baudrillard's theorization of postmodern commodity production, Parish shows that in their endeavours to capture for their clients the charisma of film stars, Akan priests in New York sew or glue strips of Hollywood stardom onto the shrine's valuable 'authentic' African Kente cloth, imported from Ghana, in an act of powerful mimesis, to create a hybrid collage of sacred devotion. One shrine priest, for example, had stuck photographs of Robert De Niro, Leonardo Di Caprio and Tom Cruise on his Kente cloth, alongside photographs of elegant eateries in New York City allegedly frequented by the 'stars', and pictures cut from magazines of rich and famous hideaways in the Hamptons, Martha's Vineyard and Nantucket. How are we to understand this appropriation of the charismatic power of a distant Other? Michael Taussig reminds us of 'the power of the copy to influence what it is a power of' (1993: 250).

The relationship between the senses and place has been much debated in recent years in anthropology (Classen 1997; Cohen 1998; Law 2005; Stoller 1989; Taussig 2004). In particular, Steven Feld and Keith Basso (1996) have argued that anthropologists should analyse the 'cultural processes and practices through which places are rendered meaningful – through which, one might say, places are actively sensed' (1996: 7). Diasporans invest time, effort and money in transforming nondescript, mundane and ugly public buildings into milieus in which all the senses are awakened in a rich display of sartorial elegance, abundant food and loud music. These celebrations and rituals are often videoed, to be sent back home, in the case of Ghanaians (Fumanti 2013), or to record the visits of Indian artists, in the case of Bene Yisrael (Shenar 2013), thus creating and recreating a shared transnational aesthetic community. Yet, as I have argued elsewhere (Werbner 2005), the translocation by Pakistani immigrants of cultural practices to Britain was never automatic, a matter of nostalgic clinging to 'tradition', but the product of locally situated gendered and generational power struggles among men and women, young and old. In their celebrations women enact and parody men.

Such satirical performances contribute to the creation of a complex, pluralized diasporic public sphere in which different cultural aesthetic traditions are celebrated (Werbner 2002: Ch. 7; 2005). Ultimately, then, diaspora is a not just a matter of 'imagining'; it is a material project requiring investment of resources, labour and imagination by self-motivated actors within the diaspora (see contributions to Leonard and Werbner 2000).

Writing the nation from afar: The literary art worlds of writers in exile

We turn now, in this final section, to the elite aesthetic works of diaspora referred to at the outset. One of the remarkable features of the late nineteenth to mid-twentieth century writers' landscape in Paris, London, Madrid and Berlin was the extent to which writers in exile created literary art 'worlds' away from home. These often centred on publishing houses, bookshops and small literary journals with limited circulation. Hence we find that the *ilustrados,* the Filipino novelists, artists and journalists who are the subject of Mark Johnson's article (2013), formed a dense network of compatriots in Madrid centred around *La Solidaridad,* the critical journal of the Propaganda movement produced in Barcelona (Anderson 2005: 96–104; Schumacher 1997). These artists and writers met in cafés, homes or art studios, such as that of the Filipino painter Juan Luno in Madrid, or the salons of wealthy Filipinos living in other European cities (Reyes 2008: xxvi, 108). They formed connected networks across Western Europe to the Philippines. José Rizal, a polyglot doctor, novelist and critic whose execution by the Spanish made him the Philippines' sanctified national hero, lived in no less than five European cities during his ten-year stay in Europe, a fact marked in street names and plaques in many European cities, including 'the singular distinction of having a garden square named after him in Paris, and a monument erected in his honour in Madrid' (Reyes 2008: xi).

Like the *ilustrado*, some 40 years later, the 'lost generation' of modernist American and Irish diasporic novelists, from Ernest Hemingway to James Joyce, clustered in Paris around 'Shakespeare and Company', a small English lending library-cum-bookshop located on the Left Bank that was owned by a remarkable American woman, Sylvia Beach. Beach acted as intellectual interlocutor, banker, confidante, postal address, patroness and much-loved friend, mediating among American writers and between them and the literary French *avant-garde* in Paris during the inter-war period. She became, ultimately, the publisher of *Ulysses* after Joyce moved from Trieste to Paris, and after all attempts to find an established publisher had failed. Her bookshop displayed banned books and held regular readings by distinguished writers living in or passing through Paris (on Beach and this period see Fitch 1983). Gertrude Stein's weekly salon was another gathering point for American writers in exile.

Francophone black African writers in Paris from the 1940s onwards clustered around another publisher-cum-bookshop and journal, *Présence Africaine*, which hosted African writers' international conferences and was home to what became known as the *négritude* or pan-African movement. For several decades, Bennetta Jules-Rosette tells us, *Présence Africaine* 'was instrumental in organising the cultural space, institutional frameworks, and market opportunities for African writing' (Jules-Rosette 1998: 2). Most American writers came to Paris because it was cheap and because that was where their readership lived. As Fitch says, 'For two

hundred years – from Benjamin Franklin to James Baldwin – (American) writers have sought Paris, walked the same streets, stayed often in the same hotels' (Fitch 1983: 163).

Despite the ubiquity of these diasporic writers' circles living in 'exile from exile', Rizal stands out as almost unique, one of the few exilic novelists to recreate in nineteenth-century realist style, tinged with humour, cruel satire and a hint of magical realism, a 'nation': the superficial manners and lifestyle of bourgeois mestizo Philippine society, the colony's elaborate class structure and deep racist biases, the unthinking gaiety of its leisured youth, the gross absurdity of its social climbers, the misery of its peasants, and above all the mendacity, sheer cruelty, greed and promiscuity of the friars who controlled the colony with an iron grip. His novel, *Noli me Tangere,* evokes an ominous sense of imminent threat and looming disaster as the nefarious plans of the clerical protagonists unfold inexorably to their tragic dénouement. The immediacy and vividness of the novel's descriptions, testimony to the power of the novelist's imagination in exile, invoke the existence of the Philippines as a 'nation' and tell a story of violent and non-violent resistance to colonial oppression.

The point for our broader argument, that diaspora aesthetics are embedded in sociality, is that the critical ideas expressed by Rizal through the novel, and even more explicitly in his polemical articles and essays, *were not uniquely his* (see Johnson 2013; Reyes 2008: Ch. 4). They were shared by other members of an elite new Filipino group known as the Propaganda movement, composed of young Filipinos educated to university level in the Philippines, which at the time boasted the only university in the whole of Asia. Their aim was to liberate the Philippines, for the first time grasped as a single country despite its multitude of islands, peoples and dialects, from arbitrary colonial rule and particularly from the stranglehold of the clergy. Few other diaspora authors have written such foundational novels narrating their nations as imagined communities. Among these, Joyce's *Ulysses,* set in Dublin on a single day, and Rushdie's *Midnight's Children,* invoking the polyglot multitudes of India, stand out exceptionally as modernist and postmodernist works respectively depicting, unforgettably, from afar, the imagined nations of their authors' birth. All three novels, as well as being experimental, are trenchant political and social critiques, and all were either banned (*Noli, Ulysses*) or regarded as defamatory (*Midnight's Children*)[5] in the countries whose stories they narrate so memorably.

Whatever the art medium, musicians, artists, playwrights, filmmakers, performers or writers often gather in diaspora to constitute art worlds in the sense analysed by Howard Becker (1983). Complex divisions of labour in such art worlds apply not merely to theatrical or cinematic productions but, equally, to the works of apparently lone artists. They too rely on resources, distribution networks, aesthetic conventions, critics, publishing houses, museums, galleries, collectors and audiences within a field of competitive cultural production which, as Bourdieu has shown, confers

distinction (Bourdieu 1984; 1993a: 34–5, 74–111). Significant in the case of postcolonial writers is that they wrote in the language of the colonizers.

Johnson (2013) argues against Bourdieu's 'methodological nationalism' that it fails to include the colonial world. The racism of the metropolis impelled the early Filipino artists and writers in Europe towards imagining a Filipino nation. That, in turn, created the possibility of hybridity – a kind of dual movement of detachment and appropriation – from the elite colonial habitus they were originally schooled in but which they now had to reclaim in new ways as their own. Thenceforth the Filipino homeland that they were both literally and figuratively distant from had to be recreated and constructed as theirs, which meant, in turn, creating for themselves a legitimate and recognizable Filipino historical past. Cultural and aesthetic appropriation, Johnson shows, implied being forced to encounter and remake anew that from which they were in part forcibly and in part electively estranged and excluded.

Conclusion

To sum up, then, we have argued here for the need to explore a multisensual, ambient, ontological diaspora aesthetics, embedded in sociality and actively produced by participants, much of it invisible to outsiders, oriented to transnational audiences elsewhere or members of encapsulated local communities in the diaspora. We argued that diaspora aesthetics is sometimes, but not always, the work of elites, nor is distinction reserved for dominant cultural groups within a society. Through performance, migrant groups, diasporans and artists in exile claim ownership both to their countries of origin and to the countries they choose to live in, whether temporarily or permanently, by creating liminal aesthetic spaces which are theirs, and which inevitably in the long run enrich the cultures of their new homes and adopted nations' identities.

Notes

1. The present chapter draws on the Introduction to a special issue of *Ethnos,* 78, 2 (2013) (see Fumanti and Werbner 2013). We are greatly indebted to the other contributors to the issue, Mark Johnson, Claudia Liebelt and Gabriele Shenar. We would also like to thank the editors and publisher of *Ethnos* for permitting us to use the Introduction, and in particular Nils Bubandt, *Ethnos* editor, and Raminder Kaur, editor of the present volume, for their perceptive and helpful comments.
2. See, for example, Sharma, Hutnyk and Sharma 1997, or Gilroy's (1993) discussion of music.

3. We use community loosely here, to refer to any social group within a diaspora whose members perceive themselves to share distinctive cultural understandings and, quite often, a sense of 'amity, mutual support, and homeliness' (Bauman 2000).

4. Anderson (1983: 26–8); for an inspiring discussion of the aesthetics of Rizal's two novels, see Anderson (1998: 235–62); and for a detailed historical account of Rizal and his compatriots' involvement in the anti-colonial movement, see Anderson (2005: 9–167).

5. *Midnight's Children* was almost sued by Indira Gandhi but she was assassinated before the suit could be pressed. *The Satanic Verses* by the same author was of course banned in India and Pakistan.

References

Anderson, Benedict (1983) *Imagined Communities: Reflections on the Origins and Spread of Nationalisms,* London: Verso.

—(1998) *The Spectre of Comparisons: Nationalism, Southeast Asia and the World,* London: Verso.

—(2005) *Under Three Flags: Anarchism and the Anti-Colonial Imagination.* London: Verso.

Bauman, Zygmunt (2000) *Community: Seeking Safety in an Insecure World,* Cambridge: Polity Press.

Becker, Howard S. (1983) *Art Worlds.* Berkeley: University of California Press.

Benjamin, Walter (1973) *Illuminations,* trans. Harry Zohn, London: Fontana.

Bhabha, Homi K. (1994) *The Location of Culture,* London: Routledge.

Bourdieu, Pierre (1984) *Distinction: A Social Critique of the Judgement of Taste,* trans. Richard Nice, London: Routledge.

—(1993a) *The Field of Cultural Production,* Cambridge: Polity Press.

—(1993b) 'Concluding Remarks: For a Sociogenetic Understanding of Intellectual works', in *Bourdieu: Critical Perspectives,* Craig Calhoun, Edward Lipuma and Moishe Postone (eds), Cambridge: Polity Press, 263–75.

Casey, Edward S. (1996) 'How to get from Space to Place in a Fairly Short Stretch of Time: Phenomenological Prolegomena', in *Senses of Place,* S. Feld and K. H. Basso (eds), Santa Fe NM: School of American Research Press, 13–52.

Chau, Adam Yuet (2008) 'The sensorial production of the social', *Ethnos,* 73(4): 485–504.

Classen, Constance (1997) 'Foundations for an anthropology of the senses', *International Social Science Journal,* 49(3): 401–2.

Cohen, Abner (1993) *Masquerade Politics*, London: Berg Publishers.

Cohen, Erik (1988) 'The broken cycle: smell in a Bangkok soi (lane)', *Ethnos* 53, 1–2: 37–49.

Derrida, Jacques (1981) *Dissemination,* trans. Barbara Johnson, Chicago: University of Chicago Press.

—(1982) 'Différance', *Margins of Philosophy,* trans. Alan Bass, Chicago: University of Chicago Press, 3–27.

Durkheim, Emile (1915) *The Elementary Forms of Religious Life,* London: George Allen & Unwin.

Ernst, Ernest (1968) *Expatriates and Patriots: American Artists, Scholars and Writers in Europe,* Durham, NC: Duke University Press.

Feld, Steven (1982) *Sound and Sentiment: Birds, Weeping, Poetics and Song in Kaluli Expression,* Philadelphia: University of Pennsylvania Press.

Feld, Steven and Basso, Keith H. (1996) 'Introduction', in *Senses of Place,* S. Feld and K. H. Basso (eds), Santa Fe, NM: School of American Research Press, 3–12.

Fitch, Noel Riley (1983) *Sylvia Beach and the Lost Generation: A History of Literary Paris in the Twenties and Thirties,* London: Souvenir Press.

Friedman, Jonathan (1994) *Cultural Identity and Global Process,* London: Sage.

Fumanti, Mattia (2010) '"Virtuous citizenship": ethnicity and encapsulation among Akan-speaking Ghanaian Methodists in London', *African Diaspora,* 3(1): 13–42.

—(2013) '"Showing-off aesthetics": looking good, making relations and "being in the world" in the London Akan diaspora', *Ethnos* 78(2): 200–225.

Fumanti, Mattia and Werbner, Pnina (eds) (2010) 'The moral economy of the African diaspora: citizenship, networking and permeable ethnicity', *African Diaspora,* 3(1): 3–12.

—(2013) 'Introduction: The aesthetics of diaspora: ownership and appropriation', in Pnina Werbner and Mark Johnson (eds), 'The Aesthetics of Diaspora', special issue of *Ethnos,* 8(2): 149–174.

Gell, Alfred (1998) *Art and Agency: An Anthropological Theory,* Oxford: Oxford University Press.

Geurtz, Kathryn Linn (2002) *Culture and the Senses: Bodily Ways of Knowing in an African Community,* Berkeley: University of California Press.

Gilroy, Paul (1993) *The Black Atlantic: Modernity and Double Consciousness,* London: Verso.

Gore, Charles (2007) *Art, Performance and Ritual in Benin City,* Edinburgh: Edinburgh University Press.

Hall, Stuart (1990) 'Cultural Identity and Diaspora', in *Identity: Community, Culture, Difference,* Jonathan Rutherford (ed.), London: Lawrence and Wishart, 222–37.

—(1991) 'Old and New Identities, Old and New Ethnicities', in *Culture, Globalisation and the World System,* A. D. King (ed.), London: Macmillan, 42–68.

Johnson, Mark (2013) 'The aesthetics of diaspora in colonial fields of power: elite nationalism, art and the love to die for', *Ethnos* 78(2): 175–199.

Joyce, James (2000 [1922]) *Ulysses,* London: Penguin Classics.

Jules-Rosette, Bennetta (1998) *Black Paris: the African Writers' Landscape,* Urbana, IL: University of Illinois Press.

—(2007) *Josephine Baker in Art and Life: the Icon and the Image,* Urbana, IL: University of Illinois Press.

Kaur, Raminder and Sinha, Ajay J. (eds) (2005) *Bollyworld: Popular Indian Cinema through a Transnational Lens*, London: Sage.

Law, Lisa (2005) 'Home Cooking: Filipino Women and Geographies of the Senses in Hong Kong', in *Empire of the Senses: The Sensual Culture Reader,* David Howes (ed.), Oxford: Berg, 224–42.

Leonard, Karen and Werbner, Pnina (2000) 'The Materiality of Diaspora', special issue of *Diaspora: A Journal of Transnational Studies*, 9(1).

Liebelt, Claudia (2013) 'Consuming pork, parading the virgin and crafting origami in Tel Aviv: Filipina care workers' aesthetic formations in Israel', in Mattia Fumanti and Pnina Werbner (eds), 'The Aesthetics of Diaspora', special issue of *Ethnos*, 78(2): 255–279.

Monk, Craig (2008) *Writing the Lost Generation: Expatriate Autobiography and American Modernism,* Iowa: University of Iowa Press.

Morphy, Howard and Perkins, Morgan (2006) *The Anthropology of Art: A Reader,* Oxford: Wiley-Blackwell.

Navaro-Yashin, Yael (2002) *Faces of the State: Secularism and Public Life in Turkey,* Princeton, NJ: Princeton University Press.

Parish, Jane (2013) 'The curse of celebrity: Akan witchcraft and New York City,' *Ethnos*, 78(2): 280–300.

Pinney, Christopher and Thomas, Nicholas (2001) *Beyond Aesthetics: Art and the Technologies of Enchantment,* Oxford: Berg Publishers.

Reyes, Raquel A. G. (2008) *Love, Passion and Patriotism: Sexuality and the Philippine Propaganda Movement, 1882–1892,* Singapore: Singapore University Press.

Rushdie, Salman (1981) *Midnight's Children,* London: Picador.

—(1988) *The Satanic Verses,* London: Verso.

—(1991) *Imaginary Homelands: Essays and Criticism 1881–1991,* London: Granta.

Schumacher, John S. (1997) *The Propaganda Movement 1880–1895* (rev. edn), Manila: Ateneo de Manila University Press.

Sharma, Sanjay, Hutnyk, John and Sharma, Ashwani (eds) (1993) *Dis-orienting Rhythms: Politics of the New Asian Dance Music,* London: Zed Books

Shenar, Gabriele (2013) 'Bollywood in Israel: multi-sensual milieus, cultural appropriation and the aesthetics of diaspora', *Ethnos* 78(2): 226–54.

Stoller, Paul (1989) *The Taste of Ethnographic Things: the Senses in Anthropology,* Philadelphia: University of Pennsylvania Press.

Tarlo, Emma (2010) *Visibly Muslim: Fashion, Politics, Faith,* Oxford: Berg Publishers.

Taussig, Michael (1993) *Mimesis and Alterity: A Particular History of the Senses,* London: Routledge.

—(2004) *My Cocaine Museum,* Chicago: University of Chicago Press.

Werbner, Pnina (2002) *Imagined Diasporas among Manchester Muslims: The Public Performance of Pakistani Transnational Identity Politics,* Oxford: James Currey.

—(2005) 'The translocation of culture: migration, community, and the force of multiculturalism in history', *Sociological Review,* 53(4): 745–68.

Werbner, Pnina and Johnson, Mark (eds) 'The Aesthetics of Diaspora', special issue of *Ethnos,* 78(2).

Wiseman, Boris (2008) *Lévi-Strauss, Anthropology and Aesthetics,* Cambridge: Cambridge University Press.

11

For Love's Sake? Changing Landscapes of Sonic and Visual Aesthetics of Weddings in the Kathmandu Valley (Nepal)

Christiane Brosius

Over the past decade, and particularly with Bollywood's[1] emphasis on (love-cum-arranged) marriage, weddings have become a globalized emblem of 'Indian' tradition, economic boom and lifestyle worldwide, since they promise a successful display of status, wealth and happiness. Weddings – like films and tourism – are a lucrative industry of a rapidly growing consumer society in (middle-class and elite urban) India (Brosius 2011, 2010). The language of glamour found in celebrity magazines, combined with ethnic and folklorized costumes and themed environments, have become dominant tropes that also spilled into the language of festivals and rituals in neighbouring South Asian countries. It is often assumed that the North Indian 'genre' of the 'Big Fat Indian (Hindu) Wedding' has become the accepted dominant form of weddings across South Asia (Brosius 2011). But this assumption is, at least to some extent, misleading. At the 'edges' and peripheries of this globalized and commodified landscape of ritual and media representation we find a variety of registers in which neither overtly 'Westernized' conspicuous consumption nor romantic love play a central role.

The chapter explores a particular way of framing and staging Newar marriage processions (*jantavanegu*) in the Kathmandu Valley by means of the wedding band and the wedding video. The focus of this chapter is precisely on these less 'glamorous' local events, on what Mark Liechty (2010) has so suitably entitled 'Modernity on the Global Periphery'. It does so by considering two highly performative 'media worlds' in the Kathmandu Valley of Nepal: wedding bands and videography. Both media worlds encourage us to deal with questions of imagined tradition and locality, ritual experience, aesthetics and emotions, with social structures beyond that of class. In the case of Nepal, Newari identity, for instance, hints at the fact that regionality and ethnicity in particular have become key markers of contested and, to some extent, conflicting political and cultural identities of local,

national and global colour. The Newars, members of the indigenous population of the Kathmandu Valley, constitute and combine multi-ethnic, highly elaborate Buddhist and Hindu religious practices, architecture and culture. By following local agents, in this case wedding bands and videographers, mainly of Newari origin, I also reflect research undertaken by Janaki Abraham (2010) and Shuddhabrata Sengupta (1999) and their emphasis on the authority and creativity of the cameraman during – and after (postproduction) – the wedding, as their work impacts and reflects the choreography, aesthetics and consumption of this crucial ritual. Most of the empirical material was collected between 2010–12 with participant observation among bands, and through interviewing band members, videographers, photographers, wedding hosts and guests in Bhaktapur and Kathmandu, mostly during the wedding seasons. The sites were chosen because of the high density of wedding bands active in these urban centres in Nepal.[2]

Nepal and India are neighbouring countries, yet there are notable differences between the two. Even though Bollywood music is very popular, the 'Big Fat Indian Wedding' syndrome is less prominent among the wedding band-leaders, photographers and videographers I spoke to. Undoubtedly, there is an aesthetic and iconographic flow of entanglements between the neighbouring countries. But there are also distinct and consciously selected differences and registers in the ways in which marriages are staged and framed by these two media realms, underlining an ambiguous positioning against mainstream Hindi film culture.

One apparent difference surfaces in what could be called a lack of interest in the theming of romance and signs of an 'international' lifestyle. There are a few instances in Nepali/Newar weddings where romance is 'coded' through sentimental film songs and visual backdrops such as waterfalls and flowers in the party palaces, the introduction of the wedding cake or an engagement ring. The staging of individual emotions such as romantic love or excited happiness is not perceived as being that important, as much as the bridal couple is not considered to be in need of a personalized choreography and display of romance and happiness. Other emotions and relations are at stake: the bonds of the parting bride towards her family she leaves behind, issues of caste and ethnic or national identity need to be audio-visually captured.

This may partly be due to the fact that consumer society in Nepal is not yet fully immersed in high capitalist leisure, even though Bollywood and, more recently, Korean films, may in some instances impact strongly on people's notions and imaginaries of lifestyle and romance, independence and internationality (see Liechty 2010: 189).[3] At times, and despite many parallels and overlappings in cultural and religious practices, India is seen as a (too) dominant and imposing neighbour, and a desire finds articulation that local cultures and rituals in Nepal must be clearly distinguishable from Indian mainstream commercial culture which is often perceived as dominating and 'alien'. Changes are certainly taking place, but the wedding choreography is surprisingly 'stable', though love-cum-arranged marriages are on the rise in the Valley.[4]

Despite these shifts, a major difference to globalized weddings is that romance as a pillar of individual subjectivity or happiness does not feature in the visual and narrative choreography in the Nepali context. Intimate feelings between two individuals are rendered invisible with the exception of the moment where the couple feeds each other for the first time affirming their commensual relationship (juto kuaunu or 'respect pollution'). What is known as Bridezilla syndrome[5] in the USA, and has also reached the shores of affluent urban Indians, is of little relevance in Nepal. Moreover, rather than class, ethnicity and locality seem to be centrestage in the performative, processual production of status (*though this is changing in some places*). This does not mean that personal emotions are irrelevant; very often they are tied to aspirations to connect to, and shape, modernity, to negotiate emotions as they are a means of embodying caste and ethnicity, class and consumerism (Liechty 2010). They are part of a social web, differentially shaped by music, space and bridal material culture. For instance, the songs are not arbitrarily chosen but reflect specific emotional qualities. With respect to wedding bands themselves, an aesthetic of ephemera is at play to do with the transience of the performative that shapes ecologies of absence and presence, where the band, for instance, creates an imaginary space with the music that is, at times, shared by the fact that the audience is familiar with the films and/or songs. Both wedding band and videos merge the taste of 'being modern', even global lifestyle with local canons of ethnicity or religious group, contributing to the emergence of a unique and multisensory aesthetic in each case, the first one with an offer of a tangible, both physical and symbolic experience at the site, the latter with a retrospective and edited interpretation of a past but memorable event.

'Band Baaja – Pyaar aaja'[6]

There was an asymmetrical ambiguity in the weddings and wedding videos I watched, based as they are on the desire for social networking and maintaining cultural heritage on the one hand, and following transnational trends on the other. This complex could be manifest in citations of popular folk songs and the emotional ecology borrowed from Hindi film or the hiring of a particular DJ and the cutting of the wedding cake. It is the combination of elements, their 'wheres' and 'whens' that is of interest for this chapter since, for instance, the simple presence of a DJ or a Hindi film song does not hint at a linear process on an imagined axis that moves from 'tradition' to 'globality', from 'ethnic' to 'transnational' or 'cosmopolitan'. Moreover, a closer look at the practitioners themselves allows for a more subtle analysis of differences across national borders, such as Nepal and India. Although in the Newari case the cameraman is important, and certainly a 'ritual expert', he does not seem to enjoy the same prominence and cinematographic authority of his Indian counterpart (Abraham 2010: 117–18). Despite their low class and caste status, the

wedding bands, are still seen as a public statement or 'speech act' (J. Austin), as signs of a successful arranged marriage and facilitator of auspicious atmosphere in Nepal. Quite differently, North Indian weddings do not consider the band as relevant for the creation of festive sanctity, or even intimate and yet collectively shared melancholy (see Booth 2005).

In the Valley, and during the wedding season, it is impossible to ignore a wedding band at work. They merge with and challenge other soundscapes of the city. The bands attract attention as they march through public space in line formations, often led by solo musicians – the band master and band proprietor, dressed in a dark Western suit – and a leading boy carrying their banner. Among the chaos and traffic noise of streets, moving through established neighbourhoods of the middle-class, new residential compounds, along dusty highways and past construction sites and fields, the wedding bands insert a different temporal and aesthetic layer as they block the traffic for a short time, capture the attention of workers, tourists, children and old people (Plates 19 and 20). Wherever they are, they create and mark a special time and place, an enclosed ritual space, sonically, visually and physically.

In 2010, there were approximately 65 brass bands in Kathmandu Valley; all of them specialized in weddings, differing from bands playing for other rituals, such as Newar boys' initiation (*vratabanda*), or the marriage of pre-pubescent girls to the bel fruit, or wood apple (*ihi* or *bel bibaha*,[7] see Gutschow and Michaels 2012). Their numbers are growing constantly due to more competition and demand, and because of an ongoing influx of people from other parts of Nepal into the Kathmandu Valley.[8] Many band members have known each other for years, if not decades, and one gets the impression of a men's business, and a 'family affair', a transfer of the profession from father to son, both often simultaneously engaged as band members. Band members largely come from the lowest castes, the Pariyār (Damāi) and Kapāli (Kusle), occupations known for sewing clothes and playing music on special occasions for their patrons. During the wedding season's peak time, 'seasonal' workers from India who also belong to the subcaste of tailors or shoemakers may join them. Sita Ram Pariyar from the Guheshvari Band states that the exclusivity of bands by caste is slowly changing since members from other, higher castes are also entering the market. This might be due to the decline in caste stigma, but also due to high unemployment and relatively secure income for band members.

The roamings of a wedding band follow a standard route and choreography. After playing at the groom's house and leading the procession to the house of the bride, the band remains and plays outside, with no other audience but neighbours or passers-by. The band marks a liminal space of ritual transition, outside the safety and cleanliness of private homes or wedding halls, guiding the marriage couple between marriage sites and musically as well as spatially appealing to, and potentially invoking key states and sentiments such as auspiciousness, sorrow and joy, and, last but not least, the pleasure of being entertained. Despite their importance in the overall choreography of the marriage, wedding bands are situated at the

margins of ritual space and impurity, precisely *because* they define and accompany liminality and thus are attendant with danger. They also do not feature centrally in the wedding videos and photo albums produced by professionals. Album and video have a different task, it seems, in Nepal, for they focus on attendance, taking notice of guests, the consumption of food, the display of presents, and some of the key rituals. Even though the wedding bands are seen as integral and even central to the public performance of wedding rituals, there is no need, it seems, to remember them in post-wedding forms such as albums and videos. Yet, so far no one would want to substitute them by a music system. Bands are relevant for a family's status declaration while leading the procession through the neighbourhood: the more band members, the more attention to and importance of the family hiring them. The band weaves together and transgresses borders between sacred and secular domains; it allures to both the world of deities and to that of popular Hindi films or Nepali folk culture, and it merges the taste of 'modern', even global lifestyle with 'traditional' canons and devotion. Nepali or Newari folk songs are clearly in the majority of the repertoire, for local music is very popular among old and young, associated with national or regional pride, with the joy of singing and dancing, and communal solidarity. Folkloristic tunes can be found on music albums, videos, and often recall a timeless Arcadian nostalgia for rustic and rural lifestyle and traditions. While the local tunes are popular everywhere in Nepal, their popularity in the Kathmandu Valley is probably a result of the fact that there is a strong connection to fields, flowers or mountains in and through rituals. Yet, at the same time, nature and farm life are increasingly vanishing from the Valley due to a dramatic influx of migrants from elsewhere in Nepal, and rapid urbanization. While villages everywhere in Nepal are turning into semi-deserted habitats because of the civil war, poverty, national and international migration, they stay, and even become stronger emblems of a 'better Nepal' and its cultural and national heritage in songs. Moreover, new Hindi films could well be considered 'vulgar' and 'too urban' and some clients would even insist on not including any Hindi film songs at all, or request a selection of songs from old Hindi films from the 'Golden Age' of romantic films. All this shapes a unique and evanescent aesthetic experience that underlines a certain local resilience towards 'mainstream', 'foreign' repertoires. But neither does this mean rejection of cosmopolitanism or globality, nor does it indicate overt national and/or regional chauvinism.

In order to reach the bride's house on time for the auspicious moment of marriage (*sāīt*) the band accompanies the groom and his family and friends. If the bride's house is too far away, a 'party palace' (e.g. banquet hall) is chosen instead for the performance of the main rituals. Then, the married couple is taken to the groom's house in a decorated car, accompanied by the band. Both on the way to the bride's home and then to her spouse's home, the marriage party of the groom's side is supposed to be in a celebratory mood, underlined by dancing of men and women. The bride's family must refrain from accompanying her on this route since the bride

has now become the 'property' of her husband's family. The marriage rituals can last until late at night. The reception on the next day does not require a band.

Neither wedding bands nor videographer and photographer engage in active self-advertising. Their best contacts are made during and through weddings, based on reputation and performance. The 'studios' and practice rooms are usually rooms at home or, in the case of bands, at their other occupation, tailoring. Only a few bands have proper showrooms (e.g. Everest Band from Patan) and invest in advertising. Some bands can now be booked through online marriage portals such as www. weddingnepal.com. Wedding-related work is seasonal and depends on ritually suitable time periods. It is rare to find someone active in the wedding business who does not have at least another job or whose ritual and other professional specialization is broad enough to stay busy throughout the year. The Santoshi Band's 'office', for instance, is occupied by five sewing machines and shared with another tailor (Plate 21). The tailor's shop is the place where potential customers contact the band first and fix a booking, mostly after having heard about or witnessing them. Tailoring also marks the inherited (low-)caste occupation, a love-hate relationship for many band-leaders and owners, because many would like to get rid of the caste stigma inscribed in their occupation. Other than the bands, the cameramen and photographers I interviewed had a different educational and higher caste background. Many of the young entre-preneurs I spoke to inherited the business from their fathers and have become used to moving confidently in a highly competitive market. While band members would work as shoemakers or tailors, sometimes even shop-owners, but at the lower end of occupational activities, camera-work allowed for a different position. From the videographers I spoke to, several had jobs at national or private TV channels, or were active in pursuing new mediatized events that have become increasingly popular and lucrative in urban and middle-class milieus: talent hunt shows such as *Nepal Talent*, *College Ambassador* or *Little Lady Bhaktapur*, a new format that would not neces-sarily earn them more money but social confidence, since these shows have come to enjoy a high reputation in terms of 'making glamorous people' out of nothing. The 'simulated glamour' is a major stimulus in their aspirational pleasures.

The sound of marriage

The song repertoire is a key marker of quality for a brass band's reputation and success at a marriage. There is a careful spatial and aesthetic choreography in terms of what songs can and must be played when, and why. This is linked to the creation of a certain mood and quality of emotion (e.g. spiritual, joyous, sentimental) that clearly goes beyond pure entertainment. There are different categories that feature for a variety of reasons, and at different moments during the long day, depending on what mood is to be generated. The wedding bands are held partially responsible for the emotional and auspicious atmosphere at a wedding. A look at the music selection

also permits a reading of the ritual event against the grain, as Debra Skinner (1994) does in her study of women songs that have been left out of scholarly consideration because text and key rituals were understood as 'more important' but that are, in fact, relevant and demotic social comments on everyday lives and sentiments

There are the so-called evergreens, sentimental, romantic and nostalgic songs, most of which are from Nepālī or Hindī films and Nepālī or Nevārī folksongs. They are sometimes referred to as 'sweet songs' (Nep. *mīthogīt*). In order to address older members among the family and invited guests, and to confirm the ethnic heritage of a Newar customer, at least one or two Nevārī songs must be played at a Newar wedding. Folk songs, often, depending on the ethnic origin of the customer, may be requested. Evergreens, underlining romance and nostalgia and played by bands such as Santoshi Band or Purna Band from Bhaktapur, have been chosen from Hindī films such as *Pakeezah* (1972), *Dilwale Dhulhaniya Le Jaenge* (1995), *Raja Hindustani* (1996) or *Suraj* (1966). One popular song, where a *band bājā* and the barat's procession feature, is *Aaj Mere Yaar Ki Shaadi Hai* (Today is my friend's marriage) from the film *Admi Sadak Ka* (dir. D. Goel [1977]). Yet another set of songs comes from Hindī action-films that convey a dynamic youth culture and friendship and have coined their popularity through particularly 'lively' and 'fashionable' song and dance scenes (e.g. *Sholay* [1975], *Dhoom* [2004]). Many customers demand songs from the most recent charts, such as – in 2010 and 2011 – *Munni badnam hui* (Munni goes infamous) from the film *Dabangg* (*Fearless*, dir. Abhinav Kashyap [2010]), and popular Nepali films or Nepali pop songs (e.g. composer and singer Shiva Pariyar's drinking song *Kya daami bho*. This was really cool, from 2010). They include 'dancing' songs, fast in rhythm and normally played during the procession to encourage the wedding participants to dance and increase the celebratory and participatory atmosphere of the event. A band must be able to perform a good mix of songs for all kinds of guests and situations. Some customers may request songs at the time of booking (there are customers who only want Nepālī songs to be played) or, more often, by the guests and family members during the wedding procession. English songs are rarely adapted, one exception being Stevie Wonder's *I just called to say 'I love you'*, which has been modified in a variety of ways.

Over the last decade the repertoire of wedding bands has changed: new types of 'disco' tunes, 'remix songs' are challenging the bands, as these songs are difficult to adapt and rearrange for the requirements of brass instruments. Bandmaster Saroj Kumar confirms this observation:

> The songs have changed a lot. Now everyone is talking about *remix*. And due to this *remix*, we face problems. In the past there used to be these very sweet songs, which let yourself feel comfortable as well, while you used to play them in a relaxed way. Now due to their noisiness, [new songs] seem to be a little tasteless (*khalo*) to me. Now there are so many songs which are really tricky, very difficult to play … But learning these songs is also part of our obligation, as we have to play them. (Personal conversation, Bhaktapur, 2010)

But as the success of a band depends on the number of bookings, which are connected to the satisfaction and taste of the customer, the band has to change with time and adapt its repertoire according to the customers' wishes and taste. Some songs are annotated, but the majority of songs are practised through listening. Some band members mentioned their mobile phones, which they use as a cheap repository for songs downloaded from the internet or traded with other musicians. They would listen to them repeatedly and apply the melody to their respective instrument. For particular songs, customers may provide CDs or audio-recordings for the bands.

Within the categories of both current hit songs and evergreen songs there are songs which are connected to the ritual context of the marriage, i.e. the text of the song refers to the ritual of marriage in general, or to a specific event or situation in the marriage ritual. These songs are played when the groom and his party are on their way to collect the bride from her family home, or when vermilion is applied on her forehead to mark the marriage. Some songs are even witty. A Nepali folk song by Arun Thapa, played by Santoshi Band upon arrival of the procession at the bride's house in Bhaktapur, informs the bride's family that *Katar, Katara timro suhaun-dojwai aayo motar ma* (Vroom, Vroom, your good-looking son-in-law is arriving by car). Besides the reference of the text to a specific situation during a wedding rite, the songs played also enable the participants to imagine a particular film song and the visual framework of the film. Thus emotions are generated by means of specific lyrics and the assumption that the audience is familiar with the films and 're-enacts' the particular scenes in their imagination. Male wedding guests in particular may imitate gestures and dance styles of a particular film, such as Mithun Chakraborty from *Disco Dancer* (1982) or Salman Khan as both comic and ruthless policeman in the film *Dabangg* (2010), dancing in a drunken state in a bar to the song *Munni badnam hui* (Munni goes infamous).

One main theme of songs played at every marriage is the reference to the bride's leaving her home for good. One of the band's staples is the song *Maithi ghar timro hoina* (Your parents' home is not yours anymore) by Dwarika Lal Joshi. It is an emotional and narrative key, and one of the few sad tunes (Nep. *duḥkhagīt*) suitable for a marriage ritual. The father bids farewell to his daughter at the time of leaving her maternal home during the marriage ritual (*kanyādāna*). This is an example of a close contextual interaction between the music played by the band and the actual ritual action, of 'ritual management of distress' (Gamliel 2010: 174). In the song, the father conveys the following message to his daughter:

> *The home of your parents is not yours (any more), (Now) go to the home of your in-laws, take a leave to come from time to time to the house where you were born. ... My daughter, your soul may be in tears. [...]Leave to spread happiness; we will dry your tears.*

For the videographer, this scene is a MUST, and has to be closely documented – as much as the handing over of the bel fruit in order to mark a change in the system

of social exchange and relations: time and again, the videographers underlined that everyone wants to see the bride crying again and again, ideally, with an intense focus on the tears. Close-ups of the eyes: 'they will enjoy watching the film later', as one videographer put it. There is thus a concern with consumer taste and preferences. Says Shankar, a filmmaker specializing in Newar weddings: 'I never miss those crying shots … at that time, most of the people are very serious, because bride, and father and mother are crying.'[9] People expect the bride to cry; it is part of an exchange of sentiments and social relations. Many informants, women and men, have underlined the fact that in such moments, you just cry, there is nothing 'fake' about it. This happens in moments such as *supari line* (taking of the betel nut, *gvēsālegu,* for which ideally two or three cameras are needed), and *bidai garne* (saying farewell to the parental house). Kedar Banepali, owner of the first photo studio and video camera in Bhaktapur, speaks about the filmic representation:

> The girl is crying and taking the betel nut … she keeps on crying. If you then have two cameras, you can take a close-up of the hand with the betel nuts and then you must have a close-up of her crying, of her eyes and tears … You also must take a close-up of the parents crying. If you do that, you will enjoy watching the film later. (Personal conversation, Bhaktapur, November 2010)[10]

The emotional triggers of such close-ups are socially conditioned and based on interactive media, underlining the strong synergies between image and sound. The bridal weeping is part of what anthropologists have called 'thoughtful' – that is, strategic, and yet spontaneous, emotional crying as socially appropriate and even expected sentiment. The crying shapes social relations and underlines the efficacy of the ritual (Gamliel 2010: 173–4). Quite another example surfaces in Sengupta's discussion of the Indian wedding videographer's iconography of close-ups in the case of the eyes, feet and hands of the bride in India, as they are all considered sacred, but most of all erotic, and are entangled with famous sentimental films and film songs (Sengupta 1999: 292). These vignettes are not so much about sharing a sentiment but the shaping of subjective pleasure and power by means of the male gaze. The language of emotions and gestures changes constantly. Recent marriage photography in affluent contexts in India has added close-ups of the backless dress of a female guest, and flirtatious looks and gestures between groom and bride, such that physical seduction is highlighted more than austere serious ritual, pointing towards another quality of emotional management qua commodification of the body.

The camera must capture the most important ritual moments (such as *sagunlaune* (offering), *swayambar* (garland giving), *sait* (auspicious marriage moment) and *mukhhernejane* (seeing the bride's face), a ritual performed among the bride's family and friends) and the guests enjoying *bhoj* (joint meal) on the day after the wedding, now with the groom's family. The camera captures rows and rows of guests eating and talking (sitting around a large table is a new element at such events; guests are

usually still seated on chairs arranged in rows), sometimes focusing on children and people (mostly men) dancing. Entertainment programmes are rare and guests would mostly attend the reception, drink, eat, maybe dance a bit and then leave the party palace. A wedding video is not expected to have a spectacular aesthetic narrative, even though beginning and end leave some space for the videographer to improvise. And because the married couple's families and friends enjoy watching who was at the wedding, wedding videos tend to have seemingly repetitive, if not even relatively monotonous shots of seated, talking or eating guests. The trigger might lie elsewhere, coded and thus not easily accessible.

There are new forms, gestures and emotions allowed or even expected in weddings aiming at presenting a 'modern touch': nowadays, explains Bikram Sakya, who also works for a Nepali television programme, the bride is expected to smile, especially on the introductory photographs, whereas 'traditionally' she was meant to look serious, with eyelids almost closed in a shy manner. Outside of Bhaktapur I came to do research on a particularly interesting photo studio. What attracted my attention was a very familiar-looking image of a turbaned groom holding his bride in his arms; she has her left hand on his shoulder, leaning against him, smiling into the camera (Figure 11.1). Responding to my question as to why this particular image had been chosen for his studio logo, Raj Kumar Bajgain says that the pose and style

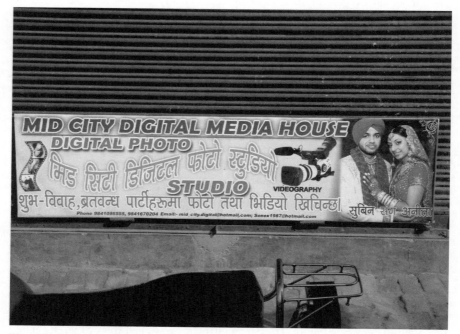

Figure 11.1 Indian couple on Nepali advertising board of videographer's studio, Bhaktapur (photo: Christiane Brosius, 2010).

were suitable in his view, but that even though very often he would ask people to pose that way, like Indians, they would be too shy (*laaslagchan*). For Kerala, South India, Abraham notes a similar unease with the idea that the newlywed couple has to perform according to 'globalized' narratives of romantic love, because this display of affection 'is in complete contrast to a public morality in Kerala in which couples are not meant to show affection in public' (2010: 119).

Functions of processional and auspicious music

Bandmaster Saroj also points out that to have no band is often considered 'empty' or tasteless *khalo* and can normally only be found in the case of an unapproved love marriage, where a procession and visit to the local shrine of the groom's family-guthi (caste-based trust in Newar society) would be missing altogether. Having a band is not just about entertainment, it also indicates that the groom's family is 'cultured' and that the marriage is an arranged one, and not a 'love marriage', which would be socially less acknowledged.

Because much is about seeing and being seen, the procession route is essential. In order to ensure that as many people as possible from the neighbourhood or the village come to know about the marriage, a few hundred metres at least have to be walked, even if the larger distance between the groom's house and the bride's house is covered by bus. If a wedding in Bhaktapur takes place in the bazaar, the procession will most probably follow a part of the traditional processional route through the bazaar. At a Śreṣṭha wedding in November 2010, the buses transporting band and guests (separated) from the groom's house had to take a longer route to stop at the old home of the groom's family and perform a procession with three songs. The intention behind this was to inform the former neighbours of the marriage, to impress neighbours and a larger constituency than that of the invited guests.

The creation of auspiciousness is a central function of the music played by the bands during the marriage ritual. Music itself is regarded as auspicious due to its association with the divine, and in particular with Saraswati (the goddess of music, arts, knowledge and science) and to local sacred geographies and ritual events (Tingey 1994; Wegner 2009). The spatial separation of the band from the wedding ritual, particularly the *sait* or exchange of *tika* (symbolic mark on forehead), when *mangaldhun* (lit. 'the auspicious tune or melody') must be played, leads to bad sound quality for the videographer. Though they were thus not able to use the original sound, cameramen emphasized the importance of dubbing these and other auspicious scenes with other versions of *mangaldhun* while the 'rest' of the video would have more scope for variation in terms of the selected music.

Only one more song is as important as the *mangaldhun* and must not be left out: *Maithi ghar timro hoina!* Nepali or Nevarifolk songs are often preferred as background music to footage from the *bhoj*. On rare occasions, when the priest

is reading out an important verse, the original sound would be audible. Without being asked about this specific element, two cameramen would underline that their clients would privilege Nepali or Newari songs over Hindi film songs because it was their own culture. In all these moments of reflection about the presence and absence of music, one part is missing: the band is omitted from the videos, visually and sonically (see also Sengupta 1999: 296). Reasons for this might vary: there is, as explained above, the lack of personal relation that the camera usually attends to, focusing on guests and family (not even the bridal couple so much), the presents laid out, and, very often, the consumption of food. The band is often seen as a 'service provider'. But one could also argue that they jar with the more slick aesthetic expected of the video, and of the souvenir. In a strange way, they are still an irreplaceable ingredient of the wedding procession; at the same time, they are not 'sophisticated', refined enough, often seen as 'noisy' and disturbing, which might be suitable for that very moment, but not for the act of watching a video or looking at an album. Moreover, they seem to obstruct the more globalized/trans-regional sonic playing field evident in videos.

As the band-leader explained above that the demand for music remix during wedding processions is hardly realizable with brass instruments, and who sees in it a kind of 'vulgarization' (*khalo,* tasteless), the videographers and photographers, too, constantly negotiate their space of authority and reputation – for instance, how to keep up with the speed of technology, image circulation and change of taste. A different kind of mixing is expected in wedding videos, when particularly the 'introduction', the first ten minutes of the otherwise two- to three-hour-long video, shows a 'summary' of best and most important shots, and presents the couple and their family, using special effects. This has become increasingly easy with digital technology and the internet, as opposed to the previously heavy, complicated and much more expensive apparatus needed for postproduction in the age of VHS from the 1980s.

Changing tunes

There is growing confidence among some bandmasters that they do culturally significant work, and even contribute to the preservation and nurturing of Nepal's heritage. Many hope that in a rapidly changing Nepal, their social status might also change, and they could gain more recognition and undergo less caste stigmatization. Others are not very optimistic; they fear growing competition, experience less loyalty and commitment among fellow musicians.

But there is also a 'danger' of this tradition fading away, at least among wealthy Westernized elites, or among Nepali families living abroad. Their position towards wedding band *bājās* is that they are reminiscent of an 'old Nepal', a country that must overcome its backwardness and become 'world class'. To them, the cacophony

of sounds and the seemingly chaotic performances, often in worn-out uniforms, is 'bad taste', if not even 'embarrassing'. To further underline the contested role of wedding bands in a globalized context, the following example of a homemade video uploaded on YouTube in 2007 by a German couple, entitled 'Newari wedding music and ceremony', should suffice. On film is the standard arrival of a brass *bājā* at a house, playing a happy Hindi film tune. The home-video, about five minutes long, is interesting because of the comments written below the video screen by different people, supposedly all Nepalis. Here, one can read the following:

> *it sounds like a joke,, i am praying i do not get this music on my wedding Ceremony..........*
> *it sounds like they are celebrating for the QUEENS 50TH BIRTHDAY...*
> *what a fuck is this .newariweeding n* (sic) *hindi sound track ?????????*
> *thatsmangaldhun.*
> *is this klezmah?*[11]
> *that music has to go! its too loud!_ I have never seen a marching band at a newari wedding, and I am married to a newari! at least edit it with some nepali folk!*
> *when are we going to learn our original songs are the best we dont have to borrow this stupid band and hindi songs from some other country to make our weddings memorable. where is damaibaja??!*[12]

Here, instead of caste discrimination, (globalized) class distinction and a revitalized ethnic and nationalistic ethos take over. While the bands might no longer be looked upon as 'impure', they are now stigmatized as unsuitable because of their 'unsophisticated', 'hybrid' appearance. They are considered 'inappropriate' by a cosmopolitan and yet provincial audience, an audience that considers itself as caretaker or custodian of a more 'sanitized' Nepali/Newar tradition. One could argue that this gaze polarizes weddings along the lines of different qualities of 'being cultured': on the one hand, the band is seen as an essential and auspicious agent; on the other hand, as ethnic decorum and 'simple', yet slightly shabby and queer entertainment. The band marks the fine and yet sometimes consciously blurred line between the party palace and the hotel lobby, the *bhoj* and a multi-ethnic buffet with wedding cake, the giving (and receiving) of betel nuts and the engagement ring.

In her study of Tamil marriage videos and photo albums, Roos Gerritsen (2009) describes how her informants chose the songs that were included in the videos with great care, because they expected the preservation and evocation of 'essential' feelings. The aesthetic, visual and sonic combinations of a wedding band or video underline the complicated emotional architecture of a marriage and its afterlife for many involved, not only the groom and bride. The evanescence of emotions, especially romance, or sentimental longing is audible in the fact that wedding band music is not recorded, and thus vanishes, like the band, with the end of the marriage ritual. And from conversations with couples and videomakers I also learnt that even the visualization is based on invisibility and intangibility: wedding videos, though made to mark eternity and highlight endless access to their consumption (if the

VHS or DVD does not fade or break), are rarely watched. Everyone has a wedding video (often more often than a commissioned photo album), but when asked whether and when they watch it, most of them decried that they did not, often laughing as they said so. Apart from just after the marriage, when the married couple and their families might enjoy an intimate and more relaxed and distanced view of this event, the videos are made for a past that can allegedly be 'stored'. All these media, music and film are so central to a wedding today in trying to hold on to, and preserving almost nostalgically, the memory of such a personal and yet publicly owned and shared, weighty and mighty experience.

This chapter studied different aesthetic and spatial registers of wedding bands and wedding videos in the Kathmandu Valley, Nepal. Despite the close historical and physical vicinity to Hindi film and mainstream (north) Indian culture, the repertoires of both music and videos do not show an overwhelming rhetoric of 'Indianization'. Instead, there is a form of conspicuous consumption that refers to a heightened sensibility of ethnic Nepali repertoires and nostalgia of cultural heritage and cultured, or 'sophisticated', habitus. Moreover, there is an interesting reluctance to draw upon aesthetics of individual aspirations and romance since the bridal couple does not feature centrally in both modes of production. The concept of 'love' as a source of happiness does not feature in the choreographies of marriage. Finally, the wedding bands reflect changes in taste as they are attributed with a host of qualifiers from 'auspicious' to 'vulgar' and 'inauthentic'. And even those aesthetic markers of distinction will move along with the bands, through time and space.

Notes

1. Bollywood is the informal term used for the Hindi-language film industry based in Mumbai.
2. The fieldwork was undertaken with the support of research assistant Tessa Pariyar. Many thanks to her as well as the German Research Foundation (DFG) who has generously funded the project in the context of the research centre 'Ritual Dynamics' at Heidelberg University.
3. Korean movies, mainly romance and comedy, have grown in popularity in Nepal since the new millennium and have since then challenged Bollywood's monopoly. Liechty (2010) coins Nepal's relationship to globalization as being 'out there', at the periphery, tied into a 'tick' asymmetry between local and global, and a strong presence of communal ties and religious practice in everyday life.
4. There are no statistics on this phenomenon, but conversations on the subject are commonplace (Acharya 2010). Love-cum-arranged marriages, or arranged love

marriage (see Uberoi 2006) are based on two people falling in love first and then, often over a period of time, convincing their parents (and family as well as close kin and caste) to approve of the marriage, so that a wedding can take place as if it had been arranged. This ensures that no one risks loss of face and integrity.

5. Bridezilla, based on the Japanese film monster and sci-fi horror movie *Godzilla* (1998), is a term used for difficult, if not hysterical and control-obsessed brides-to-be who tyrannize their friends and relatives with their worries about the 'day of their life' possibly going wrong. See Brosius 2014 (2010).

6. This could be roughly translated as 'With the band, love is coming'.

7. *Ihi* is a collective and public fertility ritual through which the pre-adolescent girls are said to be married to Lord Vishnu.

8. According to the 2011 Census of the Central Bureau of Statistics, Kathmandu district has a population of 1.74 million, the Valley counted 1.6 million people ten years ago and reached 2.51 million in 2011 (Sharma 2011). In 1970, Kathmandu's population was 150,000 (Pravakar Pradhan and Ranjith Perera (2005): *Urban Growth and its Impact on the Livelihoods of Kathmandu Valley, Nepal (= UMP-Asia Occasional Paper,* No. 63)).

9. Even though the salaries of cameramen are substantially higher than those of wedding bands, the coverage of a full wedding, including post-production, costs between €150–250; very rarely would the honorarium be higher.

10. Abraham observes that crying is not at all part of the expected emotional canon in matrilineal Kerala (2010: 124).

11. This is an interesting reference and association, as *klezmer* is the term for a musical style originating in Eastern European Jewish music, often in fusion with Roma musicians, and with a strong relation to weddings and street festivals, and even though klezmer is undergoing a revival in Europe now, it is often attributed with 'chaotic', unsophisticated music of low-class status. Brass instruments play an important role here too.

12. Comments accessed on 15.8.2011, http://www.youtube.com/watch?v=0MNn1 MaCXGQ

Bibliography

Abraham, Janaki (2010) 'Wedding videos in north Kerala: technologies, rituals, and ideas about love and conjugality', *Visual Anthropology Review*, 26(2), Fall: 116–27.

Acharya, Biplav (2010) 'New trend in getting hitched. Love-cum-arranged marriage', *Republica,* 28(7) (online version: http://archives.myrepublica.com/portal/index. php?action=news_details&news_id=21535 (accessed 25 October 2012).

Adrian, Bonnie (2006) 'Geographies of style. Taiwan's bridal photography empire', *Visual Anthropology*, 19: 73–85.

Booth, Gregory (2005) *Brass Baja. Stories from the World of Indian Wedding Bands,* New Delhi: Oxford University Press.

Brosius, Christiane (2010) *India's Middle Class. New Forms of Urban Leisure, Consumption and Prosperity* (Part III), New Delhi, London, and New York: Routledge (reprinted in 2014).

—(2011) 'The Multiple Bodies of the Bride. Ritualising "World Class" at Elite Weddings in Urban India', in *Images of the Body in India*, Axel Michaels and Christoph Wulf (eds), New Delhi: Routledge, 261–79.

Gamliel, Tova (2010) 'Performed weeping drama and emotional management in women's wailing', *The Drama Review*, 54(2): 70–91.

Gerritsen, Roos (2006) 'Tamil wedding souvenirs of predictive love. Future memories in South India', *Etnofoor*, XIX(2): 5–22.

Gutschow, Niels and Michaels, Axel (2012) *Getting Married. Hindu and Buddhist Marriage Rituals among the Newars of Bhaktapur and Patan, Nepal,* Wiesbaden: Harrassowitz.

Kendall, Laurel (2006) 'Something old … remembering Korean wedding hall photographs from the 1980s', *Visual Anthropology*, 19: 1–19.

Liechty, Mark (2010) *Out Here in Kathmandu: Modernity on the Global Periphery,* Kathmandu: Martin Chautari Press.

Sengupta, Shuddhabrata (1999) 'Vision Mixing. Marriage-video-film and the Video-walla's Images of Life', in *Image Journeys. Audio-Visual Media and Cultural Change in India*, Christiane Brosius and Melissa Butcher (eds), New Delhi: Sage Publications, 279–307.

Sharma, Nirjana (2011) 'Census 2011: Country's population 26.6m', *Kathmandu Post*, 28.9., http://www.ekantipur.com/the-kathmandu-post/2011/09/27/top-story/census-2011-countrys-population-26.6m/226749.html

Skinner, Debra (1994) 'The Songs of Tij. A genre of critical commentary for women in Nepal', *Asian Folklore Studies* 53: 259–305.

Tingey, Carol (1994) *Auspicious music in a changing society. The Damai musicians of Nepal,* London: School of Oriental and African Studies (SOAS Musicology Series vol. 2).

Uberoi, Patricia (2006) *Freedom and Destiny: Gender, Family, and Popular Culture in India*, New Delhi: Oxford University Press.

Wegner, Gert Matthias (2009) 'Music in Urban Space: Newar Buddhist Processional music in the Kathmandu Valley', *Theorizing the Local: Music, Practice, and Experience in South Asia and Beyond,* Richard K. Wolff (ed.), Oxford and New York: Oxford University Press, 113–42.

12

The Aesthetics of Pirate Modernities: Bhojpuri Cinema and the Underclasses[1]

Akshaya Kumar

Can we anticipate the rise of a people in the rise of their cinema? Or is it the other way around? At any rate, the cinematic encounter allows the audience in the dark confines of the film auditorium a certain flexibility to shift between the registers of singularity and collectivity, homogeneity and heterogeneity. Therefore, it is vital to grapple with the paradoxical and simultaneous rise of many vernacular cinemas nearly a decade after globalization's footprint became unmistakable. Not only are these located in their own cultural and linguistic milieux, they flourish precisely because of the avenues of identification they offer to the community. The key question would be: *what are the aesthetic contours of this vernacular resurgence?* Also, if we are to see film as a transaction, as a prominent arbiter of the political, how are we to assess the aesthetic terms of vernacular politics? While this chapter tries to make sense of the various tensions within Bhojpuri cinema and its reception, at its core remains an enquiry of the aesthetic disdain towards the *other* – the audiences, the theatres and the cinematic object. I situate the audience of Bhojpuri cinema in the context of (i) urban spatial segregations and (ii) aesthetic subversion of the populations that interrupt the world-classing of Indian cities. I borrow from Ravi Sundaram's concept of 'pirate modernity' and focus primarily on the accounts collected in Delhi to propose certain analytical formulations towards the research questions at stake.

Due to processes of globalization, there has been a direct and indirect mixing of imaginaries, refracting the sense of one's location through several discursive regimes of subject positioning. The self, in this scenario, is confronted by communitarian, regional, national as well as international belonging, all of which project themselves through various media forms. Not only does the global subject repeatedly adjust her location, often inhabiting multiple locales, she may also not see them as conflict-ridden. Given the caste-, class-, gender- and religion-based positioning of the self in the contemporary environment, negotiation between social conditions and narrative schemes continues to breach and shift identificatory orbits. However, within the

filmic landscape, it may be possible to assert that while Bollywood – popularly hailed as India's national cinema – tried to shift its locus outside the territorial boundaries of the nation, the vernacular voice, earlier represented through tentative identification, has discovered a rationale as well as a method to assert its autonomy from mainstream popular cinema. This is how various 'dialects' of Hindi across north India have begun to make their own mark on the media horizon through music and films. Bhojpuri cinema, because of a very high number of Bhojpuri-speaking population, is the most formidable of these culture industries. Much of the content circulating in these 'dialects' depends on the VCDs in particular, but whether or not they find theatrical exhibition, mutations of fiction films and music videos have erupted beyond Hindi-language production units of Bombay (Mumbai).

Even though the autonomy of the vernacular imaginary remains doubtful, I wish to discuss the cultural economy of Bhojpuri leisure spread across north India and several towns and cities including Mumbai. Bhojpuri is a language spoken by people from eastern Uttar Pradesh and Bihar, and travels across the country with the migration of construction labourers, rickshaw pullers and hawkers, but it commands a significant percentage of speakers in Mumbai and Delhi in particular.[2] It would not be incorrect to propose that Bhojpuri cinema belongs not so much to its native linguistic territory as to the diverse regions that Bhojpuri speakers migrate to in search of work. Given that this chapter looks at the recent phase of Bhojpuri cinema, which many scholars (such as Ghosh 2010) trace back to the unexpected success of *Sasura Bada Paisawala* [*My father-in-law is very rich*] (2004),[3] the cinema's emergence resonates with recent changes in the urban ecology, particularly in relation to the migrant working classes. Most of the observations shared here have been gleaned from my regular visits to Moti Cinema in Delhi, Leela Cinema in Lucknow and conversations with two film distributors (Joginder Mahajan and Sunil Jain) who distribute Bhojpuri films within the territory of Delhi and Uttar Pradesh. As I argue, the audience of Bhojpuri cinema is a residual population that found in this residual cinema a fulfilment pushed outside the reconfigured mainstream. However, they also found in it a cinema addressing them in their language, stars embodying their sovereign asser-tions, and a space to congregate and form the Bhojpuri public. Thus, I try to grapple with the assertive rebirth of a film industry which only produced rural nostalgia in its earlier avatars. In tracing these contours, we grapple with a cultural chunk disaggre-gated in time and space, but aggregated in the performance of an aesthetic identity. At the same time, we also come face-to-face with a critique of the mainstream from below, as the residual takes to pirate means to assert itself on the cinema screen.

The vulgar

The most resilient accusation by the middle classes against Bhojpuri cinema is that of vulgarity. At a time when almost all the components which generated anxiety

around vulgarity in 1990s films have become commonplace in the Hindi films, why is Bhojpuri cinema one of its most exclusive targets?[4] In the last 15 years or so, the upwardly mobile middle class has accommodated earlier notions of vulgarity across media forms. Wearing a bikini or 'revealing' clothes, kissing on the screen, *double-entendre* dialogues, lyrics and abusive language – each of which mobilized enormous anxiety in the print journalism of the 1990s and earlier – have now become the staple diet of Hindi cinema. Broadly within a liberal discourse, the tendency to represent such practices is defended as a matter of fair representation – of women, small towns and languages – and the filmmakers' right to freedom of expression. To be shocked by a cultural practice is often a result of one's cultural habituation, but also that of an awareness of 'our culture' – a mediated claim towards the alleged inside and outside of the shared cultural universe. Primarily through advertising and the music industry, the boundaries turned porous, particularly for the urban middle classes who aspire to the global standards.

The distaste for Bhojpuri films in the name of vulgarity is, I would suggest, indicative of the middle-class aversion to the bawdy. A distinctly performative bawdiness breathed its last through films starring the effusive actor Govinda in the late 1990s, which are broadly consistent with some of the content of Bhojpuri films. Indeed, the aversion to Bhojpuri films is also aided by the fact that being middle class is attendant with the refusal to tolerate practices that belong to *others*. The practices of others must be avoided and tagged distasteful, for refusing to do so would be the undoing of middle-classness (see Deshpande 2006; Fernandes 2006; Ghertner 2011; Mazzarella 2003). This cleansing of the other from within has not only been executed throughout mainstream film texts, but more importantly, in the spatial organization of the entire cultural economy. The spatial segregation has been facilitated primarily by a reorientation of the film trade towards the relatively expensive and plush multiplexes. While the multiplex economy takes root among urban middle classes, it continues to offer the urban middle class its own cinematic imaginaries of *others*, distanced by material difference yet available for screen consumption. The case of the small town as one of these *others* has been on a consistent rise, leading to a wide variety of films invoking the shadow region of urbanity and order, as offered in recent films such as *Ishaqzaade* (2012) and *Gangs of Wasseypur I and II* (2012) (see Kumar 2013).

In Bhojpuri films, the provincial remains a direct as well as indirect referent; it uses the province as a place but also as a metaphor. Parody is a powerful method to achieve this blending of the two, offering various modes of identification, refracting referents through rhetorical and aspirational registers. The bawdy, too, is often a resultant effect of this hybrid construction. However, this construction allows Bhojpuri films to not only project the global within the provincial, but also the provincial within the global. The fantasy of tradition eventually breaks down the mirror between the two non-identical problematics seeming to mock each other. The rhetorical and aspirational often being hyper-performative in character. They enable

certain performative practices to dominate the signifiers of provincial culture. Their constant reproduction marks the triumph of the provincial, but remains mainly a matter of performative assertion. The Bhojpuri-speaking middle class, having disowned not only Bhojpuri language but also these performative signifiers, mark their allegiance to higher orders of cultural belonging. They must continue to mark such performances as distasteful, and even deny identification with it, in order to remain unmarked.

The audience

In relation to the above, I attempt here an assessment of the Bhojpuri audience and their cinematic neighbourhood. In order to do this, I shall build on my own experiences as much as those of the regular visitors to Moti cinema in Delhi, for in our coming together in the same cinematic space, an awkward dissonance was already introduced. I shall try to capture, therefore, the experiential contours of this awkwardness, which always lies at the fringes while migrant working classes watch Bhojpuri films. On the first day of my visit, I was accompanied by a female friend to watch *Kehu Hamse Jeet Na Paayi* [*No one can defeat us*] (2011). We bought 'rear stall' tickets and asked if they had managed to sell any balcony tickets for the show at all. I was told nobody had bought balcony tickets for the show and that this was the expected routine. The balcony, a typically secluded zone for the *gentry*, serves little purpose for the working-class men who ordinarily would not pay ten rupees extra for the same film.[5] Indeed, women rarely come to these shows. However, while I joined the queue for men, my friend was asked to go through the 'women's queue' in which she was the only one. I was taken aback when I was asked by the men in my queue to go through the other entrance. One after another, several of them suggested so. When I refused, they asked me to go to the front of that very queue so I could enter comfortably without having to wait with them. The baseline for both suggestions was the same. As I clearly did not look *their* kind, I was generously granted the right to escape the ordeal which would be routine discomfort for them, the underlying assumption being that I would not be used to it.

Inside the theatre, however, the people found the space to express themselves. Given the poor footfall, they could disperse and find for themselves the kind of leisurely public space which has been on a steady decline in the cities, particularly in Delhi. While slums are 'resettled' outside the cities and public land is handed over for private enterprise, particularly big malls, the reconfigured Indian cities have left little space for lower-class inhabitants to find – not buy – leisure. Here, they could stretch themselves out, put their legs on the seat in front, eat *gutkha* (crushed betel-nut-based savoury substance) and spit anywhere, fiddle with their mobile phones at will and shout at the top of their voice, '*Chalu karo!*' ['Get on with it!']. Indeed, that is what audiences watching B or C circuit films in decrepit theatres do

in many places in India. Staff at Moti cinema were not going to tolerate any of it, however. But it often means that they have to stay vigilant and rebuke those who break the codes of decency as soon as they do so. One of these unstoppable hassles is people, particularly those consuming *gutkha*, spitting around wherever they are seated. When one of the men spat next to him, an administrator advanced and said: '*Ye sab nahin chalega yahan. Thookna hai toh bahar jao!*' ['This won't be tolerated here. Get out if you must spit!']. When the film started and darkness arrived, the various cinema employees, among them the woman at the security gate as well, busied themselves by policing people. They often flashed a torchlight at the people they suspected to check their activities and one of them also carried a wooden stick to chastise any miscreants. The people were strictly told to keep their legs off the seats in front of them, and their tickets were checked repeatedly to make sure no one had entered without one. Sure enough, when out of view, people spat around themselves, kept their legs on the seat in front and there were indeed defaulters without a ticket. There was significant rationale for the inspection drill. Yet, the administration's contempt and exasperation with the Bhojpuri audience is toned down by a business compromise. Even though Moti cinema seemed in a relatively reasonable state, the theatres that show Bhojpuri films are often in dire need of renovations; half of their seats are broken; fans may or may not work; power cuts are frequent, and the quality of projection is so poor that one barely gets to have an audio-visual experience vital to watching cinema in theatres. It is also crucial that these audiences bring no ancillary business to the exhibition trade. Indeed, the large theatre compounds, situated as they often are in crowded but high real-estate value neighbourhoods, may be used for parking and other facilities. But the negligible buying capacity of working-class men means that the sale of cold drinks, coffee and snacks during the interval or before the start of the film does not take place. Unlike many other old single-screen theatres in a rundown condition, where the mainstream Hindi fare is often consumed by front-benchers of a similar class composition, in theatres showing Bhojpuri films I did not come across any attempt to sell snacks and beverages during the interval, as is the routine practice across north India. The audience, therefore, are given little consideration as consumers who could afford a wholesome entertainment experience. It is another matter that very often these theatres are located in the midst of the *bazaar,* and some of the audience may walk across the road to get themselves a cup of tea. The theatres, however, make no attempts to provide these services as they do not see in it much economic sense. This is not, at the same time, to suggest that the filmgoing experience of the Bhojpuri audience can be reduced to their encounter with the film alone, but the ways in which the experience exceeds that encounter may be different from the ways in which a multiplex sensorium, for example, exceeds the filmic transaction. If the latter provides an environment saturated with stimulants and commodities, the former remains relatively bare. If the latter attempts to convert space into capital, in the case of the former the space remains suspended as not-yet-convertible capital. A

film ticket, for the Bhojpuri audience, not only buys them the right to watch a film, but also the right to suspend their selves in the space that the film inhabits.

Another remarkable aspect of Bhojpuri film audiences is that the theatre compound, displaying various posters of the films to be released in the next few weeks, often becomes a space which regular spectators approach to merely stare at the posters. They stand in front of each of the posters and may even discuss the films with others staring at them. This innocent routine of looking intently at movie posters satiates the viewers with a peculiar sort of cinematic pleasure, which can be conceptualized as a visual equivalent of *thali*. The idea of a *thali* meal, served all over India, is an aggregate of a variety of ingredients all served together in limited proportions.[6] Bhojpuri film posters, much like Hindi films of earlier decades, contain an indication of an assortment similar to *thali* aesthetics, with a fair dose of the heroic, the familial and the feudal spiced with erotic and violent supplements. They do not only provide a map of the filmic territory the viewers are to inhabit if they choose to watch the film, but they also provide a complete meal themselves, so to speak – a composition autonomous enough to tend to the spectator's interests without even invoking the moving image document. The elements assembled within the collage of the film poster provide an index to their distribution within the film. I would propose, therefore, that the gap between viewing the posters and watching films is analogical to the gap between a ritual and a performance. The former signifies the act of becoming while the latter performs it; yet we must be alert to their inter-penetration because signification resides in performance as much as the performative constitutes signification. It is precisely because of this inter-penetration that the two can autonomously address the same appetite. Crucial to this formulation is the implicit understanding that neither the signified nor the performed can actually become: the gap between being and becoming stays the eternal law of the 'performative contract'. It is this contract that grants near-equal legitimacy to the signified as against the performed; the audience's will is integral to its execution.

In addition, unlike multiplexes and middle-class *gentry* anywhere else in India, Bhojpuri audiences are rarely clustered within groups; most often they come alone to the theatre. Working-class men, taking a break from work, buy unnumbered tickets and scatter themselves across the theatre. They stretch themselves in a sparsely populated theatre and enjoy their free time for a few hours, some even sleeping throughout the film. The interpersonal relations among the audience remain interrupted as the audience turnout continues to slide below a critical mass. In my own experience of watching Bhojpuri films, I have seen numbers dwindle between late 2010 and mid-2012. While earlier it was common for the person sitting next to me to make a jovial comment towards the screen and nudge me into sharing the joy, the thinning turnout would lead to an audience addressed in relative silence and singularity. The cheers one heard on the dramatic arrival of the star gradually waned. This is not, however, to claim that the Bhojpuri films have no audience any more. But when I posed this question to the distributors, they claimed this had to do with the

exodus of the labouring classes from Delhi. Needless to say, this did not seem true in an absolute sense, even though, relatively speaking, there might have been a shift.

What should be noted is that the Bhojpuri cinema audience sits upon the intersection of the sites of labour and the sites of entertainment. But when the slum-dwellers of old Delhi – such as those who lived in Yamuna Pushta near Chandni Chowk – are evicted to places like Bawana outside the city, increased travel time to sites of labour also means the sites of entertainment shifting to more portable formats such as VCDs/DVDs, away from the film theatre. To better understand this relationship across space, leisure and pleasure, the continuities of Bhojpuri cinema could be traced back to what is known as the 'C-circuit'. Let us look at the specifics of this circuit to ascertain terms by which we could comprehend the Bhojpuri industry.

The C-circuit

Throughout the 1980s and 1990s, C-circuit films with elements of an indigenous horror-cum-sleaze (such as *Khopdi* [*Skull*], *Khooni Panja* [*Bloody Palm*] etc.), dubbed versions of semi-pornographic films from the West, were enormously successful across north India. Bhrigupati Singh describes the C-circuit scenario thus:

> [T]he illicit and fleeting pleasures and dangers, the gigantic posters with half-naked female bodies (usually with white women), the titillating but absurdly repetitive titles, uncomfortably translated or more often than not, just completely fabricated (*Call Girls, Night of Love, Private Tuition*) bearing little or no relation to their French, Finnish, Russian or Australian origins. (Singh 2008: 259)

Poor production standards and the absence of mainstream stars with virtually no film publicity ensured that these films operated on the fringes of mainstream cinema. Morning shows in otherwise 'respectable' theatres or dedicated theatres in the middle of the cities became a popular bastion for working-class regulars, compulsive filmgoers and students absconding from schools and colleges. While mainstream Hindi films often dealt with sexuality allusively, it thrived here among people who were brought together by an unattended appetite or curiosity. Singh, in his essay, quotes Bal Kishen Malhotra, manager of Jagat cinema in Delhi, who disgustedly calls these people *chavvanni-class ki audience* [an audience of paupers], indicating 'local rickshaw-walas and *jhalliwalas* [coolies for the various commodities that circulate around Old Delhi] and the local floating/working population' (2008: 252). As Singh also suggests, the theatres, once associated with the audience of paupers, would find it nearly impossible to attract the *gentry* unless they were renovated in entirety.

The story of the C-circuit is a most fascinating one. After the expansion of film exhibition circuits in the 1970s, a section of film theatres, having fallen out of favour with the middle classes, became drivers of other trade practices. Many

of these theatres located in the city centres were worth more as real estate than in terms of operating profits. Therefore, we are confronted by the decline of the urban neighbourhoods where cinema found its earliest home (such as Connaught Place and Chandni Chowk in Delhi, Grant Road in Mumbai) offering itself as the supreme pleasure of the *bazaar* (see Jain 2007). The architectural trajectory of the shift is fascinating in how the centre gets eliminated in favour of the periphery. The C-circuit emerged as an aggressive weed in the undergrowth of Hindi cinema at a moment when business was lean and unpredictable. Ashim Ahluwalia, whose recent release *Miss Lovely* (2012) addresses the conditions of production of the C-circuit film, has variously mentioned the confidence and originality of the design, framing and editing of C-circuit films (Singh 2012). However, as the cities expanded, several theatres in the old neighbourhoods fell out of favour with the middle classes, thereby losing out on the 'family films', which, broadly speaking, is the dominant Hindi film form reinforcing the fantasy of familial ties, and is orchestrated around a privileged address to the middle-class women. These rundown theatres would attend to the alternative economy which had always been at the periphery of Hindi cinema's moral imagination. The resultant moral deviance and experimentation found itself a more robust trade circuit. The C-circuit thrived primarily on the singularity of its audiences who were not aggregated by any easy social logic, but were symptomatic of various residual populations, residual spaces, residual time, all of which was aggregated within the *defiled* theatrical space. The residual tendencies provided a condition of possibility that appeared, lingered and then dissipated once satellite television, internet and cellular networks opened numerous new vistas of personalized audiovisual pleasure.

It may seem somewhat absurd to aggregate a very eclectic set of practices under any label, but it must be noted that the distribution and exhibition practices attending to the C-circuit freely de-standardize the celluloid product. If hundreds of small distribution companies would anticipate the potential of cheap imports and indigenous soft porn, the exhibition circuit further spiced things up by including *desi* or foreign bits of explicit sexual intercourse. Much in tune with Bangladeshi action cinema about which we learn in Lotte Hoek's recent work (2013), all such practices disaggregated the stability and standardization of the celluloid *product*, going on to reaggregate it as a provincial *service*. S. V. Srinivas' work (2008) on the mutations of Hong Kong films in this circuit down south labels these practices under B-circuit – describing it as the 'final frontier' of the film industry but positing it as an analytical instead of a descriptive category. There were also films by Kanti Shah – producer and director of various films throughout the 1990s and early 2000s, *Gunda* (1998) being the best known – some of which had ageing stars of mainstream Hindi cinema. The entire phenomenon of Ramsay horrors and later Mithun films shot in Ooty could also be included within this circuit. It is nearly impossible to aggregate these very different sets of films and the nature of their circulation, but for our purpose here, it

may suffice to note that numerous other industrial practices had been sustained by the rundown theatres and many north-Indian small towns for a long time.

What separates these films from the mainstream Hindi fare is an anticipation of residual audiences – compulsive singular filmgoers who would be unperturbed by the socially marked decadent orbits in which these films would circulate. As opposed to the inclusive but common minimum imaginary of the big-budget mass film, these other circuits did not need similar box-office returns to sustain themselves.[7] The C-circuit offered an unstable de-standardized filmic pleasure to people who would not fit into a standard. It subverted the very idea of the original by appropriating, re-making, or responding to filmic pleasure at large. In other words, C-circuit projected back on the screen a hybrid between the received image and the desired image.

Could we say, then, that the C-circuit is the direct material or spiritual predecessor of Bhojpuri cinema? Not with any amount of certainty, but there are exciting connections that must be brought to the fore. Bhojpuri cinema is watched by the same *chavvanni-class ki audience* in decrepit theatres, many of which might have had a distinguished past behind them. Despite a range of 'original' films, it is possible to argue that Bhojpuri films are recycled from the older Hindi films, particularly those released after the late 1970s through to the early 1990s; the visual and performative motifs are often directly borrowed, and several titles are a repeat of older Hindi films, whether or not the content is recycled. The regurgitation of filmic content, therefore, is to be understood not only in terms of rights of material but also in terms of a routine. There are indeed interesting thematic consistencies across Bhojpuri cinema, such as: the portrayal of rural feudal lords (*Bahubalis*); the protagonist as a vigilante cast in a familial mould playing the moral vanguard of the society; the conservative portrayal of women; the narrative devices of chase sequences mapping the rural terrain; episodes from ancient epics such as the *Ramayana* and *Mahabharata* being directly or indirectly referred to in order to situate the social imaginary; *nautanki* (a prominent folk-theatre form of north India) providing a glimpse into the *public women* and the native cultural economy. What is worthy of consideration here is how and why the schema in which Hindi cinema came to project the social totality of diverse Indian sensibilities remains the prototype of the constitution of Bhojpuri or other marginal industries.

With the multiplexes absorbing nearly all new releases, the decrepit theatres are the only *entertainment shelters* available to thousands who cannot afford to buy expensive tickets. Many among them are neither native speakers of Bhojpuri nor directly interested in Bhojpuri films, often seeking a dignified shelter in the cinematic space regardless of the film. This needs to be seen in association with the fact that the theatres screening Bhojpuri films may also screen south Indian action films dubbed into Hindi. These industries share certain aesthetic registers: an alternating comedy-action scheme played on a heightened performative scale. It is relevant to note, therefore, the interpenetration worked out in the rundown theatres

like Moti cinema: Bhojpuri films are watched by audiences who may not speak or even fully understand Bhojpuri, while Bhojpuri-speaking people also watch films made in other languages (usually Telugu or Tamil action films) dubbed into Hindi.[8] Recent Hindi blockbusters, too, draw upon this band of bonhomie, particularly after the success of several south Indian remakes starring Salman Khan, for big-budget films to tap into single-screen territories so as to minimize commercial risk. Then, while Bhojpuri films provide a *spatial continuity* with C-circuit attracting many of its erstwhile audience, we confront another important question: what is Bhojpuri about the Bhojpuri cinema?

The Bhojpuri

In order to respond to the Bhojpuri-ness of Bhojpuri cinema, we will have to look at its cross-section: the Bhojpuri language, which suffers from being considered a dialect of Hindi. As is the case with many languages that struggle for years to rise against the label of being mere dialects, corrupted versions of a 'proper' language, Bhojpuri also pays the price for its proximity to Hindi. At the same time, the making of Hindi as a 'gatekeeping language' (Mohan 2005) implicated in the nationalist movement has found reasonable academic attention, notably in Alok Rai's *Hindi Nationalism* (2002). The living languages of north India were thus turned into dialects of the standard textual Hindi – itself a product of intensive *Sanskritization*. What does this mean for Bhojpuri as an alleged dialect that continues to be spoken, either by the illiterate populations or within the domestic confines, by speakers increasingly using English or Hindi to communicate with the outside world? Also, could Bhojpuri cinema possibly escape being cast in an over-determined mould, given the decisive move of the educated middle class away from the language itself? The Bhojpuri in Bhojpuri cinema, therefore, is doubly subverted, both from within and outside the Bhojpuri orbit. It may be useful to illustrate one instance of the middle-class embarrassment with Bhojpuri cinema as noted in a blog:

> The name Bhojpuri conjures up images of ghunghat veiling the girl's glowing face, sisters wearing salwar suits, mother's sacred lap and the carefree childhood spent there, bhabhi's forehead showing off bhaia's love in the form of sindoor and father's stern yet loving voice at naughtiness and leave behind a wistful feeling. Surely, in the tales of pranks between devar-bhabhi, wild fun under the mango tree with friends and the sacred tulsi plant in the family courtyard preserves the Bhojpuri culture and qualities. Bhojpuri society goes by respect to elders and love to younger ones. In such a society was born Bhojpuri cinema.
>
> … Bhojpuri movies are also trying to make maximum profits in the least amount of time, which is pushing the industry towards vulgarity and obscenity. This is the reason the trend of item songs and double-meaning dialogues in Bhojpuri movies have flourished. As a result, Bhojpuri movies digressed from their motive and the story was limited

to anything that provides full entertainment. Kissing scenes rule and clothes of actresses started becoming shorter and shorter. Shame became a thing of the past and exposure became the rule. The songs were only meant for the hero and heroine to strut their stuff. With inciting scenes and unnecessary violence, the young Bhojpuri society is shaken up. (Blogking 2012)

There are two primary types of complaints launched against Bhojpuri films: (i) lamenting the loss of traditional bourgeois morality through culturalist nostalgia; and (ii) lamenting the slow maturity of the film industry. The films, however, address aesthetic underclasses who may not champion the cause of the cinema they watch, but are indeed not ashamed by its failing to live up to *world-class* standards. The world-class, cutting across quality standards of people, cities, institutions, industrial sectors, lifestyles, even a range of spaces official or domestic, has acquired an axiomatic hold over middle-class imaginations. The several routes to the imaginary foreclosure it offers require serious analytical engagement. The wide appeal of the world-class subverts every other modern subjecthood, thereby imposing an aesthetic subalternity onto it. Bhojpuri cinema, much in line with other vernacular cinemas, holds the opposite end of this aesthetic spectrum and continues to launch Bhojpuri-ness through a rural imaginary (see Hardy 2010). But the rural in Bhojpuri is a mere point of departure, not its location. The rural is also the anchor of the social totality Bhojpuri content uses to aggregate, stylize and distinguish itself. The urban or semi-urban interrupts the rural constantly to produce the terrain upon which anxieties, contestations and resolutions can be mounted.

The other side of the Bhojpuri question emerges from within the idea of the original. In one sweeping look around a Bhojpuri film distributor's office, I read titles such as *Khiladi No. 1* [Player No. 1], *Saat Saheliyan* [Seven Sisters], *Ghayal Khiladi* [Wounded Player], *Dushmanon ka Dushman* [Enemy of the Enemies], *Ek aur Mohra* [Another Puppet], *Shiva* [Shiva], *Diljale* [Those with a Heartburn], *Aulaad* [Offspring], *Daag* [Blot], *Diwana* [Crazy], *Jaan Tere Naam* [My Life is Yours] and *Jaanwar* [Animal]. All of these titles or popular songs are recycled from mainstream Hindi films. From the posters, they seem to be remarkably similar and familiar films, which is indeed how I would say my Bhojpuri films' viewing experience has been lately. It remains difficult to separate out Bhojpuri films, be it visually, performatively, thematically or structurally. All of them seem to be poured out of the same bottle. However, it is often believed that this bottle belongs to Hindi cinema.

Yet, the idea of a Hindi original behind them seems absurd given how Hindi films have consistently been derided – not without reason – for being rip-offs from Hollywood and elsewhere (Pauwels 2007; Gehlawat 2010). One is reminded of Hindi cinema being thought of as a 'well-mixed potpourri of popular entertainment' for 'tired untutored minds with undeveloped tastes'[9] by Satyajit Ray (as cited in Gehlawat 2010: xiii). Madhava Prasad too informed us that Indian cinema tends to be seen as 'a *not-yet-cinema*, a bastard institution in which the mere ghost of a

technology is employed for purposes inimical to its historic essence' (1998: 2). It is only in the last decade or so that Hindi films have largely sidestepped the accusation, not because they have offered more original storylines but because the visual slickness they have acquired lately has, to a large extent, countered the impression of a poor copy, rendering them a higher aesthetic quotient than they commanded earlier. Curiously, this is in spite of a large number of films still recycling international content and training themselves, as it were, to make films in the Hollywood idiom – a tendency Prasad calls the 'age of imitation' (2013) – overcoming the challenge of 'cultural backwardness' of the Indian spectator. The champions of the 'Bollywood Revolution' (Sen 2008), on the other hand, valorize an era in which old formulas fail, new filmmakers have a will to experiment, and the content is supposed to be the king. Scriptwriter Ishita Moitra also says: 'Earlier, you spoke to your friends about Batman, but not about the Hindi films you watched. That changed after DDLJ (*Dilwale Dulhaniya Le Jayenge* [The large-hearted will take the bride] 1998)'[10] (cited in Gupta 2011).

It is as an extension of the above-mentioned developmentalism that Bhojpuri cinema is seen as another 'not-yet-cinema', a bastard institution that employs not merely the ghost of technology but also that of Hindi cinema. There is an undeniable habit of using old Hindi content as ready-made material to shuffle around and produce more-of-the-same films. The distributors often complain about this, arguing that Bhojpuri films as a 'regional cinema' should represent the region, its culture and its people. They lament that what Bhojpuri films show is 'not in their culture', a complaint consistent with the Bhojpuri-speaking middle-class view. It is not my task to define Bhojpuri culture, but I would like to draw some attention towards how Bhojpuri films articulate culture to address their constituency.

From a cursory look at the range of films that have been released recently, one could postulate that a third wave of Bhojpuri films emerged around 2004 (Ghosh 2010) which is distinguishable from earlier Bhojpuri films in its star-driven action-melodrama form. These films are unlike the older familial narratives cast in a rural imaginary in the sense that they do not merely perform tradition, but militate against what seems to be 'corrupting' tradition. However, they perform the desire to reclaim tradition by provincializing, taming and parodying the centrifugal forces acting upon the fantasy of tradition. Crucially, stardom has stabilized the industry (through the durable cinematic presence of Ravi Kissen, Manoj Tiwari, Dinesh Lal Yadav 'Nirahua' and lately, Pawan Singh) for the first time. The Bhojpuri-ness of Bhojpuri cinema, therefore, has vital links with: (i) the sovereignty reclaimed by the star's body on behalf of his addressees; and (ii) the fusion of music-stardom with film-stardom. What seems necessary to fully transform oneself as a film star and achieve longevity, as Nirahua alone has been able to do, is turning into an action star. The trope of violence, necessary to the articulation of 'by any means necessary', underlines the gravitas of moral assertions made on the Bhojpuri pitch. But the film songs that punctuate the narrative still inhabit the universe of the large music video

industry, indicating an uneven terrain. The low-budget Hindi action film and the vernacular music industry, however, would be two logical antecedents of Bhojpuri cinema, and deserve sustained analysis towards how they influence and inform the film content.

The pirate sense

Indian cinemas across the map demand and produce 'a habituated audience' – an audience used to a certain mode of reception, 'insiders to the culture of commercial cinema who have developed a relationship with the films based on long acquaintance with them' (Srinivas 2002: 157). Bhojpuri cinema, in spite of its residual origins, is slowly settling down into a new sort of habituation. What are the terms of this habituation and how are they different from Hindi cinema in particular? I suggest that the habituation within Bhojpuri culture industry bristles with a 'pirate sense' that challenges the axiomatic regime of the 'world-class'. How is this pirate sense to be distinguished from a more innocent sort of cultural and linguistic translation? What are the key departures within the blatant recycling of content? Across a wide range of Bhojpuri films, one can easily notice certain patterns that privilege the subaltern and allow her the opportunity to speak for the larger whole she represents. Be it the figure of the street urchin, the *ganwaar* (rural person), or the public woman (prostitute), the films repeatedly allow them a space to launch themselves discursively, to not only attack the arrogance of the privileged but also render a moral surplus to the underprivileged in terms of a carefully adhered-to value-system. This is not at odds with the Hindi film up to the end of twentieth century,[11] but indeed is so with the films that followed – focusing on the pre-eminent figure of the non-resident Indian – where such voices were generally expunged in entirety.

Many of the above-mentioned subalternities are fused into the figure of the *Bhojpuriya*, who speaks for the region directly or indirectly. Deploying speech to rhetorical effect is nothing new in Indian cinema but its projection is often refracted through the composition of the imagined community being addressed. In *Rangbaaj Daroga* (2009), Ravi Kissen traces the history of *Gilli-Danda*, a popular game in the region, to colonial times, situating it within Bihar and UP, and accuses the British of having 'stolen our game' to transform it into cricket. Needless to say, this counterfactual historicizing has no basis in evidence; it merely delivers a proxy response – duly cheered – to the wide-ranging contempt Bhojpuri language, people and the region put up with on a daily basis. The language, too, is vital to the speech here. For Bhojpuri cinema, the language of officialdom is Hindi, analogous to how Hindi cinema before its anglicization deployed English to mark a distance between the administrative and informal. This distance is amplified particularly in interactions with civil servants who speak Hindi as the language of the state. At the other end of the spectrum, Nirahua, a street urchin in *Shiva* (2010), says: '*Jetna garmi tohre*

khoon mein ba, ohse jyada garmi hamre pesaab mein ba' ['There is more heat in my piss than there is in your blood']. The motifs of bodily fluids such as piss, spit, blood and sweat have strong cultural roots in rhetorical speech of the region and are often used by those who cannot physically dominate and violate their counterparts. This verbal violence of the rhetorical motifs occasionally lends itself to complementing or supplementing physical violence in Bhojpuri cinema.[12]

Together, several such registers are used to produce a charged affective universe that restores pride in vernacular subjectivity. The terms of the Bhojpuri habituation are overwhelmingly dominated by the pirate sense to *occupy the screen* – occupy its alleged neutrality by making sovereign assertions on behalf of the many anxieties of the Bhojpuri public. Even though this sense is not integrated into the mode of production,[13] in habituating themselves to a pirate transaction, the audience *will* themselves temporarily to produce the Bhojpuri public. I draw here upon Lawrence Liang's usage of 'pirate sense' in an essay about the Malegaon films: 'Piracy has been over-analyzed in terms of its legality and access, yet under-theorized as a specific sensibility and attitude.' He proposes that the pirate-sense, 'like a hope-sense', is 'not a foregrounded sense, but a subterranean one … ever alert to the possibilities offered in spite of the apparent impossibility of our material life' (Liang 2012). Ravi Sundaram's (2010) work on Delhi's media urbanism also studies a 'widespread culture of the copy' that plugs back into this pirate sense. Not unlike a Bhojpuri film, Sundaram tells us that 'the commodities of the copy are multi-use, recombined/recycled and in constant circulation – moving in and out of new spaces and networks' (2004). Predictably, this pirate sense has been ascribed to notions such as the 'revenge of the mofussil' (Ghosh 2010). Ambitious though these ascriptions may be, they are perhaps overstepping in enthusiasm and associating a political overtone to a socio-cultural pattern that ontologically resists such sweeping aggregations. The pirate sense is primarily a metaphor; it is interrupted by the many impossibilities of the material life and should not be falsely foregrounded to champion the residual. Sundaram, too, goes on to add that the 'pirate culture has no strategies of political mediation; it works though immersion and dispersal rather than representation and voice. It is resistant to both control as well as radical-critical strategies of intervention, inhabiting networks of disorder that are endemic to contemporary urbanism' (Sundaram 2004: 70).

Bhojpuri cinema sits at a crucial point of inflexion. Key to its emergence on the film trade map were the decrepit single-screen theatres across north India as well as in Mumbai and Delhi, which facilitated one such network of disorder. Its arrival was welcomed with surprise but, responding quickly, Bhojpuri films helped sustain a vital trade channel when there seemed no way out for most of these theatres, and the multiplex reoriented the film content and form both to the service of a reformed mode of production-distribution. Also, Ratnakar Tripathy's work has best dissected the research-worth of Bhojpuri cinema and traced the impact of several factors upon its heavy-duty emergence, particularly the electoral politics of Bihar, the rise of

middle and lower castes, the incapacity of print to even reciprocate the energy of the media industry, and the resultant prowess of media literacy as opposed to textual illiteracy (Tripathy 2007; 2012; 2013). There is no doubt that there is much more than a few cultural antecedents at stake, particularly when we take into account the rise of similar vernacular content in the idiom of Hindi cinema across north India, even in regions such as Laddakh, Jammu and Kashmir, and Jharkhand, where geographical and political belonging to India is not entirely certain (see Vishnu 2010; Vohra 2009). As we expand the empirical as well as theoretical scholarship about the provincial alternatives emerging in the shadow of Hindi cinema through its older idioms, we must also expand the filmic object of our analyses, particularly in the realm of technology, in the wake of the recent developments where alternative technologies also make imperative alternative commercial logics. However, the condition of the possibility that emerged in 2004 seems to be on a steady decline due to an overproduction of films eating into the advantage of the erstwhile residual, and the theatrical exhibition of Bhojpuri films is already losing trade ground.[14]

This chapter could only offer ethnographic and theoretical glimpses into the Bhojpuri film and its audience. Given the rapidly shifting contours of this *disorder*, we would be required to match steps with the quick-wittedness of pirate transactions that make Bhojpuri cinema happen.

Notes

1. I use modernities in the plural, instead of the singular 'modernity', to resist collapsing within one concept the variety that is germane to pirate practices, conscious as they are of their transient character. This is also informed by scholarly positions, such as that of Comaroff and Comaroff (1993).
2. Even though versions of Bhojpuri are spoken by diasporic populations in countries such as Fiji, Bhojpuri music has found more popularity than the films (see Tripathy 2013: 153).
3. Ghosh (2010) declares it to be the originary moment of the third wave of Bhojpuri cinema which forced cinema halls to search for the 'House Full' boards. Also, in a personal conversation with a hawker selling pirated CDs/DVDs at Bhagirath place, New Delhi, it was narrated to me how the hawker made good money by buying a master-copy of the film for 3,000 rupees and making countless copies out of it.
4. Actor Chhavvi Pandey, who starred in Bhojpuri film *Bidesia*, says: 'A Bhojpuri film is never seen by people of a good class. Those who see it are either autorickshaw drivers or vegetable and fruit sellers ... *Ab ek* bold scene Bollywood *mein hota hai, aur ek* Bhojpuri movies *mein, inn dono mein*

zameen aasman ka nahi, antariksh ka farak hai [There are bold scenes in both Bollywood and Bhojpuri films, but the two are galaxies apart]. If you see the posters of Bhojpuri films, you'll see an item girl exposing *ajeeb tareekey se* [in a strange way]' (cited in Wadhwa 2013). The exclusivity of Bhojpuri vulgarity is more a matter of form than content. The strangeness of delivering the 'bold scenes' in comparison to Bollywood works in close association with the strangeness of the masses – the auto drivers and vegetable/fruit sellers, who are not of a 'good class'. But it is also about the raw performativity of sexualized address as opposed to which a fast-edited Bollywood item-song – average shot length often going below 1 second – comes across as more sophisticated.

5. See Lakshmi Srinivas (2010) for more detailed understanding of the significance of balcony viewing for upper- and middle-class citizens, particularly women.

6. Another popular formulation widely offered to capture Indian cinema at large, particularly the variant that lost out to the non-resident turn, is *masala*, referring once again to a food-related metaphor, but hinting at the 'spicing up' of the menu. *Thali*, as a related but significantly different formulation, refers to a staple entertainment diet, where the spices find a place alongside the necessary. The shift in the metaphorical focus, evidently, is in the proportions.

7. C-circuit cinema has a para-industrial approach to film trade and film aesthetics. In its production values, there resides an inherent critique, an indictment perhaps, of finance and authorial capital, as there is of the bourgeois idealism and cerebral cinema.

8. To a large extent, this has to do with the incredible cultural implications of action cinema in extremely violent and hierarchical societies. The solidarity across Bhojpuri and southern content has notably arrived at a time when Bhojpuri content is gradually settling into the action genre. But the role of action in this cultural solidarity must be seen in association with comedy, even with the 'melodramatic bed' on which highly performative episodes and motifs are arranged.

9. This is a view that was also sold to us in several reports till as late as 2012, when Anurag Kashyap and Vasan Bala took their films to the Cannes film festival and allowed themselves the critical authority to tell Indian media what the international media industry thought of Bollywood.

10. Trisha Gupta writes for *Caravan*: 'It may seem unimaginable to a generation brought up on Abhishek Bachchan's *Bluffmaster!* rap and Kareena Kapoor's size-zero diet, but 20 years ago, Hindi films were not cool. In large numbers of upper-middle-class, English-speaking Indian families, children were banned from watching "that trash". Even if they grew up watching Hindi films on television (and later, video) in the company of grandmothers and household help, they would transition, by their teenage years, into thinking of them as a sort of guilty pleasure.

'But a decade and a half ago, something changed. The reemergence of the teenybopper romance, now enclosed in the cloying folds of the family, began to wean the middle-class audience away from their TV-VCR viewing and back to the cinemas—which were themselves being revamped into multiplexes' (Gupta 2011).

11. One can think of countless incidents in Hindi films where a marginal character would eventually speak up to assert a moral counterpoint: '*Ab tak maine kuchh nahin kaha, lekin aj main chup nahin rahunga!*' ['I never said anything till now, but today I won't remain silent!'].

12. This spirit of championing the subaltern is indeed continuous with the other Indian popular cinemas, and has been remarkably captured in the notion of impersonation, discussed in sharp analytical depth by Ajay Gehlawat (2007). Impersonation implying 'a form of subversion, of the illegitimate (even the monstrous) masquerading as the real thing or person, generally with the intention of displacing the legitimate' (cited in Gehlawat 2007: xx) is a schema that could be used in relation to Bhojpuri cinema.

13. It is true that the film industry, in line with most vernacular industries, works through financial stakeholders who have no stakes in the film content. However, as one of the primary thrusts to the industry comes from the flourishing music industry, it must be acknowledged that the Bhojpuri culture industry bristles with the pirate sense. Rampant piracy of content, small-time recording companies all across Bihar, and thousands of aspiring singers risking a substantial amount of capital, thus integrate the audience into the larger mode of production of cultural content in Bhojpuri (see Tripathy 2012).

14. In Delhi and UP territory, most theatres show a new Bhojpuri film every week. The next weeks' releases are pre-declared as the producers rent distribution for their films. The distributors have enough choice to decide which film to release for the week. The number of Bhojpuri films made per year increased drastically from 2006 and the decline in profits has not been able to put a stop to this number.

References

Blogking (2012) 'How to curb the increasing vulgarity in Bhojpuri cinema?', *Bhojpuri News* (28 January), http://bhojpurinews123.blogspot.in/2012/01/how-to-curb-increasing-vulgarity-in.html

Comaroff, Jean and Comaroff, John L. (eds) (1993) *Modernity and Its Malcontents: Ritual and Power in Postcolonial Africa*, Chicago: University of Chicago Press.

Deshpande, Satish (2006) 'Mapping the "Middle": Issues in the Analysis of the "Non-poor" Classes in India', in *Contested Transformations: Changing*

Economies and Identities in Contemporary India, M. E. John, P. K. Jha and S. S. Jodhka (eds), New Delhi: Tulika Books, 215–36.

Fernandes, Leela (2006) *India's New Middle Class: Democratic Politics in an Era of Economic Reform*, Minneapolis: University of Minnesota Press.

Gehlawat, Ajay (2010) *Reframing Bollywood: Theories of Popular Hindi Cinema*, New Delhi: Sage.

Ghertner, Asher (2011) 'Nuisance talk and the propriety of property: middle class discourses of a slum-free Delhi', *Antipode*, 44(4): 1161–87.

Ghosh, Avijit (2005) 'The Mofussil's revenge', *The Times of India* (1 November), http://articles.timesofindia.indiatimes.com/2005-11-01/edit-page/27857786_1_bhojpuri-sasura-bada-paisewala-regional-genre

— (2010) *Cinema Bhojpuri*, New Delhi: Penguin.

Gupta, Trisha (2011) 'Death by Dialogue', *The Caravan* (1 May), http://caravan-magazine.in/Story/872/Death-by-Dialogue.html

Hardy, Kathryn C. (2010) 'Mediating Bhojpuriya: migration, circulation, and Bhojpuri cinema, *South Asian Popular Culture*, 8(3): 231–44.

Hoek, Lotte (2013) *Cut-Pieces: Celluloid Obscenity and Popular Cinema in Bangladesh*, New York: Columbia University Press.

Jain, Kajri (2007) *Gods in the Bazaar: The Economies of Indian 'Calendar Art'*, Durham, NC: Duke University Press.

Kumar, Akshaya (2013) 'Provincialising Bollywood? Cultural economy of north-Indian small-town nostalgia in the Indian multiplex, *South Asian Popular Culture*, 11(1): 61–74.

Liang, Lawrence (2012) 'Is it a bird? A plane? No, it's a magic chair', *e-flux*. www.e-flux.com/journal/is-it-a-bird-a-plane-no-it's-a-magic-chair/

Mazzarella, William (2003) *Shoveling Smoke: Advertising and Globalization in Contemporary India,* Durham, NC: Duke University Press.

Mohan, Peggy (2005) *Is English the Language of India's Future?* Seminar no. 545, www.india-seminar.com/2005/545/545%20peggy%20mohan1.htm

Pauwels, Heidi (2007) *Indian Literature and Popular Cinema: Recasting Classics*, London/New York: Routledge.

Prasad, M. Madhava (1998) *Ideology of the Hindi Film: A Historical Construction*, New Delhi: Oxford University Press.

—(2013) 'From Cultural Backwardness to the age of Imitation: An Essay in Film History', in *Routledge Handbook of Indian Cinemas*, K. Moti Gokulsing and Wimal Dissanayake (eds), 7–18, New York: Routledge.

Rai, Alok (2002) *Hindi Nationalism,* New Delhi: Orient Longman.

Sen, Raja (2008) 'The Bollywood Revolution', *Tehelka Magazine*, 5(20): (24 May).

Singh, Bhrigupati (2008) '*Aadamkhor Haseena* (The Man-Eating Beauty) and the Anthropology of a Moment', *Contributions to Indian Sociology*, 42(2): 249–79.

Singh, Rajesh Kumar (2012) 'Indian cinema is very strong', says Ashim Ahluwalia, director of Cannes selection MISS LOVELY, *Bollywoodtrade.com* (8 May), http://www.bollywoodtrade.com/interviews/indian-cinema-is-very-strong-says-ashim-ahluwalia-director-of-miss-lovely/index.htm

Srinivas, Lakshmi (2002) 'The active audience: spectatorship, social relations and the experience of cinema in India', *Media, Culture and Society*, 24, 155–73.

— (2010) Ladies queues, 'roadside Romeos,' and balcony seating: ethnographic observations on women's cinema-going experiences', *South Asian Popular Culture*, 8(3): 291–307.

Srinivas, S. V. (2008) 'Missing in the original: Twin Dragons remade in India', *Journal of the Moving Image*, 7.

Sundaram, Ravi (2004) 'Uncanny networks: pirate, urban and new globalisation', *Economic and Political Weekly* (3 January), 64–70.

— (2010) *Pirate Modernity: Delhi's Media Urbanism*, Abingdon and New York: Routledge.

Tripathy, Ratnakar (2007) 'Bhojpuri cinema: regional resonances in the Hindi heartland', *South Asian Popular Culture*, 5(2): 145–65.

—(2012) 'Music mania in small-town Bihar: emergence of vernacular identities', *Economic and Political Weekly*, XLVII(22): 58–66.

—(2013) 'Mapping the Invisible World of Bhojpuri Cinema and its Changing audience', in *Routledge Handbook of Indian Cinemas*, K. Moti Gokulsing and Wimal Dissanayake (eds), 150–161, New York: Routledge.

Vishnu, G. (2010) 'Jhollywood is calling', *Tehelka* (3 July), http://tehelka.com/jhollywood-is-calling/

Vohra, Paromita (2009) 'Out of thin air', *Open* (12 September), http://www.openthemagazine.com/article/documentaries/out-of-thin-air

Wadhwa, Akash (2013) 'Bhojpuri cinema is sustaining on vulgarity: Chhavvi Pandey', *The Times of India* (1 September), http://articles.timesofindia.indiatimes.com/2013-09-01/news-interviews/41662417_1_bhojpuri-cinema-bhojpuri-film-bidesia

13

Intimacy Out of Place: On the Workings of Smell in an Exhibition on Human Sexuality

Susanne Schmitt

Exhibitions that address gender, sexuality and desire have increasingly been appearing on the museum scene,[1] as have their scholarly engagement.[2] Sexuality and gender as its core organizing force have, of course, always been important aspects of museum and exhibition politics, since it is hard to think of an exhibition – be it afforded by a natural history museum or a science centre, an art museum or an outdoor museum – that is not implicitly making statements about gender issues or is, as an institution, shaped by gendered power relations (Levin 2010). We all understand that sexuality can depict many aspects of being human and a multiplicity of discourses, from bio-scientific claims to identity politics attendant with the articulation of desire. Exhibitions offer a variety of descriptions and definitions of what sexuality might be, and they mostly do so in visually engaging and ocularcentric ways of representation. In this chapter, however, I intend to shift the attention by focusing on an aspect of sensation that is an important aspect of the multisensory museum experience: smell.

This chapter looks at the interrelation of sensory curating practices, specific notions on sexual attractiveness and bodily experience at the Deutsches Hygiene-Museum in Dresden, a medical history and science museum. In fact, it does not only look at it – it centres olfactory forms of representation and experience beyond the visual without completely discarding the former. What assertions about desire are made by the exhibition in question? What is the role of the senses, especially the sense of smell, in this narration and how does it interact or counteract with other sensory dimensions of the museum experience? Both smell and sexual desire are charged with culture-specific notions that characterize them both equally as transgressive, as intimate and as potentially subversive. Smell, as I will show, becomes subversive in two senses: first, it destabilizes a visual conception of attraction that is entertained in contemporary explanations of sexual attraction, and second, it disrupts the museum context that highly draws on visual forms of representation.

This chapter thus provides an ethnographic narration of the workings and interpretations of purposely used and unintended smells at the sexuality exhibition that

is part of the permanent exhibition at the Deutsches Hygiene-Museum[3] as its initial point, and weaves in commentary from other ethnographic studies in order to irritate and contextualize specific notions of the olfactory. In so doing, I draw on a particular perspective, namely, sensory anthropology, and ask how an exhibition about human sexuality is experienced by various groups within the museum. In addition, I ask what specific cultural meanings the senses of vision and smell convey in this micro-cosmic world. As we will see, the ways in which people, visitors and staff alike, experience the sexuality exhibition demonstrate moments of intensity and intimacy, an experience that is less so about desire in a sexual sense.

Exhibitions and ethnography

Museums have widely been theorized and studied as institutions that classify knowledge and disseminate dominant worldviews. [They] 'afford anthropologists the opportunity to enter both realms by considering material culture and artefacts ... while simultaneously addressing crises of representation, cultural interpretation, and issues of conflicting epistemologies' (González, Nader and Ou 2001: 107).

The site of the anthropology discipline's early representation and authority – the (ethnographic) museum – has by now become an object of ethnographic scrutiny itself as its role in the politics of representations has been more critically interrogated (see Bouquet 2001; Ames 1992). This scrutiny is increasingly reaching out to museums with a different topical focus, such as science museums (see Vackimes 1996; Macdonald 2002). The implicit assumptions that exhibitions inscribe on sexuality, however, have only recently attracted interpretative attention, especially from critics within the field of queer studies (see for example Bourne 1996; Frost 2008; Sanders 2008; Levin 2010). The recent proliferation of sex museums (Beck and Hafferkamp 2001) and the ways in which academics write and represent women's and queer social history are key to this emerging discussion (which often refers to a social constructionist framework drawing on, among others, the works of Michel Foucault, who, as he stated, attempted 'to define the regime of power-knowledge-pleasure that sustains the discourse on human sexuality in our part of the world' (Foucault 1990: 11)). Within the relatively small body of literature on exhibitions on sexuality, another shortcoming with anthropological and ethnographic engagements with museums as field sites becomes evident – namely, exhibitions are not only texts and arrangements of visual artifacts but sensory-material environments and landscapes experienced through the body. While museums have been thought of as contact zones – most famously by James Clifford drawing on Mary Louise Pratt (1997) – as sites of conflicting interpretations of objects and their histories, they might as well be thought of as visceral contact points. As David Feldman suggests (2006), they are sites of *lived experience* and corporeal and multisensory engagements with museum objects, and, as I would like to add, with the museum as experiential site

beyond single objects. One such site is the Deutsches Hygiene-Museum in Dresden, Germany, where I conducted fieldwork between 2008 and 2011.

From 'Lebensreform' to art and science: The Deutsches Hygiene-Museum

The Deutsches Hygiene-Museum in Dresden is a unique place that creatively mixes and recombines its historical trajectories as a museum built to service public health interests during the Weimar Republic with a contemporary engagement with the public understanding of science and artistic interventions. The museum is famous for its interdisciplinarity and its engaging exhibitions on topics from dance to migration that are highly acclaimed by German and international audiences and feuilletons alike. Public relations material that is available online frames it as 'neither a science centre nor a special museum devoted to a strictly defined topic area' whose 'interests centre on the biological, social, and cultural dimensions of the human being'.[4] The museum's name dates back to the *Lebensreform* movement that took place in Germany and other European and North American sites in the early decades of the twentieth century. This movement introduced new notions about the subjectivization of health and well-being. 'Natural' foodstuffs, a social criticism of urban 'unhealthy' living conditions, modernist dance, hiking, garden cities and gymnastics were all aspects of this variegated movement that spread throughout Europe and North America. The notion of hygiene was one that was strongly informed by biomedical and statistically oriented efforts towards public health that held individuals responsible for a 'healthy' self – and thus a 'healthy' society. Far from eliciting today's notions of soapy cleanliness and antiseptics, then the term hygiene implied the subjectivization of health and well-being within a corresponding educational narrative (Sarasin 2001: 17). Ultimately, the notion of hygiene became absorbed into national socialist ideology and took on the shape of racial hygiene drawing on already existing eugenic tendencies. The *Lebensreform* movement reproduced this narrative not only in books and pamphlets but also in exhibitions such as International Hygiene Exhibitions – world fairs addressing public health education worldwide. The city of Dresden saw two of those fairs (in 1911 and 1930) that laid the foundation for the museum. The institution opened its doors in May 1930 as part of the Second International Exhibition of Hygiene that took place in Dresden that year. The museum was the brainchild of Karl August Lingner (1861–1916), a famous Dresden citizen who had made a fortune as producer of the 'Odol' mouthwash that is still available today. He marketed the product by creating a brand that could easily be identified with the ideas of hygiene and well-being and at the same time applied marketing strategies like visualization to exhibitions on hygiene (Osten 2005). Lingner later financed the museum building that opened in 1930. It was designed by the architect Wilhelm Kreis in the style of the minimalist

Neue Sachlichkeit that still stands (after the extensive destruction of World War II) at the edge of the 'Großer Garten' in Dresden. From the beginning, education on topics relevant to reproductive health and sexually transmitted diseases such as syphilis were an important part of the exhibition. Today, after a substantial redesign of the permanent exhibition and the museum's reopening in a reunified Germany in 1990, the Sexuality Hall, whose complete name is 'Sexuality. Love, sex, and lifestyles in the age of reproductive medicine', is still one of the most popular halls within the museum range. Located between the spaces on 'Eating and Drinking' and 'Memory, Thinking, Learning', this large room, decorated in deep shades of red and brown, is supposed to tell a story: according to the tour booklet, it is a story that begins with the choice of a partner and ends with partnership.

At the sexuality hall

The sexuality hall is decorated in bright cherry red. The wooden panels on the wall are a warm walnut colour and the ceiling gives off a crisp white. It has always been one of my favourite places at the museum because it feels intimate in a grand way, elegant yet with a twist of kitsch. It evokes the atmosphere of a little forest as there is no straight visual axis. The pathways that the architects have laid out meander from clearing to clearing, making the voices of others appear or disappear as you bend around a corner.

The objects and installations in the sexuality hall of the Hygiene-Museum are diverse, and leave ample space for individual narratives on sexual experiences and identities to be represented. Exhibits range from first-person narratives on gender/queer youth to the sexual experiences of elderly people. Here, sex toys from a variety of times and places are located in a museum showcase from the turn of the century that warns us about the dangers of masturbation. The sensory impression that comes to my mind and made its way into my field notes is one of multivocality: even if there are no visitors, the room seems to be full of voices and stories. The sexuality hall is best introduced by Matthias,[5] a medical student freelancing as a tour guide at the time of my fieldwork in 2010, who experiences a slightly uncanny confrontation with the visual dimension of attraction whenever he conducts tours here. Those tours vary in focus and content. Some offer sex education to school classes, and others are tailored to ignite discussion of reproductive technologies. The ones that give a more general overview of the hall often engage with a core topic of the hall: the question of attraction. How do we choose a partner?

Usually, Matthias begins his tours in front of a display of male faces where visitors are supposed to learn about the golden rule of attraction. Eighteen portraits of young men present themselves to the viewer. In addition, three frames are left blank and equipped with a mirror that allows for the visitors to scrutinize their own facial structures through an imprinted grid. Out of the range of fair-skinned portrait

pictures, the tour group will be asked to pick the face they find the most attractive. We soon learn that the face that often receives the most applause has been generated by a computerized program that mixed the faces of the real men that surround it. Symmetry is attractive. The narrative that underpins this part of the exhibition aims at defining sexual attraction within an evolutionary framework following heteronormative assumptions. The explanations provided leave visitors with the idea that an average-looking and symmetrical physiological appearance is the most promising biological endowment for a successful race for procreation, the main aim of sexual attraction according to this rationale.

Other materials at the exhibition present other sensory dimensions of attraction and desire in isolation: in front of the display of the male faces, the visitor is invited to lift a phone and engage with and learn about the role of the auditory in the process of choosing a partner. A nearby touch area leaves one guessing: 'is that a knee that I touch here…?' As objects within the museum they are open to appropriation and interpretation. They are challenged by other materials that stress the cultural and social dimension and the contingencies of attraction and desire. Through their visually dominating presence, however, the male portraits open the room up to potential visitors and introduce a strong narrative that claims universal significance and operates (as we will later see) through the rationale of scientific proof. As the visitors generally testify to scientific claims laid out at the science museum, they witness and ratify (bio)scientific authority (Bellanger 2001).

I let Matthias help me introduce the visual rules of attraction as they are presented at the museum for several reasons: the fact that tours begin with the sense of vision is evidence of its central role in Western contemporary cultural make-up which has been criticized for its role in ethnographic engagement as well. 'To "visualize" a society or a culture almost becomes synonymous for understanding it', Johannes Fabian (2002: 106) wrote. The 'scopic regime of modernity' (Jay 1994: 589) finds its expression not only in the ocularcentric arrangement of urban space including the museum exhibition, but also in ethnographic writing. The latter, however, has come a long way from verbocentrism to a sensual turn to a reintegration of vision as a multisensory and diverse and situated practice (Grasseni 2007).

Matthias' experience of conducting tours on attraction reveals yet another layer of the sensory museum, and one that I will get back to presently as I discuss the workings of olfaction. While he presents a discourse on male attractiveness to his listeners, what he says and speaks about affects him deeply. Matthias carefully chooses the quality clothes he wears to work. So did I during my time of fieldwork, and so did almost everybody else I talked to and worked with at the museum. At this hyper-aesthetic and carefully managed sensorial place (see MacDougall 2006; Schmitt 2012), we all knew that we were on exhibit as well the second a visitor's or colleagues gaze met our faces and bodies. Matthias muses about the way he feels as the centre of the visitors' visual attention in an interview that we conducted after I accompanied him on numerous tours. While he stands in front of the display and

faces his tour group, the assumptions it makes about male attractiveness go under his skin to make him anxious about what others thought of him:

> And you can imagine, when I am standing in front of this wall, that I have that routine thought in my head: What do I look like right now? I really hope I do not look like this right now [points towards an image of a person with slightly puffy eyes and eyerings] … which would not be very attractive … and him [ibid.] who has been identified as an alcoholic by a former Human Resources manager. He could see that in his eyes he said. It was on a Sunday afternoon and I was wondering what my own eyes might look like.

It is precisely this intermingling of the explanatory and the corporeal, the staged and the hidden, that I will develop further as we now move to another object within the exhibition that introduces a different discourse on sexual attraction and a different set of normativities and aesthetic experiences: the informally named 'olfaction corner'.

Olfactory interventions

The 'olfaction corner' is tucked away on the left side of the hall, slightly out of the visitor's vision. The corner consists of four metal containers. A grown-up person has to bow down to in order to lift the lid and pull out the ampullae that contain the pungent smells of animal secretions that have – so the label implies – traditionally been used in the production of aphrodisiac scents. The smell is strong and pungent. Guided tours often head to the ampullae right after they discuss the visual model of attraction. The musk and the ambergris are familiar; they are regularly used in perfumes I know – especially the ones that my grandparents' generation used to wear – and I find them sweet and heavy. The others, I find, smell a bit like a trip to the animal park, reminiscent of an uncleaned cat-litter tray. Small historical but undated sketches accompany each of the four vials and individual labels define them as ambergris, musk, civet and castoreum. As the labels point out, those four scents have been in use as sole or at least the basic ingredients of aphrodisiacs for centuries. They share a common origin, as they are products of animals' genital adenoids or products of dead animals – musk, civet and castoreum from the musk deer, the civet and the beaver respectively. Visitors usually react strongly to these odours, and can often be seen jumping away and expressing their disgust in their encounters with the ampullae. Some guided walks across the museum lead directly to the olfactory exhibit. Some avoid it altogether. However, more often than not, they constitute a part of a dialectic discussion on attraction. In the socio-biological model that this part of the exhibition presents, symmetry, accessible through the gaze, testifies to health and reproductive success. Visitors who gaze at the portraits of the young men often choose the synthetic ones – the computerized synthesis of all the faces shown as the most beautiful – and thus testify to the truth claims of a model that equals

symmetry with attraction. But this assumption remains neither uncommented nor unchallenged. Some are not convinced and many claim to find faces with a certain asymmetrical 'character' more beautiful. The use of smells in the exhibit further irritates the status of the visually beautiful.

At the olfaction corner we learn from guides that 'looks aren't everything' and that there is still help available for participants should the self-testing in front of the mirror have had an unfavourable result. Perfumes have always been used to heighten attraction, we hear, although tastes have changed. The explanation that is offered is one of unconscious workings: the animal ingredients they contain are often structurally similar to human sex hormones and touch and arouse us without our knowing. In short, the strict geometry of physical attraction, the deciphered mathematics of beauty that the previously discussed portraits of men presented, are undermined by the workings of smell. The allegedly arousing odours, resembling animal pheromones, possess an agency of their own that even has the potential to overturn the visibly beautiful, so we learn. These notions draw on conceptions of the sexual power of smell that are present in contemporary discourses on the power of pheromones which have been present in more recent West European cultural history, for example in marketing strategies for perfumes or sexology's early writings, mirroring cultural assumptions on sensory hierarchies and agencies. Think of the perfume called 'Musk' by English Leather, a not so floral but rather musky bouquet that was advertised as 'the missing link between animal and man', thus promising to reinvest man (here: a male) with the animal (i.e. sexual) power they have lost by becoming civilized' (Classen, Howes and Synnott 1994: 187).[6] Today, perfumes containing a strong musk note are predominantly marketed as 'male' (Groom 1997). Or turn to Havelock Ellis, one of the founding figures of sexology in the Foucauldian sense, who famously points out that:

> We find that perfumes in many cases have the same sexual effects as are primitively possessed by the body odours. ... It seems highly probable that ... perfumes were primitively used by women, not as is sometimes the case in civilization, not with the idea of disguising any possible natural odour, but with the object of heightening and fortifying the natural odour. ... In this we may ... explain the fact that until recent times the odours preferred by women have not been the most delicate or exquisite, but the strongest, the most animal, the most sexual: musk, castoreum, civet, and ambergris. (2004: 95–6)

In his widely read history of smell in eighteenth- and nineteenth-century France, *Le Miasme et la Jonquille* (1982), Alain Corbin points out how aromatic essences extracted from animal genital adenoids came to be discredited because of their association with faeces, female body odour and animality and lighter scents like violet and daffodil came into fashion. Body odours and smells that resembled musk, civet or ambergris came to be regarded as virtually dangerous and contagious smells within the new medical and hygienic theory that claimed that infections were caused by miasmas.

A corresponding social imagination merged these smells with unclean living conditions, poverty and loose morals. Floral smells fitted into the newly emerging olfactory regime of deodorization, rendering musk as a remnant of a more primitive, polluted past. Musk played an ambiguous role in the changing olfactory trends and fashions at the turn of the nineteenth century, however, as it was used widely to compound perfumes and, as of 1888, could be industrially produced. Although most perfumes contained it, it being an actual ingredient of fragrances was rarely made explicit (Lemire 2010: 108). On the occasion of a Paris visit by Queen Victoria, *Le Messager des modes* commented on the unwomanly – or, rather, too animalesque and seductive – effects of musk and amber by stating that they 'produce the most subtle and pervasive exhalations: the snake is hidden under the flowers' (Lemire 2010: 105). Women were advised to step back from the use of such profane fragrances at all costs (ibid.).

Within the context of a guided tour the explanatory, the pragmatic and the experiential overlap as museum educators intentionally utilize smell(s) as part of their repertoire of sensory practices. Smells allow for a degree of interactive recreation after a half-tour of the museum of 30 minutes or so duration – 'I like to use them as a boost, before people get too tired', as one of the guides puts it. When this happens, disparate forces collapse into an event (Stewart 2007) that tour guides, visitors, contemporary discourses on the power of pheromones, smells, clichés and tired bodies co-create in a given moment on an otherwise slowly passing museum afternoon, leaving some deeply affected and others relatively untouched. This confrontation between bodies and the material forces at play in the museum creep under the skin and create powerful moments of intensity, and they do so in different ways for different individuals and communities at this site.

Sexual osmologies as sensory geographies

Guides strategically use smell-related (and of course other) sensory practices as a wake-up call and educational tool during tours, but smells have an entirely different meaning for the security staff roaming around the hall. Deeply familiar with the intimate sensory geography of the exhibition, they try to navigate around sources of smell while they oversee the visitors' engagement with the exhibits. They agree that the olfactory installation at the sexuality hall is one place in the museum that they prefer to avoid being close to: the immediate reactions of the visitors to the smells are so strong that the corner is a potential source of disruption. Even if they do not immediately engage with the smells, they linger and float throughout the museum space. They create uninvited intimacy and go under the skin as the skin of others makes itself 'smellable'. One member of the security services recounted:

> It really smells like a human here. If one of those scraggy, gawky boys comes near, I
> think 'Oh, oh' and stay away from him. You are so close to people here. Puberty is the

worst. When the glands start working … you can smell the children from school. And women from Eastern countries, they often use heavy perfumes. On the other hand I recently smelled a really nice perfume here, I do not know the name, and I did not even have to look at her to know that the woman who wore it was really sophisticated. And I find the smell of sweat appalling and if visitors have been drinking alcohol. Especially on Fridays, when the market was and people have been eating fish sandwiches and I work at the cash desk. But you cannot move away from there, then. And in the hall on 'Living and Dying' we are right above the air-condition from the restaurant. We smell everything they cook there. You cannot escape it. Yes, this museum is very much about odours.

In the museum's sanitized and air-conditioned environment, smells make an even stronger impression, as they dominate and manipulate the carefully managed sensory landscape. Perceptions of smells, especially from groups of schoolchildren, are an integral part of the experience of working at the museum for most research partners with whom I discussed the topic. The smells that are perceived as offensive are sexualized smells too – the 'glands start working' as one person put it. While they do not have arousing effects, they too are transgressive and cross social boundaries between museum insiders/outsiders and thus co-constitute the museum as a work-place environment rather than a rarefied institution.

It is precisely the potential workings of smells that have stimulated ethnographic and anthropological attention. In addition to the difficulty they cause when they need to be described within a comparably narrow linguistic framework, smells have often been interpreted as markers of transitions and social boundaries that find their expression in the olfactory (Largey and Watson 2006: 35). In fact, the use and significance of odours as markers of transitions or changes in categories – in our story, the categorical boundary work between humans and non-humans and the transition from neutral to desirous – is one of the better researched areas of sensory cosmologies and experience (see for example Howes 2007). Moreover, smells can be feasible markers and creators of places of engagement out of space (e.g. Pink 2004), forming part of a sensory landscape of the museum by labelling and making tangible a certain area of the permanent exhibition as more sensuous than others. The now widely used term smellscape that I suggest is a helpful concept was first used by J. Douglas Porteous, who recommended that – analogous to the visual arrangement of landscapes – 'smells may be spatially ordered or place-related' (1985: 369) and thereby situate meanings, even if 'the perceived smellscape will be non-continuous, fragmentary in space and episodic in time' (ibid.). In her mapping of the smells of New York, Eleanor Margolies finds it 'possible to navigate by smell. Were you to walk through the city blindfold, you'd know Chinatown by the smell of distinctive vegetables, fish and herbal medicines, or the financial district by the harsh perfumes and colognes' (2006: 107). Or take, for example, the Filipino women in Hong Kong who have turned a downtown square into a place that looks, smells and tastes

like a bit of home. Every Sunday, 'this dynamic interaction between food, photos, letters and other artefacts enables the production of an alternative sensorium called Little Manila' (Law 2005: 238). As these examples from New York to Hong Kong illustrate, smells – and of course the same is true for other senses, are interrelated, modes of our embodied being in the world – do not only linger in corners. They are actively being appropriated, interpreted and created by the people they surround and often refer to a specifically situated osmology – a term that refers to the notion that worldviews are conveyed through smells or that they might even constitute the very core of a sensory hierarchy. A local osmology, then, might also mark the 'Other' by its odour or identify transitions – be they of ritual nature or not – as a change of olfactory categories alone or of other categories (see for example Classen 1992; Howes 1987). These demarcations that employ culturally charged smells might become points of reference and affective engagement within a specific 'sensory geography' (Classen 1998: 4). Places, the specific sensory approaches that they require in order to be understood in a culturally appropriate way, and a connected sensory cosmology collapse into one spot, at least for some time.

The smell of sex: Transgression, (dis)emplacement and sensory normativity

Odours thus occupy a specific set of meanings and co-create specific kinds of somatic experiences within the sensory regime of the museum. Many tour guides comment on the potency of natural pheromones, arguing that these smells can make you do things you do not wish to do or they make you feel attracted to a person you did not feel attracted to before. Therefore, they subvert the visuality of attraction that has been introduced earlier as a key factor within the bio-scientific explanation of the workings of desire. One of the tour guides told me: 'It is proven that it works for pigs, for example. One doesn't really know if humans react to pheromones but you all know how you can be attracted by a nice smell. There is actually nothing you can do about it, you wouldn't even notice.'

At the same time, odours occupy an awkward position within the museum space itself: they are intimate and messy and their use transcends regulations. The phenomenon is an effect of historical legacies and cultural forces that play out in museums at large. The museum has lately been criticized as an institution that engenders specific sensory regimes, notably ones that privilege vision over any other sense. In short, it is a panopticonic apparatus that developed historically out of modes of representing and experiencing 'knowledge' that privileged other ways of sensory access such as touch (Bennett 2008; Losche 2006; Classen and Howes 2006; Classen 2007). By contrast, early museums were institutions where one could touch things and handle them. Displaying objects emerged as a mode of representation when visiting museums became a civic ritual for larger proportions

of the rising middle class during the nineteenth century. The historically specific visuality of museum display (Classen and Howes 2006; Classen 2007) now stands, as Diane Losche (2006) suggests, in alleged opposition to a discourse of museum representation that stresses the 'sensory' dimension of the 'exotic'. The visual paradigm, however, pertains: 'within the museum's empire of sight, objects are colonized by the gaze' (Classen and Howes 2006: 200). This notion of visuality, or rather, the gaze, implies a critique of ocularcentrism (see e.g. Schmitt 2012; Willerslev 2007; Fabian 2000; Grasseni 2008 for a discussion) and rightly asks for 'the symbolic attributes and social history of the "sensescape" of the museum' (Classen and Howes 2006: 201) and the embodied meanings and historical sensory trajectories of museum artefacts. 'Universally, human animals are simultaneously emitting and perceiving odours' (Largey and Watson 2006: 29). This truism notwithstanding, whatever we think of as sexually stimulating and enticing smells and even more so, if smell is the prioritized gateway to the sparking of pleasure at all, it is very much a matter of cultural variation and not the cultural constant that we so often take it to be. Just like images, smells create meanings through a productive process of multisensory carnal engagement (see Shinkle 2012) including other sensory experiences, and representation. As I lift the lid of the musk container, the scent evokes a childhood memory of a heavy perfume – and memories of a long afternoon at an airport's duty free shop with nothing to do but smell my way through dozens of perfumes. Passionate feelings or memories are the last thing the fragrance arouses.

This is not then to suggest that every museum employee relates sexuality to the animal kingdom or that sex smells the same to everybody. In fact, quite the opposite is the case. This is especially true when it comes to visitors' engagement with the scented containers: from pleasure ('just a little strong, perhaps') to disgust where the range of reactions evoked is wide-ranging. That said, few interactive objects see so many visitors jumping, overwhelmed by the strong concentration of the aromas. The sensations the smell exhibit evokes in visitors are diverse but the accounts the tour guides deliver on the 'nature' of these smells point towards their potential to transgress social, place-related boundaries. They are not only invisible but their workings are unconscious. As the guides suggest, the pheromones that lead to porcine sexual arousal might also arouse humans, challenging the human/animal boundary.

Smells are considered to be 'blurring the boundaries necessary to create and maintain the distinctions of self, other and object', at least from a vaguely 'Western' perspective that situates itself within a rationalist and compartmentalist tradition (Borthwick 2000) – one of many conceptions of the 'nature' of olfaction. This argument has been made in the discussion of the aroma of the commodity; where 'there is a sense in which advertisers have turned the very non-discursivity of perfume into a sales asset' (Classen, Howes and Synnott 1994: 187). The symbolic and experienced significance of the odours of sexual attraction is thus a twofold one. They counteract traditional modes of museum representation and work against the

grain of the museum's regime of visuality as well as against the visuality of physical attraction.

Intimacy and intensity are what smells evoke in this narration and the same holds true for many other sensory stimuli we would encounter if we went to the museum. Smellscapes are messy experiences that elude categorical and regulatory frameworks. What I have tried to show in this chapter is the sometimes irritating and sometimes productive messiness of the representational and the experiential. A representational reading of the sexuality exhibition would easily reveal the heteronormative and socio-biological assumptions that play out in our learning about attraction. A focus on the semiotic aspects of the representation of sexual attraction and desire would also address how the heteronormative and socio-biological assumptions are challenged and met. This is an important contribution because museums, as I outlined at the beginning of this chapter, are just beginning to reflect upon the ways in which sexuality (in the broadest sense possible) plays out in their exhibitions, collections, interventions and institutions. But I meant to move beyond what is written or suspended from museum walls. What has been put up on these walls, as image gallery and olfactory installations, has unintended and unexpected effects, and these effects reveal more about the workings of museums as multi-sensory experiential sites than simply meets the eye.

Notes

1. Sexuality has increasingly become the focus of science museums in recent years, often following health education goals and drawing on evolutionary frameworks and forms of representation characteristic for the body-centredness of this museum type. For example, the UNESCO-sponsored travelling exhibition 'Healthy Sexuality: The Story of Love' is drawing heavily on interactive displays and is being showcased in science museums throughout Asia. Exhibitions in art or history museums tend to talk about sexuality or desire as subject positions and phenomena that are specific and particular to periods or contexts. Examples of such an approach would be 'Gay Icons' at the National Portrait Gallery, London (2009) or the extensive online hub on sex and sexuality at the Victoria and Albert Museum, London (http://www.vam.ac.uk/content/articles/s/sex-and-sexuality-19th-century/). The positions and representations on sexuality that are being displayed are too numerous to be mentioned here. For the reader it is important to keep in mind that the Deutsches Hygiene-Museum occupies an ambiguous position in between museum 'types'.

2. For an overview and recommendable introductory reading on gender and sexuality-related thinking on museums as spaces of representation and as institutions see Levin (2010).

3. For a detailed ethnography of the Deutsches Hygiene-Museum as a sensory-affective workplace see Schmitt (2012).
4. Press material, available from the museum's website, www.dhmd.de (last accessed 13 November 2012).
5. Names and contextual or biographical references that would make research partners easily identifiable have been changed to assure their anonymity.
6. A whole product range of cosmetics and pheromone-enhanced fragrances draws on an identical discursive formation, for example the products offered by LuvEssentials (www.luvessentials.com).

References

Ames, Michael (1992) *Cannibal Tours and Glass Boxes: The Anthropology of Museums*, Vancouver: University of British Columbia Press.

Beck, M. and Hafferkamp, J. (2001) 'The era of sex museums', *Libido: The Journal of Sex and Sensibility*, 8(1).

Bellanger, Silke (2001) 'Trennen und Verbinden. Wissenschaft und Technik in Museen und Science Centers', in *Technologien als Diskurse. Konstruktionen von Wissen, Medien und Körpern,* Andreas Lösch (ed.), Heidelberg: Synchron Wiss.-Verl. der Autoren, 209–24.

Bouquet, Mary (ed.) (2001) *Academic Anthropology and the Museum. Back to the Future* (New Directions in Anthropology, 13), New York: Berghahn Books.

Bourne, G. (1996) 'The last taboo?', *Museums Journal,* 96(11): 28–9.

Classen, Constance (1992) 'The odour of the other: olfactory symbolism and cultural categories', *Ethos*, 20(2) (June): 133–66.

—(1993) *Worlds of Sense. Exploring the Senses in History and across Cultures,* London: Routledge.

—(1997) 'Foundations for an anthropology of the senses', *International Social Science Journal*, 153: 401–12.

—(1998) *The Color of Angels. Cosmology, Gender and the Aesthetic Imagination*, London: Routledge.

Classen, Constance, Howes, David and Synnott, Anthony (eds) (1994) *Aroma. The Cultural History of Smell*, London: Routledge.

Connell, R. W. and Dowsett, G. W. (1992a) '"The Unclean Motion of the Generative Parts": Frameworks in Western thought on sexuality', in *Rethinking Sex: Social Theory and Sexuality Research*, R. W. Connell and G. W. Dowsett (eds), Melbourne: Melbourne University Press.

Connell, R. W. and Dowsett, G. W. (eds) (1992b) *Rethinking Sex: Social Theory and Sexuality Research,* Melbourne: Melbourne University Press.

Connor, Steven (2005) 'The Menagerie of the Senses': Lecture given at the sixth

Synapsis conference, I cinque sensi (per tacer del sesto), Bertinoro, Italy, 1 September 2005 (downloaded 05.10.2007)

Drobnick, Jim (ed.) (2006), *The Smell Culture Reader*, Oxford: Berg.

Ellis, Havelock (2004 [1927]) 'Sexual Selection in Man', *Studies in the Psychology of Sex*, 4, The Project Gutenberg eBook.

Fabian, Johannes (2000) *Out of Our Minds. Reason and Madness in the Exploration of Central Africa* (The Ad. E. Jensen Lectures at the Frobenius Institut, University of Frankfurt), Berkeley: University of California Press.

Foucault, Michel (1990) *The History of Sexuality*, trans. Robert Hurley (2 vols), New York: Vintage.

Freud, Sigmund (1989 [1930]) *Civilization and Its Discontents,* with a Biographical Introduction by Peter Gay, New York: Norton.

Frost, Stuart (2008) 'Secret museums: hidden histories of sex and sexuality', in *Museums & Social Issues: A Journal of Reflective Discourse.* 3(1): 29–40.

González, Roberto J., Nader, Laura and C. Jay Ou (2001) 'Towards an Ethnography of museums: science, technology and us', in *Academic Anthropology and the Museum. Back to the Future* (New Directions in Anthropology 13), Mary Bouquet (ed.), New York: Berghahn Books, 106–16.

Grasseni, Cristina (ed.) (2007) *Skilled Visions. Between Apprenticeship and Standards*, New York: Berghahn Books.

Groom, Nigel (1997) *The New Perfume Handbook,* New York: Springer.

Howes, David (1987) 'Olfaction and transition: an essay on the ritual use of smell', *Canadian Review of Sociology and Anthropology*, 24(3): 398–416.

—(ed.) (2005) *Empire of the Senses. The Sensual Culture Reader*, Oxford: Berg.

—(2007) *Sensual Relations. Engaging the Senses in Culture and Social Theory,* Ann Arbor: University of Michigan Press.

Jay, Martin (1994) *Downcast Eyes. The Denigration of Vision in Twentieth-century French Thought* (1st paperback edition), Berkeley: University of California Press (a centennial book).

Krafft-Ebing, Richard von (1997 [1886]) *Psychopathia sexualis*, Berlin: Matthes & Seitz.

Law, Lisa (2005) 'Home Cooking. Filipino Women and Geographies of the Senses in Hong Kong', in *Empire of the Senses. The Sensual Culture Reader*, David Howes (ed.), Oxford: Berg, 224–41.

Lemire, Beverly (2010) *The Force of Fashion in Politics and Society: Global Perspectives from Early Modern to Contemporary Times,* New York: Ashgate.

Levin, Amy K. (2010) 'Introduction', in *Gender, Sexuality and Museums: A Routledge Reader*, Amy K. Levin (ed.), London: Routledge, 1–12.

Macdonald, Sharon (2002) *Behind the Scenes at the Science Museum*, Oxford: Berg.

Margolies, Eleanor (2006) 'Vagueness Gridlocked: A Map of the Smells of New York', in *The Smell Culture Reader*, Jim Drobnick (ed.), Oxford: Berg, 107–17.

Osten, Philipp (2005) 'Hygieneausstellungen: Zwischen Volksbelehrung und Vergnügungspark', in *Deutsches Ärzteblatt*, H. 102(45): S. A 3085–8.

Pink, Sarah (2004) *Home Truths: Gender, Domestic Objects and Everyday Life*, Oxford: Berg.

—(2005) 'Dirty laundry: everyday practice, sensory engagement and the constitution of identity', in *Social Anthropology* 13(3): 275–90.

Porteous, J. D. (1985) 'Smellscape', *Progress in Human Geography* 9(3): 356–78.

Rodaway, Paul (1994) *Sensuous Geographies. Body, Sense and Place*, London: Routledge.

Sanders, James H. III (2008) 'The Museum's Silent Sexual Performance', in *Museums & Social Issues: A Journal of Reflective Discourse*, 3(1): 15–28.

Sarasin, Philipp (2001) *Reizbare Maschinen. Eine Geschichte des Körpers 1765–1914*, Frankfurt am Main: Suhrkamp.

Schmitt, Susanne (2012) *Ein Wissenschaftsmuseum geht unter die Haut. Sensorische Ethnographie des Deutschen Hygiene-Museums*, Bielefeld: transcript.

Shinkle, Eugenie (2012) 'Uneasy Bodies: Affect, Embodies Perception, and Contemporary Fashion Photography', in *Carnal Aesthetics: Transgressive Imagery and Feminist Politics*, Bettina Pappenburg and Marta Zarzycka (eds), London: I. B.Tauris.

Stewart, Kathleen (2007) *Ordinary Affects*, Hempstead: Combined Academic Publishers.

Vogel, Klaus (ed.) (2003) *Das Deutsche Hygiene-Museum Dresden, 1911–1990*, Dresden: Michael Sandstein Verlag.

—(2005) *Deutsches Hygiene-Museum Dresden*, Munich: Prestel (Prestel-Museumsführer).

14

Consuming Culture: The Refiguration of Aesthetics in Nagaland Cultural Tourism in India's North East

Soumendra Mohan Patnaik

The history of tourism in Nagaland in north-eastern India is marked with shifting state policies in response to cultural and economic dynamics of community participation and ethnic politics. India's new tourism policy of 2001, which relaxed the entry restrictions on foreign tourists and emphasized participatory approach to tourism development, reflects the governance ethics of neoliberal economy and community involvement in tourism promotion. The question of the identity of various tribes assumes significance in the context of a strong sense of territoriality that operates throughout the state's populace. This chapter explores the continuous process of self-discovery that engages community attention in the newly created touristic spaces that carry contested symbolic and political representation for various tribes. Further it seeks to explore the commodification of culture for attracting tourists, domestic and international, and how it has created ambivalent subjectivities among various stakeholders regarding the sustainability of tourism.

The commodification of cultural objects such as artefacts, handicrafts and performances is linked to the creation of a class of entrepreneurs having little contribution to aesthetic productions, but nevertheless playing a decisive role in its economic and political circulation. This is not to imply that tourism is attendant with a complete loss of agency for host communities. Rather, it is argued that the local performers negotiate with indigenous traditions for consumption to produce new meanings, creating possible grounds for asserting and enhancing their identities at various levels. Further, touristic relationships have differential levels of power dynamics and interests that are negotiated in a variety of ways.

Commodification and cultural tourism

The nature of culture with reference to its commodification reflects an inherent paradox. Adorno and Horkheimer (1993) argue that culture is so completely subject to the law of exchange that it is no longer exchanged – in other words, that it is so blindly consumed in its mass reproduction that it can no longer be seen as credible. The roots of such a conceptualization are traced back to Marx's (1996) labour theory of value where he distinguished between use-value and exchange value, arguing that these are two inseparable parts of a whole – what he referred to as the 'dialectic of the commodity' (Keen 1993: 110). For Marx, commodities function as both objects of utility and a depository of value. He also talks about the objectification of the labour of workers through the rhetoric and dynamics of the market and their consequent estrangement. In other words, once the cultural products or performances move from the realm of community to the realm of market, their meanings are diluted. When this happens, according to Greenwood (1989), the local culture is 'altered and destroyed' and made meaningless to its people. When organically lived, inward-looking meaningful cultural practices are transformed into a public spectacle for outsiders, there is a decline of local interest. In Greenwood's words, 'the ritual has become a performance for money and the meaning is gone' (1989: 178). However, in Nagaland, the ethnographic reality poses further complexities, as will be explored through the chapter.

The commodification of culture refers to a process by which things come to be evaluated primarily in terms of their exchange value, in the context of trade, thereby becoming goods (Greenwood 1977; Cohen 1988). Arguably, the process of commodification leads to duplication and mass production thereby affecting the 'aura' and 'authenticity' (Benjamin 1931; Adorno and Horkheimer 1993). Benjamin's 'aura' is constituted in and by human modes of perception, ideas of artistic autonomy and authenticity, and the formative power of ritual and tradition. According to Benjamin (1931), the weave of 'time' and 'space' that constitutes aura can be understood in the context of its unique occurrence. Substituting a 'mass existence' for a unique one shatters the auratic weave of 'time' and 'space'. For Benjamin, the embeddedness of an artwork in the context of tradition finds expression in the cult of rituals. Tradition lends 'aura' to the art object by determining its uniqueness. Tradition not only provides authenticity to aesthetic products by facilitating their embeddedness in the past, but also takes the form of a tourism product in itself.

An anthropological understanding of authenticity is based on capturing the continuous refiguration of cultural practices. Nevertheless, the local people and tourists continue to engage in their search for authenticity in different contexts. Thus, authenticity is a much debated, negotiated and variously expressed concept (Theodossopoulos 2013). The debate on authenticity and the commodification of culture has engaged the attention of scholars in a variety of ways. While some of them appear to hold a distinction between 'genuine and invented' traditions (Davies

2011), others regard cultural invention as the symbolic construction of social life (Wagner 1975; Handler 1984; Clifford 1988) and part of a general cultural process. Thus, all traditions – Western and indigenous – are, to a greater or lesser extent, 'invented' (Hobsbawm 1983), in that they are symbolically constructed in the present and reflect contemporary concerns and purposes rather than a passively inherited legacy (Linnekin 1983; Handler and Linnekin 1984). White (1991) is of the opinion that our understanding of tradition must go beyond the examination of which aspects of culture are authentic and which are invented.

Technologies of mass reproduction detach the reproduced object from the sphere of tradition. According to Benjamin (1968), the moment the criterion of authenticity ceases to be applicable to artistic production, the total function of the art is reversed. Instead of being based on ritual, it begins to be based on another practice – 'politics', leading to the politics of aesthetics having implications for community identities. Identity formations are attributed to processes like tourist gaze (Urry 1990) and mimesis (Ricoeur 1990). Ricoeur links narratives' temporal complexity to Aristotle's characterization of narrative as 'the imitation of an action'. According to Ricoeur, mimesis, normally defined as the imitation of nature in art, is not to be seen as copy, but creation and construction. His account of the ways in which narrative represents the human world of acting turns on three stages of interpretation that he calls mimesis 1 (prefiguration of field of action) which require certain basic competencies such as a conceptual network of semantic action and use of symbols, mimesis 2 (configuration of field of action) which concerns the imagi-native emplotment in the 'kingdom of as if', and mimesis 3 (refiguration of field of action) which concerns the integration of the imaginative or 'fictive' perspective into actual lived experience. According to Ricoeur (1990), once our life stories are written, they must be read as one's own and integrated into one's identity and self-understanding. In this chapter I take the third perspective to explore its implications for the refiguring of ethnic identities through the ideas of tourist gaze and mimesis.

The chapter is divided into five parts. The first part describes the ethnographic context with special reference to the location, history and culture of the Nagaland context considered here. The second examines Nagaland tourism policy and major models of tourism introduced by the state. The processes of commodification of local culture in their specific contexts are considered in the third part. The fourth outlines the agency of host communities in dealing with aesthetic experiences in the light of globalizing currents. The final part examines how community identities are negotiated in newly created touristic sites through the process of self-representation.

Location, history and culture

The north-eastern state of Nagaland presents a rich diversity in terms of ethnic groups, culture, languages and development processes. Located on the international

border between Myanmar and India, this area exhibits a unique set of differential loyalties to the Indian nation-state, which cuts across local identities (Chaube 1970). During the colonial period, traditional identities were carved out of geo-political space, ethnic and territorial affiliations legitimized by myths and oral history (Ao 1970; Lotha 2007). Christianity informed the shaping of ethnic identities in a more specific way during the colonial period.

The state of Nagaland is divided into 11 districts inhabited by 17 tribal groups each having its distinctive dress, jewellery, headgear, tattoos, weapons, songs and festivals as identity markers.[2] Each tribe occupies a distinct territory of a district and territoriality is an important principle characterizing Naga existence (Ghosh 1981). The oral histories narrating migration stories are a very important component of Naga folklore. Slash and burn agriculture forms the primary occupation, further supplemented by hunting, fishing, animal husbandry, weaving and basket-making and, more recently, employment in the public and private sectors.

With the arrival of the American Baptist mission in 1872, some practices such as head-hunting came to an end and the institution of *morung* was abandoned. *Morungs* are youth dormitories primarily used in earlier times for socialization and recreation. The Naga people have retained their traditional festivals and rituals associated with agricultural cycles. This has significantly contributed to the tourism potential of their culture.

Tourism in Nagaland is a relatively new development due to long-drawn insurgency movements since India's independence in 1947. Consequently, Nagaland has remained cut off from development or tourism initiatives until the last decade. The origin of the Hornbill festival dates back to 1993 when Naga People's Movement for Human Rights (NPMHR) and Naga Students Federation (NSF) organized a 'Naga Week' from 1 to 5 December at Kohima on the occasion of the United Nations' declaration of International Year of the World's Indigenous People in 1993 (Longkumer 2013). Naga Week symbolized a collective desire for peaceful coexistence where other Naga groups from the adjoining states also celebrate primordiality and the exuberance of material culture. Against the backdrop of global discourses on indigeneity, human rights and autonomy, the cultural performances speak ambivalently and discursively to the audience.

The development process in Nagaland has been uneven (Zhimo 2008) as the northern districts of Mon and Tuensang remain underdeveloped whereas the southern districts of Kohima and Mokokchung clearly show signs of development. Bureaucracy and state politics is largely occupied by the Ao and Angami factions, whereas the insurgency movements have attracted those from Sumi and Konyak backgrounds from underdeveloped districts (Patnaik 2007).

State policy and models of tourism

The government of Nagaland notified its Tourism Policy on 23 January 2001 with a view to ensure sustained growth through the planned development of tourism attracting both domestic and international tourists. The policy, *inter alia,* involves the identification of regions having tourism potential, the strengthening of infrastructure, the development of tourism facilities in an integrated manner and the marketing of tourism products. Conservation and the enrichment of natural resources and other unique cultural features of the state through regulated development and the promotion of rural, ethnic, cultural and eco-tourism are some of the important objectives of the tourism policy.

The Nagaland Tourism Vision Statement (2001) endorsed the development of tourism to reflect and reinforce the uniqueness of Nagaland's rich history, and its natural and cultural resources. Officially, tourism development seeks to ensure local participation and the equitable distribution of socio-economic benefits without any serious negative socio-cultural impacts. The vision statement also focuses on the importance of environmental regeneration, building infrastructure and creating market linkages with other states of north-east India. A 20-year sustainable tourism plan was developed in 2004 by the government of Nagaland with technical support from the United Nations World Tourism Organization (UNWTO) and sponsored by the United Nations Development Program (UNDP). In order to visit Nagaland, one needs an entry permit: Inner Line Permit (ILP) for Indian citizens and Restricted Area Permit (RAP) for foreign nationals. The inflow of foreign and domestic tourists over the last decade has varied greatly. The relaxation of RAP in April 2000 has led to a greater inflow of international tourists. At least 451 foreign tourists visited the state in 2000 and the number increased subsequently to 1,453 in 2009 (Statistical Handbook of Nagaland 2011). In 2011, the government of Nagaland relaxed the entry requirements of foreign tourists for one year where they no longer require RAP to enter Nagaland. The new rules only require foreigners to register themselves at the District Foreign Registration Office within 24 hours of their arrival. However, RAP is still a requirement for Pakistani, Bangladeshi and Chinese nationals. The state initiatives point towards three models of tourism in Nagaland: (1) Khonoma, the green village promoting eco-tourism; (2) Touphema, the heritage village; and (3) Kisama, the destination point facilitating cultural tourism by organizing fairs and cultural celebrations such as the annual Hornbill festival.

The state government is keen to promote eco- or adventure tourism and prefers to go slow on cultural tourism primarily because of the state apprehension of indigenous community motives. Christianity labelled religious practices as superstitious and irrational and condemned them. The Church fears that cultural tourism, in its efforts to showcase these exotic cultural practices, may contribute to the revival of such beliefs.

The commodification of culture

The tourist information brochures brought out by Nagaland Tourism and different private tour operators project the state as the 'land of virgin forests', the 'land of unconquered mountains' and many such clichés. Ajungla, a young female tourist guide from Mokokchung, said during my fieldwork: 'Such a commodification of landscapes, forests and mountains promotes a "macho" image of the state among those tourists seeking pleasure out of adventure in a territory unknown to them.' A tourism pamphlet brought out by a private tour operator describes Nagaland as the 'land of unexpected' and the 'land of courage', where people are remembered for their heroic sacrifices in war, love and valour. The official website of Nagaland Tourism claims Nagaland as a 'land of warm and hospitable Naga' and Hornbill as a 'festival of festivals'.[4] The commoditization of cultural practices such as hospitality, art objects and ritual performances has significant consequences for ethnic identities (Graburn 1976: 22–30).

Among the Sumi people of Zhuneboto district in central Nagaland, the local youth entertain the visitors with dances and songs associated with activities such as harvest, marriage and warfare. *Ayekuzule* is an annual agricultural ritual performed during the plucking of cotton leading to the making of thread and weaving it into intricate designs in the month of November. The event involves an elaborate performance of folk songs where the elders sing specific stanzas to which the youngsters respond. In fact, these are traditional forms of pedagogy facilitating the learning of indigenous knowledge. When they are performed before the tourists, the traditional meaning is lost.

One of the war dances, *aphilekuwo* is popularly performed before tourists. A large group of 25 to 30 well-built young men in their traditional attire perform with meticulously synchronized steps and body movements, dancing around through jumping and joyous gestures as they celebrate victory. The climax of the performance comes when they create the sound of victory which symbolizes the conquest of another village, bringing it under their sovereign control. The bravest and the best warrior used to be the chief of the new village. When performed before the tourists, it is reduced merely to a commodified cultural item which nevertheless gives them a little income. Kitoholi, a Sumi girl, nostalgically remembered: 'During my childhood I was never allowed to touch the male dresses, the weapons and the headgear and while growing up I used to adore the best warrior for his valour and courage. But now such *gennas* (taboos) do not exist.'

Rhotaka, a village elder, recalls the explanation of *aphilekuwo* which he had heard from his grandfather. *Aphile* refers to body and *kuwo* means variations. It is important to understand and control the rhythms of the body and bring out the needed variations in the fraction of a moment while fighting with the enemies. As per traditional Sumi belief, *aphilekuwo* was taught to them by the spirits. There are inter-village variations in the performance of *aphilekuwo* which were well-thought-out tricks or war strategies to win over other villages. In the pre-colonial era such

variations were also useful in identifying members of enemy villages who might sneak into the party as a spy but trip over the steps. The Sumis people of Zunheboto have a relationship of animosity and competition with neighbouring tribes (Zhimo 2008). The Angami have pushed the Sumi people towards the north, who in turn have pushed the Ao further north and the Lotha to the west. The communities of Sangtham and Yimchunger on the east were defeated historically by the Sumi people.

The Sumi construction of the identity of neighbouring communities is based on their historical encounter through war, peace and negotiation. Their folk songs revolve around different themes such as the myth of origins, migration narratives, the encounter with spirits, feasts of merit, seasonal rhythms, inter-tribal issues and highly private themes such as the violation of sexual mores and the stupidity of women folk. The singers often choose a theme depending on the audience, which also includes members of neighbouring tribes who accompany the group of inter-national visitors as tourist guide, tour operator and driver. Many times the singers change the lines through omission, addition and substitution, thereby changing the meaning and effect.

One of the popular folk songs recited before every Sumi performance paying obeisance to the ancestors is as follows:

Oh my father! Khakhu,

this happens to everyone,

it is a part of life, do not feel remorseful.

It happens … go on your way.

Poor or rich, slave or no slave, brave or stupid,

nobody is allowed to leave the village with you.

May the good luck and blessings you had

remain with us, with this village today and ever.

The present generation of Sumi people does not want to acknowledge the practice of slavery or traditional gender stereotypes of associating bravery with men and stupidity with women. The modern artists would comfortably omit phrases such as *slave or no slave* and replace *brave and stupid* with *brave and bravest*. The audience laughs at the wit and creativity of the performers. On such occasions stereotypes are also mocked at, such as the clever Sumi people have 'stolen the art' of weaving intricate designs of embroidery from the straightforward and simple Lotha people, their neighbours.

This is to argue that the 'touristic gaze', produced during the watching of cultural performances, is not just a question of insider and outsider perspectives, but also different categories of insiders such as members of neighbouring communities who come with the tourists as local guides. Such people belong to the single generic group of Naga tribe and are therefore 'insiders', but to different categories of Nagas such as Lotha, Chakesang, Angami or Ao, and therefore 'outsiders' for Sumi performers. There are moments when these identities are projected, constructed, articulated and thus asserted during the show. Identities among Naga communities are a product of what Ricoeur (1990) would call 'mimesis' through the Western gaze of international tourists and the local gaze of members of neighbouring communities from within the Nagaland who accompany the tourists

A closer analysis of these cultural performances and touristic processes reveals that traditions are continuously invented and customs renegotiated (Hobsbawm and Ranger 1983). The local village residents with their distinct humour use their encounter with the tourists for various forms of self-representation, many a time lightly mocking the visitors as well as members of neighbouring tribes who accompany the tourists as service providers. Discussion about dress specific to an ethnic group often comes up. *Longpansu* is a black Lotha shawl with blue stripes which can be worn by men of great social stature, i.e. those who have given the 'feast of merit' or demonstrated great courage and bravery. But Lotha blame Sumi people not only for borrowing the garment but also for using it as an *abomini* (wrap-around or *mekhla*) by women.

At times their performative interactions almost ridicule the visitors with their self-consciousness and pride with which they manage to guard the core aspects of their cultural identity (Sneft 1999). Examining the processes of ethnic tourism and renegotiation of tradition among Tana Toraja of Indonesia, Adams (1997) highlighted that encounters with foreign tourists are prompting new challenges to meaning, power and identity within the domain of aesthetics, a subject that I next go on to explore.

Aesthetics and agency

In their accounts of aesthetics of other cultures, anthropologists have concentrated on objects that fit the Western notion of 'works of art' rather than those valued by people themselves (Coote 1992). Of late, scholars have avoided providing lists of uniquely aesthetic qualities and any narrowly circumscribed characterization of aesthetic experience (Coote 1992; Berleant 1991; Iseminger 2004). This section explores aesthetic aspects of society's activities and products by referring to aesthetics as experiences that are valued.

In Nagaland, the cultural performances, handicrafts and artefacts, in the sphere of both community and market, have aesthetic value in the ways these are perceived and experienced by the performers, artists and the audience. Thus aesthetics becomes a

product of the cultural context. In this section I consider those artefacts, handicrafts and cultural performances valued by the Naga people. These have entered the market due to the emergence of cultural tourism initiated by state tourism policy.

State information brochures and tour operators provide tourists with a first glimpse of a rich and diversified culture of local communities through 'prepackaged ethnic stereotypes' (Crick 1989). Urry (2011) rightly points out that tourists' stereotypes are transmitted to the number of local communities through the 'touristic gaze'. Many try to match visitors' expectations. In fact, locals 'play the natives' to 'live up to the tourists' image'. Vincanne Adams (1996) explains such changes among the Sherpas of Nepal using the idea of mimesis as a 'process of identity construction, the imitation of what is taken to be one's "natural" self by way of the other, through whom one's constructed identity is made visible to oneself' (1996: 17). Tourism then can become an empowering vehicle of self-representation with local communities purposely exercising choice to reinvent themselves through time, modifying how they are seen and perceived by different groups of outsiders.

A traditional Naga village appears like a fort, with high-rising stone walls and mountains forming a protective chain around the village. The village is divided into territorial wards or *khels* with majestic *khel* gates. Traditionally the *khel* gates served the important function of providing safety to the villagers during a period of internecine war among the different Naga groups. In addition to their role in village safety, the *khel* gates have always been magnificent structures providing an outlet for the creative talents of local artists, engraved with different motifs such as *mithun* (semi-domesticated cattle) heads, human skulls, male warriors, women's breasts, dancing teams and other motifs imbued with different meanings and cultural symbolism. The rich art work, colours and imaginative placing of the motifs catch the attention of both international and domestic tourists (Figure 14.1). The local tour guide recalls the comment of a German tourist: 'The village is like a living museum; each stone has something to say on village history and each motif elucidates the artist's encounter with cultural imagination.' Being an embodiment of spiritual power, traditionally the gate is believed to be inhabited by spirits, and although touching is not prohibited, any new carving, painting or working on the gate is not permitted. However, such beliefs are gradually eroding in the context of emerging touristic activities. Though the family whose house is next to the gate takes care of it under the supervision of the clan elders, the entire village feels responsible for it.

In fact, a Naga village is a territorial extension of bonds of clanship, thus the sense of a community as an extended kin unit is very strong. It was often noticed that if the village receives an international tourist as a paying guest, the monetary benefit might go to the families who take care of their stay and food but the entire village plays the role of the host. For example, in the presence of the paying guest, the family members often prefer to wear their traditional dress instead of dressing up casually. It was interesting to observe that many other village women preferred to put on their traditional dress to make the paying guest of the village feel happy.

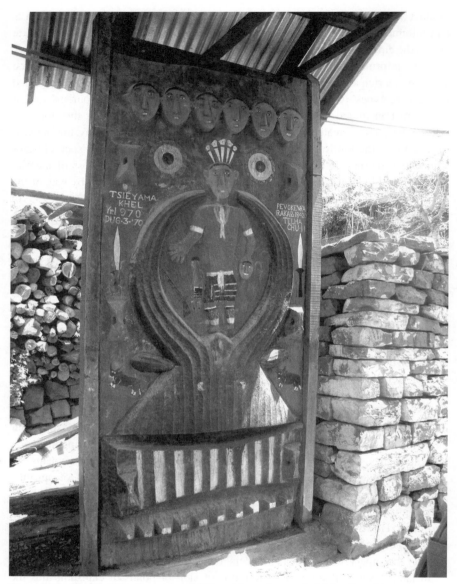

Figure 14.1 The Khel Gate in an Angami Village (photo: Soumendra Mohan Patnaik).

The tourist-host encounter becomes a microcosm of the dynamic and fluctuating changes in the production of new social relationships. The cordial and warm liaisons can also become antagonistic and hostile. On one occasion, for instance, the youth of Touphema village in Mokokchung district constructed the tourist cottages and connected the water supply from the main village tank. While the villagers had

to come to the village tank for their own use, the tourist had a plentiful supply of water in their cottages which irked the village elders, who protested and refused to part with water, so the youth had to make alternative arrangements for the tourists' consumption. Thus, at the micro level, the interaction between the tourists and a section of their hosts can be seen as a relationship based on conflict where each competes for the scarce resources available in the village.

It can be argued that the emergent cultural practices and objects are a product of mimesis. The showcasing of human skulls that were acquired in the olden days through head-hunting has become the highpoint of touristic attraction. Many villages had buried the human skulls in the *morungs* on the advice of the Church as the British government had banned the practice and Christian missionaries considered it repulsive and sinful. The residents of these villages are now losing out on international visitors, who prefer to go to those villages which showcase them. While the youth is keen on digging the skulls up again and displaying them in the *morungs*, the village elders and Church leaders oppose it.

Naga artefacts reflect the recognition of various identities at inter- and intra-tribal levels. The different colour schemes and designs on the Naga shawls have become signifiers of age, gender, social status, political power and ethnic identity. Of late, however, many Naga shawls carry modern motifs such as women in Western outfits and flags of different nations along with the traditional designs. Men's ties and jackets with traditional motifs of skulls, swords and *mithun* heads have become very popular among international tourists. Thus local artisans continuously improvise the product not only to suit the aesthetic requirement but also to serve the demands of the international market through tourism. The hand-woven clothes are brought to Sadar Bazaar, a wholesale market in Delhi, for printing of new motifs such as musical notation, images of different musical instruments, crosses in different designs and signatures of Western music notations. The international tourists buy them in large quantities, while the locals find these unattractive as they prefer hand embroidery. Studies also report that commoditization has undermined the aesthetics of forms in terms of the mass production of cheap artless souvenirs, devoid of ethnographic or what could be seen as their aesthetic value (Forster 1964; Schadler 1979).

The Naga people themselves have started to distinguish between production for local use and production for sale, a process which Cohen (1989) has called complementary commercialization. The products for the market are devoid of ethnographic or aesthetic value as their producers realize that the new buyers have little understanding of the distinctive qualities of craftsmanship while the local buyers do not have a taste for this, as stated above.

Traditionally, older Sumi women knew the art of making a ponytail or a bun (*asa putsu*) without a band or a stick in different styles with great intricacies and designs. They used a headband but not hairclips. The tourists were attracted to the *akutsu kukha* a traditional band studded with beautiful flowers made up of animal hair,

worn by Sumi women. However, the supply of headbands was limited. In response to this, in the early 1990s the local people invented a hairclip *asa kukha,* which was simpler, with only one flower. This hairclip became very popular among tourists as well as among teenage Sumi girls. Gradually, it is becoming the identity marker of the younger Sumi women, shaping the external image and identity of an ethnic group. Production of such 'transitional arts', as Cohen (1984) would call them, for an external public can become a medium of communication, through which the public can be informed of the traditional customs, the historical experiences, present scenarios or future aspirations of the ethnic group.

Since the 1990s along with the onslaught of neoliberal policies, perceptible economic transformation has come to the fore. A distinct affluent class educated in the metropolitan cities of India and abroad has emerged. People from these backgrounds are engaged in politics, bureaucracy, business and even underground militant groups. The rich and upwardly mobile class has started taking advantage of the tourism market by producing artefacts on a mass scale. Several production enterprises have come up in different parts of Nagaland, namely the Traditional Crafts Centre, Naga Weaving and Dress Craft Centre, Bamboo Plus and Zinki Souvenir Hub, where Naga artisans are employed. Very few are on the same payroll as the master craftsmen, while others are paid a daily wage. Artisans engaged in these processes, however, are left disgruntled.

Nithono, a young Angami woman employee (32 years) from Kohima, said: 'My brother is a drug addict, he has just returned home from de-addiction centre, I am the only earning member. I have crossed 30 years but still do not want to marry, men are lazy and not responsible. Earlier I used to produce nearly 5–6 pieces of masks everyday but now it has gone up to 9 or 10 but my wage is same, it does not change.'

Vitieste, a Pochuri woman (23 years), who is a part of the culture club that offers performances at Kisama, lamented: 'The owner of our club decides what should be the items of our performance depending on the demands by tourists. Sometimes we do not have required number of artists for that item, but he insists and then the performance does not come up well, it does not have that effect. But who listens to us?'

These globalizing trends are furthering inequalities in Naga society, leading to the creation of a rich and politically connected class of entrepreneurs and a growing working artisan class engaged in mass production.

Public gaze: The familiar other

The creation of destination points such as the Naga Heritage Complex in Kisama, nearly 12 kilometres away from Kohima on the National Highway 39, has attracted both international and domestic tourists. Projected as a 'window to Nagaland', it aims to provide the cultural preview of the entire state on a single platform. *Morungs*

and traditional huts belonging to different tribes showcase the traditional architecture, crafts, food and cultural activities (Figure 14.2). The emergence of a new elite with time for leisure within the state is unleashing new forces of population movement across the territorially delimited cultural spaces.

Kisama has been built on a model of tourism which provides space and ambience to recreate the cultural lives of ethnic groups for the tourists. Domestic tourists can catch the pulse of the community living of different tribes through these

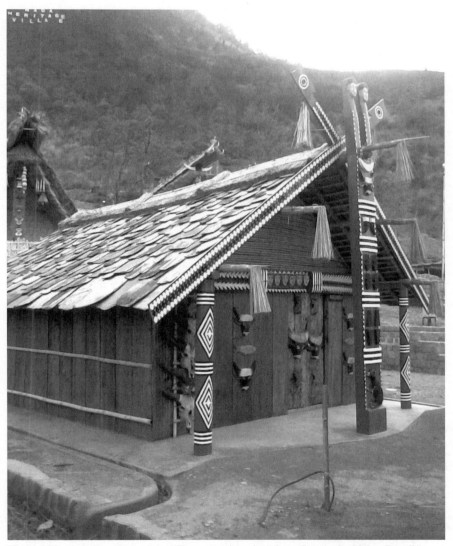

Figure 14.2 A replica of naga hut at Kisama, tourist point (photo: Soumendra Mohan Patnaik).

performances without reaching their land and territory as the state attempts to recreate the cultural diversity and its exuberance in such destination points. This has significant implications for the creation and maintenance of community identities cutting across ethnicity, class and gender. The new entrepreneurs get an opportunity to look at themselves, the manner in which such cultures are showcased and presented in these performances. The distinction between the observer and observed creates a new dialectics which can be meaningful only in the context of emerging identities of ethnic groups before domestic and international audiences. People in Nagaland have come up with a tourism product which is not only for international tourists or for domestic tourists from other parts of India, but also for themselves. Thus the same person who is gazed upon in one context is likely to gaze at someone else in another.

This phenomenon has created a new space for the tribes of Nagaland for negotiating their community identities in a meaningful way. Thus Naga people are in a continuous process of self-discovery leading to consolidation of new identities conducive to peace negotiations in the case of internecine rivalries, the emergence of an entrepreneurial class willing to take risks and the rise of civil society initiatives within Nagaland. The process of cultural negotiation is facilitated by various tribe-specific culture clubs. 'Culture experts' who know the folk songs, traditional styles of singing and dancing belonging to a particular tribe are identified. They organize and celebrate traditional festivals in their respective areas from time to time and also during the Hornbill festival at Kisama.

One could clearly discern different spaces emerging for touristic use. The 'front' is the meeting place of hosts and guests or the performers and the tourists and 'back' is the place where the members of the home town retire between the performance to relax and prepare. The tourists believe the 'back' to be more intimate and 'real' compared with the 'front' regions (Boissevain 2006). The cultural tourists systematically attempt to penetrate such back regions to glimpse and experience 'original' culture, even at the cost of causing discomfort to their unwilling hosts, even though this 'real' may well be constructed. Longkumer (2013) reports the insensitive intrusion of domestic tourists into such spaces to photograph the Naga cultural performers during a Hornbill festival.

Local youth collaborate to document the various strands of Naga culture through literature, music and film, thereby asserting the identity of their respective tribe. In the process they try to carve out an image of their tribe not only before the 'international other' but also before the 'familiar other'. Thus, 'ethnic relations and boundary construction in most plural societies are not about strangers, but about adjacent and familiar others' (Barth 1994: 13).

Discussion and conclusion

Scholars have argued that when aesthetic products and cultural practices of local communities enter the market, the aesthetic quality and auratic effect of the product is grossly undermined. In this chapter I demonstrate rather a more nuanced approach which notes the undermining of the aesthetic experiences of the community due to commodification, but there are also contexts in which this commercialization leads to the refiguration and thus revaluing of cultural artefacts.

The artisans who produce these artforms merely replicate a piece by a craftsman in a particular context of 'time' and 'space'. The presence of the artist in the artform contributes immensely to what Benjamin would call the auratic effect, and its replication and mass-production in the newly created marketing agencies lead to a loss of meaning. Coupled with loss of meaning emerges a political realm where the performers manage images of ethnic selves in touristic spaces. The movement of cultural elements from routinized everyday life to a critical sphere of cultural consumption due to tourism is negotiated along with an understanding of each others' image through the manipulation of aesthetic objects and performances. The transformation of cultural objects and performances from use value to exchange value is not leading to complete estrangement of their labour but has given a new kind of agency to the actors, which they exercise for enhancing their ethnic representation and self-understanding.

The commodification of culture tends to make people much more self-conscious and reflexive about the 'cultural stuff ' (Wood 1998) which they usually take for granted. The very act of objectifying and externalizing ethnic culture makes it more visible and subject to reflections, debate and conscious choice, the exercise of which has been termed by Waters (1990) as an 'ethnic option'. Oppitz et al. (2008) attempt to identify the cultural stuff of the Nagas, such as display of wealth and fertility associated with *mithun* (local semi-domesticated cattle), ritual sacrifices during the 'feast of merit', the *morung* system (men's dormitories and centres of collective life and repositories for head trophies), tattooing and weaving, which are perceived to constitute Naga-ness. This constitutes the basis for the touristic and domestic, inter-tribal and domestic Indian gaze which shapes Naga cultural identities through mimetic refiguration.

The Hornbill festival is a re-enactment of a shared Naga culture that has never existed in this form, a form of 'invented tradition'. In the commercialized spaces of Kisama the touristic gaze produces a new kind of cultural consumption through mimesis, leading to the exercise of 'ethnic options' for managing the cultural image on the 'front stage' of cultural performances.

The new entrepreneurial class, often merging with the political elite, tries to monopolize the state-sponsored touristic initiatives by bringing these projects to their home districts. Further, the local villagers and cultural performers may not have any decisive voice in the tourism policy initiatives and management. But they

do play a significant role in reinventing tradition through a conscious negotiation to enhance their ethnic status, thereby influencing the process that promotes a particular kind of tourism and attracts a certain category of tourists to their locality. The members of the host community are active agents in determining what they want to preserve and showcase along with purposely inventing tradition and folk art through memory and oral history for tourists, using strategies to manage the image of their community.

Finally, the ambivalent subjectivities regarding touristic practices based on the commodification of culture are rooted in conflicting moralities generated by the Church on the one hand and the market on the other, as reflected by the eagerness of youth to dig up the buried human skulls for showcasing before the international tourist, even in the face of opposition from village elders. Contemporary Naga society is continuously engaged with this contradiction by articulating different forms and images of ethnicized community representations and politics in the context of diverse channels of touristic consumption.

Acknowledgements

I extend my sincere thanks to the editors of this volume and annonymous referees for insightful comments. My colleagues Avitoli Zhimo, Kanato Chophy and Nilika Mehrotra gave useful inputs on an earlier draft of this chapter.

Notes

1. This chapter is based on intensive fieldwork conducted in Nagaland between November 2003 and April 2004 and again in March–April 2010 and February–March 2013. Secondary data was collected from national and state archives and local libraries.
2. The districts of Nagaland are Kohima, Phek, Mokokchung, Wokha, Zunheboto, Tuensang, Mon, Dimapur, Kiphire, Lonleng and Peren.
3. The 17 recognized tribes of Nagaland are: Angami, Ao, Chakhesang, Chang, Khiamniungan, Konyak, Lotha, Pochury, Phom, Poumai, Rongmei Naga, Rengma, Sangtam, Sema (Sumi), Mao (Memei), Yimchunger and Zeliang.
4. Retrieved from:http://tourismnagaland.com/index.html

References

Adams, Kathleen M. (1997) 'Ethnic tourism and the renegotiation of tradition in Tana Toraja,' *Ethnology*, 36(4): 309–32.

Adams, Vincanne (1996) *Tigers of the Snow and Other Virtual Sherpas: An Ethnography of Himalayan Encounters*, Princeton, NJ: Princeton University Press.

Adorno, Theodor W. (1970) *Aesthetic Theory,* Gretel Adorno and Rolf Tiedemann (eds), trans. Christian Lenhart, London and Boston: Routledge and Kegan Paul.

Adorno, Theodor and Horkheimer, Max (1993) 'The Culture Industry: Enlightenments Mass Deception', in *Dialectics of Enlightenment*, T. W. Adorno and M. Horkheimer (eds), New York: Continuum.

Ao, M. Alemchiba (1970) *A Brief Historical Account of Nagaland*, Kohima: Naga Institute of Culture.

Barth, F. (1994) 'Enduring and Emerging Issues in the Analysis of Ethnicity', in *The Anthropology of Ethnicity: Beyond Ethnic Groups and Boundaries*, Hans Vermeulen and Cora Govers (eds), Amsterdam: Het Spinhuis.

Benjamin, Walter (1968 [1935]) 'The Work of Art in the Age of Mechanical Reproduction', in *Illuminations,* Hannah Arendt (ed.), London: Fontana, 214–18.

Berleant, A. (1991) 'Notes for a cultural aesthetic', http://www.eki.ee/km/place/pdf/KP2_02berleant.pdf/ (accessed 4 October 2013).

Boissevain, J. (2006) 'Coping with mass cultural tourism: structure and strategies', *GazetoInternacia de Anthropologio*, http://anthropologia.unmh.es/GIa/index.htm

Chaube, S. K. (1970) 'Nagaland: its place in India', *Mainstream* (3 January).

Clifford, J. (1988) *Predicament of Culture,* Cambridge, MA: Harvard University Press.

Cohen, Erik (1984) 'The sociology of tourism: approaches, issues and findings', *Annual Review of Sociology*, 10: 373–92.

—(1998) 'Authenticity and commoditization in tourism', *ATR*, 15: 371–86.

Coote, J. and Sheldon, A. (eds) (1992) *Anthropology, Arts and Aesthetics*, Oxford: Clarendon Press.

Crick, M. (1989) 'Representations of international tourism in the social sciences: sun, sex, sights, savings, and servility', *Annual Review of Anthropology*, 18: 307–44.

Davies, Karen (2011) 'Cultural events as a catalyst for increased intercultural communication and understanding', *The Journal of Tourism and Peace Research,* 2(1): 70–9.

Forster, J. (1964) 'The sociological consequences of tourism', *International Journal of Comparative Sociology*, 5(2): 217–27.

Ghosh, B. B. (ed.) (1981) *Tuensang District Gazetteer,* Kohima: Government of Nagaland.

Graburn, N. H. H. (1976) *Ethnic and Tourist Arts: Cultural Expressions from the Fourth World,* Berkeley: University of California Press.

Greenwood, Davydd (1989 [1977]) 'Culture by the Pound: Anthropological Perspective on Tourism as Cultural Commoditization', in *Hosts and Guests: The Anthropology of Tourism,* Valene Smith (ed.), Philadelphia: University of Pennsylvania Press.

Handler, Richard (1984) 'On socio-cultural discontinuity: nationalism and cultural objectification in Quebec', *Current Anthropology,* 25: 55–71.

—(1986) 'Authenticity', *Anthropology Today,* 2(1): 2–4.

Handler, R. and Linnekin, J. (1984) 'Tradition, genuine or spurious', *Journal of American Folklore,* 97: 273–90.

Hobsbawm, Eric (1983) ' Introduction: Inventing Traditions', in *The Invention of Tradition,* Eric Hobsbawm and Terence Ranger (eds), Cambridge: Cambridge University Press.

International Union of Official Travel Organisations Document (1963), The United Nations' Conference on International Travel and Tourism, Geneva.

Iseminger, Gary (2004) *The Aesthetic Function of Art,* Ithaca, NY: Cornell University Press.

Keen, Steve (1993) 'Use-value, exchange-value and the demise of Marx's Labor Theory of Value', *Journal of the History of Economic Thought,* 15: 107–23.

Linnekin, Jocelyn (1983) 'Defining tradition: variations on the Hawaiian identity', *American Ethnologist,* 10: 241–52.

—(1991) 'Cultural invention and the dilemma of authenticity', *American Anthropologist,* 93(2): 446–9.

Longkumer, Arkotong (2013) *Who Sings for the Hornbill?: The Performance and Politics of Culture in Nagaland, North-East India* (Part I and Part II), http://thesouthasianistblog.co.uk/ (accessed 14–19 February 2013).

Lotha, Abraham (2007) *History of Naga Anthropology (1831–1947),* Dimapur: Chumpo Museum.

Marx, Karl (1996) 'Capital: A Critique of Political Economy' (Vols I–III), in Karl Marx and Friederich Engels, *Collected Works* (Vols 35–7), New York: International Publishers.

Mazzarella, William (2004) 'Culture, globalization, mediation', *Annual Review of Anthropology,* 33: 345–67.

Oppitz, Michael, Kaiser, Thomas, von Stockhausen, Alban and Wettstein, Marion (2008) *Naga Identities: Changing Local Cultures in the North East of India,* Gent: Snoeck Publishers.

Patnaik, Soumendra Mohan (2007) 'Anthropology of tourism: insights from Nagaland', *The Eastern Anthropologist*, 60: 3–4.

Ricoeur, Paul (1990) *Time and Narrative (Temps et Récit)*, 3 vols, trans. Kathleen McLaughlin and David Pellauer, Chicago: University of Chicago Press.

Schadler, K. F. (1979) 'African arts and crafts in a world of changing values', *See de Kadt*: 146–56.

Sneft, Gunter (1999) 'The presentation of self in touristic encounters: a case study from Trobriand Islands', *Anthropos*, Bd. 94, H. 1(3): 21–33.

Theodossopoulos, Dimitrios (2013) 'Laying claim to authenticity: five anthropological dilemmas', *Anthropological Quarterly*, 86(2): 337–60.

Urry, John (1990) *The Tourist Gaze*, London: Sage.

Urry, J. and Larsen, J. (2011) *The Tourist Gaze 3.0,* London: Sage.

Wagner, Roy (1975) *The Invention of Culture*, Englewood Cliffs, NJ: Prentice Hall.

White, G. (1991) *Identity Through History: Living Stories in a Solomon Islands Society*, Cambridge: Cambridge University Press.

Wood, Robert (1998) 'Touristic ethnicity: a brief itinerary', *Ethnic and Racial Studies*, 21(2): 218–41.

Zhimo, A. G. (2008) 'Cultural continuity and change among the Sumi Naga: Insights from anthropology', *International Research Journal of Social Sciences*, 1(1): 195–205.

15

Reflections upon the Meaning of Contemporary Digital Image-making Practices in India

Giulia Battaglia and Paolo Favero

The introduction of digital imaging has constituted a revolutionary transformation in the production and consumption of visual culture. By changing the way in which we produce, store and share images (cf. McQuire 2013; Hoskins 2009), digital technologies have generated a shift, signalling a radical transformation in our understanding of the nature of visuality at large (cf. Crary 1990). They have also boosted a new wave of interest and debate regarding the nature and function of images.

Scholars from a variety of different fields are today engaging with renewed intensity in an exploration of the ontological and epistemological changing status of the visible. Moreover, they are addressing the social and cultural functions of images amid a changing world (cf. Banks and Ruby 2011; Grasseni 2004, 2011; Pink 2006, 2007). While much attention has been devoted to the increased speed and size of production and distribution of images, less research has been conducted on the *practices* that characterize our interaction with them and the *range of diversity* of such practices existing in different parts of the globe. Side by side with the spread of new technologies, the last decades have in fact witnessed the growth of new image-based communication practices in the fields of art, commerce, media, to mention a few. Such practices are moulded on the basis of local contexts, adapting and responding to a variety of contingencies – namely infrastructure, socio-cultural context and ideological flows. This chapter is a first attempt to explore this topic. It will offer a series of reflections on the meaning of digital image-making practices in the Indian context. In particular, it will bring in dialogue overarching debates regarding the changing global meaning of images with ethnographic examples gathered from the Indian subcontinent.

Before starting our exploration of digital image-making practices in the south Asian context, it is important to highlight that this text is the result of a long-lasting conversation between the two authors who, in the past few years, have found a common interest in this field. Positioning itself in the interstices between anthropology, film studies and contemporary art practices, our chapter will address the

triangular relationship between technology, aesthetics and politics and reflect upon the relationship between anthropologists interested in digital/visual culture and artists entrenched in digital practices in India.

The chapter is thus divided into three sections. In the first part, it concentrates on the materiality of digital images and the way in which, in the contemporary context, these images destabilize the conventional assumptions regarding the meaning of images and visual culture at large. Here, we will also suggest that contemporary digital image-making practices facilitate the creation of new forms of collaboration, participation and political action.

The second part will analyse the specific case of India. We will draw on our ethnographic data and show the way in which questions concerning digitality, interactivity, image-making and image-sharing have been moulded in the context of the digital practices emerging in the subcontinent. In so doing, we will also explore how these practices are increasingly taking space within the already established documentary and art traditions. With specific reference to India, we will analyse the way in which digital imaging interweaves with practices of activism, archive and art-installation, offering new interactive ways to 'produce' and 'consume' images.

The final part of this chapter will attempt to raise some critical reflections regarding the possible consequences of an increased dialogue with contemporary image-makers and image-making practices for what concerns the production and communication of anthropological knowledge. In particular, we will look at the most recent 'curiosity' in digital image-making practices, which has developed within the field of visual anthropology, and suggest a redirection of these practices towards new ways of production and collaboration. Eventually, we will argue that a focus on new digital imaging technologies and practices will make anthropology more accessible outside academia but also enrich from within by offering innovative subjects of study. We will also suggest that attention to digital imaging practices will better position anthropologists in relation to their students and colleagues who for academic and/or non-academic purposes are increasingly engaging with questions and practices of digital image-making.

This chapter will act as a first theoretical and empirical mapping of the terrain of new digital imaging practices in the subcontinent. Hence, we invite our reader to approach our ideas in this light rather than as a complete mapping of this area. This chapter constitutes for us an instrument for deepening our ongoing investigation and for planning an extensive research project on the subject. We hope, nonetheless, that the account will stimulate the reader to reflect upon the meaning of images and visual culture in the Indian subcontinent.

Towards a new notion of image-making

Contemporary digital imaging technologies are posing an evident threat to our conventional ways of relating to images and visual culture at large. The ever-increasing dialogue between the visual field and digital technologies has resulted in a number of practices leading to a renewal of what we typically mean by images, photographs and/or films. Without adhering to simplistic celebrations regarding the emancipatory and democratizing power of digital technologies, nor to nostalgic complaints regarding their responsibility in causing the final dissolution of material reality (cf. Gere 2005), we nonetheless acknowledge that images' increasing ubiquitous role in contemporary wired countries[1] is indeed leading to a number of consequences. User-based platforms such as Facebook, Twitter and YouTube, the interactive screens and virtual environments used in videogames, art, museum settings and public spaces, the imaging softwares and applications present in most mobile phones and the growing popularity of interactive and participative/shared films and works of art have today become part of the everyday life of most of the citizens living in the digitally connected parts of the world.[2] Also enhanced by the development of cheap personal cameras (among them the revolutionizing mobile-phone cameras) and user-friendly editing programs (such as Photoshop and I-movie and their likes), such new technologies are progressively socializing actors into new communication languages, interpellating them not only as consumers but also as producers/authors of images (something which also contributes in blurring the boundary between amateur and professional image-making [cf. Murray 2008]). In such contexts, we seem to be faced with what Jacques Rancière (2009) called the 'emancipated spectator', i.e. a spectator skilled in interpreting and using images in innovative ways and no longer a passive consumer (and 'victim') of someone else's visions and representations. Such a shift requires a number of changes regarding not only how we relate to image users but also to the very essence of images and image-making.

In the first place, it is commonsensical to point out how digital images are different from analogue ones with their anchorage in the 'real' (cf. Sontag 1979; Barthes 1993). Digital images appear to be characterized by an undefined, incomplete, ever-changeable character (cf. Mitchell 1994). Better understood as performances rather than objects, digital images are no longer the result of a chemical/material transposition of light upon a surface (as in the analogue case) but rather the result of an electronic process of de-composition and re-composition taking place at the level of the processor (the process called 'filtering'). Such images are hence by definition non-indexical and do not contain traces of the material past that they portray. As Rosen puts it:

> Both indexical and the digital images are produced through machines, but the production of the digital begins from numbers as its mediating materiality. Therefore it can do

without an origin in a profilmic 'here and now' (or 'there and then'); hence the ease with which the indexical imaging of photography and film can be used as the defining other to digital imaging. (2001: 306)

Hence, digital images seem to constitute a threat to our conventional notions of reality. Addressing this issue from a different end, we can also acknowledge how digital images are made up of discrete units of information that can be copied endless times (cf. Mitchell 1994). In such ways, they contribute to generate uncertainty about the status and interpretation of the signifier and about the indexical power of image-making at large. If we have no copies, how can we be sure that reality and authenticity 'actually' exist? Materializing the observations made long ago by Gilles Deleuze (1997), the practices that characterize our use of digital images force us to move away from objectifying notions of representation. With actors becoming skilled in post-production we can today no longer rely upon notions of 'visualism' (i.e. of faith in the correspondence between seeing and believing [cf. Dundes 2004; Fabian 1983]). We also have to abandon the 'myth of photographic truth' (Sturken and Cartwright 2001) that has for long functioned as fundamental to our approach to images. Crary seems to sum up these insights with the following lines:

> The rapid development in little more than a decade of a vast array of computer graphics techniques is part of a sweeping reconfiguration of relations between an observing subject and modes of representation that effectively nullifies most of the culturally established meanings of the terms observer and representation. (Crary 1990: 1)

Constantly opened to reinterpretation and manipulation because of the way in which social actors consume them (namely, the act of clicking on a thumbnail, of enlarging, right-clicking on it to save it, etc.), digital images seem to resist being framed within conventional Euclidean notions of space and time. Regarding the former we may notice that, rather than residing in physical spaces (the drawer in which photographs were once kept), digital images are in fact located through the practices of tagging, sharing, mapping, embedding, etc., in networks. Regarding the latter instead, being accessed primarily through the various user-based possibilities offered by the Web 2.0 (cf. Landow 2006), images today no longer appear as just the 'embalmers of time' that André Bazin (1967: 14) once spoke about in his analysis of photography. In particular, in the context of Flickr, Instagram and Facebook, images seem to offer us entry into a more dynamic notion of time. Increasingly incorporated into and consumed through 'timelines', images are today constantly substituted by new images coming in. Hence, they seem to embody more notions of transience and temporariness (cf. Murray 2008) rather than loss and death (as it has classically been maintained for analogue photography [cf. Mirzoeff 1999]). Representing what Murray (2008) has defined as a form of 'ephemeral aesthetics', digital images therefore require from us the capacity to abandon the references of

time and space which have characterized our understanding of photography, film and images at large.

As 'new ways to reflect on who we are and how we relate to others' (Wesch 2009: 19), contemporary image-making and image-sharing practices (particularly those online) seem to also ask us to renew conventional approaches to intimacy, domesticity, identity and community-making. Instagram and Flickr (to mention a couple) have proven the emergence of a new attention to small (previously visually insignificant) details belonging to everyday life (the coffee break, the lunch menu, the waiting for the Tube, etc. [cf. Murray 2008]). And YouTube diaries, on the other hand, offer an opportunity to enter the homes of teenagers (and adults) all over the world, transforming such domestic spaces into a space of entertainment for worldwide viewers. Marking a shift in our perception and use of the divide between the public and the private, such practices signal the birth of new forms of collaboration (cf. Quiggin 2006; Kabish 2008; Chesher 2007; Ito 2005, see below). Rather than generating exclusively instances of 'net-worked individualism' (cf. Wellman 2001), digital imaging technologies appear therefore to offer to their users an opportunity to, so to speak, move beyond the screen and the 'online', and to give birth to novel forms of connection with everyday life, to new social relations, communities and forms of political action (cf. Favero 2013; De Souza 2006).

Digital imaging practices therefore seem to blur the conventional distinctions that function as the basis for our understanding of visual culture. Elsewhere, Favero (2013) identifies the field of interactive documentaries (i-docs) as a space in which most of such changes can be detected. As one of the most vibrant terrains of contemporary avant-garde filmmaking, i-docs exploit the possibilities offered by the Web 2.0 to produce a generative, multi-layered, complex, non-linear viewing experience. Deploying the language of hypertext, i-docs are constructed within the logic of what Nelson (1981) calls 'non-sequential writing', i.e. chunks of information connected by links capable of offering a series of pathways. I-docs therefore ask viewers to construct the narrative for themselves, producing meaning as they go along in the exploration of the material. Hence, by incorporating the notions of participation and sharing that lie at the hearth of the Web 2.0 (cf. O'Reilly 2005; Quiggin 2006; Goggin 2009; Shirky 2008; Leadbeater 2009), i-docs actively interpellate the viewer as a co-creator of meaning. They mark a move away from previous understandings regarding the relation between makers and users of images. Such practice mirrors what is taking place on image-sharing platforms, social media, creative archives and databases, and participatory visual arts projects. Here too viewers are actively involved (in manifold ways) in the process of meaning-making. No longer residing in the intentions of the author, meaning and narrative appear in all such contexts to be the result of a dialectic between an empowered, creative spectator/viewer and an author who starts to behave as the orchestrator of other individuals' experiences and views.

A second insight that can be gathered from the study of interactive documentary practices is the blurring of boundaries between different media units. Made up of a

variety of types of materials (data) ranging from video clips, photographs, photographs edited in video, maps, graphics, visualizations of statistics, etc., i-docs display the merging of different media units into one (see the example of *Traverse*, explored in the next section). This merging of different types of data becomes even more visible if we focus on the programming/editing structure of interactive filmmaking software. Extensively funded upon the logic of tagging, such programs today reduce all media (regardless of whether they are sound, text, still or moving image) to keywords and hence to one single code. Such insight runs in parallel with what also happens, more generally, on search engines where thumbnails can, for instance, lead to both videos as well as photographs. It is only in fact through the accompanying text and symbols that we realize whether they are index still or moving images. In these contexts it makes little sense to distinguish between different types of media. Rather, we have to acknowledge the convergence of various media into a generic sense of 'imageness' (Rancière 2008). Through this term, we may give sense to how images no longer belong to the realm of the visible but are becoming 'a regime of relations between elements and functions ... relations between the sayable and the visible, ways of playing with the before and the after, cause and effect' (ibid.: 6).

Finally, shifting our attention more explicitly towards the practices that characterize the interaction between digital images and their users, we also witness in i-docs the emergence of new forms and notions of interaction between on-screen activities and everyday life. Favero (2013) shows how such practices push the users to engage with the materiality and socialness that characterize their lives beyond 'the online'. Through the incorporation of practices and possibilities belonging to the Web 2.0, i-docs seem to bring about different types of connections. They connect social actors in diverse locations with each other, turning, through the shared used of digital images, scattered individuals into a community or even a movement. Rather than representing a form of detachment from material reality or of 'autonomous individualism' (Wellman 2001), i-docs can be seen to function as generators of new social relations and forms of participation in the material, physical and social exigencies of everyday life. Such imaging practices seem, therefore, to offer a precious window onto the social and political transformations that are affecting contemporary capitalist societies. The growing belief in the act of sharing, collaboration and cooperation which characterize contemporary digital culture seems to run in parallel with the growing sensibility for the common good, with the many experiments in creating less centralized and supposedly more egalitarian forms of community life which characterize many of the protest movements that we have recently witnessed. Space does not permit us to go into any further depth; suffice to point out how all such experiences seem to mark a shift towards horizontal and decentralized ways of living and how these notions are mirrored in the modalities of viewing, authoring and participating offered by the i-docs.

Fostering new forms of interpretation and exploration of the materials of which they are made up (videos, photographs, sounds texts, etc.), many new imaging

projects generate novel connections between life online and life off-line. Informed by the principles of participation, sharing and relationality that inform contemporary social networks, they invite us once again to leave the frame and engage with the social and political nature of everyday life. I-docs are an evident example of what Bourriaud (1998) called 'relational aesthetics'. In other words, they force us to re-think our conventional ways of addressing (and describing) image-work.

As we are going to explore in the next section, although yet to be addressed as forms of i-docs, the changing scene of imaging practices in India is surely offering a significant contribution to this global technological transformation. Our exploration of imaging practices in the South Asian context will make us reflect on the manifold ways in which digital image-making practices evolve with the context in which they emerge.

Towards multilinear practices of image-making in India

Several considerations need to be made when addressing questions of technology, production and consumption of images in the Indian subcontinent. Three of these considerations are of particular relevance for this chapter. In the first place, it is important to remember the significance of the tradition of documentary film practices in India and to highlight the way in which, in this tradition, the triangular process between filmmaker, film subject and film viewer has always been considered to be as important as the filmic text itself.[3] Secondly, we need to pay attention to the role that 'activism' has played in this tradition, varying from grassroots activities to independent artwork. Thirdly, a note on the relationship between technologies and resources/infrastructures will enable us to better locate the debate on digital imaging practices in contemporary India. It is only after exploring these points that we will be able to grasp some nuances of the contemporary practices of image-making emerging in the subcontinent.

In her historical ethnography, Battaglia (2012a) suggests that documentary filmmakers in India have always prioritized the performative and dialogic aspect of filmmaking in relation to its audience. Documentary films in India are in fact understood, to paraphrase the well-known filmmaker Sanjay Kak, as a relationship between reality, filmmaker and audience (2000: 21). Following this view, and juxtaposing this reflection with the process of acquisition of anthropological knowledge, Battaglia (2012a) talks about documentary film practices in India as constituted of a triangular relationship between filmmaker, film subject and film viewer. It is thanks to this triangular relationship, she argues, that documentary filmmakers have historically intervened in public debates and grassroots activism. In this context, activism in documentary film can be understood, as suggested by Chanan (2007), as the politically performative act of filmmakers in relation to film subjects and film viewers. Some examples will help us to clarify this point.

Among other things, in her work, Battaglia (2012a, 2014) brings the analysis of contemporary documentary practices in the subcontinent in dialogue with the tradition of 'travelling cinema' and its correlated use of (digital) technology. Similarly, in his recent fieldwork, Favero has addressed the topic looking into the encounter between digital technology and cultural and infrastructural logics – especially relating to the urban and rural infrastructural divide. A few relevant examples from his recent work may help to exemplify this discussion.

Sanjay Joshi (a Delhi-based activist and filmmaker) revealed to Favero that for him the digital has been fundamental for developing his nomadic festival called Cinema of Resistance – an event that started out in Gorakhpur, Uttar Pradesh, and that has now spread to several towns and villages of North India (Interview, April 2013). Taking the notion of the digital in a more down-to-earth terrain, Joshi suggests that new technologies allow primarily for the reproduction of film copies and mobile projections in a cheaper and more moveable manner. Hence, according to Joshi, digital technologies have been fundamental for allowing films and their constituent critical resistance to travel across the country. This tradition, however, cannot be limited to digital technology alone. As Battaglia (2012a, 2014) points out, the contemporary use of digital technology in documentary film circulation in India builds upon previous practices, particularly the circulation of videos. Furthermore, in rural contexts, digital technology often mingles with a poly-media environment in which digital, analogue and conventional media (such as, for instance, loudspeakers) coexist (cf. Battaglia 2012a, 2014). Nevertheless, in urban settings, digital technology meets documentary film practices in more sophisticated ways. Even though the technological limitation is still an important aspect to address (e.g. in relation to available electricity, internet speed, costs etc.), urban India offers important examples on the use of digital technology for image-making practices that, we believe, cannot be excluded any more from scholarly debates.

The project Bell Bajao (Ring the Bell), set up by the organization Break Through, is an example of this phenomenon. A campaign targeting men to intervene against domestic violence, Bell Bajao is made up of a series of video clips (uploaded by amateur filmmakers) telling true stories of men and boys stopping violence with one ring of a bell. In this case, the internet has played a key role in the development of the project, which allowed different forms of participation as well as creating millions of visitors.[4]

Much more innovative and cutting edge, *Traverse* (2010), a small interactive piece of work made by Bharath Haridas (a graduate student in visual communication from the Srishti School of Art, Design and Technology in Bangalore), is an example of digital imaging practices that urges further exploration (cf. Favero 2013). With the help of Korsakow (an open source software for interactive audio-visual storytelling), Bharat Haridas wanted to share his experience of being an NRI ('Non-Resident Indian' – that is, an Indian living abroad) returning to his country of birth and witnessing the many changes that had taken place during his absence.

Conceptually maximizing the use of the software adopted, this film uses multiple screens in order to generate a series of overlaps and disjunctures between space and time. In *Traverse*, the spectator is invited to explore the artist's memories, his travel back to India, as well as his visions of the future in a continuous movement between video clips, photographs, sounds and texts. This work crosses what video installations seem to be also doing in contemporary India.

Although not necessarily connected to open source software, video installations in India have a significant weight in understanding the context of multilinear practices of image-making that go beyond the traditional film narrative and film text. The Raqs Media Collective, an artist group associated with the Sarai research centre in New Delhi, is probably the best known name at a national and international level in the field of digital imaging practices.[5] The people involved in the collective started as filmmakers in the mid-1990s and have gradually moved away from it, experimenting more with digital technology and art spaces. Nevertheless, they have continued to maintain close contact with documentary filmmakers in India, often providing them with new platforms for art and film exhibitions. As Shuddha Sengupta, one of the members of the collective, suggested to Favero:

> [T]he scope of the image-maker, documentarist or artist today is no longer that of showing what was previously unseen given that today this, with the present spread of new imaging technologies, can be done by anyone. Rather her duty is to create a space in which viewers can share their own experiences and reflections around topics characterizing their everyday life. (Interview, April 2013)

Raqs Media Collective is not alone in this activity. During her fieldwork (2007–9), Battaglia interacted with several independent individuals, including Nilanjan Bhattacharya (a Kolkata-based filmmaker), Venkatnarayanan Soudhamini (a Chennai-based filmmaker), Rajula Shah (a Pune-based filmmaker) and groups of individuals such as Chitrakarkhana/CAMP (a Mumbai-based group), who have also been following this direction (cf. Battaglia 2012a). Stand-alone filmmaker and visual artist Amar Kanwar is arguably the only single individual in India who has acquired tremendous popularity at a national and international level. Since the late 1990s, he has been screening his films to an international audience varying from art installations to classic documentary films yet visualized with multilinear narratives. *A Season Outside* (1997), *A Night of Prophecy* (2001), *The Face* (2005) and *The Lightning Testimonies* (2007) are only some of Kanwar's well-known art-film work.

The work of Kanwar, along with Bhattacharya, Shah, Soudhamini and the Raqs Media Collective (to mention a few), are examples of the way in which imaging practices in India have travelled from traditional documentary film forms to more experimental, digital, multilinear practices within and outside film genres (cf. Battaglia 2012a). As we are going to point out in the next section, while crossing artistic boundaries, these image-makers have also opened up possibilities

of disciplinary cross-fertilization (cf. also Battaglia 2012b). As Kanwar narrated to Battaglia, while discussing the relationship between his work and both the documentary film and art tradition in India, '... art galleries believe they have discovered me, but I don't think that was the case. My practice has always been inclusive and not fixed to a particular art-work or genre' (Interview, June 2008). Following these examples, what we suggest here is that a look into image-making practices in India can generate key reflections regarding the assumptions that characterize our understanding of the construction and consumption of images at large.

Within this scenario, what we believe to be the most cutting-edge imaging experimentation in the Indian context is to think beyond individual initiatives and towards the creation of digital platforms that can enrich image-making production and consumption. The Public Access Digital Media Archive, better known as 'Pad.ma' (see PAD.MA),[6] is one example of these new directions. Four organizations, Chitrakarkhana/CAMP from Mumbai, Oil21 from Berlin, Majlis Culture from Mumbai, the Alternative Law Forum (henceforth ALF) from Bangalore and Point of View from Mumbai, launched this project in February 2008. In its current form, Pad.ma pursues the idea that the conventional use of video-making needs to be challenged through an open online platform which works as an archive of hard-to-access footage (such as unfinished films, found films, digitized films, outdated films and so forth). The four organizations that launched Pad.ma created an online archive of footage aimed at stimulating more interactivity among film practitioners in India, as well as among scholars, researchers and activists interested in audio-visual forms. In this archive, the uploaded footage must always be accompanied by annotations to which users can add information or comments. Moreover, users can get in contact with the filmmaker (who uploaded the audio-visual material) and request to make use of the images for other projects.[7]

The concept of shared footage and/or an interactive archive, however, does not belong to Pad.ma alone. During her fieldwork, Battaglia encountered other attempts that emerged in contemporary India with varying degrees of success (cf. Battaglia 2012a). A group of activists from all over India collected images of the Gujarat genocide in 2002 with the idea of creating a shared archive able to go beyond the linearity and completed/finished character of the documentary film. This project, however, never materialized and none of the filmmakers involved has been able to tell what had happened to the footage. Majlis Culture, one of the founder partners of Pad.ma, initiated another archive, also in response to the Gujarat genocide.[8] This archive was called 'Godaam' (2007) and it is still active today, bringing together multiple projects, such as the aforementioned Pad.ma, and more specifically 'Images from Conflict Zones' (2008) and 'City Images' (2008).[9] Following this experience, Majlis Culture worked on other multilinear art practices and initiated the successful interdisciplinary research and archive project 'Cinema City' (2009).[10] Similarly, in April 2007, the aforementioned independent filmmaker Nilanjan Bhattacharya set up a project with the Calcutta Art Research which aimed to create an 'Interpretative

Interactive Archive on Calcutta'. The project generated different 'capsules' of audio, video and written text, coming from the city of Kolkata – some of which were exhibited from February to May 2008 at the MuKHA Art Gallery in Antwerp, Belgium. However, for lack of adequate funds, the project never developed further nor did it materialize into an accessible archive. Later on, Bhattacharya was asked to reproduce a similar kind of work in Bangalore during 'BAR1 art residency', sponsored by the Indian Foundation for the Arts (IFA). The latter project turned out to be a video installation of the city of Bangalore, called *It's Open* (2009).[11]

Following these examples, there is much scope to believe that some practitioners in India are increasingly directing their documentary filmmaking towards multi-linear practices of image-making. Certainly, digital technology plays a central role here. When coupled with questions of 'digitality' such approaches open up several theoretical and practical possibilities through which contemporary filmmakers (and other image-making practitioners) in India seem today to be rethinking their practices. These new digital possibilities increasingly create an overlap between how filmmakers conceptualize their practices as image-makers and how academics (and in particular visual anthropologists, see below) contribute to an on-going trans-forming scene. This point can be explained through Rancière's (2004) concept of 'distribution of the sensible'.

In the book *The Politics of Aesthetics*, Rancière describes the notion of 'distri-bution of the sensible' as the:

> … apportionment of parts and positions … based on a distribution of spaces, times, and forms of activities that determines the very manner in which something in common lends itself to participation and in what way various individuals have a part in this distribution. (2004: 12)

According to Rancière, the distribution of the sensible reveals '… who can have a share in what is common to the community based on what they do and on the time and space in which this activity is performed (ibid.). Moreover, the distribution of the sensible is a notion in which, according to Rancière, politics and aesthetics meet and mingle. Following this logic, we would suggest that 'art' and 'activism' in digital image-making practices in India can be addressed as a combined performative process that materializes in exhibition spaces (whether they be online platforms, art galleries or film festivals). Lawrence Liang, one of the co-founders of the annotated digital platform Pad.ma mentioned above, defined Pad.ma as a political way to intervene in the sphere of the senses.[12] Borrowing from Liang, we would like to extend his definition of Pad.ma to a wider range of digital multilinear image-making practices emerging in the subcontinent; and by doing this, we would also like to challenge the way in which, concurrently, similar activities and debates are becoming consolidated within visual anthropology – yet without paying much attention to art/film practices existent outside academia.

Digital image-making practices in anthropology

Parallel to the developments delineated above, in the past few years anthropologists interested in both art and film have started investigating new ways of engaging with multilinear, art-film narratives and digital practices, both ethnographically and theoretically (cf. Schneider 2008, 2011; Schneider and Wright 2010; Banks and Ruby 2011; Pink 2006, 2011; Grasseni 2004, 2011; Ramey 2011). They have started to investigate the importance of exhibition spaces in art galleries, which today are merging different digital practices of image-making and increasingly attracting anthropological investigation (cf. Basu and Macdonald 2007; Basu 2008; Favero 2009). Conferences such as 'Fieldworks: Dialogues between Art and Anthropology' (Tate Modern, London 2003), 'Beyond Text? Synaesthetic and Sensory Practices in Anthropology' (Manchester 2007), and panels such as 'Exhibition Experiments: Technologies and Cultures of Display' (for ASA 2003 Manchester), have provided platforms for discussion for those anthropologists who position themselves at the intersection between anthropology, art and film. The Conference of the Association of Social Anthropologists (ASA) too, held in New Delhi in April 2012 and focusing on 'Arts and Aesthetics in a Globalizing World', offered another example of the way anthropology is renovating its interest for art practices and discourses as 'new media(ted)' forms. Moreover, while doing this, the conference also gave an example of the way in which India (host of the conference) prioritizes these debates, something that, as we have hinted at, is increasingly visible in seminars and film festivals across the country. As sites in which students, academics and image-makers are brought together, such settings are indeed pivotal performative spaces where exchanges between scholarship and visual practices can take place (cf. Battaglia 2012b). This can indeed constitute a valuable platform for contemporary anthropologists too. Echoing Schneider and Wright, this collaboration between anthropologists and different kinds of practitioners needs to be developed 'through a procedure of mutual respect and understanding' (2010: 21). Thanks to the multiplication of video practices at various artistic and political levels, contemporary image-making scenes (such as the Indian one) suggest that documentary film practitioners and scholars have a unique possibility to both reconsider their past history while also challenging the academic field of anthropology (as well as other disciplines) to direct its 'image-making' towards other avenues of production and collaboration. Building further upon this, new spaces for visual work and academic engagement can not only make anthropological research more accessible for audiences outside academia but also enrich it from within, allowing it to elaborate upon a sensorial understanding of culture and society. After all, as MacDougall long ago suggested, as a 'pathway to the other senses' (1997: 289) the audio-visual can offer not only 'different ways of understanding, but also different things to understand' (1997: 287).

Nevertheless, while increasingly addressing such topics, mainstream anthropology (with the exception of those scholars explicitly active in the fields of images

and the senses) seems reluctant to engage with 'image-making' (and in particular with 'new' forms of image-making) as constitutive practices of knowledge creation. Favero (forth.) addresses the importance of a creative experimentation with images as a critical form of knowledge-making. As the 'systematic production of novelty' (Pickstone in Macdonald and Basu 2007: 2) experimentation is, Favero (forth.) suggests, a transformative process that allows or forces us to rethink and update the meaning of our practice as both image-makers and knowledge creators. After all, as Ruby (1975) also suggests, a visual anthropologist needs to be an expert in both anthropology and visual communication.

The understanding of new digital imaging technologies and practices, we argue, is therefore fundamental today for better understanding our field interlocutors as well as our students and colleagues. Such social actors are today increasingly socialized into multilinear, interactive, participatory practices of image-making and, as a consequence, also of participatory modalities of meaning creation.[13] With objects/subjects turning into co-authors and with viewers turning into co-editors of our works, the act of making a visual product entails the entry into a new field of agency. Challenging the conventional notions of authorship, such experiences ought to make us rethink our approach to knowledge-communication at large. No longer a matter of conveying information from the maker/sender to the receiver, we are perhaps here faced, as image-makers, writers and scholars with the need to rethink our modalities of communication. Inspired by the notion of the 'interactive artist' (Rokeby 1995: 152) as well as by reawakening the ghosts of the 1980s 'writing culture' and of Jean Rouch's (1978) 'shared anthropology', anthropologists must perhaps start reflecting anew on the importance of aesthetical choices and stratagems in communicating ethnographic knowledge and envision their work as the creation of relationships. Rather than transferring knowledge (from the maker/sender to the receiver), anthropologists must think of their work as an experiment in what Bourriaud (1998) has called 'relational aesthetics', that is, as an activity of production of relations with the world with the help of signs, forms, actions and objects.

Notes

1. In this chapter we will not be able to devote attention to a critical discussion of the meaning of the digital divide in the contemporary context. Let us however only briefly point out how, while official figures tell us that 28 per cent of the world's population is today wired, the distribution and meaning of such access needs to be problematized to avoid taking for granted conventional geopolitical divisions (cf. also Moyo 2009). As Norris (2001) has suggested, we need today a more sophisticated typology offering insights into different types of digital

divide, such as the geographic, social and democratic divide which may be able to make sense of all variables involved and also of the way in which digital access may allow the formation of a new transnational middle class.

2. On Facebook, Twitter and YouTube see, e.g. Landow (2006), Miller (2011), Wesch (2007); on interactive screens and virtual environments see Boellstorff (2008), Weibel and Latour (2007), Basu and Macdonald (2007), Sundaram (2009, 2012); on mobile phone imaging see Ito (2005), Koskinen (2004); and on participatory art see Galloway et al. (2007), Favero (2013).

3. To read more about the documentary film genre in India and the way in which it has historically developed in relation to the triad filmmaker, film subject and film viewer, see Battaglia's (2012a) historical ethnography of documentary films in the subcontinent.

4. Bell Bajao has now reached more than 130 million people in India alone and won 25 awards, including the Cannes Silver Lion, and its clips can be explored online or seen on television. In combination with this (and in order to reach smaller places) Bell Bajao has also organized 'video vans' which have travelled 25,000 km and reached more than 7.5 million people. It has also appeared in soap operas and television quizzes (http://breakthrough.tv/explore/campaign/bell-bajao).

5. www.raqsmediacollective.net/ (last accessed 3 December 2011).

6. To visit Pad.ma website and navigate its content, it is necessary to use an open-source browser.

7. Pad.ma was created in 2007 and has continued to develop up to now. While conducting fieldwork (2007–9), Battaglia took part of two of its launches and symposia, observing, participating and collecting field-notes about Pad.ma's development and at its then associated cutting-edge discussions. Since then, the project has gradually developed depending on available international funding. At present, there are several image-makers, such as for instance Bangalore-based visual artist Ayisha Abraham, who make use of this platform to develop their independent projects. Ayisha has recently talked about her way of using this platform during the conference *Exploring Modern South Asian History with Visual Research Methods: Theory and Practice* (Cambridge 2013) with a paper titled 'Passages in Light and Dark'. Battaglia will study the relationship between this platform and image-maker practitioners in South Asia while based at the Musée du Quai Branly during the academic year 2013–14.

8. At present, Majlis Culture is no longer a partner organization of Pad.ma. Yet, it has further developed its own archive projects.

9. www.majlisbombay.org/godaam.htm (last accessed 3 December 2011).

10. www.majlisbombay.org (last accessed 3 December 2011).

11. As Assistant Director to this project, Battaglia was offered unique access to this material.

12. Liang: presentation for the public launch of Pad.ma, 16 February 2009.

13. We are aware of not being alone in this discussion. This point was indeed widely discussed during the 17th edition of the IUAES conference, Manchester 2013. Here, Battaglia presented a paper on the limitations existent within social anthropology and the need to think interdisciplinarily and collaboratively outside anthropology. Felicia Hughes-Freeland reflected on something similar. Well-known visual anthropologist Peter Crawford reinforced these points in a wrap-up discussion about the future of visual anthropology.

References

Banks, Marcus and Ruby, Jay (eds) (2011) *Made to Be Seen: Perspectives on the History of Visual Anthropology*, Chicago: University of Chicago Press.

Barthes, R. (1993) *Camera Lucida: Reflections on Photography*, London: Vintage.

Basu, Paul (2008) 'Reframing Ethnographic Film', in *Rethinking Documentary*, T. Austin and W. de Jong (eds), Maidenhead: Open University Press.

Basu, Paul and Macdonald, Sharon (2007) 'Experiments in Exhibition: Ethnography, Art and Science', in *Exhibition Experiments*, S. Macdonald and P. Basu (eds), Oxford: Wiley-Blackwell.

Battaglia, G. (2012a) *Documentary Film Practices in India: History of the Present*. PhD Dissertation, SOAS, University of London.

—(2012b) '"Persistence Resistance" in London. Between public intervention and practitioner-academic collaboration', *Journal of Studies in South Asian Film and Media*, 3(1): 43–9.

—(2014) 'The Video Turn: Documentary Film Practices in 1980s India', *Visual Anthropology*, 27(1–2): 72–90.

Bazin, André (1967) *What Is Cinema?*, trans. Hugh Gray, Berkeley: University of California Press.

Boellstorff, Tom (2008) *Coming of Age in Second Life: An Anthropologist Explores the Virtually Human*, Princeton, NJ: Princeton University Press.

Bourriaud, N. (1998) *Relational Aesthetics*, Dijon: Les Presses du Réel.

Chanan, Michael (2007) *The Politics of Documentary*, London: British Film Institute.

Chesher, C. (2007) 'Becoming the Milky Way: mobile phones and actor networks at a U2 concert', *Continuum: Journal of Media & Cultural Studies*, 21(2): 217–25.

Crary, J. (1990) *Techniques of the Observer: On Vision and Modernity in the Nineteenth Century*, Cambridge, MA: MIT Press.

Deleuze, G. (1997) *Differenza e ripetizione*, Milan: Raffaello Cortina Editore.

Dundes, A. (2004) 'Seeing is Believing', in *Investigating Culture: An Experiential Introduction to Anthropology*, Carol Delaney (ed.), Oxford: Blackwell.

Fabian, Johannes (1983) *Time and the Other. How Anthropology Makes Its Object*, New York: Columbia University Press.

Favero, P. (2003) 'Phantasms in a "starry" place: space and identification in a central New Delhi market', in *Cultural Anthropology*, 18(4).

—(2005) *India Dreams: Cultural Identity Among Young Middle Class Men in New Delhi*, Stockholm: Almkvist & Wiksell.

—(2009) 'For an AnthroPoArt: Engagement, Digital Technologies and Installation Eesthetics', in *Die Maske – Zeitschrift für Kultur – und Sozialanthropologie*, Vienna. – ISSN 1996-5249.

—(2013) 'Getting our hands dirty (again): interactive documentaries and the meaning of images in the digital age', *Journal of Material Culture*, 18(3): 259–77.

—(forth.) 'For a creative anthropological image-making: reflections on aesthetics, relationality, spectatorship and knowledge in the context of visual ethnographic work in New Delhi, India', in *Media Anthropology and Public Engagement,* Simone Abram and Sarah Pink (eds). New York and Oxford: Berghan.

Grasseni, Cristina (2011) 'Toward an Ecology of Visual Inscriptions', in *Made to be Seen: Perspective on the History of Visual Anthropology*, M. Banks and J. Ruby (eds), Chicago: University of Chicago Press.

—(2004) 'Skilled vision. An apprenticeship in breeding aesthetics', *Social Anthropology*, 12(1): 41–55.

Hoskins, A. (2009) 'Digital Network Memory', in *Mediation, Remediation and the Dynamics of Cultural Memory*, A. Erll and A. Rigney (eds), Berlin: de Gruyter, 91–108.

Ito, M. (2005) 'Intimate visual co-presence, www.spasojevic.org/pics/PICS/ito.ubicomp05.pdf

Kabisch, E. (2008) 'Datascape: a synthesis of digital and embodied worlds', in *Space and Culture* 11: 222.

Koskinen, I. (2004) 'Seeing with mobile images: towards perpetual visual contact, http://www.fil.hu/mobil/2004/

Landow, George (2006) *Hypertext 3.0: Critical Theory and New Media in an Era of Globalization*, Baltimore, MD: Johns Hopkins University Press.

McQuire, S. (2013) 'Photography's afterlife: documentary images and the operational archive', *Journal of Material Culture*, 18(3): 223–41.

Mirzoeff. N. (1999) 'The Age of Photography', in *An Introduction to Visual Culture*, N. Mirzoeff (ed.), London and New York: Routledge.

Mitchell, W. J. (1994) *The Reconfigured Eye: Visual Truth in the Post-Photographic Era*, Cambridge, MA: MIT Press.

Moyo, L. (2009) 'The Digital Divide: Scarcity, Inequality and Conflict', in *Digital Cultures: Understanding New Media*, G. Creeber and R. Martin (eds), Maidenhead: Open University Press.

Murray, S. (2008) 'Digital images, photo-sharing, and our shifting notions of everyday aesthetics', *Journal of Visual Culture*, (7): 147–8.

Nelson, T. (1981) *Literary Machines*, Sausalito, CA: Mindful Press.

Norris, P. (2001) *Digital Divide: Civic Engagement, Information Poverty, and the Internet Worldwide*, Cambridge: Cambridge University Press.

Pink, Sarah (2006) *The Future of Visual Anthropology: Engaging the Senses*, New York: Routledge.

—(2007) *Doing Visual Ethnography: Images, Media and Representation in Research* (revised and expanded 2nd edn), London: Sage.

—(2011) 'Digital Visual Anthropology', in *Made to be Seen: Perspective on the History of Visual Anthropology*, M. Banks and J. Ruby (eds), Chicago: University of Chicago Press.

Quiggin, J. (2006) 'Blogs, wikis and creative innovation', *Journal of Cultural Studies*. 9(4): 481–96.

Ramey, Kathryn (2011) 'Productive Dissonance and Sensuous Image-Making', in *Made to be Seen: Perspective on the History of Visual Anthropology*, M. Banks and J. Ruby J. (eds), Chicago: University of Chicago Press.

Rancière, Jacques (2004 [2000]) *The Politics of Aesthetics: the Distribution of the Sensible,* trans. Gabriel Rockhill, London: Continuum.

—(2008) *The Future of the Image*, London: Verso, Ch. 1: 1–31.

—(2009) *The Emancipated Spectator*, London: Verso, Ch. 1: 1–23.

Rokeby, David (1995) 'Transforming Mirrors: Subjectivity and Control in Interactive Media', in *Critical Issues in Electronic Media*, Simon Penny (ed.), Albany: State University of New York Press, 133–58.

Rosen, Philip (2001) *Change Mummified: Cinema Historicity, Theory*, Minneapolis: University of Minnesota Press.

Rouch, Jean (1978 [1971]) 'On the vicissitudes of the self', *Studies in Visual Communication*, (5)1: 2–7.

Schneider, A. (2008) 'Three modes of experimentation with art and ethnography', *Journal of the Royal Anthropological Institute* (N.S.) 14: 171–19.

—(2011) 'Unfinished Dialogues: Notes Towards an Alternative History of Art and Anthropology', in *Made to be Seen: Perspective on the History of Visual Anthropology*, M. Banks and J. Ruby (eds), Chicago: University of Chicago Press.

Sontag, S. (1979) *On Photography*, London: Penguin.

Souza e Silva, A. de (2006) 'From cyber to hybrid mobile technologies as interfaces of hybrid spaces', *Space and culture*, 9(3): 261–78.

Sundaram, R. (2009) *Pirate Modernity: Media Urbanism in Delhi*, London: Routledge.

—(2012) *No Limits: Media Studies from India*, Oxford: Oxford University Press.

Weibel, P. and Latour, B. (2007) 'Experimenting with Representation: Iconoclash!

and Making Things Public', in *Exhibition Experiments – New Interventions in Art History*, P. Basu and S. Macdonald (eds), Oxford: Wiley-Blackwell.

Wellman, B. (2001) 'Physical place and cyber place: the rise of networked individualism', *International Journal of Urban and Regional Research* 25(2): 227–52.

Wesch, M. (2007) 'What is Web 2.0? What does it mean for Anthropology?', *Anthropology News* (May).

Wright, Christopher and Schneider, Arnd (2010) *Between Art and Anthropology: Contemporary Ethnographic Practice*, Oxford: Berg Publishers.

Visual Projects Cited

Bhattacharya, Nilanjan

- *It's Open* (2009)
- 'Interpretative Interactive Archive on Calcutta' (2007)

BreakThrough

- Bell Bajao http://www.bellbajao.org (2008)

CAMP/Oil21/Majlis Culture/ALF/Point of View

- Pad.ma (2008)

Haridas, Bharath

- *Traverse* (2011) http://bh.mrinal.net/#/?snu=2971 (last accessed 1 October 2013)

Kanwar, Amar

- *A Season Outside* (1997)
- *A Night of Prophecy* (2001)
- *The Face* (2005)
- *The Lightning Testimonies* (2007)

Majlis Culture

- 'Godaam' (2007)
- 'Images from Conflict Zones' (2008)
- 'City Images' (2008)
- 'Cinema City' (2010)

16

Reflections

Marilyn Strathern

'He wriggles his toes inside the quilt that he thinks of as sky-coloured, by which he means blue, not tangerine'

From a prose poem, 'A book of hours', by Vahni Capildeo, Undraining the sea, *Egg Box Publishing (2009).*

I

This volume vividly captures much of the original conference that was at once its inspiration, in the largest sense, and also most concretely the specific source of the texts presented here. It is perhaps too obvious to remark that reappearance in textual form cannot do justice to the stimulating effect of being in conversation, or moving across the many conversations that were taking place. Then, again, the heady mix of social and intellectual interaction that – when they go well – characterizes all kinds of meetings and collective encounters may well effervesce precisely because it cannot be sustained. In this sense one might even decide that one would not wish to sustain any such thing! (Think of how horrible a year-long conference could be.) Obviously, then, the conference was a moment, a performance, whose success came partly from its temporal formatting. That cannot be repeated. Yet the text, this volume, is not a reduced or imperfect version, a less lively rendition of something that had a life elsewhere. Apart from its obvious affordances, such as durability of a sort, or the invitation to an audience unseen at the time, in written form the text has its own life. Its preparation has allowed arguments and ideas to grow, but now within the framework of writing a book chapter or observing a word limit rather than a time limit. Of course, for those used to talking preceding writing (spoken paper before text) or writing preceding talking (notes before a presentation) the flow between them may be almost imperceptible.

This volume arrests that easy assumption. It draws attention to different practices of perceptibility. A significant theme running through the chapters is the extent to

which complex forms of communication can divert conventional channels or cut across the taken-for-granted ability (as in the case of the writers of talks/texts) to talk or write about anything. For the vehicles of many of the arguments here – billboards, the idea of heritage, a cinematic underclass, prison-made dolls, music-makers, warrior poems, the flow of waste – deliberately evoked a wider sensorium. At the conference, there was no possibility of the spoken word sitting down quietly beside images suggestive of multisensory engagement, including the aural and olfactory, and perhaps we should not allow the written word any such rest either. The illustrations reproduced here serve as a visual reminder (and there were plenty of places where words did the work of illustration too).

Indeed, one might conclude that it would be a mistake to see the splendid illustrations in this book *as* illustrations; that is, they are not there to supplement the accompanying text (though they are ornaments too in the nicest sense). Rather they are like the words of poems, unglossable. Poetry can be interpreted, rewritten, turned into other tongues, and for the anthropologist contextualized by appeal to cultural or social milieux, but none of that takes its place *as* poetry. The conceptual authority of the artist's chosen form recurs in these chapters. Yet again, maybe that is a test. If one of the connotations of an art form is that it cannot be glossed – is not translatable into another genre – what about the glossing that has already happened with the graphics? One might ask about the limits of the illustrations here (a still picture from a movie, a photograph's point of view, the trimmed print), for they are all subject to techniques of reproduction and communication. Yet not in the same way as words are chosen, modulated or refined. Is this an opportunity for the reader? Between practices of editing lies a perceptible difference, and becoming aware of a double elaboration, or shortfall, perhaps allows the reader to respond to something of the original vigour of the vehicles that carry the writers' arguments. Not just editing, all kinds of 'differences' within and between genres might do this job. How genres are brought into counterpoint, then, may – or may not – yield an aesthetic effect.

II

In the Introduction, the editors have set out their hopes for the book and what it has accomplished. In particular they bring the chapters back to the governing rubric of 'globalization' in arts and aesthetics. They point to the embeddedness of its processual nature, and are wary of language that renders globalizing processes as nothing so like non-stop glossing machines, as engines of displacement, for transforming (often in the name of communication) one genre of expression into another. That borders are crossable does not mean that any border should be crossed. One focus of these chapters as a collection are those moments of creative practice, of artistic events, encounters and dialogues, that come into being (as moments) through people's attention to specific issues, personal, political and economic, or to

conditions of survival perhaps otherwise unbearable to contemplate, and draw into their making concerns that live again, are made anew, in the here and now. It simply does not matter that forms of expression can be glossed or re-presented, have come from elsewhere or will go elsewhere. For someone attending to them, what matters is the animation, the way they live.

Anthropology brings to the study of aesthetics, the volume argues, an enduring interest in the work of creation, work being understood in the double sense of purposive, relational activity and its object in some kind of sensory intervention in the way people respond to the world. The intervention may be perceptible as an 'intervention' all over again when it involves defiance or resistance, whether directed to canons of taste or to a self-serving politics, and whether unacknowledged as such by the actors or turned into assertions of ownership. The (anthropologists') interest is hardly unique to art and the arts, and some of that debate here is rehearsed in these pages. My own purpose is not to gloss what the editors have spelled out in detail, nor to gloss the potential encounters that the reader might have with the chapters of this book. Instead I return to the conference, and offer some reflections that struck me at the time.

From the point of view of ASA conferences, that of 2012 was remarkable as an interdisciplinary event. It rested on multiple collaborations and multiple sources of inspiration. Our hosts were drawn from the Centre for the Study of Social Systems and the School of Arts and Aesthetics at Jawaharlal Nehru University, as well as from the Indian Anthropological Association and the Indian Anthropological Society. It was a considerable honour and privilege for me to have been asked, as an anthropologist from the ASA, to speak at the end. It was also a bit of a joke, and circulated as such, namely the idea that anyone could offer some kind of gloss on everything that had happened. At the same time, making the attempt was part of what was happening, and the anthropological question was how to respond to the life of the proceedings. The joke was one the conference-goers shared. Everyone, by the end, was in a similar position, and this was the starting point of what I said. Here it is (more or less as spoken, that is, subject to techniques of reproduction and communication) in counterpoint to the book in your hands.

III

This has been a remarkable conference, and it is not really necessary for me to say anything at all. You will each of you know what it has meant to you, the moments that inspired, the moments that surprised, as well as those that left you puzzled or overwhelmed – or underwhelmed for that matter! My own track through the sessions has been as idiosyncratic as yours, and of course I do not presume to speak about the conference as a whole – but then also, of course, it would have been a quite different experience had the conference consisted *only* of those bits that I attended. As always

on these large occasions, the sense of the partial, of having one's experience framed by everything else that is going on, of which one has no more than an intimation, is part of the experience.

This leads me to a suggestion and a comment. The suggestion is how to use these last few minutes to reflect on what has happened. I do not want to waste them by even speaking of my regret at not being at the sessions I could not get to. On the contrary, the comment is on that sense of an intense experience that by its nature is not representative, or representational, not encompassing, not miniaturizing either, but which nonetheless touches on something of what I have understood as art and aesthetics in a globalizing world.

First the suggestion. Obviously it would be absurd for this to be a one-man show. I had thought of getting a panel together, but, as someone observed, everyone will be panelled-out by this stage of the proceedings. So instead, let's compose ourselves as all one panel. I hope everyone here will be reflecting on how they would sum up their experience of the conference. It is only a suggestion. But after a few words from me, hopefully the conversation will travel around the room – what I am going to say does not make a paper, and does not seek commentary. [There was indeed a general discussion at the end.]

Of course, for those who work closely with the concepts of art (and the arts) and aesthetics, the way in which these concepts have travelled across domains may in turn have been exciting, or scandalous, or inappropriate. Otherwise put, the topic seems to have mobilized a huge range of responses from many corners of visual studies and the social sciences. We have heard about the aesthetics of craft, of governance and pollution, science and forensics, fashion, death, wedding videos, cultural tourism, conversion, destitution. There are, we have learnt, many ways in which aesthetics shapes the apprehension of politics, religion, ritual performance, and sometimes too we have heard about economics and not least about intellectual property. All this is quite apart from how visual studies itself probes the articulation of protest, of activism, of identities, of memories, of everyday life and concepts of the self. Then there are the effects of the new media and the multiple means through which the new media re-sensitizes our reception of information and documentation, and invites further sensory explorations of experiences, or of the exercise of skill in people's encounters with materials, and their emotional and affective engagements, whether with the environment, the landscape or moral practices. And throughout all this has been the invitation to reflect upon our accessibility as observers and academics and practitioners and critics on imagery that comes courtesy of the media.

Now the facility with which certain concepts and topics have travelled has not only been due to their intrinsic power; it also lies in the nature of conferences of this sort. For it seems a very regular, if not universal, experience that whatever the organizing trope, one seemingly finds it everywhere. And that ubiquity can also seem a bit false, because everyday academic reflective (critical, performative) practice invests the concepts and topics – whatever they are (property, cosmopolitanism, art)

– with special meaning. That specialness can apparently evaporate. The very quality that commended itself as a conference theme gets dissipated in the duplication of discussion. However, let me turn that around a bit.

To do so brings me to the comment. It is based just on what I have heard. Or rather, I fly a kite, and you must forgive the audacity. [I did not identify the several specific sessions on whose ideas and presentations I drew; some are found in the preceding chapters.]

I referred to the conference experience as one framed by everything else one knows is going on but remains otherwise 'unknown'. Framed is not quite the right word, unless one thinks of the empty rows of frames in the ghostly Hermitage. Activity on the periphery of one's vision might be closer. It could be a matter of the kind of division of knowledge people experience under conditions of diaspora – and we heard about the accommodations of migrants and their multiple realities – or something a bit closer to the sign-writing by which medical practitioners display their presence, each sign implying a whole world of signs that they know is there but cannot grasp in its totality.

You might think I am talking about the globalizing process in evoking such a multiplicity and things happening in one's proximity that one doesn't know about – even, as we heard in a case of some immigrant enclaves, doesn't care about – but I am actually struggling towards a sense of what one might mean by focusing on art and the arts, and on the many contexts in which we have been invited to think about them, the many reference points involved. Isn't the moment at which one thinks 'art!' the moment at which one points to a figure against a ground of unknowns? One is specifically prompted to a realization of how partial one's experiences are, and is thereby reminded of an unknown whole. I don't mean whole in the form of (the anthropologist's) holism, but simply in terms of the universe of acts, events, reflections, objects that 'art' summons but does not encompass. (In non-art contexts that background may or may not be of particular interest.) Art is also much more, of course, than such a summoning – but bear with me a little.

Perhaps at least one dimension we have been hearing about, over and over again, is the way art and the arts bring the rest of the world – a world – in view, bring it forward. 'So people will know I am here!' says the medical practitioner who puts up a sign of his craft, like the once-peripatetic healers who now decorate their shop fronts, or a contemporary artist returning re-worked colonial objects not to the source of the object but the source of colonization, or videos for YouTube: 'Look, we were there!' For I suspect (and I suppose I am bound to say this as an anthropologist) that conjuring the background of an *unknown world* also additionally, simultaneously, has a social form. This may transcend other perceptions of space and time, as in devotion demanded at a temple or the deliberate manipulation of space in a painting. It takes the social form of the audience or witnesses who are drawn to an exhibit/ display/performance/practice, however wide the repertoire of senses. The point is that the senses are presented in a form graspable by unknown others. These others

may not literally be strangers but, like a play within a play, the artwork makes them strange to one another. World music: access to the ear of strangers. 'So people will know I'm here/we were there.' 'People' are summoned as exemplars of a generic, 'the world', whatever the community or common identity that bounds the world. For this is not the same as a universal appeal to everyone; rather it is a generic appeal *to anyone*, to a form in which particular persons do not ordinarily exist.

Does that experience of a generic capacity within oneself, as one might have as a stranger towards other strangers, have the makings of an aesthetic moment? One that results in a kind of sensory capitulation? There has to be a sense of a 'public' not encompassed by the display but drawn to it. Which is why Ruskin, who was evoked at one point, poured ridicule on the nineteenth-century manufacturers who wanted to embellish their banks [as in financial institutions] with what looked like art but could not work as art, because it only drew attention to an expenditure of wealth, which didn't need *for this effect* further engagement with 'people', a public, an audience.

One of the things I have learnt from this conference, I think, is that in present times much art is transgressive, that is, in the sense that self-identification – 'Look, I'm here/we were there'! – is transgressive: [insofar as] it cuts across other kinds of relationships, it produces the generic unknown background and the generic public/ audience/strangers who are caught by it. If so, an aesthetic response conceivably requires the obliteration of other relationships. One isn't looking at a pot to eat from or a likeness of a god or the commemoration of a battle; one is looking/hearing/ sensing shape, melody, proportion, colour, or an experience, an event, that draws sensory appreciation from the body. And one is also sensing oneself as a sensible, a sensing, agent, exactly insofar as the social relationships are eclipsed too – cook, devotee, fanatic, documenter. Feeling more like oneself, or less like oneself, both reactions are reported from the singing of protest songs. Does self-flagellation as devotional art yield a de-relationalized, and thus de-personalized, sense of being?

But I don't want to make this idea do too much work, as one of our plenary speakers observed of his concept of 'media fold'. I'm really just reflecting on the form of the conference itself. Not this one alone, but heightened by its specific focus, and speculating on the stimulation that comes from being at an event that inspires, even though one's own experience of it is so limited, and where an essential ingredient is that for all the colleagues ones knows there are so many whom one does not. We work in the presence of those 'anyones' whose work we are ignorant of, and that is partly the point. The ignorance gives a special shape to one's own responses. Which would help explain some of the magic of these meetings – or maybe just the magic of Delhi!

The question, then, on which to end is how to describe the aesthetic form of a conference. Or rather, what might one need to take from an attention to globalization and art in order to frame a question about such an aesthetics?

Index